Image
and
Word

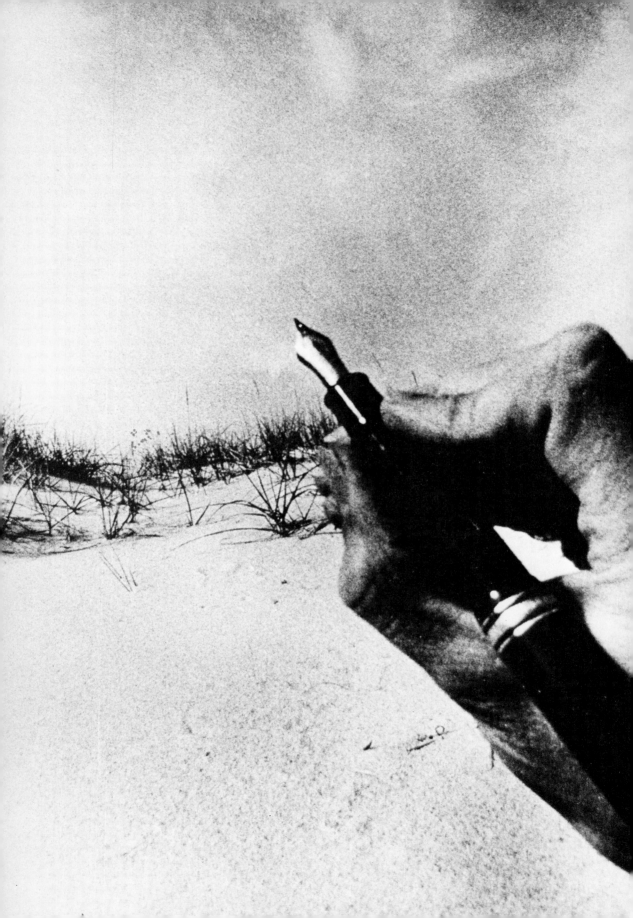

Image
and
Word

Jefferson Hunter

The Interaction of

Twentieth-Century

Photographs and Texts

Harvard University Press Cambridge, Massachusetts, and London, England 1987

Publication of this book has been aided by a grant from
the Andrew W. Mellon Foundation.

This book is printed on acid-free paper, and its binding
materials have been chosen for strength and durability.

Library of Congress Cataloging in Publication Data

Hunter, Jefferson, 1947–
 Image and word.

 Bibliography: p.
 Includes index.
 1. Literature and photography. I. Title.
PN56.P46H8 1987 770 86-18298
ISBN 0-674-44405-1 (alk. paper)

Designed by Gwen Frankfeldt

Frontispiece: Ralph Gibson. Hand holding a pen.

To Pamela

Contents

Photographs

Image and Word

Introduction

In a talk to the Harvard Camera Club, George Santayana once commented that "to complain of a photograph for being literal and merciless, is like complaining of a good memory that it will not suffer you to forget your sins. A good memory is a good thing for a good man, and to admit all the facts is the beginning of salvation."[1] Almost no one would now admit, let alone complain, that a photograph is literal. It is a contrived, composed work of art, like a piece of writing. Yet Santayana's certainty about the results of photography is not mistaken. In the twentieth century photography and writing have together given us a memory for facts and other matters, a memory on which, with suitable cautiousness, we may rely—a good memory. This book is a study of the pictorial and verbal means by which that memory has been achieved.

The subject is not photographs by themselves; not directly at issue are such questions as the historiographic uses and political reliability of the art, the formal differences between photography and painting, the varying ambitions of different kinds of camera work, and the place of photography among other sign systems. Nor is the subject texts by themselves. The subject is *relations* between photographs and texts—the complementariness of the two arts, which has often been taken for granted and often produced collaborations, and the no less interesting antipathy between them.

The most obvious thing about words and pictures is that they routinely appear together, and even the simplest joint appearances—words supplying credit lines or captions, pictures supplying illustrations—suggest how each art works, how the shown is never exactly the same as the spoken. A caption may provide mere information, or a context altogether altering the significance of the photograph it accompanies, or an untruth for the photograph to mock. In practice, the most ambitious writers and photographers have not been content with captions and illustrations but have put their works together in "photo texts"—composite publications evoking a landscape or recording a history, celebrating a community or mourning a loss. The words and photographs of photo texts contribute equally to their meaning; that is how the genre is defined. They must simultaneously

be read and viewed. One of the aims of this book is to examine a number of photo texts—collaborations by Jean-Paul Sartre and Henri Cartier-Bresson, John Muir and Ansel Adams, Berenice Abbott and Elizabeth McCausland; single-author books by Robert Capa, Clarence John Laughlin, and Wright Morris—in order to identify representative techniques of layout and captioning, representative reasons for success or failure.

Whether or not photography is a universal language, as its proponents have claimed almost from the moment of its invention, photo texts are at least an international genre. But it is in the United States that the idea of camera work has been most fascinating to intellectuals and in the United States that photo texts have been most generously funded. Beginning in the thirties, two powerful American institutions supported photographers and their collaborators: the federal government, patron of the Farm Security Administration (FSA) and its so-called Historical Section, a major source of public-domain photography; and the Luce publishing empire. *Fortune* magazine alone employed at one point or another James Agee, Walker Evans, Margaret Bourke-White, and Archibald MacLeish, making it possible for them to undertake documentary work, although their best work was eventually somewhat removed from the magazine's interests. *Life* developed new ways of bringing pictures and captions together and financed individual photojournalists lavishly. Supported by Luce or the New Deal, encouraged by a new interest in reporting, inspired by Depression-era politics, writers and photographers of the thirties produced four documentary collaborations—Bourke-White and Erskine Caldwell's *You Have Seen Their Faces,* Agee and Evans's *Let Us Now Praise Famous Men,* MacLeish and the FSA photographers' *Land of the Free,* and Dorothea Lange and Paul Taylor's *An American Exodus*—which are more ambitiously conceived than any documentary photo texts before or since. Each of these books experiments with layout to convey a distinct message; each professes a faith in documentary truth-telling which more recent photo texts have forsworn.

In a picture with its caption or in a photo text, the relation between photography and writing is functional. But because photographers and writers working in a complementary way did not always manage to find each other and collaborate, there are other sorts of relation. The unconventional portrait photographs of Alvin Langdon Coburn, Alfred Stieglitz, August Sander, and Bill Brandt refuse to characterize, to locate identity in a face, because their subjects are highly complex or highly typical; all these photographs may be matched with similarly unconventional texts by Ezra Pound, Gertrude Stein, Muriel Rukeyser, and George Orwell. No joint publications link these names— only personal affinities, shared sympathies, analogous understandings of human character. Even writers and photographers more tenuously connected than a Coburn and a Pound, a Brandt and an Orwell, put

their arts into a relation simply by expressing a critical opinion. Paul Valéry does so when on the occasion of the centenary of photography he champions the work of his compatriot Daguerre and explains what he thinks cameras can do well: register appearances, lay down "a real pictorial record of the social life" which Balzac himself might have found stimulating. Walker Evans does so when he recalls learning his craft partly from poets. E. E. Cummings and T. S. Eliot taught him "what to see, what was poetic."[2] Many such writers' and photographers' opinions are recorded, some admiring and some disparaging. Among the most interesting are those announced or insinuated by a number of twentieth-century poems about specific photographs or the idea of photography, including poems by Thomas Hardy, Philip Larkin, Elizabeth Bishop, Bertolt Brecht (author of quatrains actually printed on photos from news magazines), and Seamus Heaney. These poems purposely confuse writing and photographing or insist on fundamental differences between the two arts; they examine the relation between image making and time or between a society and the poses it admires; some of them are scarcely intelligible without a comparison to the pictures on which they are based.

This book considers only twentieth-century works, chiefly because the twentieth century offers such a wealth and variety of photographic and photo-textual material. To be sure, a book on relations between photography and writing in the nineteenth century would have material of its own to examine: Julia Margaret Cameron's illustrations to Tennyson, Henry Peach Robinson's illustrations to Shelley, Alexander Gardner's pioneering *Photographic Sketch Book* of the Civil War, Peter Henry Emerson's *Life and Landscape on the Norfolk Broads*. For all their sensitivity, however, the early works were limited by the printing techniques available to them. In Gardner's *Sketch Book*, for example, the photographs are actual prints, which had to be pasted onto the pages; the book could hardly be produced in quantity and was not a commercial success. Commercially successful photographic albums, best-selling news magazines like *Life*, large-format documentary books, short-story volumes or travel literature accompanied by photogravures, illustrated government reports, and poems and photographs published together are all technical developments of the last ninety years, all testimony to a modern liking for collaborative forms. And they are all expressions of a peculiarly modern need for a good memory.

Photographs with Captions

You spoke of the Apollo flight—the first circumnavigation of the moon—the one that produced that now familiar, but still miraculous, photograph of the earth seen off beyond the threshold of the moon . . ."small and blue and beautiful in that eternal silence where it floats." This was one of the great revolutionary moments of the human consciousness, but the moment was not explicit in the photograph nor in the newspaper accounts of the voyage. Only the imagination could recognize it—make imaginative sense of it.

—Archibald MacLeish

A photograph hung against the white brick or bleached linen wall of a museum may satisfy the eye so fully that it needs no caption. The richly toned grays or compositional lines or montage effects—whatever the photographer has employed—keep the image within the bounds of formal appreciation as securely as the mat keeps the print within its borders. In books of photographs the same wordless framing can be managed with white space. Bruce Davidson's pictures of Harlem in *East 100th Street* (1970) and Albert Renger-Patzsch's studies of natural forms in *Die Welt ist schön* [The world is beautiful] (1928)—two of many examples—are so treated. Centered on the oversize page, printed on glossy stock, self-sufficiently beautiful, they ask to be taken as exhibits; forty of Davidson's photographs were in fact shown at the Museum of Modern Art. Nevertheless, in museums and books alike, words impose themselves on the most austerely visual photographic enterprises. Somewhere in the exhibit room a placard introduces the show with a text, a few paragraphs of biography or historical background. Davidson comments on the ghetto in a brief preface, particularizing with words as he never does with images ("a Congo drummer who has two jobs and goes to night school to study aeronautical engineering"). Renger-Patzsch captions his photographs in a separate index section of his book, to indicate that an abstract of curved segments actually depicts a plant, *Sempervivum tabulaeforme,* or that the steel shapes receding on a diagonal into the distance are the guide rail of a funicular and, furthermore, of a funicular in Mathilden-Höhe bei Bad Harzburg. *Die Welt ist schön* also supplies an introduction by Carl Georg Heise.

Somewhere in the vicinity of every photograph there is a hand holding a pen, as Ralph Gibson suggests in an image from his 1970 book *The Somnambulist* (frontispiece). The hand may be at a distance, but it is there. It is closest to the image, literally, in published works combining photographs with text, in all the forms this combination may take: ordinary printed book with photographic illustrations; photographic album with explanatory, technical, or expressive captions; photo essay in *Life* magazine; catalogue of an exhibition; screenplay published with stills; photojournalistic compilation; Whitman's *Leaves of Grass* as illustrated by Edward Weston and sumptuously produced by the Limited Editions Book Club; the *First Annual Report* of the United States Resettlement Administration, for sale by the Superintendent of Documents, price (in 1936) forty cents. The process of publication, as opposed to other forms of display, such as slide programs, wall murals, and museum shows, forces a certain number of words on photography, if only in the form of a title page. But photographs also force words on themselves, as anyone who has overheard visitors to a gallery show of photographs can testify. "She took that in Herald Square, looking uptown." "The woman in that jalopy is going to get to California if it kills her." "Is that really a woman's bottom? How did he get her to lie on the rocks?" Such comments, however obtuse, point to a quality of photographs which must be understood before sophisticated analysis of them can usefully take place, namely to their entanglement with actuality, with the world in which a jalopy is a material object and not a pattern of light and dark. One visitor to a show of documentary photographs commented with admirable succinctness on what he thought he saw: "Real life."[1] Photographs touch on, derive from, belong to a real-life existence outside the complete control of photographers, though always under their partial management.

That real-life existence is one which human beings have always tried to comprehend in words. As William Saroyan remarked: "One picture is worth a thousand words. Yes, but only if you look at the picture and say or think the thousand words." A photograph invites the written information which alone can specify its relation to localities, time, individual identity, and the other categories of human understanding.[2] In most cases that invitation is most promptly accepted by a caption. Captions are a lowly genre of written art, but are not for that reason negligible. Informative or poetic, concise or expansive, they place next to the photographer's partially managed reality the form of partial management we are all capable of: language.

Meditations on a Bog Burial

P. V. Glob's *The Bog People* (1965) is an archaeological study of burials in North European peat bogs. Human remains emerge from the

soil acids of these bogs in a startlingly well-preserved state; some corpses have been mistaken for the victims of recent murders and become the subjects of brief police investigations. Most of the seven hundred Iron Age bodies found over the last two centuries, Glob argues, were in fact victims of violence, sacrificial victims, their throats cut or necks broken in propitiation of fertility gods. His text inventories the finds, marshals the evidence for his thesis, brings in the corroboration of written historical sources (Tacitus), and appends a detailed bibliography—functions, in other words, as a conventional scientific book. In such a book photographic illustrations are expected, and seventy-six of them are provided here, nearly all of them captioned in a straightforwardly informational way ("Contents of a Jutland Iron Age man's purse. From the Ginderup village site"). One plate, however, a close-up side view of the head of a man found buried in a bog at Tollund in Denmark, has invited language of a different and unlocalizing sort (figure 1). It is captioned "The dead and the sleeping, how they resemble one another," with quotation marks in the original to signal that the words are to be taken in some sense other than the purely informational. In a text paragraph on the following page Glob comments that the Tollund man's head is especially well preserved, the best-preserved human head to have survived from antiquity in any part of the world, and adds that "the dead man's lightly-closed eyes and half-closed lips . . . give this unique face its distinctive expression, and call compellingly to mind the words of the world's oldest heroic epic, *Gilgamesh,* 'the dead and the sleeping, how they resemble one another.'"[3]

Gilgamesh is not a surprising text for an archaeologist to recall, but its being quoted here, and requoted for a caption in a consciously artful way, is odd; archaeologists supply information, not poetic interpretation. The reader's sense of Glob's enterprise begins to shift. ("Quotations in my work," wrote Walter Benjamin, "are like robbers by the roadside who make an armed attack and relieve an idler of his convictions.") In this case Glob seems less the measuring, assessing scientist than the meditative onlooker, who claims he is compelled to remember an ancient epic—the image of the Tollund man forcing that perspective on him, rather than the other way round—and who willingly ventures into admiration and imaginative reconstruction: "Majesty and gentleness still stamp his features as they did when he was alive."[4] Along with Glob, readers are moved to a similar meditativeness. They see the photograph in a different way. More precisely, they see that with its caption, and only with its caption, the photograph invites a different kind of linguistic response and belongs, at least in part, to a different order of human understanding. The visual record of an exhumation turns into an exercise in extending sympathy.

The last plate in this highly idiosyncratic work of science is captioned "The Tollund man sacrificed to the fertility goddess, Mother

Earth, who has preserved him down to our own day." The uncanni-
ness of preservation, over and above its archaeological usefulness, in-
trigues Glob. The very stubble of the Tollund man's beard can be seen
on his cheeks. His leather cap is still in place. The peat burial has
defied decay. Imaginatively speaking, it has defied death. The Tollund
man lies suspended in time, eyes "lightly closed," looking as if asleep.
Standing before the glass case in the Silkeborg Museum, the viewer
sees a head "still full of life." The man of the Danish bog, who is also,
via *Gilgamesh,* a man of the ancient Near East, is like all men, like
us. Probably Glob would want it expressed the other way round: we
are like him, as alive, and as mortal. Surviving, the Tollund man pre-
sents us with a *memento mori.* The lesson of all this, of which Glob
seems fully aware, is the contradictory one that time can be stopped
and time can never be stopped. "To life we woke from all that makes
the past," runs the Thøger Larsen poem employed as epigraph to *The
Bog People.* "We grow on Death's tree as ephemeral flowers."[5]

Photography—of this Glob does not seem aware—is a medium of
preservation itself, with powers as uncanny as the bog's, and with an
analogous relation to time. Literally, the Tollund man now survives
only as an image on film; his remains, except for the head, were dis-
posed of after they had been studied and photographed. Photo-
graphed images often have the effect of stopping time, of giving a
form of permanent existence to a single moment. That effect contrib-
utes to their power to halt us in our restless movement past their
meanings. William Carlos Williams, who was devoted to photogra-
phy, as to all forms of avant-garde visual art, and who wrote his poem
"War, the Destroyer!" about the Barbara Morgan photograph of a
Martha Graham dance, once noted, choosing his term carefully, that
the well-taken "still" of a master "stops us in our tracks almost
against our wills," forcing us to "pause before the contemplation of
our lives." The English poet Molly Holden's "Photograph of a Hay-
maker, 1890"—she might be looking at one of Peter Henry Emer-
son's East Anglian landscape photographs—forces the reader to
pause and contemplate the stilled action of a man with a scythe, the
temporarily preserved life of the grasses he is about to cut: "Sweet
hay and gone some seventy years ago / and yet they stand before me
in the sun." In stopping passersby to watch the stoppage of time,
however, photographs finally succeed only in indirectly calling to
mind all the other moments which have disappeared. The picture of
a haymaker in 1890 asserts our distance from his "white shirt lit by /
another summer's sun, another century's."[6] Photographs make time
proceed to the present they do not show.

From the very first, practitioners and critics have noted this ambig-
uous capacity of the art. A nineteenth-century daguerreotypist's slo-
gan urged prospective customers to "Secure the shadow 'ere the sub-
stance fade / Let Nature [light] imitate what Nature made," while

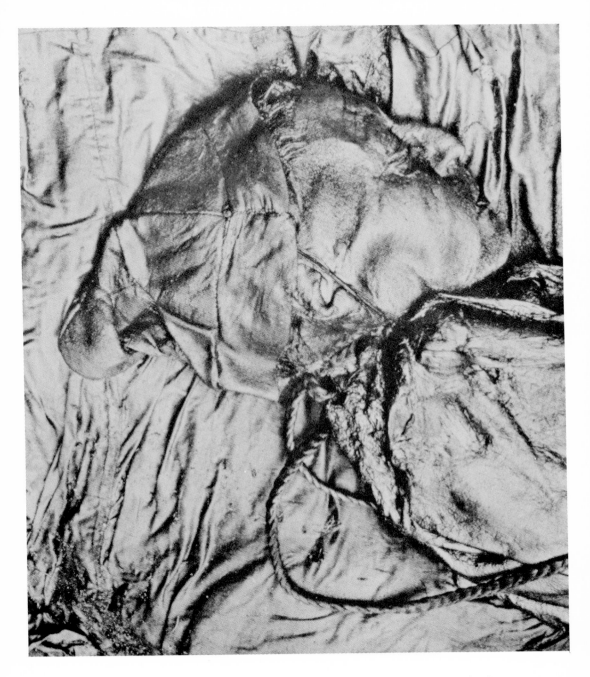

1. Anonymous.
The Tollund man:
"the dead and the
sleeping, how they re-
semble one another."

William Henry Fox Talbot himself, one of the co-discoverers of photography, noted the camera's capacity to record "the injuries of time."[7] The daguerreotypist had family portraiture in mind; Fox Talbot, no doubt, pictures of buildings subsequently demolished; but they might as well have been thinking about the same photograph, since the same photograph can provide a "shadow," so making loss tolerable, but only in a way that finally makes the loss painfully apparent. One twentieth-century viewer of photographs, Seamus Heaney, has written movingly about his habit of looking at the envisioned past and present together, meditating on the injuries of time and pausing before what Williams called "the contemplation of our lives." A half dozen of Heaney's most complex poems are specifically about the figures of Glob's book—the Tollund man, the Grauballe man, the goddess Nerthus, the Windeby girl—set beside the sacrificial victims of contemporary Northern Ireland. The poems draw what one must finally call political meaning from the entanglement with actuality Glob disclosed when he first put unusual words under his photographs of bog people.

In her deliberately provoking role as critic of photography, Susan Sontag considers time-traveling via images a danger, an invitation to sentimentality: "Photographs turn the past into an object of tender regard, scrambling moral distinctions and disarming historical judgments by the generalized pathos of looking at time past." It is true that photographs fail to control the responses they invite and that nostalgia, private associations, and emotional self-indulgence, together with all the written or overwritten comments generated by these variants of tender regard, are always possible. If Glob were the kind of captioner who constantly nudged the reader toward generalized pathos, or the kind of archaeologist who ascribed preservation solely to the gratified ego of the fertility goddess, he would be censurable by Sontag's standards. But he is in fact antisentimental, both in the dozens of photographic plates he comments on in a strictly factual way and in the care he takes, when meditating on the Tollund man, to turn the reader's sensibility in a specific direction, for limited and specific purposes. He regards the past which his photographs bring him as a subject for study, conceiving "study" in an admirably broad way, devoting equal attention to the fertility goddess and tannic acid. He also regards that past as the basis for historical judgment. The same is true of Heaney. No inherent quality of a photograph sets it adrift into Sontag's despised "soft abstract pastness"—paintings, verbal images, or remembered actual scenes are no less likely to be detached from their original contexts and victimized by irresponsible misreadings—though such driftings must be checked, or at least noted, when they occur. Sontag is rightly severe about the historical pretensions of a work like Michael Lesy's *Wisconsin Death Trip* (1973), which puts gloomy newspaper articles and records of mental

asylums next to nineteenth-century photographs in a willfully tendentious way. For good or bad, a photograph is always an object in a context, and the context is determined most obviously by the words next to the photograph. In Roland Barthes's oddly melancholic terms, written as if in longing for a purely visual, purely "denotative" photography, "the text loads the image, burdening it with a culture, a moral, and imagination."[8]

The Varying Appearances of a Plantation Overseer

It follows that different captions for the same picture can give rise to different meanings, and that the different meanings should be evaluated by whatever standards—moral, aesthetic, documentary, historical—seem most appropriate.[9] Roy Stryker and Nancy Wood's *In This Proud Land* (1973), an album of photographs made in the thirties for the FSA, includes a picture by Dorothea Lange showing a white man standing complacently in front of a small group of sitting black men (figure 2). Even without the information at the bottom one can tell that the scene is a small town, the period not the present, and even without a knowledge of the sort of photographs Lange habitually took one can tell that this picture has to do with relationships between representative people. The italicized words at the top, an excerpt from Stryker's preface to the album, seem to direct interpretation more specifically, though it is unclear whether this image, and the fifteen that follow before the next italicized comment appears, are viewed as saying "labor," "capital," "Depression," or all three. In fact, Lange's and the other photographs in the album "say" nothing at all themselves. They collaborate in the meaning which the whole context creates. For example, Lange's photograph and the following one by Marjory Collins, in which a smiling newsboy holds out a *Lancaster New Era* with the headline "AEF Heading Toward Rommel; U.S. Tank Units Enter Oran," form a contrast of a familiar photojournalistic sort: on the left, the sullen relations and helpless inactivity of both labor and capital in the Depression, if the blacks are seen as laborers and the white as capitalist; on the right, the economic bustle of wartime. Bemusement versus excitement; 1936 versus 1942. Such an interpretation would have to be qualified, though, for the presentation of both photographs, in prints of this quality, on paper of this glossiness, with margins of this generosity, in a book of this cost, turns them into artifacts, items valuable in themselves and independent of history. *In This Proud Land* is one of André Malraux's museums without walls; in spite of conscientious efforts to the contrary, it tends to keep the viewer's attention focused on formal qualities.

The same Lange photograph, severely cropped, appears in Archibald MacLeish's photo text *Land of the Free* (1938), with a facing-page poetic "caption" parodying a naively American belief in free-

There are pictures that say labor
and pictures that say capital
and pictures that say Depression.

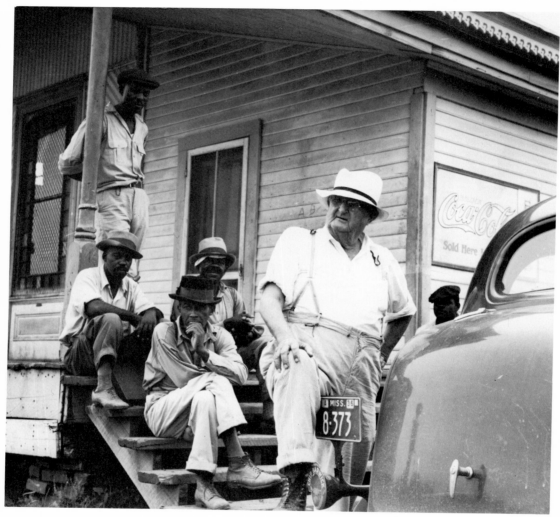

2. Dorothea Lange. Plantation owner near Clarksburg, Mississippi, from *In This Proud Land.*

dom: "We were free because we were that kind . . . We told ourselves we were free because we said so" (figure 3). In his adaptation of Lange, MacLeish allows the photograph to show only the white man, taking him almost entirely out of the Clarksburg, Mississippi, context in which Lange found him. So isolated, the white man looks more like a plain farmer than a plantation overseer. As a plain farmer, he may plausibly be thought of as speaking in MacLeish's "pioneer"

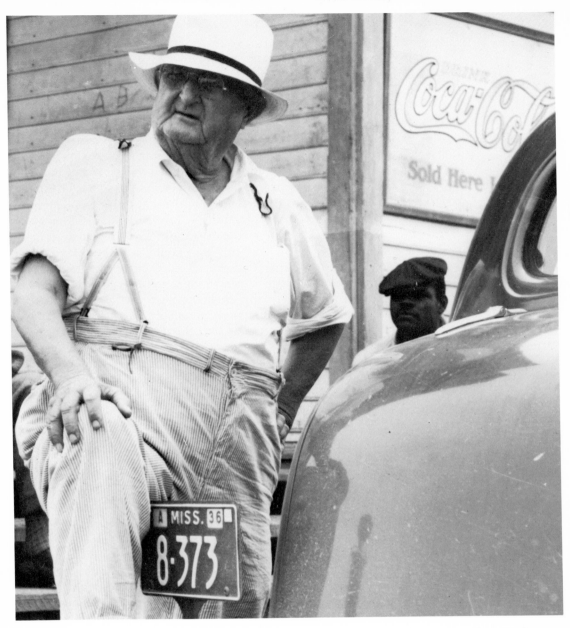

3. Dorothea Lange. Plantation owner near Clarksburg, Mississippi, from *Land of the Free.*

tones: "All you needed for freedom was being American." [10] This is cockiness rhetorically exaggerated into bluster (in adjacent lines, Whitman at his most chauvinistic is quoted) so that it can more tellingly fall off into the confusion of the caption on the following page—the single line "Now we don't know," illustrated by the most famous of all images of Depression helplessness, Lange's "Migrant mother."

The image of the overseer is reprinted in a 1966 collection of

Lange's work, introduced by George P. Elliott, in almost the full size of the plate in *In This Proud Land*. Elliott thinks the image a much more complex statement than anything in MacLeish, a portrayal of "a ruler among his ruled in a social pattern which both the middle-aged white man and the young colored men obviously know and are existing in without evident strain. The Coca-Cola ad is for all of them; the machine is his and his foot is on it." Lange's own reading of the picture, available in a 1982 volume of her work, is similar: "Earlier, I'd gotten at people through the ways they'd been torn loose, but now I had to get at them through the ways they were bound up. This photograph of the plantation overseer with his foot on the bumper of his car is an example of what I mean . . . a man as he was tied up with his fellow." Elliott, who could not have known about Lange's remembered intention, makes no claim for definitiveness on that account; he holds that a 1936 view, the artist's or anyone else's, will be followed by equally credible views as time alters context. What the picture he prints shows, "especially clearly to us thirty years later," is that the Coca-Cola ad and the car "will destroy the whole system of power which seems to the six men in the nature of things. The photograph does not make the usual liberal complaint about this system of power, 'How awful this is'; it says something far more subtle and enduring, 'This is, and because of the way it is, it will cease to be.'" [11]

In 1966 it was relatively easy to dismiss the awfulness of the system of power as the "usual" liberal complaint, but a quarter century earlier Richard Wright had been obsessed by the awfulness. His book *12 Million Black Voices* (1941) combines a florid prose text—half sermon, half populist history—with FSA photographs, among them Lange's of the plantation overseer, once again in a relatively uncropped version but expressive now of a far angrier vision. Where Lange sees people being "bound up" and Elliott sees a "social pattern," Wright sees "a fiat which artificially and arbitrarily defines, regulates, and limits in scope of meaning the vital contours of our lives, and the lives of our children and our children's children." The photograph is embedded in words; that is, it is printed without caption on a page crowded with text, and in another sense it is overwhelmed by words, made to serve as visual corroboration. The white man's casual proprietorship "reads" as slave ownership: "we must be compelled to labor at the behest of others . . . as a group we are owned by whites." The black men, who in a different verbal setting might seem to be neutrally posed, as insignificantly at ease on the porch as the white man is at ease with his foot on the bumper of the car, "read" here as victims of "what this slavery has done," their personalities "still numb from its long shocks." [12]

The reprintings and recaptionings of one photograph may thus go on indefinitely, turning what was news into history, what was propa-

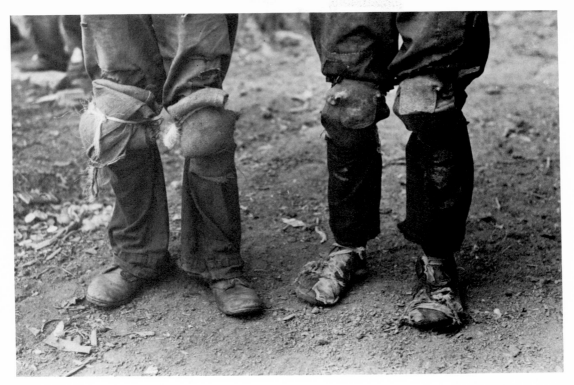

4. Russell Lee.
Arkansas cotton pick-
ers with knee pads.

ganda into art, or vice versa, altering the relation of the photograph
to actuality, confounding hopes for a single, authoritative, stable
meaning. When MacLeish crops Lange's picture, he is not somehow
violating the integrity of an essential, unchangeable significance, any
more than the photographic historian F. Jack Hurley is betraying
Lange when he also crops the image, in a different way, for his own
purposes. Nevertheless, in looking at photographs and their verbal
contexts, one is not bound to an indefiniteness of interpretation that
renders all reprintings equally effective. The handling of the photo-
graph in *12 Million Black Voices,* for example, can reasonably be
questioned. The words develop, somewhat incoherently, a metaphor
about the confinement of black people in a white culture, about being
"situated in the midst of the sea of white faces we meet each day," but
the image above the words shows a white surrounded by blacks.
Throughout the book Wright's stylistic extravagance is at cross-
purposes with the reticence of at least some of the photographs. A
long disquisition on the tyranny of cotton farming, including such
statements as "cotton is not only dictatorial but self-destructive, an
imperious woman in the throes of constant childbirth . . . the harshest
form of human servitude the world has ever known . . . the ritual of
Queen Cotton became brutal and bloody," cannot effectively be illus-
trated by a Russell Lee picture of the makeshift kneepads of two Ar-
kansas cotton pickers, a picture which is "eloquent" exactly in the
degree that it is understated (figure 4).[13] It should be said in Wright's

defense that he may have exercised no artistic control over the choice or placement of photographs; the "photo-direction" of *12 Million Black Voices* is credited to Edwin Rosskam, a photographer and editor who performed similar services for a number of authors in the forties.

Similarly, one can fault Charles Morrow Wilson's *Roots of America* (1936), another production of the documentary thirties, for an arbitrary combining of text and illustrations. The pictures, largely FSA photographs, often have little to do with what they purport to illustrate. A dejected, careworn, lost-in-thought farmer caught by Theodore Jung is labeled "Mr. Missouri" and forcibly connected to the chapter of the same title, a monologue by a sturdily optimistic, indomitable, articulate farmer-philosopher. Youths laboring on a construction project in a photograph by Carl Mydans, above the words "Where a strong back and a weak brain are all you need," are made by those words to "represent" a rural hotelkeeper who has talked about the forgiving mind, strong back, and weak brain you need in his line of work (figure 5). These incongruities may lead one to make judgments about inauthenticity: there is something underhanded, in a book arguing consistently against government action and for pri-

5. Carl Mydans. Civilian Conservation Corps boys at work, Prince Georges County, Maryland.

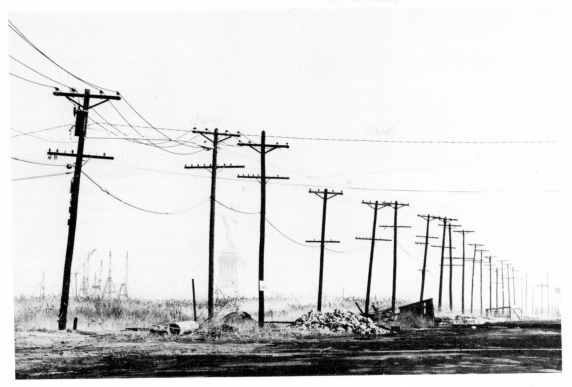

vate initiative, about depending on a government agency for illustrations and particularly about taking those illustrations completely out of their original contexts. The strong back, weak brain photograph actually shows Civilian Conservation Corps (CCC) boys at work on the United States Agricultural Research Center in Beltsville, Maryland.[14] Yet judgments about photographic propriety, which depend on secondary evidence, may not always be possible, and it is important to distinguish them from critical judgments about stylistic consistency or tone, which depend on the primary evidence of what is seen and read and which are always possible. A picture treated in ways that are deeply troubling—cropped, retouched, mislabeled, employed in a fashion its maker would not have sanctioned—may, unlike the CCC photo Wilson mistreats, fit its new context perfectly. Neither photographic beauty nor complementariness of words and images can guarantee evidentiary value.

Smug Texts and Truth-telling Pictures

The Statue of Liberty hovers over a desolate New Jersey wasteland of utility poles, blackened dirt, and wind-blown trash, in a photograph flattened out of perspective by a telephoto lens (figure 6). Printed next to the image is Emma Lazarus's Statue-of-Liberty sonnet welcoming the entry of a metaphorical wretched refuse through a metaphorical

golden door. In a second photograph, a dilapidated house sits in a weed-grown yard; no sign of life anywhere. Underneath, a caption from *Leaves of Grass* celebrates the "land of those sweet-air'd interminable plateaus! / Land of the herd, the garden, the healthy house of adobie!" In a third photograph, a strong sidelight rakes across the front of a Negro schoolhouse in the South, dramatizing every cracked clapboard, the rotten sill, the sagging door. The caption quotes the state constitution: "Separate but equal." In juxtapositions of text and image like these all the uncomplementariness one could wish for, and more, is made available for ironic purposes, for the silent victory of shown precision over spoken rhetoric. Few editors or photographers have been able to resist such victories. Irony is after all a telling effect, and one of the few indirect effects compassable in a medium defined by directness. Irony is also conveniently adaptable to comic purposes; it does not always have to focus on the miseries of poverty or the injustices of racism. A photograph by John Gutmann showing a kid drawing with chalk on a busy street is given the ingeniously hyperbolic caption "The artist lives dangerously."[15]

Still, irony's capacity for serious photographic "statement" is what has made it useful to so many photographers of the twentieth century. Mere depiction, such as the blank ugly wall of a house with cheap siding in David Plowden's *The Hand of Man on America* (1971), the source also of the Statue of Liberty photograph, turns to bitter insinuation when accompanied by high-sounding words from Ruskin's *The Seven Lamps of Architecture:* "Architecture is the art which so disposes and adorns the edifices raised by man for whatsoever uses, that the sight of them may contribute to his mental health, power and pleasure."[16] The familiar modernist tactic here is to champion the past at the expense of the present and hold Black Tom, New Jersey, sneeringly up to Venice, but Plowden urges the reader to a more sweeping pessimism. What people claim as virtues they write about; what they actually do they dispose randomly about the landscape, in cluttered junkyards and derelict buildings, for the camera to record.

In Plowden's book, and in photo texts generally, caption-versus-image ironies grow less effective as they grow more frequent, as is the case with other obvious rhetorical contrivances. It is all too easy to turn language into slogan and to replace argument with clashing juxtapositions. A work consisting entirely or almost entirely of these ironies can quickly become self-defeating. Frederick Barber's pacifist tract *The Horror of It: Camera Records of War's Gruesome Glories* (1932) means to shock the reader with pictures of carnage ironically captioned. Barber favors tight-lipped single-word or single-phrase comment: "Silent" under the picture of a decomposing body; "Field of glory" under a panorama of corpses; "Civilization (?)" under a siege gun being fired; "Good soldiers" under the shrouded figures in a mass grave.[17] Relentless, unwearied, unsubtle—the photographs must be appallingly horrific, the antiwar poetry quoted must be blunt,

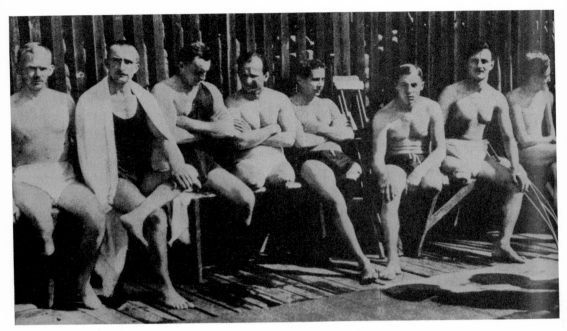

7. Anonymous.
A place in the sun.

and "Civilization" must be followed by a question mark—the book persists in its anger and in the same sarcastic expression of its anger until the reader can hardly bear to turn its pages.

That is not the final effect of an equally relentless antiwar book, Laurence Stallings's influential compilation *The First World War: A Photographic History* (1933). This work, devoted to irony and embittered, is relatively complex in purpose. In it the co-author, with Maxwell Anderson, of *What Price Glory?* and the dramatizer of *A Farewell to Arms* supplies familiar captions for photographs of the battlefields or the home fronts, playing assurance off against the disillusion he and his generation found in the trenches and then, with a maximum of self-consciousness, brought home. Stallings is more adroit than Barber. "Oh God our help in ages past" serves as caption for three different photographs, of clerics blessing English, Russian, and German troops. A picture of German amputees meeting at a swimming pool is captioned "A place in the sun" (figure 7). A Russian village in flames appears above "Keep the home fires burning," a townhouse in ruins above "We bombed the fortress of London successfully." All this is preceded by a sardonic introduction, in which Stallings justifies his method by claiming that a history of the war in the usual terms—strategic, narrative, logical—is impossible: "The editor is conscious of his shortcomings in the matter of captions. Many should be more expert, more military. A military expert, to paraphrase, is one who carefully avoids all the small errors as he sweeps on to the grand fallacy. This book, at least, avoids that fallacy."

There is no conclusion to it . . . The pictures are placed more or less chronologically, but for the most part in a senseless fashion. Who, looking on them, can give the riddle of them?" At first, Stallings goes on, he had hoped to be more exact in the matter of definition and legend, hoped to reveal photographically the world of Ludendorff, Haig, and Foch. But the bearing these "giants of that day on earth" had on events became questionable and, along with it, the bearing pictures had on comprehension. What Stallings can present is only the "camera record of chaos." [18]

In these circumstances of willed disbelief irony becomes a subject, not a method, and therefore tolerable in the quantity Stallings supplies. Irony implies a doubleness of understanding morally superior to the singleness of intention implicit in the world of Ludendorff, Haig, and Foch, and it constitutes a psychological defense as well. The shell-shocked or picture-shocked sensibility retreats into mockery to keep itself sane, to acknowledge in an acceptable way the senselessness or chaos of it all. There is nothing particularly original about such a posture, which had been adopted in most of the antiwar novels, plays, and poetry collections that (starting about a decade after 1918, as far as the prose works were concerned) made their collective attack on the grand illusions of European nationalism. Stallings's *The First World War* is the pictorial-verbal counterpart to Wilfred Owen's poem "Dulce et decorum est," with its savage pairing of a gas attack (the scene visualized) and an old Horatian lie (the words quoted: "Sweet and proper it is to die for one's country"), or of Siegfried Sassoon's "Does It Matter?" with its clash of battlefield realities and homefront platitudes ("There's such splendid work for the blind"), or of the multiplied juxtapositions and satiric collages of John Dos Passos's *1919*.[19] All these works occupy the artistic space between an intolerable directness, which for Stallings is the photographs, and a contemptible logorrhea, which for Stallings is the captioned fatuities under the photographs, and they move about this no man's land with bitter ironic gallantry.

As if to acknowledge a general debt to the novelists and poets, Stallings includes unidentified scraps from their work in his captions, such as "Only the monstrous anger of the guns" under the picture of a howitzer, "Im Westen nichts neues" under a German cemetery in France with row after row of crosses, "No more parades" under corpses, "Little man, what now?" under a German family walking the street, "If I should die think only this of me" under a London recruiting depot, and finally, predictably, "Some corner of a foreign field that is forever England" under a huge crater left by a land mine.[20] Mocking Rupert Brooke, reworking Erich Maria Remarque's or Ford Madox Ford's mockeries, Stallings shores these fragments against his ruin. To put him in the company that phrase suggests seems pretentious, and yet Stallings does with his pictures and captions essentially what T. S. Eliot does with his images and allusions.

Both men, fearful of being thought susceptible to the spurious logicality, the liking for connectedness, of a Lord Kitchener or a Lord Tennyson, forage over the littered ground, retrieve occasional meanings, and savor discrepancy ("When lovely woman stoops to folly" next to the typist smoothing her hair with automatic hand; "How still this quiet corn-field is tonight" next to photographed headlines announcing war). Eliot's sensibility in *The Waste Land* has been most often thought the *flâneur's* or the hallucinator's, but it is also the battlefield scavenger's—that of the stretcher-bearer whom Isaac Rosenberg dramatizes in "Dead Man's Dump" or the "queer sardonic rat" the same poet apostrophizes in "Break of Day in the Trenches." *The Waste Land* (and *Hugh Selwyn Mauberley*) are part of a tradition stretching from the War Poets to Stallings, who culminates it by anthologizing it. Stallings and Eliot differ, admittedly, in their attitudes toward what is seen, Stallings prizing it as a check on attitudinizing, Eliot distrusting it until he can place it, with language, somewhere in his history of sensitive observers. Eliot's image of commuters streaming across London bridge is by itself an oversimplification and plays its proper role in the poem only when it is "captioned" by the Dantean allusion to the many, so many, undone by death.

In the specialized history of photo texts, Stallings's *The First World War*, along with Charles Cross's *A Picture of America* (1932), is the direct ancestor of works like Pare Lorentz's *The Roosevelt Year* (1934) and Lincoln Schuster's *Eyes on the World: A Photographic Record of History in the Making* (1935). The latter anthology of news photographs, headlines, cartoons, and the like is explicitly compared to Stallings's book by the publisher and is dedicated to him. Schuster's excitement about what he is doing with this "new and experimental technique" and its "dynamic arrangement" of "pulsating source-material" promises a bright future for the single-volume photojournalistic compilation, but that future turned out to be brief, as news magazines like *Life* (founded 1936) and *Look* (founded 1937)—with their chief European counterparts, the English *Picture Post* (1938) and the French *Vu* (1928)—took over that part of its functions (and some of its ironic captioning techniques) not taken over by newsreels like the *March of Time* and *Fox Movietone News*. By 1935 Stallings had in fact become an editor for the Fox series, and by 1936 Lorentz had become a documentary filmmaker. Pictures with captions were easily transformed into talking pictures; within a few years there would be traffic in the other direction too.

Words from Real Life

Captioners may set words up to be ridiculed or contradicted by an image in any way they like, including excessively pat or predictable ways. License of this sort allows Stallings to put the picture of a completely desolated French farm under the caption "Pastoral." A differ-

ent combination of words and picture in Stallings, however, suggests a method of avoiding facile ironies: let the words be determined by the real world, let them come to the viewer as uncontrived evidence, and they will contend more subtly with the given image. Douglas Haig's Special Order of the Day for April 11, 1918, printed in facsimile, contends more subtly with the accompanying photograph of British dead (figure 8) than the single portentous word "Harvest" contends with its picture of casualties. The two photographs are paired as if Stallings wished to draw attention to their different captioning techniques. Even the most strident newspaper headline in a photo collage—Schuster's *Eyes on the World* employs a great many of these—may work better than a specially written caption, because it seems (and only seems) less coercive, less insistent on the viewer's getting the point. The two most effective pages in Maisie and Richard Conrat's *Executive Order 9066,* a photographic study of the internment of Japanese-Americans during the Second World War, print on the left a headline from the *Los Angeles Examiner* of May 10, 1943, "Treachery, Loyalty to Emperor Inherent Japanese Traits," and on the right a picture of a young Nisei mother going off to the camp with her sleeping daughter in her arms.[21]

8. Anonymous. Special order of the day.

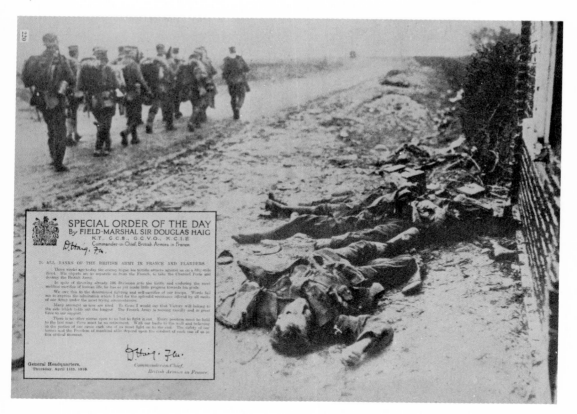

Tabloid language falsifies in one way, bureaucratic language in another. "Death of a Valley" (1960), an *Aperture* documentary by Dorothea Lange and Pirkle Jones, exposes the mechanistic understanding of government men. First, however, it celebrates the beauty of the doomed Berryessa Valley in Northern California, "a place of settled homes and deep loam soil." The captions, printed as prose poetry in handsome sans-serif capitals, venture into metaphor ("the valley held generations in its palm"). They also indulge in sonorous repetition:

> There was still time in the summer of 1957 to bring the cattle down from the hills,
> Time to ship them out of the valley,
> Time for one more harvest.

The captions bespeak a sensibility as fine as Lange's in the photographs, and they clash as sharply as the photographs do with the government specification quoted, as an additional sort of "caption," at the midpoint of the work:

> [The reservoir site] shall be cleared of all trees, stumps, brush, and other woody growth more than 5 feet high and having a butt dimension of more than 2 inches. All fences shall be removed . . . no logs, or branches or charred pieces shall be permitted to remain.
> Buildings shall be removed completely and adobe or concrete structures shall be leveled.
> The contractor shall pile the material to be burned in such a manner that the piles will be as nearly consumed in one burning as possible.[22]

To point up the contrast, the specification is reproduced directly from typed copy, leading one to imagine the government-issue typewriter which in some distant Bureau of Reclamation office has produced all the bland references to burning of material and removal of concrete or adobe structures. What the words "shall be removed" and "shall be cleared" really entail is shown in the photographs that follow, smoke-filled scenes of bulldozers at work and terrified horses running. Once again, photography rebukes a misuse of language.

A yet more rigorously "documentary" clash is captured when words are actually incorporated within the image, when the photographer alone, without the aid of captioner or collagist, conveys by purely visual means some ironic point—usually the discrepancy between promises and events, propaganda and fact. In the Depression the poor wallpapered their shacks with newspapers, as picture after picture records; newspaper ads selling luxury items in bold type thus form a background of riches by which one may measure a foreground of poverty. In a Walker Evans photograph the words "The Lord will provide," framed and hung on a wall, are contradicted by the mean clutter in the adjacent room. Billboards are another obvious source

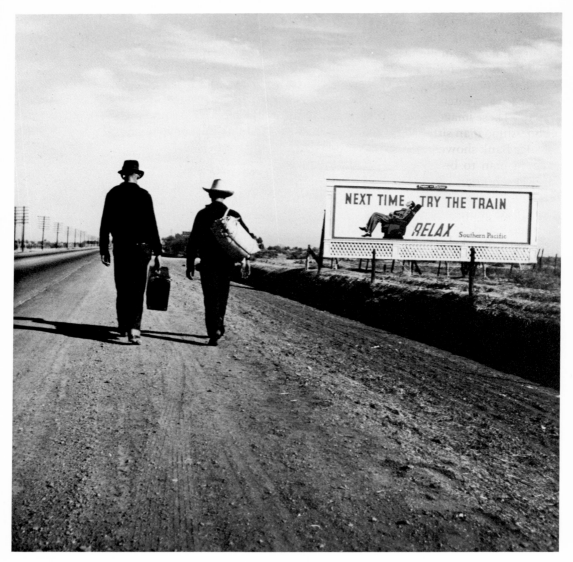

9. Dorothea Lange. Southern Pacific billboard.

of texts to be photographed. A Southern Pacific billboard showing a traveler at ease in his seat, with the slogan "Next time try the train—Relax," looms over a dusty western highway, down which two migrants are walking on their slow way to California (figure 9). This image is so immediately comprehensible that it was turned into a scene in the movie version of John Steinbeck's *Of Mice and Men*. A second railroad billboard puts the words "Travel while you sleep" over a makeshift migrant camp—three families and fourteen children—on U.S. 99. A Ford advertisement on the side of a building in

a small southern town says "All signs point to FORD V-8" and shows a sedan humming along the highway, while in the foreground of the picture a black man plods down Main Street on an ox-drawn cart. To drive the point of this last image home, the author of the book in which it appears adds the caption "The South is a land of contrasts, perhaps no greater than in other regions, but more closely juxtaposed." These images are all by Lange. Arthur Rothstein photographs a shoe-shine man sitting idly on a whisky crate, beneath a New York Savings Bank showcase quoting Disraeli: "The secret of success in life is for a man to be ready for his opportunity when it comes." The English photographer Humphrey Spender shows a church poster reading "Heaven above is sweeter blue, / Earth around is sweeter green," the church itself being soot-blackened, the adjacent street fog-shrouded, and the passersby dressed in black.[23]

Generically, all these pictures are indistinguishable from those in which one part of the wordless image contradicts another part—in which, say, the Statue of Liberty hovers over the Jersey wasteland, as in Plowden's photograph; or the dome of the Capitol building floats serenely over a foreground of Washington slum houses; or Russian citizens sit peacefully on a park bench while in the background a gigantic poster shows heroic air-raid workers disposing of incendiary bombs; or young Chinese womanhood marches confidently into the future on a poster, while in the street beneath bicyclists whizz obliviously on the crisscross errands of routine life in the city.[24] Irony requires only a clash, not a clash between image and words, but it is usually sharpened by an image-word clash, since words convey meaning instantaneously, in a way that can contrast verbal crassness with pictorial sensitivity. Every photograph exposing the assertiveness of advertising claims or the bluntness of propaganda is in effect trading on a secret antipathy between the two modes of expression.

The best known of antiword photographs is undoubtedly Margaret Bourke-White's view of Louisville blacks waiting in line beneath a billboard showing a white family in a car and reading "World's highest standard of living . . . There's no way like the American Way" (figure 10). The blacks are flood victims (Bourke-White took the photo on assignment for *Life*, covering the Ohio Valley floods of 1937), but the picture hardly conveys that fact; it is invariably taken as a general condemnation of economic injustice and racism— "breadline" versus touring car, despair versus smiles, blacks versus whites. Simple the picture's point may be. It confirms at a glance attitudes everyone shares about Chamber of Commerce boosterism and the patient virtues of the oppressed. But the means by which it reinforces a moral position, since photographs can never *create* moral positions, are not as simple as they first seem. The scene on the billboard, for example, is painted in a style that might be thought photographically realistic. It looks like a close-up from a movie; certainly

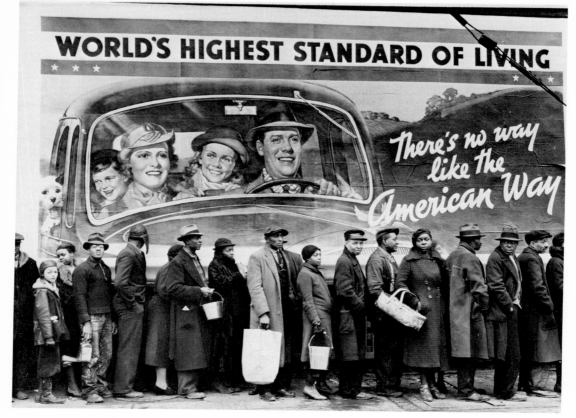

10. Margaret
Bourke-White.
Louisville flood
victims.

viewers of movies or photographs in the thirties, especially FSA pho-
tographs, would have seen a great many faces framed by car wind-
shields or side windows. If the white family is "photographed," then
"World's Highest Standard of Living" becomes a caption. All this
means that Bourke-White's genuine photograph attacks both a
pseudo-documentary style and a particularly specious kind of cap-
tioning, a particularly false application of words to pictures. Her own
"caption" takes the uncompromisingly truthful form of photo-
graphed human figures, the blacks lined up like words underneath the
billboard, commenting silently on its falsity (one of them is appar-
ently looking at it). Bourke-White's photograph, in other words, is
about what slogans can do to sight, not just what whites can do to
blacks, or rich to poor.

"There's no way like the American Way" caught other photogra-
phers' eyes. Rothstein put the billboard in the foreground of a picture
showing cars in a parking lot, shacks, and the backs of buildings.
Lange shot a similar billboard—this time reading "World's Highest
Wages" and showing a father coming home from work and picking
up his little girl, while the mother stands smiling in the doorway—
which perches on top of a bleak dirt slope (figure 11). Edward
Steichen printed Lange's image in a 1939 selection of FSA photo-

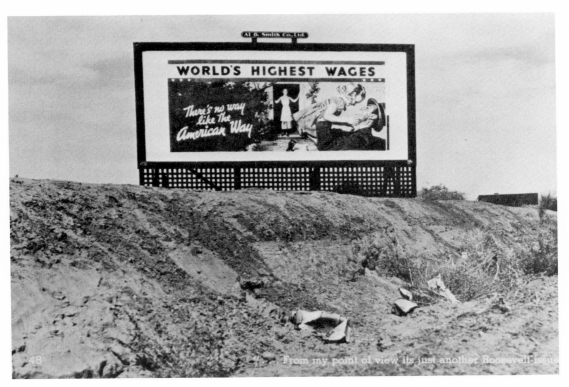

graphs from the International Photographic Exhibition held in New York City in 1938. Steichen's introductory note, one of the first and most important approvals of government photographic enterprises during the Depression, distinguishes FSA work from work that might seem comparable to it, official Soviet photography, by noting that "the whole tenor of these Soviet photographic documents would seem to strive to get in under a caption such as is presented on the 'World's highest wage' poster . . . which proclaims 'There is no way like the American way.'" Instead of believing claims from the political Right or Left, Steichen suggests, viewers should simply cast their eyes on an FSA picture of a sharecropper's residence and children (figure 12).[25] Steichen, that is, argues for replacing an unacceptable verbal caption with a truth-telling pictorial one. The pictured sharecropper's residence does just what Bourke-White's line of blacks does: it points an irony and illustrates, if only in this one instance, the superiority of picture to propaganda.

Visitors to the Grand Central Palace show, in a pleasing period gesture, had been encouraged to write down their comments, and many of these Steichen reprints along with the photographs. Most are highly approving; a few are technique-minded ("Too much grain"); and some are critical ("Purely propaganda for Communism," "Lousy

bunch of prints. Make them more sensational. P.S. More nudes," "Typical of the New Deal bunk at tax payers' expense," "Teach the underprivileged to have fewer children and less misery"). When, for ironic purposes, Steichen uses the critical comment "Subversive propaganda" as a caption for one of Lange's mothers nursing her baby, he is indirectly condemning clichés and even more obliquely complimenting the sort of understanding, and understanders, a picture requires. To be sure, he does not consistently denigrate language. For every captioned miscomprehension he includes a captioned comprehension, placing, for example, "A Few words written here don't matter. Do something" under Lange's picture of a migrant woman sitting on her bed in despair, or "Did or didn't you know slavery was abolished?" under Lange's image of the plantation overseer with his foot on the bumper.[26] In captioning other photographers' work, Steichen thought with exemplary care about the full range of possible relations between words and pictures.

Simple Texts and Complicated Pictures

A pair of photographs in Richard Whelan's "comparative look" at photography, *Double Take* (1981), shows Paul Strand's blind woman of 1916 (figure 13) and Lisette Model's blind man of 1937. The blind woman has a sign around her neck reading, in enormous letters, "BLIND"; the blind man has a similar sign reading "AVEUGLE." It is possible to be impressed by the Strand photograph in a great many

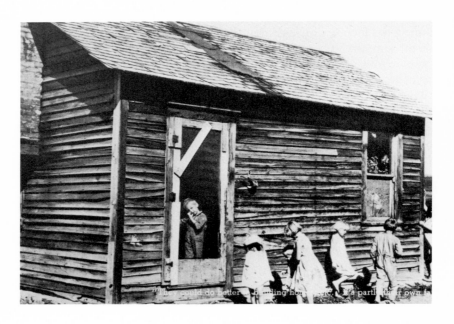

12. Russell Lee.
Cabin in the South.

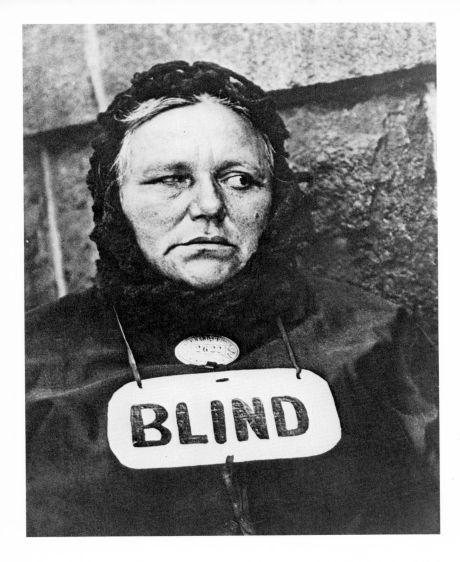

13. Paul Strand.
Blind woman.

ways. Alfred Stieglitz was so impressed by it and other Strand pho-
tographs of 1915–1916 that he devoted the last issue of *Camera Work*
entirely to the young photographer. Walker Evans, no admirer of
Stieglitz, found the "Blind woman" the *only* deeply moving photo-
graph in the fifty issues of *Camera Work*. As a candid street portrait,
Strand's picture is seemingly uncontrived, technically accomplished,
and utterly without condescension. As a composition—in the way,
for example, the woman's license badge is placed, slightly off-center,
against the dark field of her coat—the picture is admirably serene, the
more admirably when one recognizes how disquieting the subject is
that Strand has made serene. Some additional part of the photo-
graph's effect comes from the word it reproduces with black-and-
white violence, "the blunt announcement of her crudely lettered
sign."[27] "BLIND" intolerably contradicts Strand's manner of refusing

to "announce" anything; it labels the woman at the moment when viewers have been shown how difficult it would be to understand her. Considered as internal caption, "BLIND" is a subtler version of "Next time try the train—Relax." Considered stylistically, it epitomizes a finer contrast than that between advertising and reality, namely, the contrast between communicative simplicity and expressive sophistication. While the sign conveys a one-word message, Strand conveys an articulate sense of his austere control of light, tonal consistency, and avoidance of the anecdotal and the photogenic—everything, in short, that, thanks to Stieglitz, has been associated with photography as an art. Strand's artistries here do not need a foil, but they certainly receive one in the plainness of the sign. Model's word "AVEUGLE," by contrast, is more regularly printed and therefore closer to the aesthetic mode of the rest of the photograph. Her image makes an attack on labeling or verbal oversimplification like Strand's and Lange's, but it misses Strand's complications. It is not a photograph about folk art, high art, and the superlative art which juxtaposes them.

14. John Vachon. Abandoned farmhouse, Ward County, North Dakota.

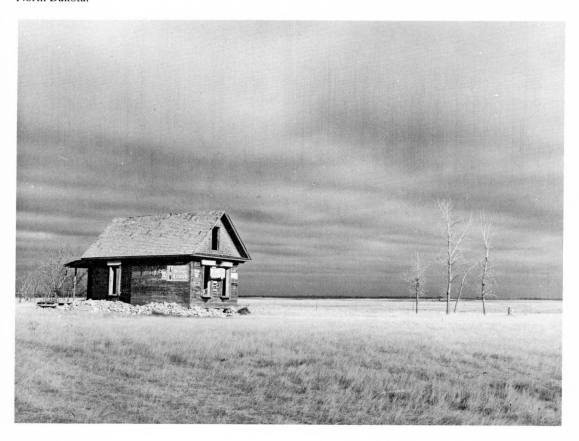

In photographs of the naive by the sophisticated, it does not greatly matter what form naiveté takes. That form may be genuine folk art, as in Walker Evans's picture of the sign on a Louisiana butcher shop, a stylized bull within an oval, or as in Marion Post Wolcott's photograph of the side of a rural building on which a letter from FDR, thanking its recipient for the gift of a chair, has been painstakingly reproduced.[28] Or the naiveté may be commercial: posters, billboards, storefront lettering. John Vachon photographed an abandoned farmhouse in Ward County, North Dakota, on the weathered siding of which is an ad for Orange Crush (figure 14). In all three of these photographs the essential contrast is between simplicity and complexity, both of means and of intentions. The Orange Crush ad works only with its two words and a picture of a bottle of the soft drink, whereas Vachon's photograph of the Orange Crush ad works with a "palette" of finely toned grays and a careful sense of placement; the farmhouse appears on the far left, so as not to be boringly centered, and is balanced by a clump of wintry trees. The Orange Crush ad asks its viewers to buy; the photograph asks its viewers to enjoy the contrast between an ad and a composition. Wolcott's letter-from-FDR picture, meanwhile, examines an artless faith in display: if the President's congratulations can somehow be shared with everyone, everyone will feel better.

In this photographic style the kind of understanding derived from the reading of messages is always examined by the kind of understanding derived from visual analysis. The words "This is your country dont let the big men take it away from you" on an air pump photographed by Lange are examined and found pitiable, according to the standards of an artistic sensibility which can find beauty even in an air pump. Similarly, the words "Rex Theater for Colored People" on the facade of a small-town movie house demonstrate the limited understanding of a community in the South. The words relegate, categorize. The photograph of the facade assimilates, connects.[29] It regards the lettering as it regards the movie posters, the fanciful tiling, the doors and windows, and the strongly sidelighted brickwork, with affection for all the discordant surfaces, and it is therefore a muted form of social criticism indeed.

Nevertheless, the Rex Theater photograph has something to say about segregation. It is not so pure a study in contrasted styles as Walker Evans's photographs of daily specials scripted on the windows of Bowery lunchrooms. In Evans's picture of the window of the People's Restaurant (figure 15), as in Berenice Abbott's similar picture of the window of the Blossom Restaurant (the two photographs are printed side-by-side in another pairing of Double Take), the antipathy between writing and picturing finds its most rarefied expression. The words offering corned beef hash for ten cents or breaded veal chops for fifteen are by no means oversimplified, politically suspect, or

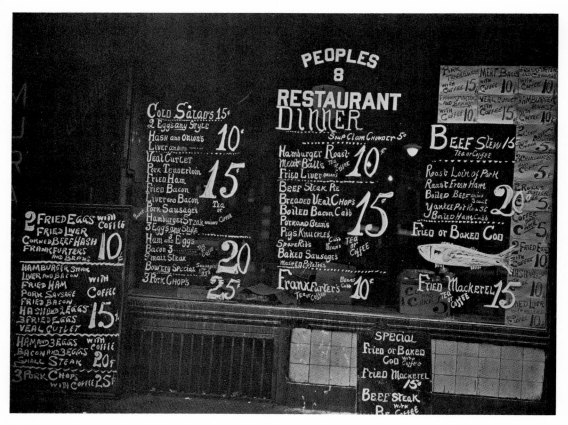

15. Walker Evans.
Window of Bowery
restaurant.

crass. They are simply supplied in quantity. The words overwhelm the window and bombard the passerby with information. They represent a vernacular style which must be assertive if it is to get the price of a meal out of Bowery dwellers. The photographs, meanwhile, represent a style of extreme restraint. They show nothing but restaurant windows. They say nothing, in the midst of all the touting of fried cod and pigs' feet and kraut. They invite an aesthetic reaction—how strange, and how wonderful, that all this photographic discipline should be devoted to scenes of urban clutter—which first seemed called for when Eugene Atget took his photographs of Paris shop windows (Abbott was Atget's great champion in the United States). "The Cow with Five Legs . . . Alive . . . the Sight of a Lifetime" reads an overstated amusement-arcade banner in Humphrey Spender's understated 1937 photograph of Blackpool.[30] Whatever the locale—Paris, the Bowery, the South, Blackpool—the effect is the same: the explicitness of ordinary communication is rescued for art by being made part of a complex composition, and it thereupon becomes acceptable to those who like their messages whispered, implicit, or avoided altogether.

Collaborations

Those ancient and magnificent inventions of speech and writing helped human memory to retain only those things which the understanding had already worked over: they recorded and transmitted the intelligible, the describable, what has passed through the processes of abstraction and verbal expression: our humbler art of photography has come to help us in the weakest part of our endowment, to rescue from oblivion the most fleeting portion of our experience—the momentary vision, the irrevocable mental image . . . Henceforth history need not be a prosy tome in fine print without illustrations: posterity will know of us not merely what we did and thought, but how we looked and what we saw. The reportable outline of events will be filled in with the material of sense, faithfully preserved and easily communicable.

—*George Santayana*

The scene is Peking, 1908. The French novelist, essayist, and travel writer Maurice Barrès is strolling back slowly from a brothel and thinking that he might write a *Bérénice chinoise.* Suddenly he stops to examine a bundle of material at his feet. In China, when an infant dies, they wrap it up in red cloth and abandon it at night on a street corner; in the morning, the carts of the street sweepers carry it to the city ditch. Barrès is touched, moved to pity by this pretty custom. With pure aesthetic delight he begins to contemplate these little scarlet heaps, which set off the gray of the dawn with a gay and lively touch. Next to this particular heap they have deposited a dead cat. A dead cat, a dead brat: two little romantic souls. Barrès links these in a common funeral oration and then passes on to more elevated parallels: at this very moment, perhaps, the beautiful warm body of a concubine, enveloped in purple silk, is being led to the Imperial couch. A little warm body, a little cold body. On both, the same spot of blood. There you have it: blood, sensuality, death.[1]

This entire vignette was invented by Jean-Paul Sartre. It is to be found in the remarkable introduction for Henri Cartier-Bresson's 1954 album of photographs *D'une Chine à l'autre* [From one China to the other], the pictorial record of China's passing from civil war to Communist rule, and it is the most imaginative though not the bitterest part of a sustained attack on language. Sartre's contempt for

words is such as to make Stallings's look trivial. He blames language for aestheticizing poverty and making China quaint: "The picturesque takes refuge in words." Words shape for Sartre—shape for Europeans generally—an exotic, artificial world of eunuchs and concubines, strange costumes and stranger customs, incredible and pointless subtleties, the inscrutable soul of the Orient. Words bestow a "carapace" on the Chinese, transforming them into "superior arthropods." Not only Barrès's words but all words lie by fictionalizing. Sartre imagines himself presenting an old eunuch in words and so making him exotic: he lives in a monastery with the other eunuchs, carefully hoarding his precious things in a jar. At the time when the Empress Tseu-hi, the yellow Agrippina, was still only a concubine, he used to take her clothes off on certain evenings, wrap her in a purple shawl, and carry her in his arms up to the Emperor's couch: "Impératrice nue, Agrippine concubine—ça rime—châle pourpre" [the Empress naked, Agrippina the concubine—that rhymes—purple shawl]. All these words, Sartre observes, ignite each other reciprocally with their fires.

The way out of linguistic indulgence, Sartre claims, is signed by Cartier-Bresson's photography. The pictures preserve reality; they display the materiality of human beings—their bodies, their needs, their labors. They make people stop evoking the silk shawl and silken flesh of the beautiful Tseu-hi and start thinking about how we could keep infants from dying in the street. *D'une Chine à l'autre* announces the end of "tourism" and bids farewell to European poetry; tactfully, avoiding useless pity, it teaches that misery has forever stopped being picturesque. Photographically rendered, the old eunuch ceases to be poetic or exotic and becomes, in his misery and greed, only an old parasite of the deposed regime.

This faith in the artlessness of photography, its ability passively to record "the material truth" and redeem Europeans from lying, seems surprising in a polemicist so politically knowledgeable and so learned in the theory and practice of partisan art. Sartre could hardly have thought of World War II photographers as mere recording cameras, objective and impersonal, and yet by 1954 he seems eager to think of Cartier-Bresson in this way. The year has something to do with the eagerness. It was a time for simplicities, for definite alignments, and for the celebration of that sort of human commonality which can be seen, must be seen, through a lens. Sartre hates the language of picturesqueness because it puts the Chinese in a separate category, whereas Cartier-Bresson's "nominalism" insists on their likeness to Italian laborers or French peasants. That which separates people, Sartre notes, must be taught. That which joins them is visible at a glance. In a snapshot taken at a hundredth of a second we are all the same, "all at the heart of our human condition"—a phrase which might well have been employed in 1955 as one of the literary captions

for Edward Steichen's vast photographic show The Family of Man, the twentieth century's most optimistic exhibition of truth visible at a glance.

The introduction to *D'une Chine à l'autre* has interest as a period piece and as an influence on French thinking about photography, since some of Roland Barthes's confidence in the authenticity of photographs seems to derive from Sartre, to whom he dedicates *Camera Lucida*, but Sartre's introduction also advances a challenging argument. His own teaching about separation is that writing and photographing are radically different acts, at least when they address unfamiliar, potentially disturbing subjects. If this is so, then large-scale combinations of writing and photography are doomed to failure. Significantly, in the large-scale combination Sartre is himself introducing, he does not presume to "collaborate" with Cartier-Bresson in any way, as by writing captions. He excepts some writing from the general condemnation, praising the poet Henri Michaux, author of *A Barbarian in Asia* (1932), for describing the Chinese "without soul or carapace" and China itself "without lotus or Loti," the allusion being to Pierre Loti, nineteenth-century writer of exotic travel books. But the best argument for the reliability of writing, and therefore for the potential complementarity of writing and photography, is provided, inadvertently, by Sartre himself. More than one passage of Sartre's introduction constitutes verbal nominalism, or writing of an unpicturesque and sharply focused descriptiveness—writing foregoing pictorial touches like "spots of blood" and aural effects like "that rhymes" for the better posing of hard political questions and the clearer picturing of the family of man.

Following one of Cartier-Bresson's photographs Sartre examines a peasant eating his rice soup in the open air of the city. Weary, famished, solitary, the Chinese peasant has brothers in all the great agricultural cities of the world, from the Greek peasant who herds sheep through the boulevards of Athens, to the Chleuh tribesman, come down from his mountains, who wanders through the streets of Marrakech. "Happy Barrès," remarks Sartre ironically, who carried his secret of a good conscience into the tomb; we unhappy others have seen infants killed like rats in bombardments or in the Nazi camps. Sartre adds a word painting of a dead baby glimpsed in a slum house in Naples. His language here and elsewhere is hardly objective, but then neither are the images of Cartier-Bresson's photography. Both writer and photographer are demystifiers, antisentimentalists. They "see" contemporary China in the same way and they belong between the same covers. The same cannot be said for Cartier-Bresson and the editors of *Life,* who published some of the photographer's China pictures in the photo essay "A Last Look at Peiping" (1949). Cartier-Bresson had been in China in the first place on assignment for *Life;* with Luce money behind him, he took one hundred rolls of film—

3600 exposures—on this trip. The magazine text for the pictures includes such comments as "ice was decking the lakes which mirror the gold roofs of the old Ming palaces" and "a warming record of a city and people whose deep equanimity is still a light in dark times, a nostalgic reminder of a China which has lived through many conquests," which are a perfect example of the sentimental or picturesque writing Sartre despises.[2]

The basic principle, then, is that combinations of photography with writing work, when they do work, not by some impossible feat of mixing incompatible artistic modes but by discovering similar artistic predilections, using analogous techniques, drawing on the strengths rather than the weaknesses of each mode, and in general finding common ground. Collaborations employ discursive and pictorial means to the same end and sometimes attain that end most quickly when they do not insist on a perfect affinity. Discourse can be used against picture, and vice versa, as in such local ironies as photograph turned against its too pat caption. Perfect affinities are unlikely; affinities, like that between Cartier-Bresson and Sartre, are not.

Development of the Photo Text

Before there can be any remarking of an affinity between someone's photographs and someone's text there must be mechanisms for bringing photographs and texts together in the first place, agreed-upon means of publishing composite works. By the mid-fifties such means were well established. Readers could buy photo documentaries with prose commentary like *D'une Chine à l'autre*, issues of *Life* magazine with photo essays, large-format books celebrating architectural or natural beauty, exhibition catalogues, photographically illustrated works of fiction, photojournalistic annuals, and single-artist photographic albums with personal or poetic annotation. Especially in America readers could choose from a great variety of separately published or periodical photo texts.

The history lying behind this outpouring of material, all of it based on the principle that photographs and words are of equal importance, is not easy to trace. The authors of photo texts rarely mention antecedents; their prefaces often speak of collaboration as though it were a brand-new phenomenon. One identifiable part of the history is the tendency to give mere captions an expanded role, thereby turning pictorial works into photo-textual ones. In 1933 Stallings keeps the verbal tags of *The First World War* quite brief; only two years later Lincoln Schuster is making more of them in *Eyes on the World*. Later still, as designers begin to experiment with layouts and readers grow more sophisticated and demanding, captions escape from a subordinate position altogether. Printed amid much white space on pages facing photographs, given stylistic latitude, and above all credited to a named author, they stand revealed as a full-scale text.

The reverse process is no less important: mere illustrations in a book can take on more importance. They perhaps begin to do so as early as Adolphe Smith and John Thomson's pioneering collaboration *Street Life in London* (1877). Thomson's Woodburytypes, though referred to as "illustrations" and limited in number, are essential to the book's documentary purposes, unlike the engravings-after-daguerreotypes in Henry Mayhew's *London Labour and the London Poor* (1850), the immediate model for *Street Life in London*. Smith and Thomson's documentary successors make photographs progressively more important. In fiction, photographic illustrations visibly turn into something less conventional and more interesting in the curious transitional work *The Door in the Wall* (1911), a volume of H. G. Wells's short stories with photographs by Alvin Langdon Coburn. On one hand, *The Door in the Wall* looks back to standard nineteenth-century illustrating practices. Readers of Dickens novels with Phiz engravings or of Victorian fictions serialized in illustrated magazines would have found nothing surprising in its layout or proportions, there being one or two photographs per story. On the other hand, *The Door in the Wall* looks forward by giving Coburn an expressive freedom which Phiz never enjoyed. The photographs do not illustrate happenings in the plots—without elaborate sets and costuming, how could they?—but interpret a locale. Each picture is titled, in token of its topographic and artistic integrity. Coburn's "Capri" shows where part of Wells's story "A Dream of Armageddon" takes place. Coburn's "The Embankment," with its street lamps reflected in the still Thames at twilight (figure 16), responds to the weary mood of Wells's "The Diamond Maker." The narrator of the title story speaks of having "a photograph in which that look of detachment has been caught and intensified." The catching and intensifying of a look is the function of all the photographs of the book, as well as the function of Coburn's photographic frontispieces to the successive volumes of Henry James's New York Edition, the project that may have first brought Coburn to Wells's attention. James and Coburn had collaborated by wandering in St. John's Wood or down Portland Place in search of an "aspect of things" which might speak "of its connections with something in the book." So too did Wells and Coburn collaborate—in another marked difference from Dickens and Phiz—by making the final selection of images for their work together.[3]

There are weak or irrelevant photographs in *The Door in the Wall,* but there is no general sense of discrepancy between fiction and photography. Coburn's softly diffused Pictorialism, especially as emphasized by photogravure printing, goes well with the crepuscular tone of the book and the liking for "fine effects" on the part of the characters, one of whom appreciates a constellation of green-and-red railway lights glimpsed through a steamy window and the fog of a murky London twilight. Coburn's pictures aspire to imaginative seeing,

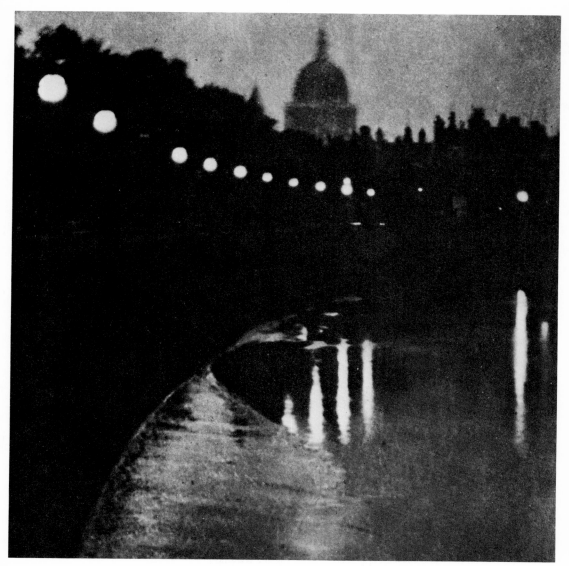

16. Alvin Langdon
Coburn.
The Embankment.

which is to say to the realm of art, and therefore belong with imaginative writing. Coburn complements Wells, or vice versa. Not quite the same thing can be said of two collaborators working forty years later, Langston Hughes, author of the novella *The Sweet Flypaper of Life* (1955), and Roy De Carava, photographer of the New York City scenes about which Langston's narrator, Sister Mary, chats with humor and forbearance. Hughes and De Carava are equally sharp-eyed, equally unpretentious, and they seem equally determined to explore ordinary black family life, to produce a book celebrating routine hap-

piness. "We've had so many books about how bad life is," Hughes writes, "maybe it's time to have one showing how good it is."[4] This is another sentiment suitable for The Family of Man; the publication date is not all that links Hughes with Steichen. The problem with *The Sweet Flypaper of Life* is, first, that the pictures weaken Sister Mary's narrative authority, turning interest away from her personality to Harlem as a social phenomenon, and, second, that they so obviously belong to actuality, not an imagined world. They are sharply focused, straightforward, documentary-style renditions of appearance, and for all their success in illustrating West 134th Street, they cannot, except with a distinct sense of oddity, illustrate a fictional character like Sister Mary; they cannot avoid being associated with "the truth."

By 1955 *The Sweet Flypaper of Life* is running counter to the prevailing view of photography, the view best publicized, most generously funded, and most often translated into the images of photo texts—namely, that photography supplies evidence. The illustrations in Russell Lord's *Behold Our Land* (1938) supply evidence of soil erosion and of government measures being taken to stop it. The illustrations by Doris Ulmann in Julia Peterkin's *Roll, Jordan, Roll* (1933) supply evidence of the lingering results of slavery; the publisher calls the book "a powerful picturization, in two mediums, of the Southern Negro."[5] These and many other works are nonfictional (though sometimes not purely so: parts of *Roll, Jordan, Roll* are told like stories), and it is in combinations of photography with nonfictional prose that the photo text achieves its fullest development.

The descriptive term *photo text* covers a range of authorial situations: writer and photographer working together and so literally collaborating; writer and photographer brought together by an editor; writer captioning, introducing, linking, or otherwise meditating on already published photographs; and photographer illustrating an already published text. When two literal collaborators produce a work, no principle is more often asserted than the absolute equality of their contributions to it. On their title pages Hughes and De Carava, Peterkin and Ulmann, are given equal credit. So are Laszlo Moholy-Nagy and Mary Benedetta in their collaboration *The Street Markets of London* (1936), a pleasing, unambitious essay in "literary and impressionistic photo-reportage." In typical introductions to collaborative works writer and photographer are spoken of as creative peers. The preface to *A Russian Journal* (1948) emphasizes that John Steinbeck and the photographer Robert Capa are partners in the enterprise. In the documentaries *You Have Seen Their Faces* (1937), *North of the Danube* (1939), and *Say, Is This the USA?* (1941) Erskine Caldwell and Margaret Bourke-White declare their joint authorship.

Some kind of balance between pictures and text is essential. One of the reasons that *A Russian Journal* makes no lasting impression is that Capa fails to live up to his advance billing. Through no particular

fault of his own, inasmuch as he encountered severe prohibitions and censorship, his photographs are overwhelmed by Steinbeck's narrative. In the volume of Isaac Bashevis Singer stories *A Day of Pleasure* (1969), with photographs by Roman Vishniac, writer and photographer focus on the same place, the Warsaw ghetto, at roughly the same time—1938 for Vishniac, or about a generation after the time remembered by Singer—and record living conditions in the same detail, but that is the extent of their collaboration. Much of Singer's interest lies with folktales, imps, childhood nightmares, demons, and other unphotographable matters. This bookish son of a rabbi lives in an unseen world where Vishniac cannot easily follow him.[6]

Still, balanced photographic and literary contributions, though desirable, are no guarantee of final consistency. The political study *The Crime of Cuba* (1933) gives equal prominence to its text by Carleton Beals and its photographs by Walker Evans. The pictures are gathered in a portfolio at the end of the volume, as if constituting a distinct but parallel work to be consulted after the text is read—or even after the text is ignored, since Evans never bothered to read it. Beals seems to prepare the reader for Evans's work when, at the start of his own "volume," he discourses on Cuba's black-and-white tonality: "The sharp blade of the sun divides the world. High-noon brilliance, as I gaze over the indigo Caribbean Sea, lifts the waters like a black wall . . . Chalky palm-trunks, dazzling sands, low calcium buildings transform Cuba into a shell-white island floating on a black ocean." All would be well if Evans were a black-and-white photographer. But he is a photographer of grays. His style is cool, detached, and undramatic even when he depicts appalling wretchedness, as in prewar Cuba he had plentiful opportunities to do. He refuses to be rhetorical or to be horrified. His photograph of a beggar and her children, possibly the most distressing human subjects he ever found, is captioned "Family," with a verbal flatness matching his consistently understated visual manner (figure 17). Other captions are "Beggar," "Cinema," "Street corner," and "Pushcart." Beals, as extended quotation would make all too clear, is an overstater: "I had the sensation of being ever in the remorseless grip of strange black and white checkerboard evils unceasingly gliding in and out and poisonously dangerous."[7] Whether he is describing Havana as a dangerous woman thinking gainfully of sin or, more prosaically, reporting on the ways American business has exploited the Cuban people, Beals is in the remorseless grip of his own style. If "Family," as a caption, is meant to comment ironically on all the other responses one might make to this sight of poverty—all the other titles one might give to Evans's photograph— *The Crime of Cuba* unintentionally presents a series of ironical undercuttings of language by image. The book is in fact an example of what Sartre hates about picturesque words, not an analogue to what Sartre and Cartier-Bresson do together.

Landscape Photo Texts

The conditions of photographic and literary affinity can be seen with particular distinctness in the best-selling category of photo texts, the large-format books celebrating a region or natural landscape. Three works may be taken as representative of this genre: Ansel Adams and Nancy Newhall's *This Is the American Earth* (1960), Newhall and Paul Strand's *Time in New England* (1950), and Adams and John Muir's *Yosemite and the Sierra Nevada* (1948). *This Is the American Earth* was one of the earliest in the handsome series of Sierra Club exhibit-format books, issued under the general supervision of David Brower, which came out in the sixties and seventies to critical acclaim and excellent sales. No one would deny that these books made a great deal of magnificent photography easily available and, in providing icons for the environmental movement, played a significant political role. About their aesthetic achievement, however, there is some question. *This Is the American Earth* combines superbly printed black-and-white photographs by various hands, but chiefly by Adams, with Nancy Newhall's prose poetry, a vaguely rhythmical text in the style of Old Testament prophecy, sermon, or Whitmanesque oration. There is an air of worshipfulness and moral endeavor about the enterprise, an air associated with that secular church the museum; the book in fact originated in a museum exhibit of photographs and accompany-

17. Walker Evans. Family.

ing text, shown first in Yosemite Valley, then worldwide. Newhall's commentary is of the sort to benefit from illustration, but the photographs do not illustrate it; they draw attention to themselves and turn the text into a rambling, eventually dispensable caption. The photographs dominate the book, tacitly shifting its emphasis from the contemplation of nature's meanings—traced through history, put in an American context, and considered ethically—to the viewing of its beauties and of man's occasional uglinesses: there are a few photographs of desecrated landscapes in the collection. The premise of the book, which works against its form as a collaboration of words and pictures, is that mental activity in relation to nature may consist chiefly of seeing and recording the seen. In the preface David Brower, speaking of a moose glimpsed by a young boy, remarks that the "image fixed well, as wild images do, on that perfectly sensitized but almost totally unexposed film of his mind."[8] If the mind is a film, does it need the excitation of words?

In *Time in New England* a decade earlier, Newhall acts as compiler rather than author, assembling extracts from such writers as Cotton Mather, Roger Williams, Jonathan Edwards, Emerson, Thoreau, Hawthorne, Sarah Orne Jewett, and Robert Frost to make a single, admirably coherent document about one much-contemplated region. To this the Strand photographs are added. From the start, as the collaborators' correspondence makes clear, they were wary of pitfalls: words should not dominate pictures, pictures should not dominate words, words and pictures should not be juxtaposed too literally or too aptly. "I am sure there cannot be too close a relationship between the photographs and text," Strand wrote to Newhall, "for it would be impossible to in any real sense illustrate the text. The question is, how loose can it be?"[9] On occasion, in spite of wariness, the finished work flirts with the too-close, as in placing a skull-decorated gravestone next to an Edwards hell-fire sermon, but its larger problem is the too-loose. Newhall's gathered extracts are about persons and history, about time, as the title suggests, whereas Strand's photographs are about form. That is, the photographs show form in the lines of granite outcroppings, foliage, or the steeples of town halls (figure 18), and simultaneously they imply that form is self-sufficient, a source of beauty that can never quite be abstracted away from a social setting (the viewer guesses at the New England green from which the steeple rises skyward) but that never really interprets the setting.

Strand can show everything about the New England spirit, the definition of which is the announced common goal of writer and photographer, except the movement of events, human relationships, and arguments determining that spirit—namely, except time. *Time in New England* is thus a book of photographs and of words, separately excellent. Possibly recognizing the separateness, Strand worked differently in 1955 in his collaboration with the Italian writer Cesare Zavattini. The photographs in *Un paese* [A country] show a more used,

18. Paul Strand.
Town hall, Vermont,
1946.

inhabited landscape, that of Luzzara and its hinterland, and indeed often show the inhabitants themselves, whose comments, recorded by Zavattini, become captions. The peasants "speak," as they would in a documentary film. Strand's experience as filmmaker—in the full-length documentary *Native Land* (1942), for instance—thus provides one working method for combining image and language in a book. The publisher of *Un paese* suggests that the "synthesis" of photographs and verbal testimony also draws on the "new contact with reality" characteristic of Italian cinema in postwar years. Strand collaborated earlier with Claude Roy in *La France de profil* [France in profile] (1952) and later with Basil Davidson in *Tir a' Mhurain: Outer Hebrides* (1962) and James Aldridge in *Living Egypt* (1969), though Aldridge's text makes no claim to equal status. The pictures really tell all, the words being at best "a faint and barely audible variation to the theme [Strand's] photographs sustain so powerfully by their own graphic force."[10]

Yosemite and the Sierra Nevada solves many of the problems of composite books, partly by design, partly by sticking closely to the subject of mountain beauty. Extracts from John Muir's writing, edited by Charlotte Mauk, are gathered in one part of the book, Ansel Adams's photographs in another, and the photographs are accompanied by phrases or sentences from Muir, the latter being selected by Adams with the help of Newhall. Text and pictures keep their integrity, in other words, but are also brought together in an effective, unpretentious way. One reads Muir, then looks at Adams and is encouraged to remember Muir. There is no question of passages being pressed into captioning or, on the other hand, pictures being pressed into illustration.

The compositional felicities would be ineffectual without a near identity of artistic methods in Adams and Muir, which is the underlying strength of *Yosemite and the Sierra Nevada*. The writer and photographer are both expressionists. They are both inspired by natural beauty, with a consistent literalness that reinvigorates the old romantic cliché, and they make it their business to record what inspiration leads them to see. This recording they contrive with full awareness of the artistic means at their disposal. Brower could not be further from the truth when, in his preface to *This Is the American Earth*, he describes Adams as a recipient of nature's unstinting bounty: "if a cloud were needed for a given composition, or a highlight or a low-light, wilderness could provide it."[11] On the contrary, Adams himself provided the lighting effects in his compositions, as his technical notes in *Yosemite and the Sierra Nevada* make clear:

Minimum exposure, prolonged development. The subject was very soft and dark, requiring an exaggerated separation of values. A literal interpretation of the values of the cliff would have required a gray value to the rock, but the emotional impact of the subject demands a deep, somber tonality [figure 19].

19. Ansel Adams.
Sentinel rock in
Yosemite Valley.

General mood of gray values . . . In scenes such as this the contrast must be carefully controlled; too much contrast results in an image of harsh, chalky values quite opposed to the soft mood of the scene.

Extremely dark and stormy scene, with thunderstorm light on cliffs. Strong filter was used to intensify contrast of cliffs and distant valley and clouds. Less-than-normal exposure and prolonged development further intensified contrast. Problem was to convey emotional quality of storm light and powerful mood of mountain thunderstorm.[12]

It would be just as misleading or inadequate to describe Muir's technique as "literal interpretation." The photograph described in the first of the notes just quoted is accompanied by a passage from Muir's *The Yosemite* (1912): "Every rock in its walls seems to glow with life. Some lean back in majestic repose; others, absolutely sheer or nearly so for thousands of feet, advance beyond their companions in thoughtful attitudes . . . Awful in stern, immovable majesty, how softly these rocks are adorned . . . the snow and waterfalls, the winds and avalanches and clouds shine and sing and wreathe about them." Agreeable to contemporary taste these personifications and eloquences may not be, but they are complementary to Adams's images. Just as Adams intensifies contrasts or conveys emotional qualities, Muir exclaims, heightens adjectives, sets nouns and verbs in rhythmic series, or rises into imaginative hyperbole: "the thunder was so gloriously loud and massive it seemed as if surely an entire mountain was being shattered at every stroke."[13] Muir no more "records" nature—*The Yosemite* was rewritten from magazine essays and previous books, which in turn were painstakingly rewritten from newspaper articles—than Adams simply points his camera at a mountain and clicks the shutter. Separated by fifty years, the two "collaborate" in thinking alike about the artist's obligations to his subject.

Collaborating with Oneself

Erskine Caldwell's text in *North of the Danube* is political. Germans bully a Jewish woman on a train; traveling American journalists speak with patriotic Czechs or Nazi propaganda agents. Margaret Bourke-White's photographs in the book show native costumes, Slavic faces, typical interiors, landscapes, factory and cottage-industry scenes, and children at play; perhaps some social commentary of a not very pointed sort is managed by alternating pictures of Czech workers in the fields with pictures of the fields' owners, Hungarians usually, in wealthy repose. As the collaborative effort of two presumably co-operating artists, the book fails. Its incoherency grows more obvious when compared with the straightforward purposefulness of the books Bourke-White produced on her own: *Shooting the Russian War* (1942), *Dear Fatherland, Rest Quietly* (1946), and es-

pecially *Eyes on Russia* (1931), the portrait of an emerging industrial giant. In *Eyes on Russia* Bourke-White's photographs of tractors, generator shells, blast furnaces, and cranes against the sky correspond exactly with her notes about the symmetry and force of machines, their "symbolism of power." "This is a wonderful age we live in," she announces, "with locomotives and steel mills and power plants . . . subjects that are alive and vital and rich with the breath of doing." [14]

Men at Work: Photographic Studies of Men and Machines (1932), a book almost contemporaneous with Bourke-White's and sharing its enthusiasm for aesthetic industrialism, comes from the controlling imagination of Lewis Hine. It is as coherent a monograph as can be imagined. The preface, epigraph from William James's "The Moral Equivalent of War," photographs, and captions all dramatize the heroism of workers, the titanic accomplishments of the men "of courage, skill, daring, and imagination" who rivet the Empire State Building together or build the nation's dynamos (figure 20). [15] By contrast, Hine's *Women at Work* (1981), a gathering of photographs taken over a period of thirty years and captioned partly by Hine, partly by the editor Jonathan L. Docherty, has no compelling argument to advance. The pathos of factory hands imprisoned in their looms or spinning machines is there in the photographs, haphazardly, waiting for the verbal exposition and distinct editorial shaping Hine gave heroism in *Men at Work.*

Bourke-White's and Hine's is the obvious way of avoiding the complications of joint authorship: supply photographs and write at the same time, "collaborate" with oneself. Their single-author photojournalism is like that of Edwin Rosskam, who produced the not very impressive *Washington: Nerve Center* and *San Francisco* (1939), and of David Douglas Duncan, author of *Self-Portrait, USA* (1969), a sharp-eyed and outspoken examination of the nation's political processes at a time of crisis. Walter Kaufmann has singlehandedly tried to give philosophy a sense of art by issuing three large-format volumes, *Life at the Limits, Time Is an Artist,* and *What Is Man?* (1978), bringing his own photographs of Indian village life or eroded rock surfaces together with his own poems and his own or others' speculations about *Man's Lot,* the overall title of the trilogy. Gordon Parks and Minor White are among the photographers who have written poetry to accompany their pictures—Parks in *A Poet and His Camera* (1968), *In Love* (1971), and *Moments without Proper Names* (1974), White in *Mirrors Messages Manifestations* (1969). All these works are confessedly experimental, even improvisatory; one of White's texts reads:

> I delight in photographs
> I delight in words
> I delight in mixing both
> To see what happens if they blend.

20. Lewis Hine.
Derrick men.

Somewhere in White burns the desire to be a contemporary Blake. He issues his own Memorable Fancies and in them describes the change from verse to photography as a mere "change of media," not a change of "the core." [16]

Two other books by writer photographers working just after and just before the Second World War warrant a closer look, in that they are ambitious, interested in more than a delightful blending of genres, and also public-spirited, dedicated to more than the interdisciplinary

expression of the creative self. They demonstrate what complete authorial control can achieve and what it finally cannot guarantee. Moreover, their subjects say a good deal about the versatility of the form. Artists of profoundly different interests and temperament have found it congenial to put their own words next to their own pictures.

The first of these books is Clarence John Laughlin's *Ghosts along the Mississippi: An Essay in the Poetic Interpretation of Louisiana's Plantation Architecture* (1948). The work consists of one hundred individually and poetically titled photographic plates such as "In the shadow of the urn" and "Titanic arcade," each with extensive prose commentary on the facing page. The plantation houses are taken up in order of construction, as befits that part of Laughlin's interest which is historically and architecturally learned. He examines Francophile influences, decorative plastering, column and wall design, and costs of construction, establishing the grammar of an indigenous architecture, and he simultaneously traces the story of each house from its origin in the grandiose dreaming of sugarcane, cotton, or rice grandees to its lapse into hard times in the Civil War and its final abandonment to poor relatives or ruin in the floods of the encroaching river.

Sometimes Laughlin rejoices in a house's restoration, but more often in the somber beauty of its decay; his perspective is poetic as well as technical, and poetry is for him precisely decay, though precision plays no part in his evocations. His text, like the Spanish-moss-draped oaks of his photographs, is grayly festooned, with "mournful," "tragic," "funereal," "sad," "melancholy," "elegiac," "ruinous," "enigmatic." Verandahs are "haunted," flowers "moon-amorous," labyrinths "of our blood," magic "deathless." Final paragraphs begin with the long sad light of sunset and end with the loneliness and dismay of years beyond recall. Sentiments have their falls into weary elision: "power endures for so little a while . . ." Baudelaire and Huysmans are invoked, though unaccountably Laughlin fails to quote Baudelaire's famous call for photography to "rescue from oblivion those tumbling ruins, those books, prints, and manuscripts which time is devouring, precious things whose form is dissolving and which demand a place in the archives of our memory."[17] The words perfectly express Laughlin's motives. He rescues Louisiana's plantation houses from oblivion and restores them to melancholy. They are shown as having literally dissolved under the cold winter rains or as standing empty in weed-grown fields. Almost never are they photographed with people, except for the ghostly figure, a model costumed in black gown and veil, Laughlin sometimes poses on a verandah.

In style and gallant purpose Laughlin is, in short, an extravagant romantic. Reviewing two 1973 shows, A. D. Coleman called him an "obsessed romantic," a southerner fixated in "guilt as a fetish object, decay as a perfume." Largely indifferent to political and ethical issues,

such as the economic basis of plantation life in slavery, Laughlin considers the "disturbing and mournful beauty" of his photographic views an adequate, if "tragic," compensation for the human misery implied in the houses' falling to ruin. The aestheticism of *Ghosts along the Mississippi* can seem suffocating, and it is therefore no favor to the book to emphasize how well it matches aesthetic prose with aesthetic pictures, but that matching is finally the most valuable lesson Laughlin has to offer. His verbal contrivances never fail to be carefully aligned with photographic contrivances. He frames views with tree limbs or swags of moss, angles shots dramatically upward, takes long perspectives down deserted garden paths, poses models, gives the models appropriate props ("the last camellia, held by a weeping figure in a carriage from another time"), cuts and reassem-

21. Clarence John Laughlin. Mementos of unreturning time.

22. Clarence John Laughlin.
Elegy for moss land.

bles prints into a collage ("Elegy for the Old South," a title given to no less than six plates), and arranges bric-a-brac in a still-life against the backdrop of the charred cypress wall of the burned Chateau des Fleurs (figure 21).[18] Things—columns, capitals, carriages, battered statuettes, the cracked and faded photograph of a once beautiful woman—are shown to be suffering as much in the present as their former owners suffered in the past. One can pity the things. Indeed, one must pity them. That is the function of Laughlin's objectifications, to direct attention away from people troubling in their complexity to things pitiable in their simplicity. The viewer moved at all by the still-life photograph and its prose comment forgets such matters as slaveholding and the suicidal extravagance of the planters and thinks only of how much beauty they wished to have, how much beauty they lost.

In "The besieging wilderness," a deliberate double exposure sets a spreading oak tree against or even "inside" a plantation house, thus symbolizing a much-discussed theme of the text, "the terrible and prolonged struggle between the plant forms, and the architectural forms, so characteristic of Louisiana." Another double exposure, "Elegy for moss land," begins the book by picturing a plantation and its reflection in a marsh through the image of a black-gowned dreamer and a moss-behung tree (figure 22). The photograph confuses out-

lines and confounds space relationships, while the associated words defy logic: "In the evocative figure rising from the marsh—the earth which is unsubstantial and reflective; the inverted landscape like a swampy mirage; the plantation house, sitting in the tree of dream— is presented an image of those who seek to completely summon the past; those who fall beneath the magic spell of memory." [19] The words within dashes, unsyntactically piled up inside the sentence, are analogous to the dreaming figure and tree inside the house. Together, the photograph and its caption exhaust the artistic potential of superimposition.

The extreme picturesqueness of Laughlin's decayed houses, apparent even in his plainest single exposures, requires extreme representational methods, as does the baroque history of plantation house owners. Understatement would not suit this Louisiana; Walker Evans could not have photographed it, though he photographed other aspects of life in the state. Laughlin himself suits the state less well when he photographs it in a somewhat subdued way for a 1960 *Life* photo essay. The real weakness of *Ghosts along the Mississippi* is not overstatement per se but the need to rationalize every overstatement. Laughlin cannot let photograph and text simply imply something or create a mood; he explains what they are meant to imply or luxuriates in the beauty he says they are creating: "In this plate the true gray of the moss is conveyed." "Behind [a Bayou girl], on the whitewashed shelter of her simple abode, the shadows of a leafless crepe myrtle make a dramatic and beautiful pattern." "The chain, used for tying the cow up nights, and the upturned tub, in which the pigs are fed, play important parts in the composition." In the worst instances the explanations are self-congratulatory: "And despite their poverty of appearance, many of these churches, when approached by someone sensitive to purely photographic effects, can become invaluable material." The naiveté here is more troubling than the naiveté involved in the innocent use of a phrase like "her simple abode," because it violates a basic protocol of photo texts. The words accompanying a picture should comment in some way, direct or indirect, on what the picture is showing, but they may not comment on how well it is showing its subject. To do so is to violate the integrity of the work; the captioner abandons the role of collaborator and assumes that of critic. To comment on how well the picture shows its subject is also to insult the viewer. Laughlin's finely expressive photograph of a falling-apart plaster medallion on the ceiling of Chrétien Point Plantation seems less fine when the text urges viewers to "see how its delicate acanthus leaves, one by one, have been dropping into the whirlpool of time." [20]

Although Robert Capa's *Death in the Making* (1938), a photographic report on the first, still hopeful phases of the Spanish Civil War, urges the reader in a certain direction, it avoids Laughlin's self-

conscious coerciveness. Its ethos, which is that of a sharply defined caste at a sharply defined moment—foreign volunteers in thirties Spain—considers self-consciousness a bourgeois indulgence, and stylistic extravagance a luxury to be avoided for the duration of the fighting. In the old Spain, Jay Allen comments in his preface to the book, youths yearned for French preciosities, for "Cocteau stuff." But under the Republic youths "began to swim and hike, to cleanse their bodies of the old crust." Allen and Capa believe that actions matter more than words, that one must be suspicious of eloquence, that good eyesight and honesty are "about all one wants from a correspondent. Or a cameraman."[21]

In spite of the preface by Allen, the "arrangement" or layout by André Kertesz, and the share of the book's photographs taken by Gerda Taro, *Death in the Making* is clearly the work of one man, Capa, the Hungarian-Jewish photojournalist who became suddenly famous with the publication, in a 1936 issue of *Vu*, of his photograph of a Loyalist soldier being hit by a bullet. Most of the photographs and all of the captions in *Death in the Making* are his. Writing only six years after Laurence Stallings, Capa nevertheless works in a wholly different artistic climate and so produces a different kind of war reportage. Cynicism and corrosive irony are gone, replaced by admiration and a will to encourage. A two-page spread of soldiers marching to the front, skirmishing there, taking a building, and suffering casualties (a single dead body is shown)—photographs that Stallings would no doubt have captioned "Im Westen nichts neues" or "No more parades"—Capa captions with tributes: "The boys of the new army. Veterans they may be, too." The sentiments are not necessarily those of the recruiting poster. Capa notes that "Many will not live" to see the future they are fighting for and that, with reference to the photograph of the dead soldier, their fine hope "more often than not ends like this."

The captions sometimes describe what the photographs show, as in "They laugh often at memories of the past" next to a row of smiling peasant faces. At other times the captions speak for people in the photographs, usually adding a comment: "The farmer points to the village on the horizon, that unknown distant world, and says 'It may be the front begins there, we aren't sure.' Nobody was sure of anything in the first days." In general, Capa's photographs concentrate on and come intimately close to the people actually fighting the war, just as his words do. The soldiers and heroic citizens of Madrid are shown without expressive tricks; they "speak," or are spoken to, without pretense. *Death in the Making* exploits the artistic potential of directness. In particular, Capa draws the reader into scenes familiar in Spain, but elsewhere unknown or threatening, by his casual use of the pronoun "you": "When you get up you put the mattress against the wall and shoot from behind it," as though it were the most natural

and expected thing in the world to be there in the workingman's cottage in the besieged quarter of Madrid. "You" is a favorite device of documentary writers—one much employed by George Orwell, for example—and one improved on here by photographs taken so close to their subjects that they give viewers the illusion they are actually within the field of view (figure 23).[22]

One page from the book exemplifies particularly well Capa's verbal and pictorial "honesty," which, given the time, place, and political climate, is hardly disinterested. His picture of soldiers at mass is captioned "On Sundays early, before the rebel planes came over to spit death along the green hillsides, masses were said" (figure 24). Language like this is both informative and expressive, and it identifies Capa as a journalist, a "recording camera," who is not willing to remain a journalist. The rebel planes must be morally judged, must be said to "spit." In exactly the same way the photograph is both informative and expressive, objective and propagandistic. On the one hand, there is a jumble of books and vessels on the altar, the celebrant is awkwardly posed, a banner flaps untidily into the picture, and a

23. Robert Capa.
University City,
Madrid.

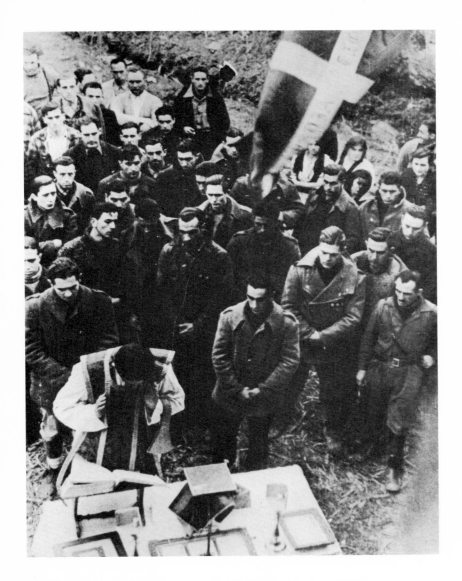

24. Robert Capa.
Celebration of mass.

few of the worshipers look more absent-minded than devout: photography captures reality in all its insignificant random disorderliness. On the other hand, the picture is shot downward from a steep angle, "bowing" each head a little more, and is taken at the climactic moment when nearly all eyes are turned to the priest: photography arranges reality to make a point, which here is the common, self-abnegating will of the group and the faith of soldiers often accused of fighting in an antireligious cause. One may think what one likes about the politics underlying this picture and about the present relevance of those politics. Time has dated all of the book's urgencies and made pathetic all of its faiths—in good eyesight, in swimming and hiking,

in the Loyalist cause. But there can be no doubt that its pictures and captions, thanks to the single artistic consciousness devising them, make the politics and the cause instantly, and memorably, comprehensible.

The Work of Wright Morris

A career that would produce, by 1985, nineteen novels, four books of essays, three autobiographies, and four exceptionally interesting photo texts began around 1934 when Wright Morris returned to California from a *Wanderjahr* in Europe and began to write a series of short prose pieces, lyrical in nature, in which he attempted to capture a moment in time. The pieces seem a young man's work, even as revised, presumably, for later publication, being absorbed in themes like loneliness and the failure to make sexual connections. Generally they are folksy exercises in a vernacular lyricism, as if influenced by the oral histories and documentary fictions of the decade, but a few of them are self-consciously oblique: "Space is a thing we lean upon." Others are epiphanic in the manner of Stephen Dedalus and the interchapters of *In Our Time* (Joyce and Hemingway, as famous emigrés, had drawn more than one young American to Europe and new ideas of art):

> She came in with the eggs and he came in with the milk. She held them like clothespins in her apron and with her thumb nail scratched off the hen spots. He picked up *Capper's Weekly* and sat down to take off his shoes. He put his socks to dry out in the cob bin, turned up the lamp. She sat on the rocker near the stove and when she rocked her high button shoes came unbuttoned and the lumps in her stockings showed. He held out his hand and she pulled from her head a long gray hair. He stretched it over the lamp chimney and when it singed he turned down the wick. What was left of the hair he handed back to her. He read, but she didn't care to read. She rocked and wound her hair around and around her finger and looked at the picture of her mother on the wall. Everybody said how much it was they were just alike. Everybody knew she had worked right up till the day she died.[23]

Eventually Morris thought that with a camera he might photograph what he was attempting to capture in words, and in California and New England he started to take pictures, almost exclusively of objects or structures "that were used and abused by human hands." Toward these things he felt affectionate and protective; the Depression had created a world of relics which it became his task to preserve for the sake of the human history implicit in them, as in a portrait the farm wife preserves the memory of her mother. By 1939 Morris was putting the prose pieces together with his photographs and showing both to friends; to the public in a show at the New School for Social Research; to James Laughlin of New Directions, who published a selection in 1940; to the Guggenheim Foundation, which awarded

Morris his first fellowship in 1942; and finally to Maxwell Perkins of Scribner's, who published the full collection, titled *The Inhabitants,* in 1946.[24] This history says much about the generosity of American support for photo texts.

The Inhabitants carries on its salvage work in the format of *Ghosts along the Mississippi,* by printing text on one page and photographic plate on the opposite. The pictures are of houses and farm buildings, grain elevators and churches. There are neither interiors nor people. Morris's West and Southwest, eerily depopulated, are regions of weathered surfaces across which the slanting light plays. Doors and windows give entry to rooms which viewers know will be vacant, though in another sense, as the first prose piece of the book insists, vacant rooms are always crowded with something, the impressions left by their one-time occupants: "An Inhabitant is what you can't take away from a house." The book proceeds to save all the intimations of former life it can—one page shows the shingles coming off the roof of a house on the prairie (figure 25), and the opposite page

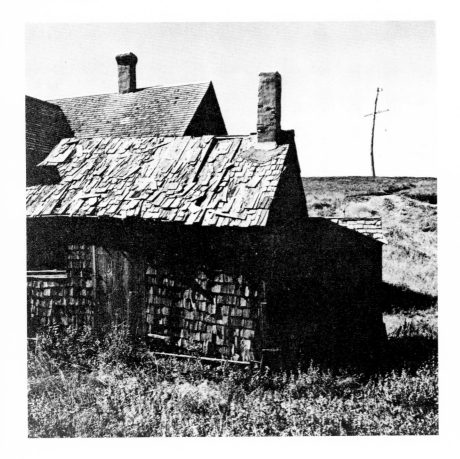

25. Wright Morris. Farmhouse.

describes the equally ramshackle habits of someone who might have lived in that house, reported in the language of someone who might have lived there too: "He was lyin' there. Willie, I said, why the hell ain't you up loafin'? Then I looked an seen he was dead. Now Willie must've died mid-winter 'cause the tree he had through the window wasn't anymore than half burnt. Willie burnt just one tree a year. He'd prop it through the window with one end in the stove and push on it now and then when it burnt. And there he was. One leg was hangin' with the boot half laced and a piece of the lace was still in his hand." No interpretation is added to this speech. Morris simply preserves it, with affection and respect, as he preserves the wooden barrels or small-town barber poles of the photographs. In this first photo text Morris feels it sufficient to let each subject speak for itself.[25]

"Speaking," however, is for photographs only a metaphor, and *The Inhabitants* never quite succeeds in employing words and pictures in a complementary technique. The book overcomes literal clashes— such as that between a text beginning "When I was a kid I saw the town through a crack in the grain elevator, an island of trees in the quiet sea of corn" and the facing-page photograph of a grain elevator in a desolate townscape, with neither trees nor corn in sight—but it cannot overcome shifts of perspective that are neither explained nor developed from page to page. Whatever significance the passage "When I was a kid I saw" has must involve that *I*, that particular human consciousness remembering the past and how it once observed the world, namely with a childlike mixing of the relevant and the irrelevant: "That had been the day the end of the world was at hand . . . we could see T. B. Horde driving by with his county fair mare." The prose pieces of *The Inhabitants* set unidentified characters moving through time and memory. They amount to unconnected little plots. Conversely, the pictures of the book are impersonal deliberate sightings through a lens and a view finder, and they stop time, forever, at one particular instant. Nothing is so still as a Wright Morris photograph of the side of a barn. No one is implicated in a Wright Morris photograph but the photographer himself, the careful framer of form and texture. Morris once called a mattress with the hollowed impression of many sleepers "a film that records numberless overlapping exposures."[26] It is a striking and just metaphor, but not one that applies to his own art of painstaking single exposures.

The format of *The Inhabitants* encourages the reader to seek a more direct relationship between text and image than any Morris can sustain. If prose looks like a caption, it should comment on the photograph opposite. The format of Morris's next photo text, *The Home Place* (1948), the fruit of a second Guggenheim Fellowship, is changed, perhaps to forestall irrelevant expectations. *The Home Place* is recognizably a novel, a narrative about the return of a native son to Nebraska, and the photographs on every other page are rec-

ognizably illustrations to a novel. Morris does not despise a certain homely literalness of depiction. The narrator talks about sitting on a straight-backed chair placed on a linoleum floor, and the photograph opposite shows a straight-backed chair placed on a linoleum floor. "There was a strong, stale smell, flavored with cobs": Morris looks down from above on a basket of withered corncobs. The photographed Nebraska of the book is just as depopulated as the nameless regions shown in *The Inhabitants*—only two people appear in photographs—but now the depopulation does not matter, because the relatively modest role of photography in the book is clear. The text will provide people. The pictures will show settings, familiar objects (a pair of boots, kitchen implements, sheet music on a piano, an empty barber's chair); they will furnish a world. For Morris, that means furnishing the starting point for the characters' only real activity: imagining. The narrator explains that his daughter "can't see, feel, or smell anything, without comparing it with something else."[27]

In its combination of fictional words and apparently nonfictional photographs *The Home Place* sometimes reads oddly, like *The Sweet Flypaper of Life*. One wonders whose real possessions have been posed so that the characters will have furnishings. One wonders also whether to ponder or ignore the book's discrepancies. The old people discuss a family photograph in a black frame covered with glass, while the accompanying picture is of a photograph mounted on a card and nailed to an outside wall. On the whole, however, *The Home Place* is an intelligible and stylistically consistent work of illustrated fiction. Its moderated photo-textual ambitions anticipate those of Morris's travel book *Love Affair: A Venetian Journal* (1972), the photographs for which originated as color snapshots taken with a 35mm hand-held camera; for the other books Morris used a view camera on a tripod. Like any traveler, Morris photographed a city he loved; like any returned traveler, he displayed his pictures to others and added personal commentary; the published result is an unexceptionable memoir and exercise in sensitivity.

In between *The Home Place* and *Love Affair* comes the best of Morris's composite books, *God's Country and My People* (1968), which again portrays Nebraska, the scene of Morris's youth, and in fact reuses a number of already published photographs. Returning to the format of *The Inhabitants,* in which a paragraph of comment faces a photograph on the page opposite—both caption and photograph being surrounded with generous white space, like artifacts on a museum wall—*God's Country* asserts the coequality of images and words. Moreover, it makes images and words co-operate. Words constitute Morris's first-person reminiscences; these are somewhat fictionalized, no doubt, but they are consistent, and they create none of the problems of the unconnected fictional vignettes in *The Inhabitants*. Everything in *God's Country* is discussed, directly or indirectly,

by a single voice, and everything is seen, directly or indirectly, from a single controlling perspective. Whether Morris is speaking for himself or quoting relatives, he joins language of considerable subtlety and sophistication, generally without the folksiness of *The Inhabitants,* to similarly artful photographs. The straight-backed chair on the linoleum floor can now do more than illustrate. It symbolizes Aunt Clara's rectilinear virtues as witnessed by her admiring and educated nephew: "the triumph of the form following function." The towering grain elevator in a desolate townscape, captioned in *The Inhabitants* by a child's memory, here is captioned by an adult's ironical speculations on the vertical structures Nebraskans erect to escape from their plains. A much-slept-upon mattress receives a quiet comment on the impressions left by things. Two nearly identical small-town buildings look across the page to a reminiscence about twin boys who married sisters and died within a year of each other. The close-up photograph of a family photograph already used in *The Home Place* is again discussed by Aunt Clara and Uncle Harry, but now there is no mention of a confusing black frame. The right page matches the left page perfectly. Both Morris's unfading photograph of a fading photograph and the quoted melancholy discussion of it reveal something about the habit of keeping pictures to mark and grieve for the passage of time, and therefore something about the purposes of *God's Country* itself. Although he is less simple than his relatives, who observe of one who has died, "Way we'll all soon be gone," Morris is no less elegiac. Just as the relatives put portraits within frames or snapshots in a drawer, he puts black-and-white photography in a book. "A crack in time had been made by the click of a shutter, through which I could peer into a world that had vanished," Morris comments later. "By stopping time I hoped to suspend mortality."[28]

A photo text like *God's Country* works as well as it does not because it avoids mistakes and sticks to conventional methods—being in fact less conventional than *The Home Place* or *Love Affair*—but because it concentrates on themes calling for photo-textual treatment. In other compilations the linking of images with words can seem arbitrary or merely self-aggrandizing, the occasion for a display of dual talents. Here, even more than in *D'une Chine à l'autre, Men at Work, Ghosts along the Mississippi,* or *Death in the Making,* the linking seems functional. It clarifies what would remain obscure if it were only written about or only pictured. Consider the second photograph of the book, which shows a chair by a door with a dusty oval pane of glass (figure 26). Through the glass comes the glaring light which would be the point of the photograph if it were actually hung by itself on a museum wall; the museum-goer would naturally "read" the picture from left to right. Placed next to Morris's comment, however, which begins with the literal description of what can be seen—"Pillars of cloud loom on the horizon"—the picture reads from right to

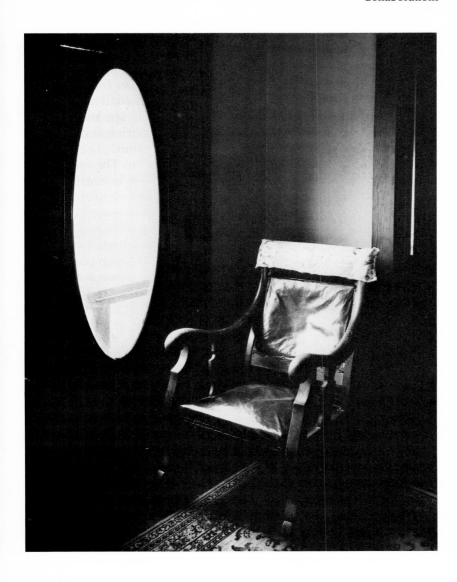

26. Wright Morris.
Chair and window.

left and means something else. It is about the habit of looking out on and imaginatively possessing a landscape. Nebraska has always encouraged its inhabitants to take transforming views of its flatness, dryness, and blankness. The plain "seems to dissolve into the sky," the comment goes on; the shadow cast by a cottonwood turns into "a hole prepared for the tree's burial." The Indians' perspective counters the barrenness in one way, the white men's counters it in another. "Pillars of cloud loom on the horizon," for example, suggests the Bible (surely it could be found in the parlor behind the chair), which has shaped the white men's perspective. The men call their place "God's country," and the women ask, "Who else wants it?"

In other words, Morris's essential subject is a time- and place-bound kind of looking, the act by which men and women reproduce a locality in intelligible forms, and to do justice to his subject, he expounds it in words and pictures both. *God's Country* opens with a question about looking and understanding—"Is it a house or an ark?"—and adds reference after reference to sight. Each Nebraskan's vision is as lovingly preserved as a grain-elevator facade or photogenic tangle of harness:

On a clear day a man with eyes in his head, and a cupola window, could see forever. In one direction it often looked as if it might rain; in three it did not.

Seated on a cushioned board placed across the chair arms [of a barber's chair], I first appraised the world from a point of elevation . . . In the mirror where the things of this world were reflected my father and mother exchanged their first glances.

Under the stoop . . . Light comes in through the crisscross of slats on the side. A boy seated in the soft, powdery dust can see out better than you can see in.

Through its spinning blades [of a windmill], like a swirl of water, she could see the granite stones in the cemetery, the names blurred by the wagging shadows of the long-stemmed grass.

Once a day, from where he leaned in the window, Ed could watch the Burlington come down from the north.

Meanwhile every picture of the book reminds the reader that there is also such a thing as photographic looking and that Morris the photographer is a true son of his native state, a framer of views, a transformer of townscape and landscape. Some of his photographs, like the one showing the chair at the door, insist on the importance of looking by depicting such openings to the world as windows, mirrors, including an oval-framed mirror reflecting oval-framed photographs, doorways through which something in the background is visible, and long perspectives down roads.

Even a house front, the commonest of all Morris's subjects, implies in the context Morris gives it the act of looking. One photograph of a house front (figure 27) appears in two contexts. *The Inhabitants* accompanies it with the "epiphany" already quoted, *God's Country* with a history of viewings from its windows:[29]

In the evening sunset the window burned like a house on fire. The Grandmother, bedridden with childbirth, had an eye for such details. As if she feared what she might see in her sleep, she often slept with her eyes open. The moon seemed to emerge, like a swollen pumpkin, from the shingled roof of the privy; between the house and the barn the yard was like a table scoured by the wind. Invisible as air, it nevertheless made itself seen. Against the crack of dawn, like light beneath a door, the Grandmother watched the foolish chickens leave the hen house, then sail off, like paper bags, in a puff of the wind.

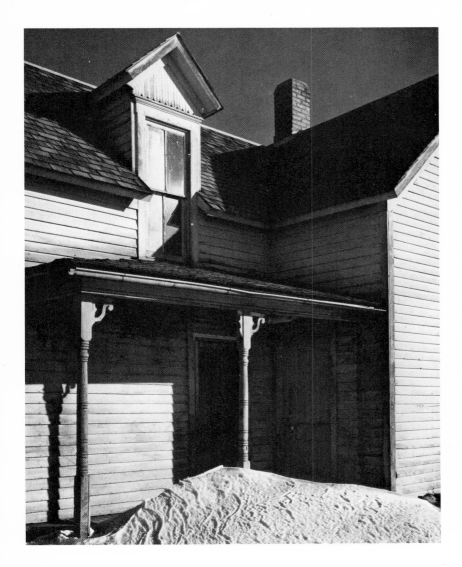

27. Wright Morris. Farmhouse porch and snowdrift.

The old woman sees things idiosyncratically. Morris photographs things idiosyncratically. In this picture he omits any sign of habitation in the house, he depicts the snow as piling up menacingly against the porch, he waits for the light to strike across the window panes and make them opaque, and he contrasts his blacks with his whites as dramatically as possible. He records a vision. Like everyone else in the place he comes from, he elaborately preserves simplicity. "God's country," the last sentence of the book runs, "is still a fiction inhabited by people with a love for the facts."

American Documents

Photographs are relics of the past, traces of what has happened. If the living take that past upon themselves, if the past becomes an integral part of the process of people making their own history, then all photographs would reacquire a living context, they would continue to exist in time, instead of being arrested moments. It is just possible that photography is the prophecy of a human memory yet to be socially and politically achieved. Such a memory would encompass any image of the past, however tragic, however guilty, within its own continuity. The distinction between the private and public uses of photography would be transcended. The Family of Man would exist.

—John Berger

At the Walker Evans retrospective at the Museum of Modern Art in New York in 1971 a teenaged boy and girl stood before a photograph titled "Sharecropper's family, Hale County, Alabama, 1936" (figure 28). Evans had published the photograph in the first edition of his and James Agee's *Let Us Now Praise Famous Men* (1941), so for thirty years this family—Ivy, Ellen, Pearl, Thomas, and Bud Woods, and Ivy's mother Miss-Molly—had been posing in wary dignity for the world outside Hale County.[1] The boy and girl gazed at the sharecropper's family in silence for a while, wondering and awestruck, as if gazing into a past as remote as the Bronze Age, and then the girl turned to her companion and asked "Nineteen thirty-six . . . was that the Depression or something?"

Not every inadequate response is a parable of the postmodern condition. As early as 1938 a visitor to the First International Photographic Exposition commented on this same photograph, "Object very much to the picture of the boy without pants. Shameful to hang it." The girl's 1971 response is less crass, less quick to dismiss, but ultimately more troubling than the earlier one because it comes out of a profounder ignorance. At the moment she spoke, the girl stood for a generation cut off from the most important events in the history of her people and innocent of any lesson the Woods family could teach.[2] She had missed such book learning as would have told her in detail about 1936 and the Depression, and missed also the more private form of history preserved in family and community memory.

Had she listened to no stories of poverty or survival during the thirties? Were there no reminiscent teachers or grandparents to tell her what had happened? For all their poverty the Woods children had perhaps had that much: a closeness to the personal, familial, and racial history the older generation might transmit. In Evans's photograph Miss-Molly sits on the right, turned in slightly to her daughter and her daughter's children. Possibly Evans posed her thus, but even a deliberate pose suggests assumptions about the way the old may or should turn to the young.

Walter Benjamin's essay "The Storyteller," another artifact of 1936, observes that the act of storytelling is coming to an end—becoming rare, embarrassed, and artificial—because Europeans have had taken from them something that seemed inalienable, the securest of human possessions, the ability to transmit experiences. Experience itself has fallen in value, Benjamin claims, and is continuing to fall into bottomlessness. Men have returned from the battlefields of the First World War grown silent—not richer but poorer in communicable experience, and accordingly helpless to transmit anything to later generations. Indeed, there was nothing they could communicate. Putting Laurence Stallings's dismay into generalized terms, Benjamin notes, "Never has experience been contradicted more thoroughly than strategic experience by tactical warfare, bodily experience by mechanical warfare, moral experience by those in power. A generation that had gone to school on a horse-drawn streetcar now stood under the open sky in a countryside in which nothing remained unchanged but the clouds, and beneath those clouds, in a field of force of destructive torrents and explosions, was the tiny, fragile human body." [3]

For American history this explanation must be slightly modified. Our inability to exchange experiences, to communicate memories, is as marked as anything Benjamin saw in Europe, but the event that contradicted experience on this side of the Atlantic was not the First World War but the Depression itself. The Depression confused national values and altered patriotic lore. It showed a substantial population of Americans that they could not depend on laboring as their parents had labored, or trust the same institutions, or even, when the drought began, look for the same rain from the sky. Contradicting politicians and communal wisdom alike, the Depression made history incomprehensible and left behind, as its legacy, tiny, fragile human bodies set in a countryside where nothing remained unchanged but the clouds. That image, figurative in Benjamin, is literal in the work of thirties photographers like Dorothea Lange, Russell Lee, and Arthur Rothstein. Their pictures show Okies heading west on lonely desert highways, or tractored-out tenant farmers squatting in the dust, or migrant laborers lost among the pathetic furnishings of their improvised lives.

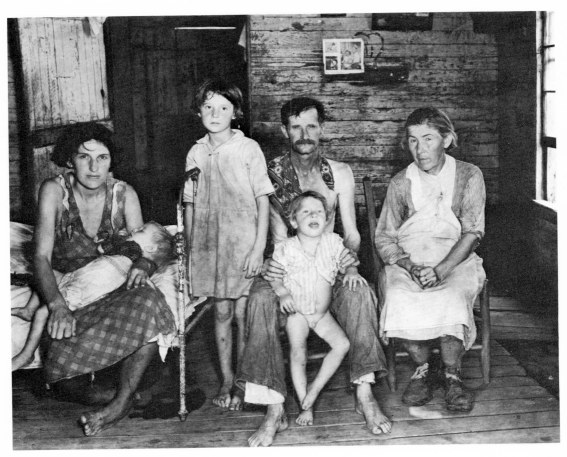

28. Walker Evans. Sharecroppers, Hale County, Alabama.

Over and over again thirties photographers and writers, not content with picturing the results of change, make change—a vast economic, social, and emotional dislocation—the explicit subject of their collaborations. Berenice Abbott titled her 1939 photographic study of the city *Changing New York*. As Audrey McMahon notes in her preface, Abbott preserves "scenes which were here two years ago" but are gone today. Changes "which are taking place are recorded in their relationship to the environment which remains. A truthful, sometimes humorous and often bitter commentary ensues." Even those who wished to avoid bitterness by regarding the dislocation as temporary or by running away from its consequences had at least to acknowledge the dislocation. "The big world outside now is so filled with confusion," Sherwood Anderson comments plaintively in *Home Town* (1940), that "our only hope, in the present muddle," is "to try thinking small." In this book he thinks small by celebrating small-town continuities, enlisting FSA photographs in the cause. But the words and pictures do not always cooperate. A Walker Evans picture

of two young men, called "Main Street faces, 1935," in Evans's *American Photographs* (1938), is here captioned "All boys do not leave their home towns"[4] (figure 29). The young men in fact convey nothing about home-town contentment and everything about sullen unhappiness.

The thirties critics and cultural historians—Malcolm Cowley, Archibald MacLeish, Anderson in *Puzzled America* (1935), Edmund Wilson, Edward Steichen in his 1939 *U. S. Camera* article "The FSA Photographers," Alfred Kazin—saw clearly that the changes of the decade called for new representational methods or, as Cowley put it, a "new art, one that has to be judged by different standards." The new art was documentary. In the strict sense, documentary provided factual "documents," such as photographs, case histories, reportage, statistical tables, and eyewitness accounts; in the loose sense, it was devoted to truth rather than fictiveness, social significance rather than formal complication, current events rather than the past, and a responsible questioning rather than a complacent answering. Documentary was "a register of the learning process, an example of a new social consciousness in America whose greatest distinction was the very fact of that consciousness in itself, the sense of a grim and steady awareness rather than of a great comprehension."[5]

Kazin's phrase "a grim and steady awareness" suits well the black-and-white photography in which visual documentary was almost exclusively conducted in the thirties. Color film was then available, but few photographers used it, for technical and aesthetic reasons. Black-and-white film gave them both a fidelity to fine gradations of light and a reassurance that their business was serious, was a matter of

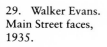

29. Walker Evans. Main Street faces, 1935.

recording actuality rather than coloring it with their own sensibility or liking for beauty. In a typical documentary of the decade, the 1939 article "I Wonder Where We Can Go Now" from *Fortune,* black-and-white FSA photographs by Dorothea Lange and Horace Bristol are grouped in a portfolio and accompanied by "extracts from a reporter's notebook." Both text and pictures are clearly meant to seem "fresh from the field," documentary in the strict sense, grimly and steadily aware of conditions for migrant workers on the farms of California, whereas the Millard Sheets watercolors also illustrating the article give an altogether different impression of vibrant activity under a bright sun.[6]

Since the publication in 1973 of William Stott's comprehensive *Documentary Expression and Thirties America,* the types of documentary and the assumptions on which the genre relied have been laid out clearly for all to see; Stott has made the astonishing thirties outpouring of caseworker studies, I-am-a-camera narratives, and on-the-backroads-of-America journalism fully comprehensible. Stott has not, however, made clear the distinctive achievement of the composite book combining documentary photographs with text, chiefly because he values so highly one example of the form—*Let Us Now Praise Famous Men.* In praising Agee and Evans, he discounts the achievement of Erskine Caldwell and Margaret Bourke-White in *You Have Seen Their Faces,* of Archibald MacLeish and a host of FSA photographers in *Land of the Free,* and of Dorothea Lange and Paul Taylor in *An American Exodus.* All four works take for granted the evidentiary purpose of their enterprise, but they are willing and even compelled to experiment with the relation of the visual to the textual evidence. That experimentation, that scrutiny of the ordinary caption-picture relation to see how it might be transformed and what it might be made to imply, gives the works a lasting interest which might not have appealed to their authors, who, with the partial exception of Agee, were experimental only in order to be more timely.

The Subject's Point of View

In 1936, just after photographing coffee plantations in Brazil and just before becoming staff photographer for *Life,* Margaret Bourke-White toured the South with Erskine Caldwell, the author of *Tobacco Road,* gathering material for a book of words and photographs on agriculture in general and cotton tenantry in particular. After another research trip, their work *You Have Seen Their Faces* was published to acclaim in 1937. Its topic was timely, its method inventive. The photographs supplied visual evidence of economic injustice; the text, in a reciprocal process, provided a context to make the photographs' meaning intelligible. Politically conscientious northerners were receptive to stories that could be "written," as Cowley said, "in the gullied soil, the sagging rooftree of a house or the wrinkles of a tired face."

Reviewers like Norman Cousins and Margaret Marshall were deeply moved and thought others would be moved.[7] It did not hurt the book's sales, moreover, that a few days after publication *Life* ran a selection of its photographs and admiringly summarized its argument.

Criticism of *You Have Seen Their Faces,* when it came, had perhaps as much to do with the book's success and the celebrity of its authors as with its substance. "Have you really seen their faces?" runs a caption in H. C. Nixon's *Forty Acres and Steel Mules* (1938), under three Lange photographs no less typifying than anything Bourke-White printed; Nixon's implied claim for greater objectivity is unconvincing. As if to acknowledge his bias against big-city reporters, Yankee degradation seekers, Nixon begins his text by remarking that his "book is a hillbilly's view of the South."[8] Meanwhile, James Agee's anger at Caldwell and Bourke-White was exacerbated by the difficulties of getting his own book into print. He cannot forgive Bourke-White and Caldwell for making money out of appalling poverty, for "exploitation," but his only significant criticism is that they are racially condescending.

When the FSA photographer Marion Post Wolcott was traveling through the South at the end of the decade she was sometimes mistaken for Bourke-White and criticized for her depiction of southern life. The anger of southern plantation owners and managers, unlike Agee's, was a response to the topical, if narrow, argument of Bourke-White and Caldwell that the sharecropper's life was appallingly impoverished, sharecropping itself a bankrupt and irremediable agricultural system. By whatever definition, *You Have Seen Their Faces* is topical journalism. It addresses a current problem; it provides factual information; and it exposes abuses and suggests solutions: collective action by the farmers or government control of cotton farming. Like other journalistic works of the period, it oversimplifies and misses distinctions. Caldwell, for example, uses "sharecropper" and "tenant farmer" interchangeably, as Agee is careful not to do. *You Have Seen Their Faces* also arranges facts, verbal and photographic, in a way calculated to impress. It manipulates its human subjects. But it does not transform them into "entirely piteous" creatures, as William Stott claims. They are not brutalized in the text, rendered abject in the photographs. A *Look* article of 1937 includes an FSA photo of a southern farm family with the caption "Sharecropper children are often hungry. Undersized, scrawny, with large heads, misshapen bones, they are easy prey of disease."[9] That is exactly the sort of brutalization that Caldwell and Bourke-White avoid.

Caldwell says, to be sure, that the old tenant farmers are "depleted and sterile," "wasted human beings whose blood made the cotton leaves green and the blossoms red." But the young "still have strong bodies and the will to succeed"; they can "look their landlords squarely in the eyes and say they will not be intimidated by threats."

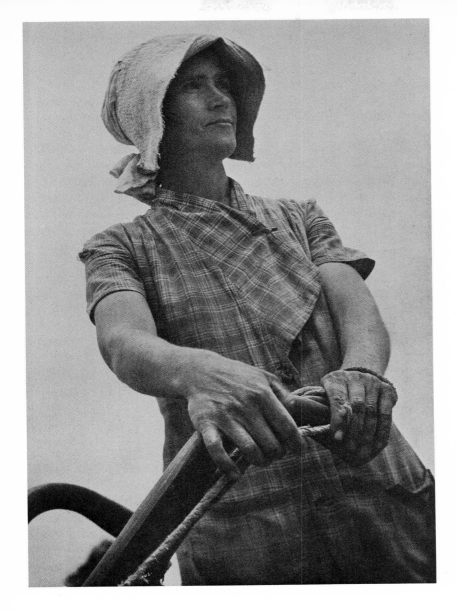

30. Margaret
Bourke-White.
Woman plowing.

As social analysis, this may be simplistic, but it is not pityingly sim-
plistic. Bourke-White's photographs even more obviously grant hope
to the young. The first picture in the book, of a boy plowing, is taken
at a sharp upward angle in order to set him heroically against the
sky—a pose much favored by Bourke-White and other thirties pho-
tographers. To look up at a face, especially when that face is gazing
thoughtfully into the distance or addressing itself to the task at hand
or squinting into the sun, is to idealize the strength of rural character,
not to render victims abject. In another photograph a woman in
Hamilton, Alabama, puts her hands to the plow and looks coura-
geously out from under her sunbonnet (figure 30). "We manage to get
along," the caption has her saying. A cocky black man says, "Every-

body likes to fish, but nobody likes to rustle up bait, so I expect that's why I make a sizable living"; an ornery white couple remarks, "I think it's only right that the government ought to be run with people like us in mind." These and similar figures are as prominent in the book as the blacks on the chain gang, the goiter- and toothache-afflicted mountain people, and the helpless and despairing mothers. Anger and apathy both appear. So do less ideologically significant emotions: a child enjoys eating watermelons, a black boy stands shyly by his dog, and one man contentedly plays the guitar for another. The expressions on these faces are meant to be human, not southern. *You Have Seen Their Faces,* as a title, implies that Americans should recognize something of their own ordinary satisfaction, courage, or weariness in these photographs of an "alien" people. Robert Van Gelder observed that the photographs allow for "the confusion of reality," capturing beauty, ease, contentment, even happiness, as well as suffering and apathy. Thanks to Bourke-White, the pictured southerners seem to live "about as completely as most of us in the richer North." [10]

In the drawing together of northerner and southerner, viewer and viewed, for purposes other than that simple bestowal of pity or contempt which is possible only when viewer and viewed are kept apart, the authors' chief device is the caption "quoting" the human subject of each photograph, repeating his or her language without editorial commentary. You are seeing faces which might be in a mirror and hearing voices like your own, the book constantly suggests. Nowhere in the journalistic antecedents of *You Have Seen Their Faces* is such a device systematically employed—not in Jacob Riis's *How the Other Half Lives,* Bourke-White's own *Eyes on Russia,* Rupert Vance's *How the Other Half Is Housed* (1936), or Charles Morrow Wilson's two books of reportage with pictures. Nor are captions formed exclusively from subjects' words in the magazine journalism of the period, including Bourke-White's own magazine journalism. In a 1935 report in *Fortune* on the modest prosperity of a paint sprayman in a Detroit auto factory, Bourke-White, or her editor, keeps the captions routinely informational: "The Corkums live at 6183 Townsend Street, Detroit, which is the fourth house from the left. It is distinguished by its foundations of concrete blocks and its new coat of paint." Bourke-White's articles on Russia in *The New York Times Sunday Magazine* in 1932 and her photo essay for the first issue of *Life* in 1936 make equally conventional use of captions. With one exception, articles in Paul Kellogg's *Survey Graphic,* the journal first to use photography extensively in the service of social investigation, do not employ quotations as captions. In a 1936 *Survey Graphic* article on southern farm tenancy, for example, FSA photographs by Rothstein and Ben Shahn are captioned "In the past decade the number of Negro sharecroppers has decreased as a result of mass movements to the cities." Other pictures are simply left uncaptioned, like the Lewis Hine photographs in a 1934 report on the Tennessee Valley Authority.[11]

It was left for Caldwell and Bourke-White, in 1937, to restrict captions to the sharecroppers' point of view. They are not only original in doing so but also punctilious, since they note carefully that the words used are not quoted verbatim but express their own conceptions of the sentiments of the individuals portrayed. Admittedly, they conceive of sentiments in ways sometimes demeaning to individuals, especially blacks; Caldwell and Bourke-White are not above putting a comical speech in an old black woman's mouth and then smiling at her simplicity. But these failures in sympathy are relatively infrequent, especially in comparison to the dramatizations of southern sentiment in *Tobacco Road* or *God's Little Acre,* and the authors' decision not to be documentarily accurate finally matters less than their apparent wish to give the silent some kind of representative, expressive voice. *You Have Seen Their Faces* allows sharecroppers to "speak up" like human beings. Although the *Life* article praising *You Have Seen Their Faces* reproduces the photographs exactly and quotes the original captions, the magazine suddenly becomes conventional when it adds information: "In the sharecropper country, writes Mr. Caldwell, dancing such as this is a common form of worship."[12] In the delicate business of setting text next to picture, not to mention the yet more delicate business of surveying a people and a region *de haut en bas,* even a minor adjustment is likely to have an effect, and this addition to the captions noticeably changes Caldwell and Bourke-White's human beings into primitive, exotic, sociopolitical specimens.

Coequal Work

The photographs in *You Have Seen Their Faces* are numerous, large (often full page), relatively well reproduced, and, for a greater cumulative effect, gathered into seven photographic sections, each with eight or nine images related in some way and put into a sequence. All these factors make Bourke-White's contribution to the book fully as important as Caldwell's. At the same time, the captions link the photographs to the text, both in format simply by putting words on the photographic page and in substance by connecting one quoted sharecropper with the many other sharecroppers quoted in the text. The pictures of *You Have Seen Their Faces* are deeply involved with its words, and in this context it hardly matters that the involvement is nonliteral, that the pictures identify no individuals discussed in the commentary and Caldwell mentions no pictures. What counts is that the pictures invite language. Furthermore, the style of language invited matches the style of what is shown. Bourke-White and Caldwell are committed journalists and unashamed rhetoricians. The photographer's striking camera angles and dramatic lighting parallel the writer's sarcasm, hyperbole, whereby the South becomes the "dogtown on the other side of the railroad tracks that smells so badly every time the wind changes," and repetitive, hammered-home know-

ingness. Everything in *You Have Seen Their Faces* works consistently to the same end, as is less successfully the case with Caldwell and Bourke-White's later documentary collaborations.

An announced premise of *Let Us Now Praise Famous Men* is that Walker Evans's contribution to the book is fully as important as James Agee's. The photographs, far from being "illustrative," are "coequal" with the text, "mutually independent, and fully collaborative," as Agee comments at the start, warning that readers will have to submit themselves to the idiosyncratic ways of the book. Certainly the photographs are coequal in care of execution, which means among other things an extreme care for the feelings of "those of whom the record is made." The dignity Evans grants the tenant families as he allows them to pose formally for their portraits is the dignity Agee grants them in writing. Agee, however, is less successful when he simply asserts this dignity, as in the comment "the partition wall of the Gudgers' front bedroom is importantly, among other things, a great tragic poem," than when he lovingly records the ordinary objects of their existence.[13] Writer and photographer both take infinite pains not to be patronizing. Evans's pictures and Agee's text are also coequal in technical accomplishment. Certain verbs of Agee's dedicatory poem—"Sharpen and calibrate," "Order the façade"— are exceptionally well suited to Evans's sharply focused and supremely well ordered photography. In composition, management of tonal values, and even quality of reproduction Evans's photographs are as self-sufficient as anything Bourke-White published. But Evans's work is not linked by captioning or any other device with Agee's work; "mutually independent" is a far more accurate phrase than "fully collaborative" for the elements of *Let Us Now Praise Famous Men*. In this book, the best known of all American photo texts, the two arts stay curiously uncombined.

To begin with, the photographs are sequestered, in a section before the text rather than after it, as was the case with Evans's photographs in *The Crime of Cuba* and as would be the case again in his little-known "collaboration" with Karl Bickel, *The Mangrove Coast* (1942). The readers of *Let Us Now Praise Famous Men* first peruse a photographic album printed entirely without localizing information, then encounter a text referring only three times, briefly and casually, to the photographs. In the first section, "Inductions," Agee writes at length about the taking of a photograph of the Gudgers, but this photograph is not printed in either the first or the revised edition of the book.[14] Although in actual practice readers can refer back from the text to the pictures, putting names to faces, it is significant that their first exposure to the pictures must be purely visual. They must study anonymous human countenances, interpreting them without the aid of captions. Evans deliberately imposes strict rules on his work, doing without the ironies made possible by the understated captions in *The*

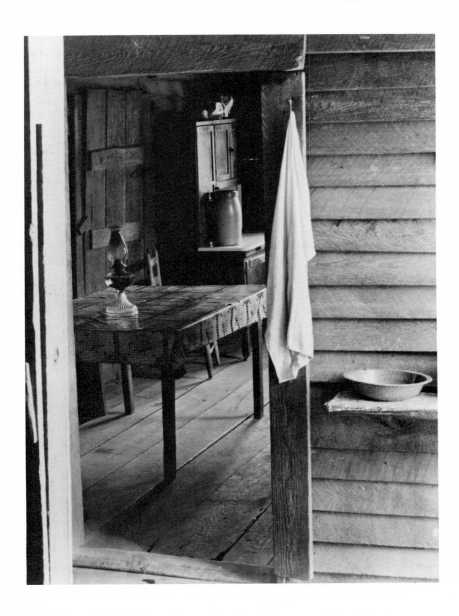

31. Walker Evans. Interior, sharecroppers' cabin, Hale County, Alabama.

Crime of Cuba, let alone the supplying of information characteristic of captions in *Survey Graphic* or *Life.* Evans's pictures do not invite language. He insists on an austere, nonverbal purity that should match the purity of line in the Gudgers' stoneware jug or the purity of texture in the weathered pine boards of their house (figure 31).

Although Evans avoided captions throughout his career (there are none in *American Photographs* or the 1966 volume of subway portraits *Many Are Called*), there is no reason to think he alone was responsible for their omission in *Let Us Now Praise Famous Men.*

There was something opposed to captioning in Agee as well. The caption is after all a literary form developable only within limits, and Agee's ambition was obviously to defy limits. As early as 1934, when Agee wrote the text for a *Fortune* article on "The Drought" and supplied captions for pictures by, of all photographers, Margaret Bourke-White, he chafed against the limits of the form. Next to a pair of contrasting landscapes, a wheat field being harvested and stunted corn barely surviving on the parched earth, Agee multiplies the adjectives and images, as if in competition with the photographs. Rich farmland is "the rooted sea" pouring the sheen of "its proud plain wealth"; scorched farmland is a "turning hearth, glowing before the white continuous blast of the sun." Elsewhere, readers are hectored ("Then, gentlemen, you might begin to know what it can mean") and told to recall, as they look at the corpses of cattle, "that noble motet which begins: *Plorate, filiae Israel*" [Weep, daughter of Israel]. Under a high-angle shot of starving animals, Agee quotes lines from Keats's "Ode on a Grecian Urn." [15] Captions like these work against the image they nominally serve, by distracting attention, by making the plain seem flat and the factual seem irrelevant.

One might, perhaps, think of the text of *Let Us Now Praise Famous Men* as an enormously expanded, limit-defying caption, but it is a caption working against the Evans photographs. Agee's prose, though less brashly allusive, is otherwise like that of "The Drought"—strongly metaphorical, repetitive, rhythmically assertive, and above all self-conscious. It draws attention to itself. Indeed, it insists that one of its topics is the way it draws attention to itself. Self-consciousness is for Agee the "most complex and malignant form" of the disease of being, "our deadliest enemy and deceiver," but simultaneously "the source and guide of all hope and cure"; it is for him what cotton farming is for the tenant families, a task having "the doubleness that all jobs have by which one stays alive and in which one's life is made a cheated ruin." On and on the contradictions and paradoxes go, distancing Agee's discourse ever more from the photographs in their section, which can mean different things and hint at different intentions but which cannot contradict themselves. Nor can they move in time. Like all photographs, they stop time, holding Bud Woods in his cotton field or Louise Gudger on her front porch forever in the same pose. "Monumentally static," Agee calls Evans's art elsewhere. Agee divides art into the static kind, with a Tolstoyan nobility or Joycean denseness "resolved in its bitter purity," and the volatile or lyrical kind, with its way of seeing "most nearly related to the elastic, casual, and subjective way in which we ordinarily look around us." Agee himself is among the most volatile or lyrical of artists, the most elastic of perceivers. His words put Bud and Louise and his consciousness of them in motion, shifting forward and backward, speeding up or slowing down. One of Agee's chief purposes is to con-

fuse time's passage, rendering it a medium completely subject to artistic control, as the play of tenses in the last sentence of the book indicates: "each of these matters had in that time the extreme clearness, and edge, and honor, which I shall now try to give you; until at length we too fell asleep." [16]

To be more particular, Agee's self-consciousness is of the questioning, late Romantic sort best able to regard itself by admiring what it is not. He puts an enormous value on impersonality, drunkenly praising sobriety. In this he is close to his older compatriot Henry Miller, who in the twenties prowled the streets of Paris with his friend the Rumanian photographer Brassaï, as in the thirties Agee prowled the sodden fields of north Alabama with his friend Evans. Brassaï taught Miller to see differently, since the photographer had the "rare gift" of normal vision: he had "no need to distort or deform, no need to lie or preach." But as Miller goes on championing normal vision, his language grows more and more inventive, distorting, fictive, and self-conscious: "I have felt the penetration of his gaze like the gleam of a searchlight invading the hidden recesses of the eye, pushing open the sliding doors of the brain. Under the keen, steady gaze I have felt the seat of my skull glowing like an asbestos grill." [17] Miller's comments on Brassaï become a study of Miller; objectivity is subjectively presented; the novelist and the photographer are revealed as having a friendship and a city to share, but no comparable technique.

Agee similarly champions the normal vision of Evans's instrument, the camera, "incapable of recording anything but absolute, dry truth." After describing the facade of the Gudgers' house, Agee admires the textural beauty of its wood, seeming for a moment to emulate camera work. Evans, after all, as shown by his portrait of Annie Mae Gudger, is no less interested in the grain of wood than in the lines on a face (figure 32). But if Agee here puts on a photographic manner, the absolute, dry truth is scarcely what he records. In smothered light, the wood of the facade has "the aspect of bone"; in rain, the hues of bone become "the colors of agate" until the whole wall is "one fabric and mad zebra of quartered minerals and watered silks." Later, at the end of the book, Agee supplies two paragraphs which again hint at a photographic fidelity, in that they are mere "descriptions of two images," not words. Perhaps he guesses that readers are at this point wearied of words; perhaps he wishes to balance the photographic images at the start with verbal images at the end. What he actually puts on the page, however, is not mere description. It is full-blown, Harvard-educated eloquence applied to Squinchy and Annie Mae Gudger and Ellen Woods, the rendering of a nursing in a hickory chair as a pieta, and a celebration of the life force flowing from a child's body until it shall at length outshine the sun. [18]

For all his self-deception about mere descriptiveness here, in this obvious peroration, Agee admits elsewhere in the book the inherent

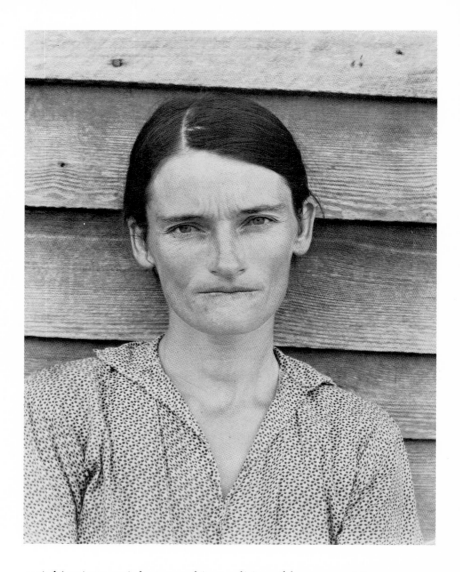

32. Walker Evans.
Annie Mae Gudger.

antiobjective, antiphotographic qualities of language. Most memorably, a passage coming just after his praise for the camera establishes the impossibility of genuine linguistic "naturalism" or "realism." A writer may try to capture the reality of a city street in its own terms—abjuring all metaphor, symbol, selection, and temptation to invent; holding strictly to materials, forms, colors, bulks, and textures. But all writing "gathers time and weightiness which the street itself does not have: it sags with this length and weight." Words, alas, "are the most inevitably inaccurate of all mediums of record," and they come at what they do by a "Rube Goldberg articulation of frauds, compromises, artful dodges and tenth removes." Like Sartre, Agee believes that the picturesque takes refuge in words. Unlike Sartre, he issues no

condemnation of words, holding, as Sartre would no doubt judge, to a Barrès-like aestheticism (Agee says, notoriously, that the aesthetic success of the tenant families' houses is even more important to him than their functional failure).[19] Verbal mastery, extravagance of style, is what Agee knows he is uniquely qualified to bring to Alabama. The restraint of Evans's camera and its absolute, dry truth he can love only at a distance, as he loves the helpless innocent sexuality of Emma Woods, caring for it the more in knowing he cannot have it.

Clarence John Laughlin, a less talented, less original, and more naively egotistical version of Agee, had only to produce in *Ghosts along the Mississippi* a text suitably accompanying the photography of Clarence John Laughlin. In *Let Us Now Praise Famous Men* Agee has the harder task of suiting Evans, whose style at nearly every point is the opposite of his own—cool rather than warm, circumscribed rather than expansive. But the divergence of the two artists is not automatically to be regarded as a failing, an unforgivable flaw in the structure of *Let Us Now Praise Famous Men*. One can (like Stott) admire the disparate excellences of Agee and Evans, and value these more highly than the putative excellences of the work which would have been achieved if Agee had been more restrained, Evans more rhetorical. Agee and Evans, separately, go about their business with great integrity. Knowing they work in different ways, they refuse to employ any conventional devices linking words and photographs, such as captions or discussions of specific pictures in the text, even though these might disguise their differences. In this refusal Agee and Evans are radical innovators. Their work affronts the ideal of stylistic consistency as it affronts much else. Yet *Let Us Now Praise Famous Men* hardly breaks paths for other books to follow. The principle that collaborative efforts succeed when they employ similar artistic personalities, use analogous techniques, and in general find common ground still remains basic to works combining literature with photography. *Let Us Now Praise Famous Men* stands by itself, admirable and infuriating, uninfluential now, unsuccessful in 1941, "experimenting" with the idea of collaboration by spurning it, insisting that, for all their coequality in the task of praising those who have no memorial, pictures and words praise in different ways.

Talking Pictures

The twenty-one years between Archibald MacLeish's first book of verse, *Tower of Ivory* (1917), and his poem with photographs, *Land of the Free* (1938), can be matched, for paradigmatic neatness of poetic development, by no comparable period in the careers of other modern poets. In the first short stanza of a poem from his first volume, MacLeish refers to Euripides, Horace, Euclid, Michelangelo, Darwin, Virgil, Socrates, Don Quixote, Hudibras, and Trinculo. At

age thirty—or as the title of a poem has it, at "L'An trentiesme de mon eage"—he contemplates expatriation in the European Waste Land, acknowledging that he has come upon the place "By lost ways, by a nod, by words," but leaving it to the reader to surmise that the words are Eliot's and Pound's as well as Villon's. "Ars Poetica" (1926) supplies objective correlatives ("For all the history of grief/An empty doorway and a maple leaf") to show that poems should not mean but be.[20]

By *New Found Land* (1930), however, MacLeish has started to come home to American issues; by *Conquistador* (1932) he is studying military adventurism in the New World; and by *Frescoes for Mr. Rockefeller's City* (1933) he is versifying a current controversy, the removal of Diego Rivera's murals from the walls of Rockefeller Center. Poetic being now seems less important than poetic action. "What is necessary," he explains in introducing Agee's poems *Permit Me Voyage* (1934), "is to make the thing *happen* in the poem as it has never happened before." By title alone MacLeish's *Public Speech* (1936) declares the new purpose. Aware of suffering, longing to be responsible, the poet is ready to forget everything that has mattered before, the riddle of the sphinx and the tone of Roland's horn, and search instead for a genuine national tradition. The "silence waiting in the hall" that he once heard with weary Prufrockian anxiety is replaced by the noise of America speaking. Sometimes it speaks in a down-home, folksy tone, as when *Land of the Free* plays with phrases like "grit in your craw" and "the gall to get out on a limb and crow before sun-up." At other times America shouts out the anger of a Wobbly orator:

> The right to assemble in peace and petition?
>
> Maybe.
>
> But try it in South Chicago Memorial Day
> With the mick police on the prairie in front of the factory
> Gunning you down from behind and for what?

MacLeish came a long way, as T. K. Whipple commented, from "I" to "you" to "we," the "we" being the exploited and expropriated American people whom MacLeish and Sandburg alone among modern poets cared about. Although in 1936 MacLeish was working for *Fortune,* employment at that magazine, as the careers of both James Agee and Dwight Macdonald suggest, was no impediment to leftist thinking. To balance the articles MacLeish wrote on Ivar Kreuger, J. P. Morgan, Walter Chrysler, and George V, he wrote articles on housing (with photographs by Aaron Siskind), Soviet art, unemployment relief, and the National Recovery Administration.[21]

It was almost certainly in the course of writing and editing for *Fortune* that MacLeish became aware of the FSA photographers and their work. Their section chief, Roy Stryker, did his best to get mate-

rial from his growing picture file into the national press, especially the Luce press. MacLeish conceived the idea of illustrating a poem with such photographs, of surveying Depression-era America in words and pictures, and he sold the idea to C. A. Pierce of Harcourt, Brace, who approached Stryker with requests for photographic material. Stryker, in turn, asked his photographers to be on the alert for suitable subjects. He wrote Dorothea Lange, for example, that this "very important job" proposed by MacLeish, which had the blessings of prominent New Dealers like Will Alexander and Henry Wallace, would be on the general theme of "stranded peoples left behind after the empire-builders have found new areas for their exploitation." He wanted from her pictures of "Ghost towns left behind from forest and mining exploitation; the abandoned homes of people who waited for water; the aftermath of irrigation booms." Later he wanted her to photograph a "great sweep of open land," the "widest possible space of treeless empty country." Although this is not exactly what Lange provided for the book, she and other photographers did provide pictures to order, on themes suggested by Stryker and no doubt indirectly by MacLeish, who met with Stryker in Washington to dump file drawers inside out and discuss the project. The photographers followed a "shooting script" only somewhat less detailed than those Stryker routinely distributed to his agents in the field. MacLeish's later claims that his work is subsequent and subordinate to the photographs and that *Land of the Free* is "a book of photographs illustrated by a poem" are therefore disingenuous. He is less a respondent to objective photographic reality, "vivid American documents," than an assignment editor, who sketches the sort of story he wants, makes selections from his reporters' eyewitness accounts, and puts the whole into unified shape, freely changing the original conception as he does so. MacLeish can be believed when he says that the power of the photographs altered his plans.[22]

MacLeish and his "collaborators," who include Lange, Rothstein, Lee, Theodore Jung, Shahn, Evans, Mydans, and a few unidentified photographers from other governmental agencies and commercial firms, see a variety of things as they move out into the America of 1938. They see, first, faces that do not know which way to turn, as in Lange's study of a Missouri farmer who has become a migrant farm laborer in California (figure 33). Where is he going to go? MacLeish's accompanying text is "We aren't sure." The words suit the image, but only the image in its cropped state. The original photograph, as revealed in the FSA files and in a 1939 *Fortune* article on immigrant labor in California, includes the figure of the farmer's wife, who snuggles into her coat with remarkable complacency (figure 34). "We aren't sure" is what the farmer and those like him would say if they were given a voice. This phrase and its variants—"we don't know," "we're wondering"—are repeated twenty times in this short text.

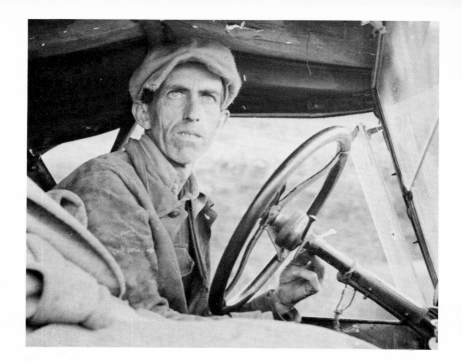

33. Dorothea Lange. Migratory farm worker on the Pacific Coast, from *Land of the Free*.

34. Dorothea Lange. Migratory farm worker on the Pacific Coast, as originally photographed.

"We don't know," "we aren't sure," is MacLeish's refrain, the burden of a melancholy ballad. Faces of ordinary Americans which in other contexts might seem heroic here seem full of doubt. MacLeish's "we don't know" on the page opposite an Iowa farmer photographed by Russell Lee makes him appear to be troubled by what he sees. His brows are knit in perplexity, not stoic effort. He is a dweller "in a world in which things don't quite hang together, in which there are odd discrepancies between the good will and humanity of each individual and the unfathomable harshness of the system in which all live."[23]

For a long time, MacLeish observes in *Land of the Free*, Americans have been telling over the old pieties: "We cut our brag in the bark of the big tree—'We hold these truths to be self evident.'" He recalls the oral tradition of liberty: the Declaration of Independence remembered from generation to generation, along with phrases from Lincoln's speeches and even a few scraps from Whitman, poet of democracy. But now the Depression has broken the tradition by making the remembered phrases seem automatic. "We told ourselves we were free because we said so," MacLeish comments, mimicking the incantatory smugness and circular logic of ritual.[24] In the face of poverty, strikes and strikebreakers, the pollution of the land, the Dust Bowl, migrant camps, and the relief lines, Americans have neither freedom nor words. They can say nothing, even about loss of freedom, if they do not know, are not sure. In Lange's "Migrant mother," reproduced by MacLeish, the woman is presumably looking into the future, and the children she is protectively embracing are turning away from it. But they might also be looking into the past, which cannot justify or explain their plight. In *Land of the Free* memory is devalued because it leads nowhere.

"Maybe" is another recurrent word of the poem. Maybe the self-evident propositions were all a peculiarly American form of self-deception. Maybe the land itself was the better expression of freedom. In the middle section of his work MacLeish explores this possibility, always in the tentative, improvisatory tones of a man forced out of the ivory tower into a puzzling landscape. Maybe the expansion westward convinced Americans they had no limits. The photographs show the Rockies, prairie grass, creeks working west to the Mississippi, or roads leading into the distance, as in a melancholy sunset scene by Willard Van Dyke. A poetic catalogue of blue ash, hickories, homestead oaks, and cypresses suggests that the forests once led west; and the grass led west, holding out the same promise to father and to son. MacLeish lingers over the sage smelling of men and tasting of memory. The problem is that this past of abundance and continuity is entirely in the past tense and out of reach. The grass *was* always ahead of pioneers heading west; the forests of Michigan "lie behind," inaccessible.

In 1938 Americans are still moving west. Carl Mydans photographs the migrants on the cotton choppers' road. Awaiting them is labor in the fields in an endlessly repeated progress from Colorado and the melons to Billings and the beet crop. MacLeish names the agricultural localities in a list that ought to sound exuberant but sounds merely tired. Whitman has been turned into a litany of sorrow, but then Whitman has already been discounted. The lilacs are odorless now, and they bloom in another's dooryard. Finally, California awaits the migrants, for MacLeish the place of Hoovervilles and broken images. Photographs by Dorothea Lange depict Okies' tents tied to, held up by, a barbed-wire fence. Barbed wire keeps coming into this book, in words and photographs, forming the barrier between the rich past and the impoverished present. Yet there hardly needs to be a fence between men and the land in their actual state. The Alabama farm boy in an image by Arthur Rothstein is free to move out to his gullied land, but he is held in thought, his instinctive American confidence eroded away (figure 35).

35. Arthur
Rothstein.
Eroded hillside.

In *Land of the Free* MacLeish faces the artistic dilemma of having to illustrate the Depression and its victims without evoking the simple, condescending, and useless response of pity, or evoking pity alone. His solution, like Caldwell and Bourke-White's, is to suggest ways for the victims to act, to give them some backbone and control over their own lives. Americans receive no help from the land or from the self-evident truths they once had passed on to them, and consequently they do not bother to pass on wisdom to their children. They remain silent. But there are different ways of remaining silent. *Land of the Free* finally depicts Americans stubbornly, even truculently, keeping their damn mouths shut and standing there. That is the text accompanying Russell Lee's picture of an old lumberman who, like a defiant farmer captured by Lange, seems to await the moment when he may speak out actively, radically, and collectively in a political protest. The book ends with the vaguely hopeful suggestion of a liberty based on men, not land; a liberty defined in a new way, unconnected with the past. The questions have finally been turned outward to all those sons of bitches of company lawyers and other city folk in authority. The rhetoric grows stirring. Maybe, maybe. At the end MacLeish's populist voice is still wondering, still not knowing; the rhetoric is still not stirring enough to make one forget all the earlier doubtings and losses, chief among which is the past, wisdom handed on from generation to generation, memory itself.

The format of *Land of the Free* hints at MacLeish's trust in one artificial means of communication, which is what Americans have left when storytelling lapses. That format, on the face of it, is unremarkable: a photograph on the right-hand page, bled out to the side margins but given much white space at top and bottom, with a few lines of poetry "captioning" the photograph on the left-hand page. There are only so many ways of arranging words and pictures in a book, and MacLeish cannot find a strikingly new way. But he can suggest an analogy. He prints a blue horizontal line at the top of every text page, and at the start of the book labels this blue line "The Sound Track," signaling that his work is to be taken as a documentary film, the words being a kind of "voice-over," running commentary, or occasionally overheard monologue. Text and pictures are to be perceived simultaneously, as they would be in a film. They are to make a direct and immediate impression. They are to dramatize current history in a printed style analogous to the cinematic style of the Luce-sponsored newsfilm series *March of Time*, begun 1935, with its studio re-enactments of actual events, or of Pare Lorentz's government-sponsored documentary films *The Plow That Broke the Plains* (1936) and *The River* (1937). In the book form of *The River* (1938), published in the same year as *Land of the Free*, Lorentz printed the script under stills from the film. In the book version of Joris Ivens's documentary film *The Spanish Earth* (1938), the Hemingway script is ac-

companied not by stills but by woodcuts by Frederick Russell; the volume is divided into six "Reels," a labeling device much like MacLeish's "Sound Track." Three years later John Steinbeck published a book version of his Mexican documentary film *The Forgotten Village*. The end of the decade, in other words, was pre-eminently a time for blurring generic distinctions in the service of a political cause, for expanding the scope of the relatively familiar documentary photo text with techniques adapted from the relatively unfamiliar and exciting documentary film. "Talking Pictures," *Time* headlined its review of *Land of the Free*. The pun is an apt phrase for all these late thirties books posing as movies.

MacLeish knew how to write scripts, publishing two radio verse dramas, *The Fall of the City* (1937) and *Air Raid* (1938); he also helped with the funding for actual documentary films, contributing with John Dos Passos and Lillian Hellman to *The Spanish Earth;* and his awareness of films was shared by the still photographers who provided pictures for *Land of the Free*. A field note by Lange for May 23, 1937, for example, just at the point when she was beginning work on the MacLeish project, mentions the *March of Time* and the historical film on the subject of drought migration.[25] *Land of the Free,* like *Let Us Now Praise Famous Men,* comes from a time and a set of artistic personalities that could hardly be ignorant of film. In such matters as the creation of a mood and the reliance on a visual "logic" (advancing a work by the sequencing and juxtaposing of images rather than by the marshaling of argument), *Land of the Free* benefits from lessons taught by filmmakers like Lorentz, Robert Flaherty, and John Grierson. Yet the book does not really make its readers feel, even for a moment, that they are watching and listening to a film. The pages must be turned. The "Sound Track" must be read, either before or after the photograph on the facing page is scanned. Like any author of a published screenplay or like Strand and Zavattini in their film-style collaboration *Un paese,* MacLeish does not literally manage the "coinciding of the picture and the printed word in *space,*" which would correspond to a film's coinciding of sight and sound in time.

The quoted phrase comes from Elizabeth McCausland, a photographic critic and documentary reporter active in the thirties. McCausland's is by far the best period criticism of photo texts and their experiments with format. In her article on "Photographic Books" for Willard Morgan's encyclopedia *The Complete Photographer* (1943) she defines the genre and traces its history back through Lewis Hine's *Men at Work* to P. H. Emerson's *Life and Landscape on the Norfolk Broads* (1886); she reports on avant-garde developments in Germany as shown by Werner Gräff's *Es Kommt der Neue Fotograf!* (1929) and Hans Richter's *Filmgegner von Heute-Filmfreunde von Morgen* (1929); she comments perceptively on *You Have Seen Their Faces, Death in the Making, An American Exodus,* and *12 Million Black Voices,* if rather perfunctorily on *Let Us Now Praise Famous Men*

("strictly speaking, not a photographic book at all"); and she quotes the prospectus she wrote for the format of *Changing New York,* her collaboration with Berenice Abbott:

The form sought should be in its fundamental intellectual aspects related to the form of the documentary film, in which commentary accompanies the visual image seen on the screen, the spoken word complementing and accenting the pictured fact.

Shifting from the moving picture to the still photograph, one encounters a problem of technic as well as form. In the documentary film the appeal to sight and sound occurs simultaneously in *time.* The parallel for the superimposition of visual and auditory image must be in the photographic-book-with-text, a coinciding of the picture and the printed word in *space.*

McCausland finds old layout formulas unacceptable and argues for innovative freedom, such as "a small detail inserted in the letter-press, with the effect of being a pictorial footnote or a typographical flower." She urges writers to endow their texts or captions with a scenario- or plot-like continuity, even though she concludes ruefully that the layout finally chosen for *Changing New York* has none of these filmic virtues, juxtaposing as it does a static type page with a dynamic picture page and failing to achieve a "perfect equilibrium."[26] She understands that perfect equilibrium is something not to be achieved but rather approached, either in documentary films or in the books, like *Land of the Free,* imitating them. She considers MacLeish's work in keeping with the "modern technological spirit" but inferior as poetry and generically discriminatory, since only the writer, not the photographers, is named on the title page.

Thanks to the generality of *Land of the Free,* which of all the Depression photo texts is the one least focused on a specific problem or area, and thanks also to the fame of its author, the book encouraged other writers and photographers to approach ever more closely a quasi-cinematic technique, a balance of elements, a reworking of old ideas of captioning and illustrating. It inspired voice-of-the-people captions in *Tenants of the Almighty* (1943) with text by Arthur Raper and FSA photos by Jack Delano: "Our hands and feet know the feel of this land." It also influenced the captioning style of Carl Sandburg in the 1942 Museum of Modern Art exhibit The Road to Victory: "In the beginning was virgin land and America was promises—and the buffalo by thousands pawed the Great Plains." It may underlie, as A. D. Coleman notes, the structural technique of Morris's *The Inhabitants,* the jacket copy of which refers to the text as "the sound track."[27] But after the Second World War the photographic book and the documentary film both began to yield pride of place to a medium more technically advanced and potentially influential than anything yet seen. Insofar as documentary survived into the fifties and sixties as a distinct genre, television became its dominant mode of expression, eventually replacing even the all-powerful *Life* and *Look,*

and relegating photographic books to a limited and consciously artistic role. This development was one that Walter Benjamin could not have foreseen but would have understood. When wisdom is devalued, information takes its place. When common experience is devalued, as in the current world where there are no Miss-Mollies living at home and where phrases from Lincoln and Whitman seem to come from a distant and dimly remembered past, sophisticated artifice is what we have left.

Notes from the Field

The collaboration between Dorothea Lange and Paul Taylor which produced *An American Exodus: A Record of Human Erosion* (1939) was the most intimate of any carried out by writer and photographer in the thirties. Lange and Taylor were married (as were Bourke-White and Caldwell, though more happily and durably); they agreed exactly on what they were doing and how to accomplish it; they had enormous respect for each other's abilities and each other's medium. In letters to Sacramento or Washington bureaucrats, Taylor insisted that photographic documentation was essential to the kind of economic research and popularization he was doing. When he addressed the Commonwealth Club in San Francisco in 1935, summarizing the plight of migrants to California and urging the construction of camps to house them, he spoke in a room hung with Lange photographs, the corroboration of his own eyewitness testimony. He could say to his audience, in an injunction that was not merely figurative, "See the shiny cars of tourists, the huge trucks of commerce . . . and at intervals the slow-moving and conspicuous cars loaded with refugees from drought and depression in other states." Lange, for her part, wanted her images to be supported by words and even felt it her task to record those words. She was the most diligent of FSA photographers in writing captions for her pictures and mailing them in to the office, pleasing Stryker in this if finally not in much else. She knew that language alone, whether hers, Taylor's, or a migrant's, could ground a photograph in actuality and so make it useful politically or, for that matter, impressive artistically; Lange thought that beauty owed much to specificity. In 1936 she photographed two pea pickers ugly in every regard except the dignity they maintain as they sit on the running board of their jalopy. Dignity is what Lange's picture of them is transparently meant to convey and what she must have known she was expressing even better in the quoted words of her caption: "Ma'am, I've picked peas from Calipatria to Ukiah. This life is simplicity boiled down." [28]

The economist and the photographer began working together in 1935, producing reports for government relief agencies. They studied housing for migrant farm laborers and the influx of drought refugees into California. Their first report had fifty-seven photographs, the

second thirty-nine. Years later Taylor ascribed the success of the first report, which produced an emergency requisition for the first federally funded housing in the United States, to the images of suffering Lange provided. At the time, in a letter sent along with one of the reports to Washington, he put an equal emphasis on the transcribed words and stressed above all the fundamental authenticity of both images and words: "The attached document presents notes which are fresh from the field. The very words of the persons photographed are quoted as much as possible in order that the expression of the conditions, needs, and hopes of those in distress may be transmitted faithfully."[29] The third Lange-Taylor report, a spiral-bound notebook with twenty-seven photographs, rehearses techniques later to be employed in *An American Exodus,* including paired, contrasting images; on the left, ramshackle Hoovervilles appear; on the right, orderly, government-sponsored camps. The captions stylize the encounter between investigator and refugee:

Mother of five children. Drought refugee from Oklahoma.
 "Making a living?"
 "Oh, I guess we're getting along as good as us draggin' around people can expect—if you call it a livin'."
 May 22, 1935[30]

In 1935 Lange and Taylor brought out in *Survey Graphic* the article "Again the Covered Wagon," their first published collaboration and the only one in which Taylor's text clearly overwhelms Lange's pictures. It has only six photographs, illustrations merely, though they are captioned with quotations in a way that anticipates the nonillustrative and coequal function of the photographs in *You Have Seen Their Faces.* For that matter, the words "God only knows why we left Texas 'cept my man is in a movin' mood" under a picture of refugees in their car anticipate those infrequent Caldwell and Bourke-White captions which look down on their subjects, finding amusement in folksy simplicity. Lange and Taylor could have defended themselves against a charge of condescension, had they faced one, by insisting that their quoted caption is transcribed directly from life, as Caldwell and Bourke-White's words were not.[31]

 After 1935 Lange and Taylor entered into a period of federal government work intensive enough to preclude major publications. Lange was on Stryker's photographic staff in the FSA; Taylor did research for the Social Security Board. They could often go on field trips together, taking notes, shooting pictures, listening to stories of those on the roads or in the camps. Their travel was to central California, the Dust Bowl region of the Southwest, chiefly Texas and Oklahoma, and, to a lesser extent, the cotton and tobacco belts of the South, so when in 1938 they began to plan a documentary book, perhaps encouraged by MacLeish's example, it was natural for them to shape the book around the regions they knew well, to give it the theme of

mass movement from the wind-blown and tractored-out high plains to the field work and transit camps of the West. Movement, exodus, was their particular subject, as confusion was MacLeish's and cotton tenantry was Caldwell and Bourke-White's.

In six discrete sections, titled "Old South," "Plantation under the Machine," "Midcontinent," "Plains," "Dust Bowl," and "Last West," the book, which they named *An American Exodus,* accompanies the migrants on their way along Highway 66. Each section begins with captioned photographs and concludes with three or four pages of text, which comment on the region and its problems, usually by way of summarizing its history, while keeping to the unpretentious style of the captions and photographs. Even with space at his disposal Taylor is succinct and specific. His discussions of policy invariably focus on effects on individuals; he likes anecdotes, hard-luck stories, and cautious expressions of hope, and he values cranky opinions as much as Lange values weather-beaten faces. He ventures an occasional irony or metaphor, as in mentioning that migrants have been scattered over the West "like the dust of their farms," but on the whole he prefers to describe and argue, sometimes letting description become an argument: tenant displacement "manifests itself clearly on the landscape, now dotted with abandoned tenants' houses, windows boarded, and fields cultivated close." [32] He speaks, in other words, like someone who has learned a discipline of seeing from the Lange photographs and who allows himself to speculate about possible solutions only in an afterword. Taylor's unassertive prose may be definable only in negatives, because he lacks Caldwell's anger, Agee's eloquence, and MacLeish's ventriloquial ingenuity, but it is not for that reason ineffective.

As Lange and Taylor composed *An American Exodus,* they relied on working methods already established. Their basic resource was their hundreds of pages of field notes: memoranda, notes on locations and conditions, dates, figures on crop production and prices, excerpts from books and government reports, and above all quotations from migrants and their families. In one process of composition the field notes were expanded into a text, the exposition of the migrants' history and current problems; in another process the notes were compressed or abridged into photo captions. Lange's field notes and the dummy book which Lange and Taylor used in mocking up *An American Exodus* indicate the detailed carrying out of the second process. Two and a half pages of notes taken at a gas station in McQueen, Oklahoma, on June 21, 1938, become captions for a double-page spread (figures 36–37). The landlord is on one side, saying "I let 'em all go in. In '34 I had I reckon four renters and I didn't make anything"; his displaced tenant is on the other, saying "The people ain't got no say a comin'." [33] In 1937 in Hardeman County, Texas, Lange and Taylor met seven young farmers, all living on relief. The farmers

36. Dorothea Lange.
Landlord at gas sta-
tion, McQueen,
Oklahoma.

37. Dorothea Lange.
Tenant at gas station,
McQueen, Oklahoma.

were reticent at first, then talked about their personal dilemmas, and finally came shyly out of their shack to have their picture taken. Lange and Taylor left the meeting with a page of notes and photographs of an Evans-like poised solemnity (figure 38). The dummy book caption for one of the photographs reads:

> On a Sunday morning in June 1937 we drove across the Low Plains of north Texas and the Panhandle on US Highway 370 . . . Over a dirt road a couple miles north and a mile east. We knocked at a screen door and waited. The inner door opened and seven men filed silently onto the porch. We passed our credentials through the screen and waited as every man took the card and read. Then slowly they began to talk.
>
> All were displaced tenant farmers. The oldest was 33.
>
> All were native Americans, none able to vote because of Texas poll tax.
>
> All were on WPA. They supported an average of four persons each on $22.80 a month.

38. Dorothea Lange. Texas farmers on relief.

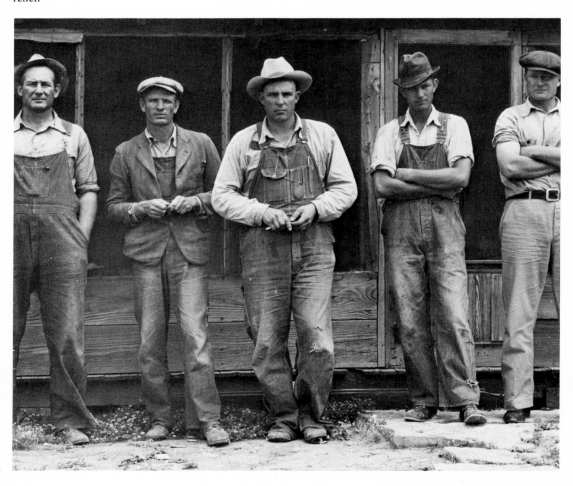

"Where we gonna go?"
"How we gonna get there?"
"What we gonna do?"
"Who we gonna fight?"
"If we fight, what we gotta whip?"
Who'll listen to these renters of the Texas plains?[34]

In *An American Exodus* as actually published, this material becomes:

ALL-DISPLACED TENANT FARMERS. THE OLDEST 33
 All native Americans, none able to vote because of Texas poll tax. All on
WPA. They support an average of four persons each on $22.80 a month.
 "Where we gonna go?"
 "How we gonna get there?"
 "What we gonna do?"
 "Who we gonna fight?"
 "If we fight, what we gotta whip?"
 North Texas, Sunday morning, June 1937[35]

The references to Lange and Taylor are omitted, to throw more em-
phasis on the farmers; and the mild editorializing of "Who'll listen to
these renters of the Texas plain?" disappears, lest the farmers' own
plaintiveness be thought insufficiently expressive of their misery.
Other revisions move the captions in the same direction, toward sim-
plicity, toward the virtually unadorned presentation of people who
can speak for themselves or show what they are in the pictured ob-
jects of their life. Information is provided, but only enough to create
an immediate context. Lange and Taylor want readers of their book
to think of themselves as traveling investigators there in Hardeman
County with the FSA photographer and the Social Security Board
researcher, seeing what they saw, jotting down notes as they did.
 An American Exodus is not merely derived from photographs and
field notes but also designed to look like photographs and field notes,
"notes fresh from the field," incontrovertible and eloquent in their
spareness. It hints at verisimilitude, just as *Land of the Free* with its
"Sound Track" hints at one kind of artifice. Lange and Taylor's con-
tribution to the art of textual-photographic design in the thirties is
precisely this disguising of finished work as preliminary research. Be-
tween the covers of their book appear facsimiles of a bulletin of a
Delta experiment station ("Making cotton cheaper—Can present
production costs be reduced?"), the front page of a Memphis news-
paper, and a 1925 handout advertising farm and dairy lands in Cold-
water, Texas—as though the bulletin, front page, and handout were
all genuine documents picked up in the field and stuck casually in a
notebook. Under a photograph of the Oklahoma State House is the
list:

1867—Cattle on the Chisholm Trail
1889—"Boomers" and "sooners" rush for homesteads
1905—Oil
1907—Statehood

The impression given is that Taylor or Lange has been reading a text-book of Oklahoma history and jotting down important dates. Elsewhere extracts from other books and from letters to newspaper editors are scattered at random in captions, as though just recorded and haphazardly applied to a particular photograph. Throughout the captions and text, figures are set down in finicky detail, especially when the farmers or migrants supply them: "In 1934 I give a year's work for $56.16 sharecropping 16 acres of bottom land in Love County, Texas." A line from an old Oklahoma song is put into service, or a stray remark ("I've turned four horses abreast many a day"), or a photographer's quick note on what she is about to capture on film ("Three families, 14 children"). The various type styles used in the captions—small capitals, plain roman, and italics—are not intended, as McCausland thought, to convey messages of two sorts, emotional or human overtones in the big type, specific data in the small type; they are in fact unsystematically assigned to different categories of information. Sometimes the big type summarizes, as in "ENTERING CALIFORNIA THROUGH THE DESERT"; sometimes it quotes, as in "COME TO THE END OF MY ROW IN ROCKWELL COUNTY, TEXAS"; and sometimes it records facts as in "CABINS $4 A WEEK, NO RUNNING WATER." The very typography of *An American Exodus* has something of a notebook's casualness about it.[36] And its language has or, if necessary, is made to have the casualness of note taking. The verbs in the dummy-book caption for the Texas farmers, for example, are omitted in the public version, to make the style seem telegraphic and up-to-the-minute. This is no past-tense helplessness the farmers suffer.

Revision of *An American Exodus* continued after 1939. In 1970, five years after Lange's death, a new edition of *An American Exodus* was published, with many changes in photographs and captions and with a wholly new section, "End of the Road: The City," to bring the story of westward migration up to date. Taylor's newly written captions for his wife's pictures of Bay Area subdivisions, auto junkyards, and wartime shipyards in no sense resemble field notes. Instead, they say portentously what the photographs mean: "City in transition," "End of the shift—whither?" "Resurrection of hope," and "Love and hate" for a pretty defense worker flirting with the camera on one side and a pretty defense worker glaring at a man on the other. John Szarkowski noted disapprovingly that the captions "demonstrate precisely how not to combine words with photographs."[37] They demonstrate more clearly how to combine words with photographs if the goal is to achieve undocumentary, distanced effects. By 1970 Taylor

was looking at photographs, a different thing from looking at photographed scenes. "End of the Road: The City" actually complements the new version of *An American Exodus,* which no longer offers itself as a work about contemporary problems. The subtitle is changed to *A Record of Human Erosion in the Thirties*; the facsimile newspaper pages and advertising handouts are excised, along with the extracts from thirties books, the sketch maps, and the occasional pictures from commercial sources; and Lange's photographs are reproduced so beautifully that they seem to be exhibits in a museum. News is changed into art.

For all these reasons, only the original edition of *An American Exodus* still reveals the motives behind the work. By minor artifices and a major effort to record experience truthfully, as they witnessed it, Lange and Taylor seek to convey a sense of immediacy: "So far as possible we have let them speak to you face to face." Face to face is how the rural people, tactfully approached and encouraged, found themselves able to speak to this writer and photographer. In emulation, Lange and Taylor speak honestly and directly to their readers—"Here we pass on what we have seen and learned"—in the closest approximation to unmediated documentary truth the thirties produced.[38]

Photographic Contrivance

"We adhere to the standards of documentary photography as we have conceived them," Taylor and Lange announce in their book. They mean in part that "Quotations which accompany photographs report what the person photographed said, not what we think might be their unspoken thoughts."[39] Taylor and Lange are more scrupulous captioners than Caldwell and Bourke-White. But what else Taylor, Lange, and the other documentary artists of the thirties conceive documentary photography to be and, more generally, what the photographers think of themselves as doing while they move through the countryside putting the Depression on record are not beliefs easy to interpret.

The photographers seem to think they are finding and expressing the truth. They set out to approximate the receptiveness of their equipment, the lens open to the world, the film recording every ray of light to fall upon its surface. Lange, for example, thought a good way to work photographically would be "to open yourself as wide as you can, which in itself is a difficult thing to do—just to be like a piece of unexposed, sensitized material." Though the remark comes from a 1960–1961 interview, it arises from an attitude Lange held throughout her working career. For much of that career she had a motto from Francis Bacon tacked up on her darkroom door: "The contemplation of things as they are, without substitution or imposture, without error

or confusion, is in itself a nobler thing than a whole harvest of invention." This respect for "things as they are" is most marked in Lange, among all her contemporaries, and most articulately expressed by her, but it is perceptible in a host of documentary photographers and critics, whose statements of purpose almost always explain that photographers open themselves as wide as possible to seek "what is out there," "the real story," "the unvarnished truth," "the facts." In 1940 the photographer and editor Edwin Rosskam, finishing up Anderson's *Home Town* with an encomium on the FSA, commented that "in the homeland of Hollywood tricks and advertising campaigns, 35,000 bald picture-statements of fact, widely distributed, are doing much to keep photography an honest woman." Eudora Welty, who worked briefly for the WPA in Mississippi as publicity agent, junior grade, wrote up its construction projects and took photographs of them and of much else, learning in the process "the real State of Mississippi, not the abstract state of the Depression." Her photographs, not her written reports, amount to "a record of fact, putting together some of the elements of one time and one place." Lincoln Schuster, introducing *Eyes on the World* in 1935, declared forthrightly that "the camera will not lie, and cannot flatter or defame . . . the art and science of photography . . . can now reveal human beings of flesh and blood as they really are, and not merely as they are made to seem in the banal poses of the studio . . . In the right hands, an artist's lens is an instrument of truth, a probing and searching instrument." In 1938 Elizabeth McCausland praised a traveling exhibit of FSA photographs for dispensing with the usual "Art world" diet of "cream puffs, eclairs and such" and presenting instead a "hard, bitter reality." In its first issue *Life* announced grandly that its intention was "To see life; to see the world; to eyewitness great events; to watch the faces of the poor and the gestures of the proud; to see strange things." Nothing was said about captioning, cropping, putting pictures in expressive sequences, or any other method of editorializing with photographs; everything, for *Life*, was a matter of seeing.[40]

Other sources of information, including inferences about working methods drawn from published books and photographs, reveal a radically different picture of photographic practice in the thirties. What Bourke-White, Lange, Evans, and all the FSA photographers carried with them into the field was no passive receptivity to the truth—no mind like unexposed film—but an acute, active consciousness of the truth they wished to see, the "hard, bitter reality" they wanted to present. If anything, their film was like their minds, selectively and exquisitely sensitized to suffering. In 1859 Oliver Wendell Holmes had remarked of the silver nitrate photographic paper of his day that it was "sensitive," endowed with a "conscience," and a later era made his description almost literally accurate.[41]

The photographers of the thirties, like all photographers before and since, turned their cameras in certain directions and not others, clicked the shutter at certain moments and not others, arranged lighting, set up shots through windows and doorways, and posed subjects—or devised artificial methods of keeping subjects unposed. In the darkroom they stressed certain light values and not others: Ansel Adams in his mountain pictures made chemical adjustments to produce the right pictorial effect. Photographers cropped out irrelevancies or contradictions and on occasion used the airbrush to take something entirely out of an image: Lange had "the best retoucher in the Pacific Coast" use an airbrush to remove a "flaw" from the "Migrant mother." In planning their books, photographers chose to print some pictures rather than others, and then put the "keepers" in certain pairings or sequences. Dispatchers of photographers, analogously, provided story lines, itineraries, and research material in advance, then afterward edited and censored. Only in the beginning days of the FSA Historical Section could Stryker have claimed to be directing a purely disinterested and factually documentary enterprise. Arthur Rothstein, the first photographer hired, had no instructions and so took pictures of "every scrap of paper that crossed Stryker's desk, every office memo, interior work that was being done to improve Resettlement Administration Offices." Later he and the other photographers received specific instructions from the director—Stryker's famous "shooting scripts"—which defined the significant and the visually useful in considerable detail: "Search for ideas to give the sense of loneliness experienced by the women folks who helped settle this country. This idea might be developed around an abandoned dwelling on a plains homestead."[42] As for *Life,* the newsmagazine kept its photojournalists on an even tighter leash. It might have declared more honestly that it aimed to see the life its photographers and editors together thought they wanted to see.

Some photographers were open about technical contrivances. Rothstein, for example, commenting on "Direction in the Picture Story," discussed at length how he got the right, photographable expression on the face of a southern woman standing at the door of her cabin. She posed graciously for him, but Rothstein wanted "sad expressions," "worried faces," and "apathetic gestures," so he had a friend engage the woman in conversation until these appeared, then snapped the shutter (figure 39). On FSA assignment in Alabama, Rothstein sought a picture indicating the need for soil conservation. Alabama provided him with a farmhouse and a badly gullied field, but Rothstein himself had to supply a human focus of interest by posing a boy against the house and asking him to look at the field. The result— figure 35— dramatizes, exactly in the way Rothstein had planned, "the human aspects of an otherwise unemotional prob-

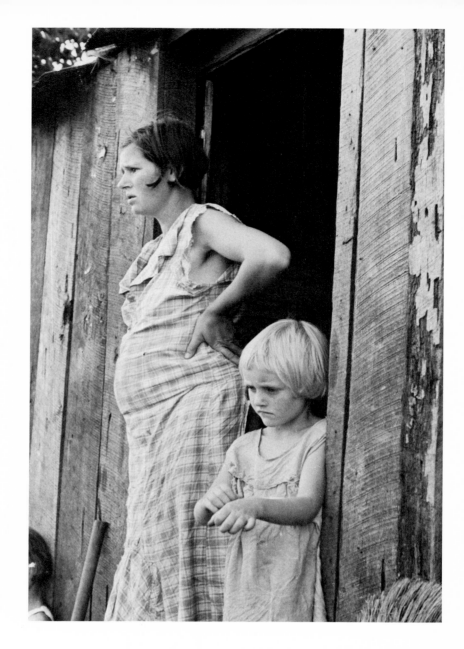

39. Arthur
Rothstein.
Wife and child of a
sharecropper, Wash-
ington County,
Arkansas.

lem." In the Dakotas, Rothstein wanted a picture of aridity and
moved a cow's skull onto an alkali flat to produce the right effect,
touching off a controversy about props, inauthentic settings, and pho-
tographic lying that briefly threatened all FSA photographic activities.
On assignment for *Fortune* in the Soviet Union, Bourke-White
adopted similar tactics. She routinely posed Russian factory workers
in ways that expressed her admiring view of the country's develop-

ment.[43] That is, she imposed a sensibility on her subjects of 1931 just as later she and Caldwell, making up words for their sharecroppers to "say," imposed a sensibility on the South.

Rothstein and Bourke-White were more than ordinarily communicative about their photographic activity. Bourke-White especially was caught up in the romance of her work, conscious of the ways her machinery carried "the symbolism of power," chatty about the difficulties she faced, and happy about the way she—a woman in a man's profession—moved people around and got things done. She took pleasure in living the part that circumstances, and *Life,* assigned her, the role of the celebrity photojournalist toting her cameras on board airplanes, up to front lines, and through the gloom of steel mills in pursuit of dramatic flashlit exposures. But in making and especially in choosing pictures for publication, neither she nor Rothstein was noticeably more manipulative, more given to artifice, than other photographers. The others also managed reality for artistic or political effect, though sometimes more offhandedly or obliquely. Walker Evans did not pose his tenant families; he allowed them to pose themselves. But there is a measure of artifice in that sympathy. Every self-presentation is a self-interpretation. Every chosen background, whether the front porch of a tenant farmer's house or the artificial palm fronds of a seafront photographer's outdoor studio (as shown in an Evans photograph for *The Mangrove Coast*), excludes other backgrounds and simplifies the confusion of reality. Evans must have known that his subjects' self-consciousness as they presented themselves to the camera was one part of their essential being, an aspect of their shy formality, but only one part, and not necessarily the most important part. The Gudger, Woods, and Ricketts families had gazes other than the unblinking frontal one Evans favored, using it in photographs of house facades as well, and chose deliberately to capture. After his field work, Evans published certain images and not others, composing a single consistent north Alabama out of all the potential north Alabamas implicit in the unpublished photographs. Even after the pictures were chosen, further adjustments to their "reality" became necessary. At one point in the complicated process of publishing *Let Us Now Praise Famous Men,* Harpers agreed to bring the book out only if certain unsightly flyspecks were removed from photographed scenes, and they were duly removed; later, a photoengraver for Houghton Mifflin had to restore them by hand, painstakingly nicking the plates.[44]

Dorothea Lange's artifice, like Evans's, was chiefly a matter of selecting one photograph rather than another. Her contact sheets contain hundreds more images than she could actually use in magazine articles or *An American Exodus.* She had to choose among different views of a scene or face, and almost always the reasons for her choices are patent. From two photographs of a cabin and a tractor in the

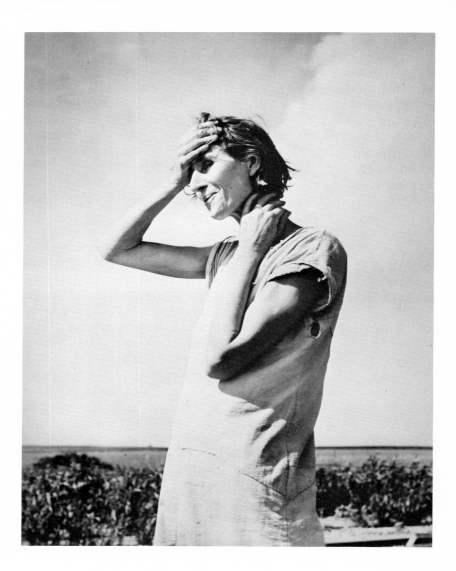

40. Dorothea Lange.
Farm woman in Texas
panhandle.

midst of fields, she chose for *An American Exodus* the one without a
figure standing on the porch, because the photograph was meant to
illustrate the theme of "tractored out." From five photographs of a
farm woman in the Texas panhandle Lange chose the only one to take
the woman entirely out of a social context, her house and her chil-
dren, and set her misery against a wide, empty sky (figure 40). "If you
die, you're dead—that's all," the caption quotes the woman as saying.
When Lange went over her photographs of young farmers on relief in
Hardeman County, Texas, she picked for publication the two images
that made the most ideological contrast. Five standing figures (Lange

did some cropping) look out challengingly to the camera, as if asking the bitter questions printed in the caption: "Where we gonna go?" (figure 38). Four seated, hapless figures appear above a captioned quotation from the President's Committee on Farm Tenancy: "Instability and insecurity of farm families leach the binding elements of rural community life" (figure 41). This photograph dramatizes the process of leaching before the viewer's eyes. The most expressive, or antidocumentary, choice of all involves views of a young family hitchhiking on Highway 66. The picture of them in *An American Exodus* emphasizes fatigue, confusion, and loss of spirits: "They're goin' every direction and they don't know where they're goin'," says a farmer in the caption (figure 42). Lange took eight photographs of this family, showing them in various attitudes and states of mind. The photograph she picked to print is the only one to show the father with his head bowed down, the older child with her hand to her eyes as if crying, and the mother without her thumb out signaling for a ride, and the only one to include a long perspective on the highway,

41. Dorothea Lange. Texas farmers on relief.

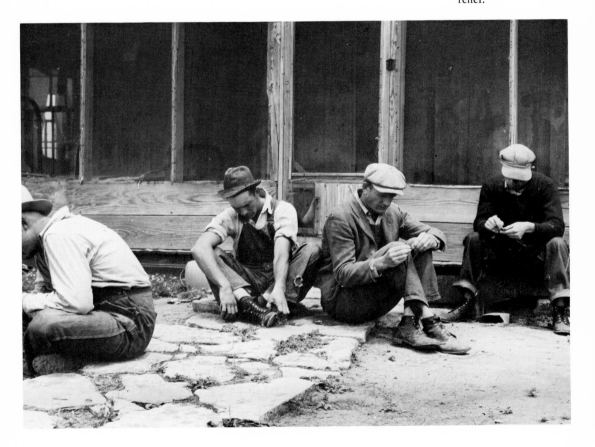

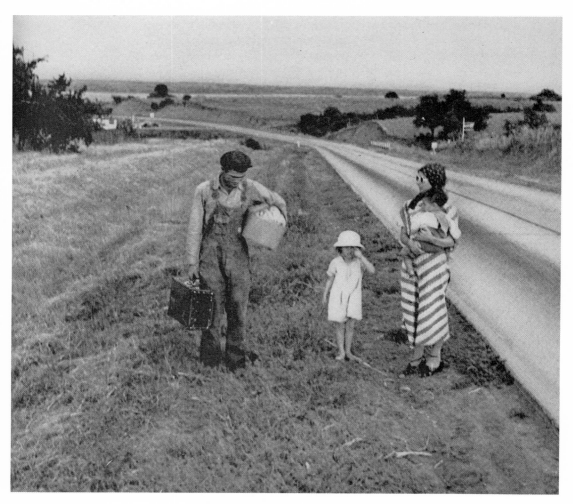

42. Dorothea Lange.
Family hitchhiking on
highway.

the weary distance they must traverse.[45] It is the only photograph, in short, to depict Lange's conception of life on the road—or Lange and Taylor's conception, since in all these choices both the photographer and her collaborator probably made the final decisions.

All these photographic contrivances, Lange's and everyone else's, do not necessarily contradict the truth-telling aims of the documentary genre once these are properly understood. For an instant Lange's hitchhiking family did actually appear in the way they are shown, and Taylor and Lange nowhere claim they are revealing the whole truth about human erosion in the thirties, every possible human situation and posture, every moment in the life of a family. It is enough for them to reveal a partial truth. Posed photographs, furthermore, may depict genuinely characteristic moods or predicaments: in this sense,

Rothstein's photograph of the farm boy and the gullied hillside truly depicts the human effects of erosion. And props may legitimately symbolize a truth about the natural or man-made world: in this sense Rothstein's photograph of the cow's skull truly depicts aridity. It would be wrong to regard the first photograph by itself as evidence for an historical inquiry, to say that it shows conclusively how poor white trash stood about their shacks doing nothing or went outdoors with one shoe on, but that is another matter.

The fundamental subjectivity of photographs takes various forms and lends itself to various uses; there are meaningful differences between, say, "Hollywood tricks and advertising campaigns" and the work of a Lange or an Atget. Reviewing one particular group of early documentary books, Civil War photographic albums, Alan Trachtenberg argues that the photographs in them are not incontrovertible, not free from the obscurities or covert ideologies which afflict other sorts of evidence. Thus Gardner's *Photographic Sketch Book* and George Barnard's *Photographic Views of Sherman's Campaign* (1866), in distancing the working war from their images, make an ideological statement. At the same time, the pictures in Herman Haupt and A. J. Russell's *Photographs Illustrative of Operations in Construction and Transportation* (1863) reliably if inadvertently establish a social fact, the use by the Union forces of free black labor. These photographs "show particularities as generalities, events and objects particularized—as only the camera was able to perform that representational act—for the sake of demonstrating a general point." [46] In 1863, even with its operator's mind on other matters, the camera cannot help but show black laborers and substantiate a fact about black labor; in 1938 it cannot help but show a family hitchhiking on Route 66 and substantiate a fact about dispossession.

Photographers and critics in the thirties did not themselves feel compelled by the apparent contradictions between truth-telling professions and truth-managing practices to look with some skepticism and rigor at their business. Stryker perhaps came closest to such an investigation when he wrote about honest and dishonest kinds of posing, the multitude of choices confronting every working photographer, and the complexity of documentary truth: "a balance of a lot of elements." The photographers themselves, however, were untroubled by apparent contradictions, saying nothing about them or blandly stating there was nothing contradictory. According to Rothstein, "With the aid of my friend's skillfully directed conversation, I had controlled the action, expressions, and attitudes of my subjects. At the same time, a factual and true scene was presented." According to Jack Delano, "One of my favorite pictures is of a Negro girl standing in a doorway looking down a long, long hallway where her grandmother is sitting on the steps in back. It's all carefully composed and very formal, but it is as documentary and direct as anything we

were doing" (figure 43).[47] To be sure, the photographers were too busy photographing to theorize. But there was more to their aesthetic naiveté than that. They held fast to an unexamined ideal of truth-telling documentary because that was what compelled them to photograph in the first place. However much they framed, cropped, or selected, the photographers believed they were devoted to and responsible for a reality beyond their manipulations and out of their control. The book of carefully chosen and arranged photographs appears in the guise of field notes; the most stylized presentations of reality imaginable—figures silhouetted against the sky, faces shot carefully out of focus, entire areas of a scene cropped out—are sent into the world as "things as they are." To admit complication, bias, personal idiosyncrasy, or propagandistic purpose would be for the thirties photographers to admit defeat.

Erskine Caldwell, Paul Taylor, Archibald MacLeish, and James Agee—the photographers' collaborating partners—showed no analogous faith in the truthfulness of their literary work. Language, as Agee said more frankly than any of them, is a Rube Goldberg contraption, an inherently distorting medium, and truth is "a balance of a lot of elements." The truth he could think of pursuing in *Let Us Now Praise Famous Men* is in fact "undiscernible." The only human being properly to be compared with a photographic plate is a child, because only a child is capable of mere "receiving." When Welty turned from camera work to the "story-writer's truth," she thought of herself as moving from objective facts to subjective long looks and growing contemplations, to "insight"—which "doesn't happen often in the click of the moment, like a lucky snapshot, but comes in its own time and more slowly and from nowhere but within." In *Goodbye to Berlin* (1939) Christopher Isherwood, an English counterpart of these American writers, described his documentary fiction in terms that became famous: "I am a camera with its shutter open, quite passive, recording, not thinking. Recording the man shaving at the window and the woman in the kimono washing her hair." But even a photographic receptivity requires later artifice. Isherwood went on to say that the man, the woman, and their street "will have to be developed, carefully printed, fixed"—metaphors corresponding to the judgmental adjectives, careful rhythms, and formal similes Isherwood devotes to Berlin. As an observer, Isherwood may be recording, but as a writer, he is thinking all the time, in words.[48]

Writers value photography and perhaps think of collaborating with a photographer in the first place precisely because they can invest a faith in it which they cannot invest in the complicated evasions and elaborations of literature. It is their vicarious authentication. MacLeish's contribution to *Land of the Free* is a poem, whereas the FSA photographers provide "vivid American documents" with a "stubborn inward livingness." That "stubborn inward livingness" is a char-

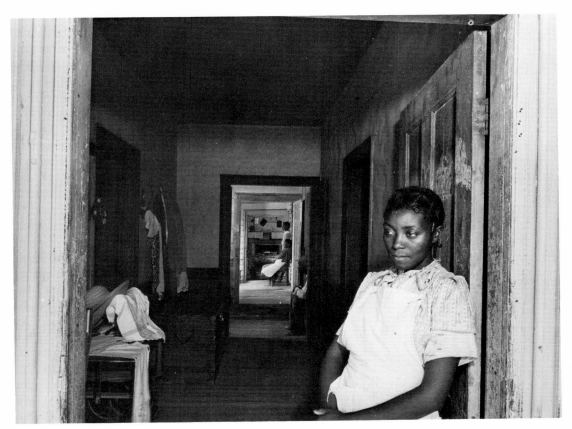

43. Jack Delano.
Interior of house,
Greene County,
Georgia.

acteristically evasive, elaborate, and literary way of saying "reality," "truth." Caldwell could substantiate a novelistic or dramatic view of the South no better than by choosing to collaborate on a new work with a documentary photographer.[49] No less than the photographers, the writers of the thirties needed to believe in reportable truth, and if the truth was not available in writing, they made it available in pictures.

Loss of Innocence in Contemporary Documentary

The qualities of *You Have Seen Their Faces, Land of the Free, An American Exodus,* and *Let Us Now Praise Famous Men* appear more distinct in comparison with newer American documentaries, works that sometimes avoid the label themselves, shrinking from its old-fashioned associations. Recent photo narratives and dream sequences have experimented with captioning techniques and layout; recent works combining documentary photographs with a text have not. Since *The Inhabitants* in 1946 no device comparable to a "Sound

Track" has been in sight. Daniel Seymour's *A Loud Song* (1971) claims to present a montage of images with a "soundtrack" written in words, a "storyboard" for a movie, but in fact the book resembles a home photo album with handwritten captions: "Here are my mother and father together." In any case *A Loud Song* is autobiography rather than outward-directed documentary.[50] There are no genuine soundtracks, nor any of McCausland's wished-for pictorial footnotes or typographical flowers, nor even any great number of human subjects "speaking out," Caldwell-and-Bourke-White style, in an italicized caption.

There is less excitement about documentary now, in all of its forms, and less feeling for the need to attempt two things at once, art and social investigation, as in the sharecropper's work-worn face which invites the viewer both to contemplation of its planes and angles and to tears or anger. Bruce Davidson's *East 100th Street* (1970) devotes itself chiefly to the appearances of Spanish Harlem, beautiful or intricately fascinating as these may be made to seem by artful visualizing, while Bob Adelman's *Down Home* (1972), a "social portrait of rural Wilcox County," takes a sociological or anthropological approach to changes in one carefully delineated area of Alabama over a carefully delineated five-year period. Adelman, or the editor of his text, Susan Hall, uses quoted words extensively in captions: the work is close in purpose to *You Have Seen Their Faces,* though far more cautious and impartial. Davidson and Adelman are specialists, the one tending to the museum, the other to the academic monograph. Robert Frank in *The Americans* (1959), though not to be categorized so easily and perhaps not to be considered a documentary artist at all, is a specialist in the sense of concentrating on one milieu, the highway culture with its lower middle-class Americans riding in their cars or listening to juke boxes in roadside cafes, and in the sense of stripping his photographs of any possible social or political meaning. He is an anti-ideologue, the late-fifties counterpart of John Gutmann, another European photographer fascinated by the mere strangeness of American culture. Though influenced by Walker Evans in other ways, Frank avoids commentary of even the muted sort Evans favored, the ironic juxtaposing of the old culture and the new; in *The Americans* he does without an editorializing or commenting text of any kind. The only words in the book come from Jack Kerouac, in an enthusiastic introduction. Kerouac is no Agee to provoke or move the reader. But he does say accurately that, after viewing the Frank pictures, "you end up finally not knowing any more whether a jukebox is sadder than a coffin," or whether any one item in the urban landscape is sadder or more significant than any other item.[51]

Neither is Michael Lesy an ideologue in *Time Frames: The Meaning of Family Pictures* (1980), nor Alex Harris in his two collaborations with Robert Coles, *The Old Ones of New Mexico* (1973) and

The Last and First Eskimos (1978). The Harris and Coles books are admiring rather than compassionating of their subjects, anthropological and psychological rather than political, but they differ most tellingly from thirties books in inciting the reader to no action, providing no evidence for the evaluation of a social state. Coles's method, like Lesy's, is to quote photographed subjects *in extenso*, keeping his own comments insignificant. If asked about his purpose, he might reply it is "to pay special attention" to New Mexicans and Eskimos now little known. His agenda is at once simpler than Caldwell's or Paul Taylor's, yet subtler and more elusive. Harris's complementary method is to portray individuals with an attention so respectful as to make any judgment about the way they live seem crude. The somber, uncommunicative dignity in the Eskimo faces he photographs rebukes the white man's trust in ideas, the confident social "understanding" which in fact understands nothing.

In *Killing Time: Life in the Arkansas Penitentiary* (1977), Bruce Jackson, after qualifications and self-imposed restrictions, finds himself able to conclude about incarceration only that "most people in prison are damaged by the experience in ways the Chi-square analyses of social scientists can't begin to calculate." In *Out of the Forties* (1983), a compilation of documentary photographs taken by Esther Bubley and others for a Standard Oil (New Jersey) project in 1943–1950, with a text locating the subjects of the photographs and tracing their personal histories to the present, Nicholas Lemann asserts with a flatness and predictability equal to Jackson's that "as Americans have grown materially better off and personally freer, the old bonds of family and community have grown weaker, and from that has sprung an infinity of consequences that have touched us all." On all sides contemporary documentary artists reach out for the largest and vaguest perceptions, including perceptions about their personal responses. The last sentence of Davidson's introduction to *East 100th Street* reads "I entered a life style, and, like the people who live on the block, I love and hate it and I keep going back." Except for the claim about going back, this sounds like a condensed version of Agee's attitude to north Alabama. But Agee added social commentary to his confessions of ambivalent feeling—calling his subjects, for instance, "an undefended and appallingly damaged group of human beings"— which Davidson never does. He withholds something: "there is caution in his eyes as well as in those of his subjects."[52]

To those who have taken or seen a great many photographs, photography can seem to make nothing happen. The fine photographic technique and social sympathy of Adelman in *Down Home* or Bubley in *Out of the Forties* may be wasted, because all their poor southern blacks or children in New Jersey nurseries have familiar faces and seem to dwell in a world that photography has never been able to alter and will never be able to alter, in spite of the pricked consciences

and enlightened understandings it creates. *Is Anyone Taking Notice?* is the title of and last desperate caption in Donald McCullin's 1971 documentary about the world's combat zones—Biafra, Ulster, Cyprus, and Vietnam. Every now and then in this disturbing book McCullin insists on the pointlessness of his art: "Who needs great pictures when somebody's dying and he's only five years old?" "Without the action/the smell" of the battlefield, without the throat wounds that make terrible sucking noises, "you have no truth," and "Photography's got nothing to do with that."[53]

Alternatively, it can seem that photography *has* a point, namely to make something illegitimately exploitative happen to its poor subjects. The manner in which picture taking invades and disrupts private lives—the "violence" it does to its human subjects, or its "predatory" nature, to use Susan Sontag's terms—is a kind of psychic burden which some modern photographers carry about with them and which leads to strategies of tact rivaling and eventually outdoing those of Agee and Evans. Davidson, a white photographer in a black slum and therefore an artist more than usually beset with ethical complications, was careful to give prints of his work to those Harlem residents he pictured. He also worked with a large-format camera on a tripod, eliminating any possibility of candid, image-stealing techniques, and invited his subjects to attend the opening of his show of their photographs.[54] McCullin explains in his own book that it "belongs to the people in it." An exchange between equals is the ideal for which these photographers are striving. Equals stare at the viewer from the pages of *East 100th Street,* confronting all who look at them with a regard as unwavering as that of any camera. The convicts in *Killing Time* look at the viewer in the same way, man to man. To catch them off guard would be to humble them in ways the photographer cannot accept. To impose captions on them, even captions in the form of quotations, would be to compound the injury by putting words in their mouths and taking their sentiments out of context, whereas quotation at length, in a separate text section, provides context and becomes permissible. Convicts may speak. The documentary artist may not speak for them.

Significant as delicate considerations for the rights of photographic subjects may be, they are still less significant than a change in attitude toward documentary itself. Contemporary practitioners have held themselves back because they know how insistently personal views crowd into the picture frame. They are on guard against the pretensions of photographing "the truth" or "things as they are." Take Bruce Jackson as an example:

I would like to think that the photographs are objective, but I worry about objectivity in enterprises more analytic than parking a car or weighing buckets of mud or long division. A photographer, however much he seeks to document something real, spends a great deal of time learning and deciding what he will and won't shoot, what negatives he will and won't show others, what

juxtapositions of images he will permit on a gallery wall or on published pages . . . it is impossible to do serious social documentation with a camera without some informing theory.

Jackson's phrase "I worry about" is revealing. He cannot simply accept subjectivity as a given of photographic seeing but worries about it and thinks himself potentially compromised by it. He even feels guilty about it at moments when the subjectivity strikes him as being a form of personal privilege: "The information on television, in the press, and even in books like this is packaged and arranged neatly by people comfortably outside and far away from those high walls and barbed wire fences." Again this is reminiscent of Agee, but Agee's amply confessed slummer's guilt never limits his opinionizing about cotton tenantry, the South, human possibility, or the meaning of the Gudgers' front bedroom, while Jackson's guilt-tinged self-consciousness limits his speculative ambitions. *Killing Time* makes a prison visible and the voices of prisoners audible, but beyond that point it does not go. Jackson's dismissal of the notion that one can photograph *any* complex institution and show it as hellish—"There is some truth there, but also something of a lie"—would serve as the self-deprecating epigraph for his own book.[55]

Whether their knowledge comes from careful self-examination, extreme self-consciousness about technique, or the teaching of contemporary theorists like Joel Snyder and Allan Sekula, who vigorously debunk the "myth" of documentary and the "folklore of photographic truth," photographers now know that they consciously or unconsciously picture things as they would have them be. Though Alex Harris is not, in general, a photographer who draws attention to himself, he includes in *The Last and First Eskimos* one plate consisting of twenty-two images in a contact sheet. By itself, the contact sheet hints at a thoroughgoing objectivity: everything on that strip of film is included. Set beside the other images of the book, it demonstrates how much expressive choice has gone into their selection, enlargement, and printing. Meanwhile, the photographer's expressive vehicle becomes the viewer's indeterminate meaning. Sekula argues that "the same picture can convey a variety of messages under different presentational circumstances"—even a picture as apparently automatic and "unpolluted by sensibility" as those taken by bank holdup cameras. Such a picture might show a young white woman holding a submachine gun. But what does it mean? A fugitive heiress, a kidnap victim, an urban guerilla, a willing participant, or an unwilling participant? Accompanying words can shape a photograph's meaning, as testimony in a courtroom can shape the interpretation of visual evidence, but words themselves are at more than one remove from objective truth. "The innocence of 1935 may be gone," the photographic historian Hank O'Neal comments in a dispirited explanation of why there could be no FSA project in the mid-1970s. By "in-

nocence" he means a now-lost faith that the government can accomplish something with social programs rather than just getting lost in "too many ideas, with people on staffs and committees talking about them," but the word may stand for all those attitudes about seeing the facts and showing them to others which permitted Lange, Bourke-White, Evans, and other photographers to get their work done.[56]

It is important not to idealize the past and underestimate the present. A contemporary like Bruce Jackson unquestionably gets work done, as does Douglas Harper. In *Good Company* (1982) Harper studies freight-train-riding tramps, quoting their talk, depicting them in fifty-two photographs, and interpreting them in conventional sociological terms. *Good Company* is painstaking, handsome, and cogent in its points about the ways tramps live. The only difficulty is that it makes these points in a stiffly social scientific afterword, not in the documentary parts of the book where Harper describes his travels and presents the photographs. These narrative sections Harper undervalues. He cannot believe he has gotten through his own tramp conciousness to the tramps: "what we learn is deeply influenced by how we are with those we study." He is skeptical of the validity of generalizations and stricken with awareness that he is an outsider: "I never really learned to experience the world as a tramp and I knew that unless I moved completely into that life my values would probably remain in the world of relationships and commitments." He even doubts the propriety of documentary in the first place: "for me the rights and desires of the individuals we choose as subjects are more important than a final purpose that would justify making images when they would not be welcomed." Harper so distrusts what he is doing in the boxcars and the hobo jungles that one wonders how he got a book finished, let alone a book as good as *Good Company*. It is true that Harper subsequently speaks of his tramp photographs as a "rich document" specifically illustrating "elements of tramp reality," and he confidently reads his images for their informative content; one of them suggests "the relationship between the skid row men and an outside population." Nevertheless, he remains doubtful about using pictures as evidence because the conventions for interpreting documentary photographs, which provide the "public image of the derelict," preclude any simple interchange of information between photographer and viewer.[57] Skilled sociological analysis is required to make reliable sense of photographed tramps. "You have to be shown how to see their faces" would be the proper motto for this enterprise.

More than any other contemporary work, Bill Ganzel's *Dust Bowl Descent* (1984) requires comparison with the thirties documentaries since, like *Out of the Forties*, its purpose is to find and rephotograph the people in earlier photographs. Ganzel uses field notes and caption information to identify people once thought nameless. Dorothea

44. Arthur Rothstein. Fritz Frederick, Grant County, North Dakota.

Lange's "Migrant mother," Florence Thompson (Lange never knew her name), poses for Ganzel's camera in the backyard of her daughter's home in Modesto, California. She and her children look prosperous now; they wear double-knit pants suits. Nettie Featherston, the high plains woman quoted in *An American Exodus* as saying, "If you die, you're dead—that's all," says additional things to Ganzel. The youngest child in Rothstein's famous picture "Fleeing a dust storm," taken in Cimarron County, Oklahoma in April 1936, turns out to be Darrel Cobble, who kept a hand-colored version of the photograph on the wall of his living room. All this is superior human-interest journalism, but whether it is documentary, as Lange or Rothstein would have understood the term, is debatable. Ganzel tries to match their practice picture-for-picture, contrivance-for-contrivance, as in discussing a Rothstein picture:

The photograph of Fritz Frederick in 1936 [figure 44] needs its caption to explain that his outstretched hand is showing "how high his wheat would grow if there were no drought." That's the context of that photograph. When

45. Bill Ganzel.
Fritz Frederick.

I photographed Fritz in 1977 [figure 45] the context had changed. Although the drought was no longer a threat to his livelihood, high agricultural expenses were, and that became a context for my photograph. Yet the two images still had to relate to each other. So I asked Fritz to stand in the field with his new combine behind him and adopted the same frontal, formal pose that Rothstein had used. We can see how high his wheat is and how large the combine is, he tells us what that means to his farming operation.[58]

Context, for Rothstein, means the Dust Bowl, a farmer's understanding of what the Dust Bowl may do to him, and perhaps Rothstein's conception of a farmer's understanding of what the Dust Bowl may do to him. For Ganzel, context means the same things, high costs being substituted for the Dust Bowl, but with one thing added, an awareness of a photograph as a photograph. Ganzel's picture is obliged to be a formal element in a book and an artifact in the history of photography: "the two images still had to relate to each other." It is like two photographs in Chauncey Hare's *Interior America* (1979)—retakings of well-known FSA images by Russell Lee in Hidalgo County, Texas, 1939, and by Walker Evans in Bethlehem, Pennsylvania, 1936.[59] Together with every other art form of the last dec-

ade, photographic documentary has been absorbed by and into the *hommage*.

Dust Bowl Descent goes even further than *Interior America*, marking the point at which documentary becomes the study of photographs of scenes. Ganzel stands somewhat diffidently before his topic—thinking of the shooting scripts of the FSA photographers and his own more complicated agenda, seeing all the possible ways to portray things as they are—and he is therefore reluctant to say what the things mean. His efforts at historical generalization, like Lemann's, are halfhearted. Times have changed, he suggests, since the FSA subjects are almost uniformly better off now and strip mining has replaced cotton farming; but then again times have not changed, since migrant laborers, Mexicans now, still work the fields and North Dakota farmers still fetch mail in sub-zero cold. Ganzel foregoes metaphors like "human erosion" not because he believes that erosion is a thing of the past, but because he fails to see contemporary history in such comprehensive and communicable terms. He fills out the documentary record on certain individuals, leaving the value of record keeping in doubt.

Roland Barthes thought photographers, like Cassandra, unable to lie. But even with Barthes's qualifications—that photographers have their eyes fixed on the past, not the future; that photographs tell the truth only about the existence of a thing, not about its meaning—this view is hard to accept. The thirties photographers did lie, if by lying is meant any departure from purely automatic, passive, and value-free recording. The photographers and the writers with whom they worked departed from the ideal of objectivity in each collaboration of their expectations with actuality to produce documentary. Lying, called simply that or, more benignly, "the individual sensibility," "the selective view," "the camera with a conscience," is in any case less at issue than the uses to which it is put. Caldwell and Bourke-White, Agee and Evans, MacLeish and his FSA photographers, and Lange and Taylor were confident that the uses of documentary were more important than methodological considerations. They did not photograph themselves photographing, admit doubts, hold back from the full exercise of their sympathy and understanding, or do what Barthes advised all picture takers not to do, in another, more convincing application of Greek mythology to camera work: "The photographer's 'second sight' does not consist in 'seeing' but in being there. And above all, imitating Orpheus, he must not turn back to look at what he is leading—what he is giving to me!"[60]

Varieties of Portraiture

He freed himself from the cloth and straightened up again. He was going about it all wrong. That expression, that accent, that secret he seemed on the very point of capturing in her face, was something that drew him into the quicksands of moods, humors, psychology: he, too, was one of those who pursue life as it flees, a hunter of the unattainable, like the takers of snapshots.

He had to follow the opposite path: aim at a portrait completely on the surface, evident, unequivocal, that did not elude conventional appearance, the stereotype, the mask. The mask, being first of all a social, historical product, contains more truth than any image claiming to be "true"; it bears a quantity of meanings that will gradually be revealed.

—*Italo Calvino*

The basic ambition of portrait photography has always been to fix personality, to draw a distinct character from someone's face. From Albert Southworth and Josiah Hawes daguerreotyping Lemuel Shaw in 1851 to Lee Friedlander capturing city people in the 1970s, photographers have recorded that ambition along with the faces on their plates. In photographs of his lover and fellow photographer Tina Modotti, Edward Weston conveys sensual and emotional arrogance, believing that the "aim of good portraiture in any medium is not to make face maps or superficial likenesses, but to capture and record the essential truth of the subject." In his *Daybooks* (1961) Weston makes no bones about saying that he has "caught" Tina's face "with its every subtle change" or boasting that nothing could be more characteristic of Guadelupe Marin de Rivera than the "heroic" portrait head he has done of her, mouth open, talking, in direct sunlight. So with his portraits of Robinson Jeffers, Nahui Olín, D. H. Lawrence, and Manuel de Hernandez Galván: "the camera should be used for a recording of *life*, for rendering the very substance of the *thing itself*, whether polished steel or palpitating flesh." When Weston photographed José Clemente Orozco in 1930, he was pleased that the muralist's "piercing eyes" were accentuated by reflections from unscreened light upon his thick eyeglasses (figure 46). Weston felt he had captured the thing itself. As he noted, he could not stop down his lens beyond f/6.3, "so the definition is not perfect, but practically satisfac-

46. Edward Weston.
Jose Clemente
Orozco.

tory." These words sum up Weston's and every portrait photographer's aim, the rendering of not perfect but practically satisfactory images, the defining of individuality in the terms permitted by such circumstances as failing light, a balky camera, or a sitter's vanity. "The portrait is a form of biography," the photographer Arnold Newman has commented, and though Newman thinks that photographic biography is unlikely to capture "the complete man," he nowhere doubts that it can capture much of a man: his physical image and personality traits, his consciousness of being portrayed, and his relationship to his environment.[1] Newman's *One Mind's Eye* (1974), consisting largely of portraits—Stravinsky by the black abstract of a

piano lid, Lyndon Johnson leaning on statute books in a Senate an-
techamber—is predicated on the belief that character is visible.

Nonetheless, some exceptional portraits fail to convey a sense of
character, and fail not through simple ineptitude. They are taken by
photographers less conventional than Weston and less devoted to the
cultivated vital personality, or by doctrinaire formalists, or by pho-
tographers especially sensitive to the social maneuverings of the stu-
dio. ("In front of the lens, I am at the same time: the one I think I am,
the one I want others to think I am, the one the photographer thinks
I am, and the one he makes use of to exhibit his art").[2] How is an
exceptional portrait like Robert Frank's of a movie star at a Holly-
wood premiere, with its out-of-focus central figure, to be categorized?
(figure 47). To begin with, the picture certifies Frank's independence.
He is no media hack but rather the sort of artist who at a premiere
focuses (literally) on the crowd. Does the picture expose the star's
essential emptiness, her failure to own a real personality beneath the
Hollywood gloss? If that had been Frank's purpose, he would surely
have taken her in sharp unflattering focus, as he takes most of his
satiric targets in *The Americans*. The blurriness here suggests some-
thing else. The star has a real personality, but it is not a strikingly
photogenic or easily captured one. For a moment she is mysterious,
as alluring as she will shortly appear when projected on the screen or
as she appears now to the celebrity seekers behind the rope. Her jew-
els, like the highlights in her blond hair, are spots of light arranged to
make an effect, but her eyes are shadowed and unreadable. Blurred in
this way, as if a soft-margined pre-1910 beauty taken by Clarence
White or Gertrude Käsebier, she seems genuinely elusive, the bearer
of a private identity unrelated to and hidden under the public person-
ality fashioned by the costumer and publicity agent. She is like James
Dean as darkly photographed by Dennis Stock in 1956, an actor hid-
ing in a role, which Stock shows by throwing Dean's silhouette on the
wall, gangster-movie style.

The women looking at Frank's star, in contrast to her, have entirely
readable eyes and expressions. The camera reads them at a glance.
They admire and envy the star. One woman, wearing a kerchief,
smiles in her excitement; another, biting her nails, apparently, frowns
in concentration, determined to remember it all. With their dark hair
and clothes the women blend into the night; Frank includes one dis-
tant neon sign to set off its blackness. The women belong to the night,
here in the street or in the form it will soon take in the darkened
theater. That is, the women are defined by obscurity, from which they
have come to the brightly lit glamour of the premiere. The strictness
of their definition invites a certain sympathy, though it also allows
one to dismiss them with a phrase, "celebrity-seekers."

Frank's image in fact combines two different kinds of uncharacter-
izing portrait. One kind shows complex people: stars, performers,

and even more significantly, intellectuals, artists, and writers. Their faces, perhaps sufficiently familiar not to need virtual depiction, are blurred, fractured, repeated, shadowed, or otherwise obscured in acknowledgment of the fact that they express identities that are not simple to characterize on film. Roy Lee Jackson's 1945 portrait of

47. Robert Frank. Movie premiere, Hollywood.

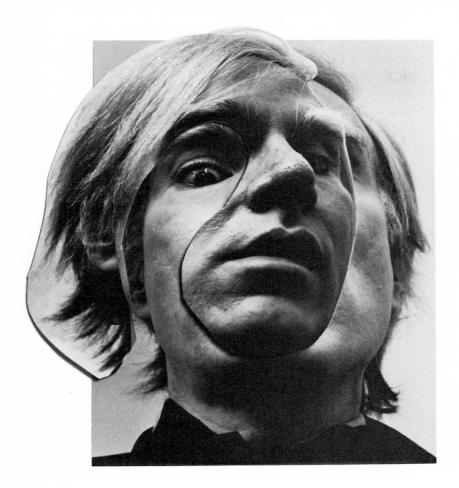

48. Arnold Newman.
Andy Warhol.
© Arnold Newman

Gertrude Stein shows only the back of her head; Michel Brodsky's 1937 portrait of Colette only a pair of sandals among books.[3] For such people "character" is an oversimplification, "individuality" the arbitrary selecting of one aspect or the artificial stopping of a process. Photographers and writers of analogous purpose, who make their own uncharacterizing portraits out of words, portray such people best when they imitate them, dramatizing their complexities, foregoing the possibility of any final meaning. Arnold Newman, who depicts Jackson Pollock, Frank Stella, Marcel Duchamp, Georgia O'Keeffe, and Henry Moore in a perfectly straightforward, Westonian way, tracing the lineaments of character, putting a face in intelligible context, at least once obscures biography in a photograph: his 1973–1974 collage portrait of Andy Warhol cuts up the well-known face and then reassembles it into what looks like a jigsaw puzzle, thus alluding to the unconventionality of Warhol's painting and the arbitrariness of his character (figure 48).

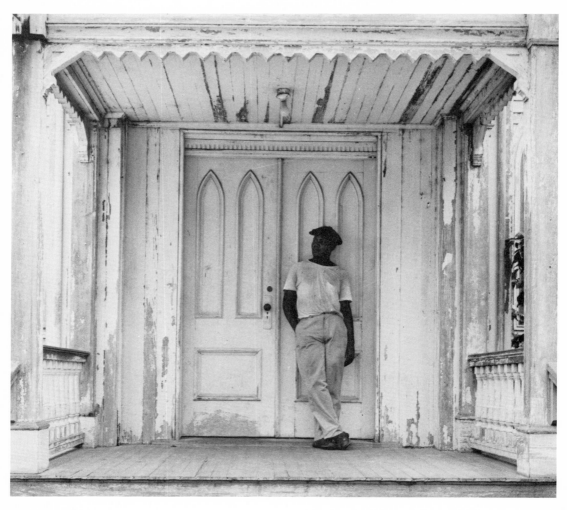

49. Arnold Newman.
Man on church porch.
© Arnold Newman

The other kind of uncharacterizing portrait shows simple, ordinary people. Unremarkable, insignificant, though often strikingly photogenic, their faces give up meaning immediately, and the meaning is always expressible in a few general words: a farmer resting from work, a woman at her loom, a soldier on his way to the front, celebrity seekers. For them, whether they are named or not, individuality is something out of reach, typicality an ordinary condition. If willing to speak at all, they seem most ready to say "we," like the confused Okies of *Land of the Free* or the discouraged sharecroppers of *You Have Seen Their Faces.* Photographers and writers who would compliment such people, sympathize with them, or interpret their straitened circumstances politically must match them in simplicity. Newman may have worked as hard to produce his 1941 portrait of a black

man on a church porch in Florida as his portrait of Warhol, but what he allows the black man's photograph to show is a simple pose and a direct gaze in an austere setting (figure 49). The influence of Walker Evans is obvious here, in frontal technique and unspoken ethos; to be photographically elaborate would be to insult the subject. It is difficult to imagine this man leaving his pose on the porch, wearing different clothes, or otherwise eluding the camera's understanding of him as a southern black with nowhere to go. Automatically one interprets him in social terms. The portraiture suiting him comes close to a genre scene or documentary study; that is, it calls into question the very concept of individuality itself, understood as something apart from the conditions of living and picturable in isolated faces.

To reproduce faces too rich or too poor for identification is the choice available to portraitists challenging the basic premise of the genre. Among the portraitists of the rich are Alvin Langdon Coburn, Ezra Pound, Man Ray, Alfred Stieglitz, and Gertrude Stein; among the portraitists of the poor are August Sander, Alfred Döblin, Dorothea Lange, Muriel Rukeyser, George Orwell, and Bill Brandt. All of them would contemptuously reject a purely economic interpretation of "rich" and "poor," being primarily concerned with a wealth or poverty of character. But the portraitists of the poor did accept in their working careers a close connection between money and character, economics and personal freedom.

Vortographic Portraiture

The American photographer Alvin Langdon Coburn was born in Boston in 1882, the son of a wealthy shirt manufacturer who died when he was seven. Coburn began photographing at eight, hung prints in his own studio at fifteen, and at seventeen, in company with his domineering mother and the American pictorialist photographer F. Holland Day, sailed for London and Paris. In London he, Day, and Edward Steichen exhibited prints; in Paris, where he met Frank Eugene and Robert Demachy, he found life "richly flavoured." For the next twenty years Coburn charmed writers and artists into sitting for his camera: Mark Twain in America, Gertrude Stein and Henri Matisse in France, celebrity after celebrity in England, including H. G. Wells, Hilaire Belloc, George Meredith, Augustus John, W. B. Yeats (taken in the act of reciting a poem), Edward Carpenter, Bernard Shaw (posed most memorably in the nude, as Rodin's *Penseur*), G. K. Chesterton, and Henry James, whose fictions might have provided Coburn with models, had he needed them, of the ambitious American innocent abroad. James gave Coburn a presentation copy of *The American* in 1906, at the start of this latter-day Christopher Newman's culminating triumph in cultivated Europe, his taking of photographs for the frontispieces of James's New York Edition.[4]

The portrait Coburn took of the novelist in 1906 represents a collaboration between the sitter's self-presentation and the photographer's sympathetic interest; Coburn tried to steep himself in the books or paintings of those he was to photograph and tried even harder to like his subjects. But the portrait reveals no complications in the act of photographic seeing or expressing personality. It is obviously meant to convey James's character. Nearly all the portraits of Coburn's collections *Men of Mark* (1913) and *More Men of Mark* (1922) convey a celebrated character. According to Coburn, Feodor Chaliapin's photograph is, "as was the man, virile and dynamic." G. K. Chesterton's photograph shows him "growing larger as you look at him," "swelling off the plate," and thus responding in kind to his "large, abounding, gigantically cherubic" personality. (The words come from Shaw, who enthusiastically championed a 1906 Coburn show in a catalogue preface making the photographer out to be a Gainsborough, a Holbein). Meredith is serene; Stein is monumentally enigmatic; Frank Brangwyn is posed by his own painting, which interprets him. Nothing in these faces shows a dissatisfaction with conventionally artistic portraiture. Coburn is as dedicated to the understanding of his subjects as Weston, or as the great Victorian portraitist Julia Margaret Cameron, whose photographs Coburn arranged to show in New York in 1915, making prints from copy negatives he had taken from the originals. Cameron had benefited, Roger Fry noted, from the fact that in the 1860s and 1870s "England was enjoying a spell of strong individualism." People then "were not afraid of their own personalities" and "had the courage of their affectations; they openly admitted to being 'intense.'"[5] Now, in the first decade of the twentieth century, Coburn benefited from a similar cult of individualism. On a London rooftop Jacob Epstein stared heroically into the distance, and on the stage of St. James's Theatre Shaw enthusiastically showed the actors in *Androcles and the Lion* how to conduct a fight in an arena. Coburn caught them both.

It took a personal intensity of a different sort to change Coburn's ways of working. Coburn had met Ezra Pound as early as 1913, when he took the highly conventional portrait photograph that would serve as frontispiece to *Lustra,* and he was pulled further and further into the poet's swirling vortex of artistic energies. Coburn and Pound attended gallery shows together; Coburn was supposed to join the faculty of the College of Art the poet was planning in London; Coburn would take the "best possible" photographs of Henri Gaudier-Brzeska, photographs which Pound thought Harriet Shaw Weaver might buy. Probably through Pound, Coburn met two other veterans of the avant-garde *Blast* magazine, Wyndham Lewis and Edward Wadsworth, and photographed each in front of a vorticist canvas. By 1916 Pound's influence, directed at this period toward the exploding of old ideas, had combined with the cubist theories Coburn had

picked up from his American friend Max Weber and with the feel for abstraction Coburn had himself developed in his city photographs since 1912 to produce a new kind of portraiture. This portraiture fragmented appearance, and with it human personality, into geometric shapes. It achieved this by means of a newly invented machine, the Vortoscope, annexed to that familiar machine and appropriate depictor of the Machine Age, the camera. The Vortoscope was a triangular assemblage of mirrors—pieces of Pound's shaving mirror—interposed between lens and sitter. It was as adjustable and as delightful to Coburn as a kaleidoscope. Pound, who spelled the device "vortescope," called it "an attachment to enable a photographer to do sham Picassos," but he was willing enough to sit for it and see his face broken up into rectilinear forms.[6] Coburn took several vortographic portraits of Pound, and apparently only of Pound, perhaps as a gesture of thanks to *il miglior fabbro*. The poet's profile is doubled and set blackly against a square of light in a window or imprisoned inside a structure of black bars. The most striking as well as the most representational of the images is a series of full-face, eyes-forward portraits set within each other and expanding outward, sometimes called "The centre of the vortex" (figure 50). The frame barely contains Pound's face. He swells off the plate like Chesterton in the earlier Coburn portrait, though with a noticeably different effect: Chesterton is slightly out of focus, whereas Pound is divided into aspects each of which is sharply in focus. No one of the planes on which the poet works sufficiently defines him, and all must therefore be depicted. His multiplied eyes stare directly at viewers, challenging them to recognize a complex identity.

The photograph inventively dramatizes Pound's notions about the masks or personae through which troubadours, great ladies, romantic outlaws, gods (Christ as the "goodly fere"), and most of all poets, in their "tales of old disguisings," express themselves. When Pound looked "On His Own Face in a Glass," as a poem from *A Lume Spento* (1908) has it, he saw a strange visage and then a series of strange visages, which he could best challenge seriatim:

> O ribald company, O saintly host!
> O sorrow-swept my fool,
> What answer?
> O ye myriad
> That strive and play and pass,
> Jest, challenge, counterlie,
> I ? I ? I ?
> And ye?[7]

Later, in "Portrait d'une Femme" in *Riposte* (1912), Pound sketched a feminine identity as composite as his own, a "Sargasso Sea" of cu-

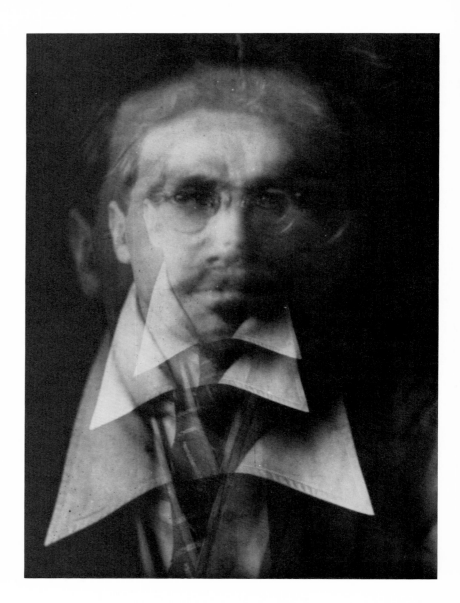

50. Alvin Langdon
Coburn.
Vortographic portrait
of Ezra Pound.

rious suggestions, facts leading nowhere, and "deciduous things" imposed on the lady by those who know her and by her own receptive, elusive personality. Both poems document the modernist rejection of character as something to be simply understood, a rejection which had begun years before, even while Julia Margaret Cameron was photographing her intense personalities on the Isle of Wight, but which reached its culmination in London of the early twentieth century—in James's complexities and Virginia Woolf's belief that human character changed in 1910, in Hugh Selwyn Mauberley's and J. Alfred Pru-

frock's poses, in the velleities of the woman Eliot described in his own "Portrait of a Lady," and in *The Waste Land*'s enclosing circles of loneliness, which no outsider can penetrate.

Thanks to Pound's example and shaving mirror, Coburn seems to participate in the movement. Chesterton characterized becomes Pound vortographed. Self-confidence yields to the use of masks: in 1916 Coburn photographed Yeats's *At the Hawk's Well* as staged with literal masks by Edmund Dulac. Still, Coburn's corroboration of literary ideas may be unintended. Nowhere does he say anything about recording a fragmented personality or an "accelerated grimace" of the sort the age demanded, whereas he says much on various occasions about recording an "appreciation of the artistic achievement of the times." With his vortography Coburn hoped to emulate the adventurousness of leading spirits and in the process to compliment the figure farthest in the lead, Pound, by treating his face as an artistic medium, a source of forms interesting in themselves. In this Coburn did no more than Gaudier-Brzeska had done with his bust of Pound in 1914 or than Dulac would do with his caricature of 1917. Pound's face was the common property of his artistic equals. "Is not our Ezra always with us?" Coburn asked in *More Men of Mark:* "At almost any private view of the very latest thing in Super-Modern Art are not his Leonine Mane and Large Lapis Coat Buttons to be found at the very heart and centre of the Vortex? Who in nine short years has displayed so great a variety of beard and moustache? Surely only a cubist of the deepest dye could do full justice to this unique tonsorial achievement!" The arch tone and supercilious capitals belong to 1922, for in 1916 Coburn had really believed in supermodern art. He wrote at the time, in "The Future of Pictorial Photography," that he admired those moderns "striving, reaching out toward the future, analysing the mossy structure of the past, and building afresh, in colour and sound and grammatical construction, the scintillating vision of their minds." Photography, like painting, should "throw off the shackles of conventional representation." The camera should be as abstract as possible. After photographing Pound, Coburn followed up these views by taking purely abstract, strikingly cubist vortographs of pieces of wood or crystal, and with considerable courage he showed eighteen of them at the Camera Club in London in 1917. Other photographers were puzzled by the designs, but Shaw was wittily supportive of them and of Coburn's art in general, while Pound, who contributed a preface to the catalogue, welcomed the photographer to the fold and pronounced the photographs' triumph: "In vortography he accepts the fundamental principles of vorticism . . . THE CAMERA IS FREED FROM REALITY." The "modern," Pound wrote, would enjoy a particular vortograph "not because it reminds him of a shell bursting on a hillside, but because the arrangement of forms pleases him."[8]

Since vortography is essentially an abstract art independent of natural forms, human faces, or recognizable happenings, such as the wartime scene even Pound could not quite get out of his mind, it is best matched with an abstract literature, insofar as that exists. Coburn's vortographs are less like any Pound or Eliot poem than they are like the *Cubist Poems* (1914) of Max Weber, a slim volume to which Coburn contributed a foreword and which he arranged to have published. Weber's "The Old Me and the New Me" juxtaposes simultaneous personalities, and his "The Eye Moment" tries to make words represent nothing but repeated forms:

> Cubes, cubes, cubes, cubes,
> High, low, and high, and higher, higher,
> Far, far out, out, out, far,
> Planes, planes, planes,
> Colours, lights, signs, whistles, bells, signals, colours,
> Planes, planes, planes
> Eyes, eyes, window eyes, eyes, eyes.[9]

The limitations of this sort of poetry are obvious. Words, unlike photographic exposures or painted forms, cannot be geometrized and disposed interestingly in space, and in the remaining poems of the volume Weber largely abandons the cubist style.

With much less justification Coburn abandoned vortography after 1917, returning to conventional styles of portraiture and landscape photography. His autobiography of 1966 gives no reason for the abandonment and indeed professes a continuing interest in these "intriguing combinations," but the reason is plain. Coburn's enthusiasms were strong but not particularly lasting and his interest in abstract photography was succeeded by interests in pianola playing, astrology, Freemasonry, country life in Wales, and religious mysticism. His closeness to Pound was an enthusiasm of this type. For a brief period the photographer fell under the poet's sway and was fascinated by the visual possibilities of his face—it is impossible to miss the dominance of Pound's personality in figure 50, the sense of a face coming almost threateningly at the viewer—but then Coburn escaped from Pound's influence, as he had previously escaped from James's and Day's; no doubt Coburn was resentful at Pound's condescension to the photographic art, as shown in the poet's remark that "any imbecile can shoot off a Kodak."[10] Without Pound's constant excitation and example, Coburn lost interest in abstraction and passed on to new involvements.

As a result, the future of this kind of pictorial photography lay with others—with Pound himself, briefly, during a 1923 attempt to adapt the Vortoscope to movie making, and with photographic abstractionists like Laszlo Moholy-Nagy, Christian Schad, and Herbert Bayer. The future of abstract *portraiture* lay with Alexander Rodchenko, El Lissitsky, Anton Bragaglia (who as early as 1913 had published a time

exposure of the painter Giacomo Balla showing him in motion and tactfully alluding to Balla's experiments with multiplied images), and especially Man Ray, the expatriate American painter, photographer, and cultural entrepreneur. *Photographs by Man Ray 1920 Paris 1934* is *Men of Mark* brought up to date, expanded, shifted to the Continent, and given a dadaist gloss. The faces are now "solarized," or darkly outlined by an exposure of the developed film to naked light, rather than vortographed, or they are printed in reverse tones, or they are doubly exposed; they are accompanied by texts by Paul Eluard, André Breton, Tristan Tzara, and "Rrose Selavy" (Man Ray himself). But the general effect is like that of "The centre of the vortex": the faces are anything the photographer wants to make them; they are at the disposal of art, free to be mysterious because their owners are themselves free and richly significant. Breton might have been speaking for Coburn the vortographer and Pound the author of "Portrait d'une Femme" when, in his introduction to the Man Ray photographs titled "Visages of the Woman," he describes them as surprising "human beauty in movement at the very point where it reaches its full *power*," and portraits of a loved one as presenting "not only an image at which one smiles but also an oracle one questions."[11]

Serial Portraiture

The double-exposed, contradictory, or otherwise uncharacterizing portrait belongs to no one period. Coburn's vortograph of 1916 and Truman Capote's prose of 1959 analogously present Pound's face— the "satyr-saint's face," as Capote describes it, insisting that he (unlike "a certain Judge Bolitha J. Laws") is not going to impose simple categories, such as "incurably insane," and render Pound in less than his full complexity. A different sort of uncharacterizing photography, the serial portraiture made up of many views taken at intervals, achieves the same goal. Coburn took repeated views of Shaw, Newman of Stravinsky. The contemporary American photographer Mark Berghash produced, in the exhibit "Aspects of the True Self," a number of composite portraits or self-portraits by having such subjects as the artist Thomasina Webb trip a prefocused camera at successive moments when they were thinking most clearly about their parents, siblings, or selves.[12]

Serial portraiture is nevertheless firmly associated with one photographer, Alfred Stieglitz, and one phase of Stieglitz's career, the two decades from 1917, when he first photographed Georgia O'Keeffe at his gallery "291," to 1937, when he virtually stopped creative work. Stieglitz took hundreds of images of O'Keeffe, or of aspects of O'Keeffe—her eyes, body, clothes, hats, and hands. He did so with the devotedness of a lover: Stieglitz lived with O'Keeffe from 1918, married her in 1924, and often said that he made love when he photographed. He also photographed O'Keeffe with the discipline of a

mature artist who has stopped hoping for new developments and wishes to concentrate on a few motifs. The O'Keeffe portraits are études, elaborate variations on a given theme, like the thousands of end-of-career pictures Steichen has taken of the flowering tree outside his home in Connecticut or the repeated studies Stieglitz himself made of clouds and poplar trees at Lake George. The serial portrait of O'Keeffe depends on accumulation and so runs counter to the principle of artistic selectivity. Thanks in large part to Stieglitz's own early teaching, this principle has been a fundamental tenet of photography. The camera is supposed to record the moment of aesthetic balance, the carefully chosen moment, holding it up for special scrutiny; the darkroom artist is then supposed to select one frame from the contact sheet. Stieglitz finally chose to ignore such considerations, endlessly recreating his one sitter at different moments of her life, no one of which could be regarded as more decisive, or definitive, than any other. Even before 1917 Stieglitz had distrusted the thought of perfection in his own craft or in the life of a potential sitter. His protégée Dorothy Norman said that he could not bring himself to photograph people "basking in success," considering themselves finished products. No one looking at O'Keeffe as portrayed by Stieglitz could ever think her finished or her serial portrait finishable. Her identity has been "fragmented into a powder of images," as Italo Calvino wrote of a woman portrayed with Stieglitz-like obsessiveness by the fictional Antonino in "The Adventure of a Photographer."[13]

O'Keeffe herself has written that Stieglitz dreamed of photographing a child at birth and continuing to photograph it in all of its activities throughout adult life. What keeps the portraits of her from being discrete parts of a "photographic diary" in this sense, separate entries in a particularly distinguished family album, is first of all a fact of public display. Stieglitz did not simply produce O'Keeffe studies over the years of his life with her and show them at random. He exhibited twenty-six of them at once under the title "A woman [one portrait]," as part of the "Demonstration of Portraiture" in his 1921 show in New York. So many images brought together forced onlookers to share Stieglitz's view of a woman who was complex at any given moment, not just developing through time the sequential complexity that everyone displays. The images were one portrait, not many. They were the "sharp focussing of an idea," as Stieglitz said of all the photographs of the exhibition, and the idea was about both O'Keeffe and the right way, the only possible way, to depict her. At least some onlookers understood the idea as a refutation of conscious identity. They looked at the Stieglitz portraits and saw "characters comparable only to the studies in the unconscious of the great psychological novelists and of the Freudian school of psychoanalysis"; they looked at the O'Keeffe photographs, the "hands and breasts, torsos, all parts and attitudes of the human body seen with a passion of revelation,"

and saw an aspect of human nature hitherto hidden, censored (some were still censored, since a few prints of the nude were withheld from public view). Stieglitz had translated the "world of blind touch into sight" and shown how blind touch, beginning in the sexual act, would eventually form "the entire relationship of two personalities."[14]

The fifty-one photographs gathered in *Georgia O'Keeffe: A Portrait by Alfred Stieglitz* (1978), the only place where they are now on public display, communicate an elemental feeling of this sort, and elemental feeling in turn invites generalized thinking. In the repeated images—the nudes especially, but not only these—it is possible to lose sight of O'Keeffe entirely and to see instead a figure of woman such as Stieglitz described in 1919, one who "*feels* the World *differently,*" who "receives the World through her Womb. That is the seat of her deepest feeling. Mind comes second." But the photographs will finally not let O'Keeffe be subsumed into Woman or O'Keeffe's identity be simplified into her sexuality. She stares boldly at the viewer in some prints, holds herself back in others; she poses and is candidly snapped; she lets her hair down loosely and wears her strange hard black hat. Most significantly, she stands in front of her own paintings, asserting her artistry. She makes, in fact, a well-publicized New York "debut."[15]

So much for the reception of the World through the Womb. It was a creative fellow-worker whom Stieglitz portrayed. More than any other part of O'Keeffe he photographed her hands, sometimes setting them directly against the canvases they make. The unspoken directive, Stieglitz remarked in 1919, is to behold "Woman unafraid—the child—finally actually producing art!"[16] Stieglitz thought that female artists previous to O'Keeffe were weak and secretive: "Woman was afraid," reticent, "Man's Sphinx." For all her strength and assertiveness, O'Keeffe herself remains somewhat sphinx-like for Stieglitz. Her poses are enigmatic, her expressions elusive. Stieglitz is fascinated and challenged by this woman, as opposed to being summarily knowing about Woman. He is so fascinated by her that at least once he photographs her entirely without apparent artistry (figure 51). This picture, with its awkward turn of the head and ugly shadow, would have been rejected out of hand by a conventional portraitist. Stieglitz prints it because it depicts a real aspect of O'Keeffe and because it implies a real aspect of their relationship, which was not limited to careful arrangements of a subject by a master.

A phrase about women better than any Stieglitz devised comes from his friend and critical advocate Paul Rosenfeld: "the multiple appearance of the determinately individual woman" was what Stieglitz had to photograph in his ongoing examination of the "restless reaching and over-reaching soul" of America today. For a multiple appearance, multiple photographs are needed. Stieglitz's procedure is

democratic, in the broadly conceived sense of the term which he used throughout his career: all moments in a life have their right to be recorded. A portrait of O'Keeffe bringing the moments together achieves a democratic consensus and may rightly be considered a tribute to her. Similarly, a serial or composite portrait of "291"—comprising sixty-eight individual shots, all answering the question "What is 291?"—achieves a consensus, and for that matter so does the entire corpus of Stieglitz's photographic work on America, a serial "portrait" on the grandest scale. All three entities—woman, art center, and nation—though never to be defined, can fittingly be portrayed in repeated exposures, each urging the viewer or reader away from simple "character" toward a celebration of variety. Just as the photographer approaches the elusive meaning of one photographic negative by making repeated positive prints of it, each of which is "a new experience, a new problem," in Stieglitz's words of 1921, so the democratic portraitist approaches the meaning of the individual before his lens by tripping the shutter again and again, finding a new experience and a new problem each time.[17]

Coburn and Stieglitz make an interesting contrast. Coburn is emulative, impressionable, casually curious about many things, and untheoretic; Stieglitz is dominating, opinionated, concentrated, and highly theoretic—an ideologue for his kind of photography. Though willing on occasion to accept chance aid, such as when he accidentally took a double exposure of Dorothy True and printed the result as a composite portrait in the style of Coburn or Man Ray, Stieglitz in general planned his work carefully, deriving the plans from principles carefully thought out. Where these principles came from, besides his own experience, is difficult to know. The circle around Stieglitz at "291" and at his later gallery An American Place took ideas from him but also altered his opinions. In a visual parallel, he photographed his colleagues and disciples (O'Keeffe, John Marin, Dorothy Norman, Paul Rosenfeld, Marsden Hartley, and Waldo Frank) and also let himself be photographed, painted, or described in words. Stieglitz's face in New York, like Pound's face in London, became common artistic property, the basis of a cubist portrait by Man Ray in 1912 and a photograph by Paul Strand in 1929. When seven years earlier Strand had described the new meaning of "the whole concept of a portrait" as "a record of innumerable elusive and constantly changing states of being, manifested physically," he spoke as someone who had seen the O'Keeffe photographs and listened to Stieglitz pontificate about them, but he himself may have influenced the older artist. Strand's candid street portraits, published in the last volume of *Camera Work,* are striking. Assumptions that both Strand and Stieglitz made about "changing states of being" may ultimately have derived from Henri Bergson, for along with its gravures, *Camera Work* printed excerpts

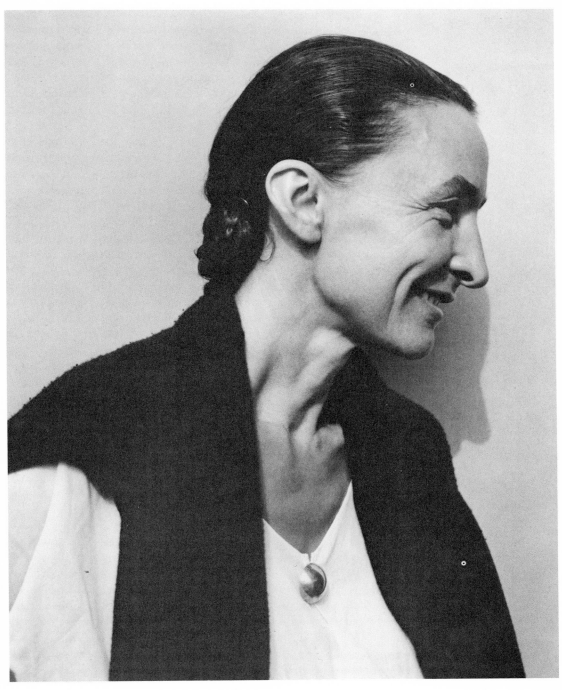

51. Alfred Stieglitz.
Georgia O'Keeffe.

from *Creative Evolution,* and the philosopher's formulations about process, "becoming," seem to underlie the notion of a series of photographs becoming a portrait and so doing justice to a vital human being. The Bergson who wrote "The Cinematographical Mechanism of Thought and the Mechanistic Illusion" might have penned Stieglitz's antiperfectionist comment: "To demand *the* portrait that will be a complete portrait of any person is as futile as to demand that a motion picture be condensed into a single still."[18]

At a further remove Stieglitz may have been influenced by D. H. Lawrence, the scorner of the old stable ego of character, the literary portrayer of complex personalities, including complex artistic personalities. Lawrence contributed to *The Seven Arts,* the short-lived arts journal with which Stieglitz was intimately associated, and Lawrence unquestionably supplied the language Paul Rosenfeld applied to Stieglitz's portraits. In reviewing the 1921 show, Rosenfeld wrote that the "dark wet quick of man" was approached there as it had not been approached before. According to Rosenfeld's *Men Seen* of 1925 (it was a moment for photographic titles, as Waldo Frank's *Time Exposures,* 1926, shows even more clearly), D. H. Lawrence "expresses numberless states of being that have lain hitherto underneath the lintel of the mind, and come strange to the day-pour like islands cast up by submarine eruptions." The "numberless states" of O'Keeffe's being were what posed before Stieglitz's camera. Whether or not the photographer remembered Rosenfeld's or Lawrence's language (endlessly analyzing, say, Gudrun Brangwen) as he worked, he was working like them. Rosenfeld and Lawrence are literary analogues to Stieglitz. So is Frank in his comparison of Georgia O'Keeffe to a peasant "full of loamy hungers of the flesh" or to a tree: "her voice, like leaves, has a subtle susurration."[19] All three writers prolong description, sometimes beyond the bounds of conventional effectiveness, in pursuit of the living essence; their subjects, they think, necessitate multiple images.

Stylistically, in the way they electrify or empurple language, these writers resemble the early Stieglitz, who is emotive and given to purple pictorial effects of his own. Stieglitz's photograph "City of ambition (1910)" is the unafraid rhetorical equivalent of Rosenfeld's *Port of New York* (1924), Stieglitz's soft-focus portrait "Miss S. R. (1904)" of Frank's word painting. A writer stylistically akin not to the early but the later Stieglitz, who recorded O'Keeffe again and again in sharp focus, is the radical innovator and theoretician of portraiture Gertrude Stein. Although *Camera Work* published Stein's early appreciations of Picasso and Matisse, she was never a member of the Stieglitz circle, and her essay "Portraits and Repetition," from *Lectures in America* (1935), came too late to affect Stieglitz's work with O'Keeffe. Yet the arguments of this essay might have been ad-

vanced in support of Stieglitz's methods. Stein regards "any life that is alive" as eluding conventional understandings, such as a writer's semantic distinctions between clarity and confusion or a photographer's choice of a single decisive moment, a single definitive image. Fixed interpretations, especially the fixed interpretations of memory, falsify the reality which can be seen at any moment and which must be seen as changing at every moment. In order to portray this reality in flux, Stein adopts the techniques of motion pictures, which are merely Stieglitz's serial techniques elaborated: "Funnily enough the cinema has offered a solution of this thing. By a continuously moving picture of any one there is no memory of any other thing and there is that thing existing, it is in a way if you like one portrait of anything not a number of them . . . in the Making of Americans, I was doing what the cinema was doing, I was making a continuous succession of the statement of what that person was until I had not many things but one thing." It does not matter if, at the period of *The Making of Americans* (1906–1908), Stein had not actually seen the cinema, because "any one is of one's period and this our period was undoubtedly the period of the cinema and series production. And each of us in our own way are bound to express what the world in which we are living is doing." [20]

Stein's ideas generate such writing as her own two portraits of Carl Van Vechten, a "series production" on a smaller scale but of the same kind as Stieglitz's O'Keeffe series. In the first portrait, Van Vechten comes aspect by aspect into Stein's view finder: "In the ample checked fur in the back and in the house, in the by next cloth and inner, in the chest, in mean wind . . . In the best most silk and water much, in the best most silk." The problem here is not so much the incomprehensibility of each aspect (though there are obvious difficulties with that) as the incomprehensible relation between aspects. Fur and silk are in focus, but fur has little to do with silk. Similarly, O'Keeffe's hands caressing the shiny wheel of a car have little to do with her breasts nakedly displayed. Stein and Stieglitz would both maintain that there is no necessary narrative, logical, or associational connection among the aspects of their subjects. What counts is the accumulation, the full inventory of moments and appearances as responding to the reality of Van Vechten and O'Keeffe, and beyond that the arrangement of aspects in some satisfactory formal design. More than they imitate the cinema, Stein's writings imitate painted or photographed portraiture; by intention, they imitate cubist painting, but without complete success. According to Wendy Steiner, Stein's prose, "trying the impossible," only illustrates the real barriers between visual art and literature. [21]

If Stein's full-scale portraits set out to depict the complexity of human beings by imitating it down to the last stray image and inconse-

quential transition, thus frustrating or boring the reader, they defeat their own purposes, like Weber's cubist poem. Stein could be more effective, which is to say more comprehensible, memorable, and personal, when she worked casually. She composed a short tribute to Stieglitz for *America and Alfred Stieglitz* (1934) which enfolds within its expressions of regard and gratitude a two-line portrait of the photographer:

> I remember him dark and I felt him having white hair.
> He can do both those things or anything.[22]

This is modest and admirable. It sheds light on Stieglitz while allowing him some mystery. Like the O'Keeffe photographs, to which it is a tiny counterpart, it is both a compliment and a convincing likeness.

Photographing Simplicity

In 1910 the German photographer August Sander, who had been working in Austria as a conventional studio portraitist, returned to his native region, Cologne and its adjacent Westerwald, and took the first step into what his son would call "a new photographic world." Sander began traveling into the country to photograph peasants in their own surroundings. He captured their likenesses outdoors, against a background of wood or tilled fields, or indoors, in favored chairs or holding objects apparently of their own choosing—a cane, a Bible, a pipe. Almost always he took them looking straight at the camera, holding a pose that presents them formally to the world. After the First World War Sander continued his excursions into the countryside and city, capturing more faces and changing one technique: he began printing his portraits on a glossy stock which emphasized detail and precluded the flattering softness of his earlier gum-bichromate prints. In essence he shifted from a pictorial to a documentary or objective style. The inflation of the 1920s in Germany hurt his business but allowed him time to gather his newly printed, unretouched, properly objective photographs into an archive, as Sander regarded it from the beginning, an inventory of faces from all walks of life and classes of society, to be called "People of the Twentieth Century." Sander thought this immense project a "declaration of faith in photography as universal language" and in photographable "physiognomy" as a reliable guide to human nature. The photographer believed "that people are formed by the light and air, by their inherited traits, and their actions, and we recognize people and distinguish one from the other by their appearance. We can tell from appearance the work someone does or does not do." Indeed, "every person's story is written plainly on his face."[23]

Many of Sander's portraits were collected in a 1971 volume with the misleading title *Menschen ohne Masken* [Men without masks]. The photographer certainly thought his task was to strip away the artificial masks of the photographic studio. There were to be no fancy costumes, directed poses, or painted backgrounds, and no retouching. He may further have thought he could strip away the masks of conventional self-understanding. But in fact his photographed peasants and Cologne intellectuals do not submit to the lens without self-consciousness. Self-consciousness, the mask of vanity or humility, is exactly what Sander's formal portraiture depicts. The story written plainly on everyone's face is in part autobiographical. Introducing *Menschen ohne Masken,* Golo Mann comments that when someone thinks he is not being photographed and the operator catches him that way, in movement perhaps, then character is revealed; but "if he approaches the camera with a certain solemnity, with the intention of showing himself off, then he has become something more than himself: he is revealing a secret self-image . . . Then the type is created."[24] Sander's sitters become types in the process of being photographed. One by one they tacitly acknowledge what they think of themselves, which is what they think circumstances have made them. They are confirmed as types when they are collected in an archive printing only occupational titles, not names. Blacksmiths in Wuppertal pose by their anvil and hammers; a pastry cook holds his bowl and whisk; an orthopedic shoemaker looks up at the camera from his last; a gowned Cologne lawyer carries briefs; an art dealer displays a rolled-up avant-garde magazine; an unemployed touring actor leans gracefully against a support; the wife of a Cologne painter shows off her trousers and mannish tie, defiantly striking a match for her cigarette.

Selective listing can only hint at the richness of this visual archive. With hundreds of photographs, many of them individually superb, Sander fulfilled his ambition of putting together a collective portrait of his society, a general physiognomy of his time, even if it is not quite so unmasked a physiognomy as he thought. Sander's photography shows definitively the way early twentieth-century Germans wanted to be seen and therefore the way they looked. Unintentionally perhaps, Sander succeeded in something else, namely in detecting a relation between social class and individual freedom. All his sitters may be types, but his working-class sitters are more sharply defined and limited types. They are more tellingly expressed by the tools they grasp so firmly. They wear uniforms. They pause in the midst of identifiable acts. They belong to their backgrounds: a peasant family sits on the ground which has just been harrowed, a foreman bricklayer emerges from the wall he is building. One of the finest Sander photographs shows a hod carrier with a load of bricks, which closely surround his head (figure 52). The bricks categorize him absolutely, as a

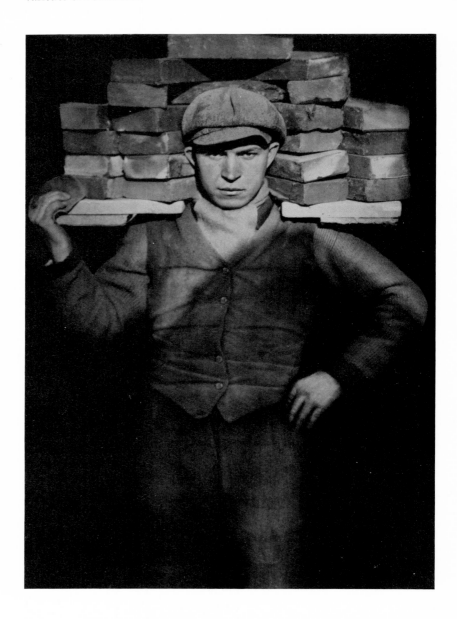

52. August Sander. Hod carrier.

halo categorizes a painted saint; Sander's dramatic raking light from above invites such an analogy. The man is once and for all a "hod carrier." Similarly, Sander's shaven-headed figure holding his hat in his hand is once and for all an "unemployed man" (figure 53). Lacking tools, work clothes, activity, or even a workplace, since the streets behind him are empty and out of focus, he has nothing and is by social definition a nonentity. Sander's businessmen and intellectuals present themselves in ways less easy to read; the self-assured figure in the chair could be an architect, actor, civil servant, or industrialist.

Some of the middle- and upper-class sitters in *Menschen ohne Masken* or in Sander's collection *Antlitz der Zeit* [The face of our time] (1929) are named or identified by initials, like the composer P[aul] H[indemith], which keeps them from seeming typical, or else they have recognizable faces. They are individuals. They freely express themselves, as their confidence before the camera suggests. More often than the working-class sitters, they look away from Sander, as if escaping from his commanding presence. The unemployed man, too, looks away from the camera, but with what must be interpreted as shame, not confidence.

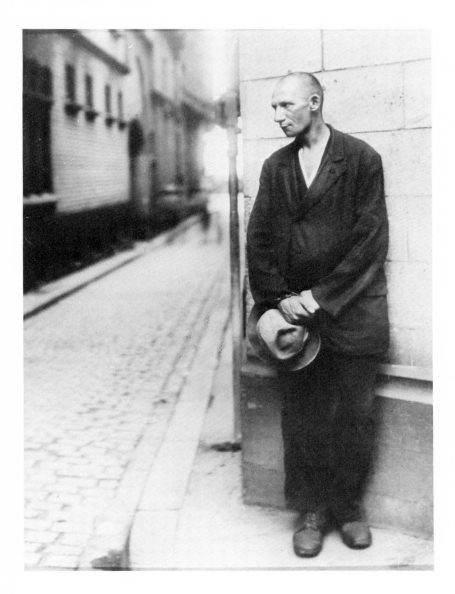

53. August Sander. Unemployed man.

Antlitz der Zeit is introduced by the physician and novelist Alfred Döblin, author of *Berlin Alexanderplatz* (1929), itself an inventory of social types and a tract on social determinism. In his strange, wandering, ironic essay Döblin compliments Sander, though mentioning him by name only once, and plays metaphorically with photographic language, as in "let us rewind a little" for the recalling of an earlier stage of his argument. After summarizing the medieval debate between nominalists, who believed only in individual entities, and realists, who believed in universal kinds or types, Döblin then abandons philosophy to investigate the face of a suicide, a young unidentified woman who threw herself into the Seine. The woman's face, like the faces of all dead human beings, has experienced a "flattening" (*Abflachung*). There is something negative about the face; it has lost individuality; "Death has undertaken a massive retouching" of it. The faces of the dead, preserved in death masks or photographs, are stones rolled in the sea for decades and worn away. But only one kind of flattening is produced by death. The other kind is produced by human society with all its classes, occupations, and levels of culture. Döblin has a portfolio of photographs of the living before him, and their faces too are flattened into typicality; they are tumbling in the sea that rolls us all. At last the medieval debate becomes pertinent. The realists were right about their universals, one of which stands revealed in these photographs: the "collective power of human society." People are themselves rendered universal by this power. Seemingly individual, they become typical when seen at a distance, as ants become undifferentiable when seen by human observers. At the distance fixed by Sander's portraiture his sitters are revealed as hod carriers or unemployed men, pastry cooks or peasants—peasants recognizable even without their plows and fields because "a coarse, hard, monotonous calling" has made their faces hard, "weathered" them.[25]

Like other texts accompanying photographs, Döblin's is not determinative of visual meaning. Nor is it irrelevant to that meaning, despite its occasional departures from the photographic evidence. Sander, for example, resists "flattening" to the extent of captioning one photograph "Professor Dr. P., Berlin" and another "Professor Dr. Schl., Berlin," while conveying with both photographs a marked sense of individual character. Döblin is more political than Sander, but no less tidy-minded and devoted to classification. Alongside the photographer's social types Döblin sets down his own three types of photographer. The first is artistic, for whom faces are a raw material and before whose work one says "sehr interessant" or "sehr schön" or "originell." Although Döblin himself mentions no names, one who could be placed in this category is Sander's near-contemporary Helmar Lerski, who in *Köpfe des Alltags* [Everyday heads] (1931) views faces of ordinary workers in extreme close-up. As pictured by Lerski,

skin looks like rock planes or weather-beaten boards; human beings become all texture. Lerski's plates are inconsequentially titled "Painter" or "Young beggar from Bavaria," because what counts is the play of light over surface and the artful positioning of heads. The second kind of photographer, called nominalist by Döblin, is dedicated to accurate portrayal. This photographer believes in individuality and hopes to capture it in the best likenesses possible. Most portrait photographers, from Weston on down, fall into this category. The third kind of photographer is Sander himself, the true realist, the anatomist of cultural, social, and economic history.[26]

Besides Sander, this third category includes the 1930s English documentary photographers Humphrey Spender and Edwin Smith, anatomists of Bolton and Tyneside respectively; Brassaï in Paris, gathering his nighttime faces, observing the flattening effects of poverty, petty crime, and alcohol; and especially the FSA photographers of the United States. Their depiction of working-class Americans, which was virtually the only kind of portraiture they were assigned and were interested in doing, is strikingly like Sander's depiction of laborers in Cologne or peasants in the Westerwald, even though the Americans—except for those photographed by Evans—pose less formally than the Germans and often seem less at home in their surroundings. The Americans are simplified into typicality in a way Sander and Döblin would have understood. Photographed, they become the migrant mother, the sharecropper, the angry striker, the plantation overseer, the southern black, the fruit picker, the panhandler, the hitchhiker on Route 66. That is how they understand themselves and how others see them. *Abflachung* Americanized is "simplicity boiled down," the phrase that Lange's pea pickers of 1936 used to define their existence. The pea pickers are boiled down, reduced, given no chance to make themselves over, flattened into predictability, and identified by what they do. Individual character they have had to leave behind in Arkansas or Oklahoma.

It seems absurd to call the Texas woman photographed by Lange in 1938 a mere type (figure 54). Is her face not full of "character"? Yet that casual descriptive term really means that experience has both marked her and brought out certain strengths, such as dignity. The experience and dignity are those of her class, race, sex, and historical moment. She has the gaunt beauty of the Scotch-Irish hill woman, the frailty of those with not enough to eat, or the sad purposelessness of the migrant. To Lange she was simply a migrant woman. Bill Ganzel later discovered her name, but Ganzel belongs to a generation of photographers less ready to generalize than Lange's. Every attempt to describe what this portrait shows must include a social interpretation and therefore a simplification. Her homemade dress: how poor they are or, alternatively, how stubbornly they contest poverty. The comb

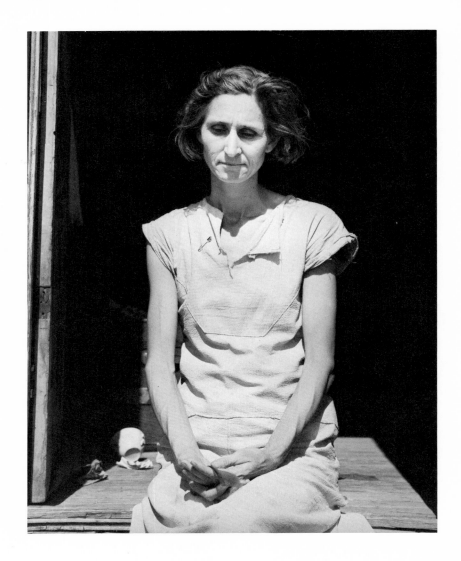

54. Dorothea Lange.
Farm woman in Texas
panhandle.

in her hands: how little they have, how hard it is to keep up their self-
respect. The broken cup: what ramshackle lives they must lead.

Lives picturable in and determined by possessions, surroundings,
or other appearances might well seem pitiable, now or in the thirties,
but such lives were then politically useful. They admitted extenuating
circumstances for failure, of the sort tactfully described by Agee in
Let Us Now Praise Famous Men or crassly announced by Rupert
Vance in *How the Other Half Is Housed* (1936): "It is too much to
expect human nature to rise above the squalor evinced in the interior
of this share cropper's hut." Simplified lives furnished images for sim-
plified teaching; Lange's photograph of the migrant mother was

widely reprinted in newspapers and later turned into posters. These images made it possible to generalize from particulars: one life expressed by a flour-sacking dress is like all lives expressed by a flour-sacking dress. Lincoln Kirstein thought the power of Walker Evans's work was of this generalizing kind. His pictures of men and his portraits of houses "have only that 'expression' which the experience of their society and times has imposed on them." The single photographed face, "isolated and essentialized," strikes with the strength "of overwhelming numbers, the terrible cumulative force of thousands of faces." In short, the lives photographed by Lange, Evans, and the other thirties photographers provided the comfort of understanding at a time when it was much needed, for whatever Kirstein may say about the "terrible cumulative force" of the pictures, he values them artistically and relies on them as evidence: "The photographs are social documents." Elizabeth McCausland remarked of Russell Lee's picture of the hands of an old homesteader in Iowa (figure 55): "The knuckles are gnarled, the fingers are deformed from work; this woman, one knows, has worked hard all her life, fighting off the taxes, fighting off the mortgage, fighting off the sheriff. Her hands are the story of her life, her heroism."[27] Meaningless, random ugliness is

55. Russell Lee. Hands of an Iowa homesteader.

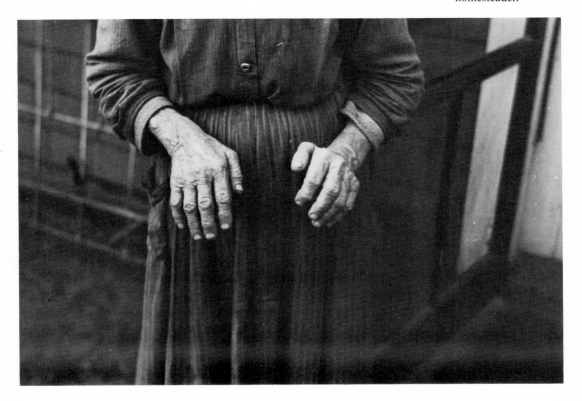

one thing; gnarled hands or wrinkles in a face telling the story of a life are another. The key phrase of McCausland's is "one knows." To know is not to be helpless; it is to detect heroic purpose in an appearance and perhaps even to share it. McCausland's strenuous analysis emulates the old woman's fighting spirit. Kenneth Fearing, not a writer normally associated with Iowa homesteaders or FSA concerns, nevertheless speaks for the thirties commentators from Döblin to McCausland when in "American Rhapsody (I)" (1936) he describes the passage they all made from looking to knowing:

> At a distance these eyes and faces and arms,
> maimed in the expiation of living, scarred in payment exacted through
> knife, hunger, silence, hope, exhaustion, regret,
> melt into an ordered design, strange and significant, and not without
> peace.[28]

"Distance" here means exactly what it does to Döblin: detachment, knowledge, the capacity for social generalization, the sympathetic or condescending sense of differentness that complicated people bring to their encounters with simple people.

Endurance of the Primitive

In 1938 Muriel Rukeyser reviewed *Land of the Free* for *New Masses.* Though she took MacLeish to task for poetic looseness and sentimentality, she must have been stimulated by his example, because a year later she published her own prose-poem-with-photographs in the improbable setting of *Coronet* magazine. This compilation, titled "Worlds Alongside: A Portfolio of Photographs," does not credit the pictures to individual photographers, though some are by Lange, including her shot of migrants walking past the Southern Pacific billboard. In the accompanying text, Rukeyser juxtaposes rich complication with poor simplicity. On the left of a two-page spread, for example, a tuxedoed waiter fills wine glasses ranged neatly on a bar ("the elaborate formal gesture," runs Rukeyser's comment). On the right a straw-hatted farmer drinks from a tin cup ("the simplest motion"). Mont St. Michel on one side confronts on the other side the "poverty-thin" religion of a clapboard gospel church. These paralleled worlds "bring together faces." The photographed face of an African woman, seen in profile and tilted up, is "the primitive waiting face that is ready to receive history upon itself, a dark genesis for us all . . . beautiful and receptive, a living rock," and the opposite face of Martha Graham is "the finished face of the dancer turning to her audience."[29]

Rukeyser's purposes in this work are obscure. "Some are lucky," she comments, and "speed across one world while the other world waits, a man in the road waiting for the car ahead to move," as if she were still writing for *New Masses,* but elsewhere she prefers artistic

detachment to sympathy, admires the two worlds dancing in what she calls "unique balance," and enjoys her own elaborate, formal gestures of pairing picture with picture and picture with text. What can confidently be said about "Worlds Alongside" is that it denies individuality to dwellers in the poor, simple world. The Virginia postmaster photographed by Russell Lee is fully interpreted, and thus fully categorized, by "a ritual of business, belief in a god in the room, a few household objects, and his face." [30] The African woman in Rukeyser's central pairing is portentously symbolic, nameless Primitive Woman, as passive as a stone, whereas the finished dancer, in control of her life, turning to her audience, is specifically identified as Martha Graham. The photograph Rukeyser actually uses of the African woman makes her resemble a stone or one of the "flat lands that have no features." She is like a Helmar Lerski sitter seen in close-up and rendered almost exclusively in texture. The image and Rukeyser's words collaborate in going a stage beyond the uncharacterizing portraiture of Sander and Döblin, Lange and McCausland, to arrive at an elemental portraiture, a transformation of human being to "living rock."

Whenever an imagination of a certain sort comes into contact with simple people, no matter whether the imagination is visual or literary, such an elemental portraiture is likely to result. In *From Incas to Indios* (1956), a picture book about the Andes in the same series as *D'une Chine à l'autre,* Manuel Tuñon de Lara's literary imagination bestows on a half-caste's face a "mask of immobility." The caption grants him "not so much as a twitch of the muscles to betray the secret of that inscrutable silence deposited by all the centuries during which they have played the underdog." [31] The silence is "deposited" by the centuries, as though the half-caste's face were the stony bed of a stream of time; he is both silent and unmoving, like the mountains surrounding him. Meanwhile, the Robert Frank photograph which all this language addresses shows a face that is unforthcoming and perhaps secretive, but not primitively rock-like. In Paul Strand and Basil Davidson's collaborative portrait of the Outer Hebrides, *Tir A'Mhurain* (1962), the elemental imagination is visual. The islanders whom Davidson names and puts into a detailed political-economic history Strand photographs against the stone walls of their cottages, adjusting his tonal values to match their faces with those stern, gray, craggy surfaces. Kate Steel, Archie MacDonald, Neil MacDonald, and Donald MacPhee are all portrayed in this way, as figures growing out of the bones of their island.

There is much rock in all these photographs and figuratively in all these captions, including "captions" in the form of general commentary: "I am thinking about the photographs by Doris Ulmann . . . Good God, the stories those faces tell! They are like striated rags of rock on a gulley to a river." [32] The reason is that rock weathers and also resists weathering. Rock is the perfect vehicle for expressing

mixed attitudes toward people like Hebridean crofters, Andean Indians, African natives, and Appalachian mountaineers. These types of primitive humanity—and they are always types, never individuals— are in one sense completely shaped by the landscape around them, wholly acted upon, "ready to receive history," and therefore not to be blamed for any ignorance, any failing. To endow figures with elemental simplicity is to go beyond the extenuating circumstances offered by an Agee or a Vance and to excuse human beings entirely from judgment. The half-caste is no more responsible for his degradation than the mountain is responsible for its erosion or the Arkansas sharecropper is responsible for his dispossession. Although American photographs from the thirties do not routinely liken victims of the Depression to rocks, they put wrinkled faces next to eroded fields and in that way link human nature to landscape. In another sense primitive types are resistant to exterior forces. They extend unchanged to the distant past, as may be gathered from Rukeyser's phrase about "the dark genesis for us all." Primitive types are strong, like rock; they endure, and in their endurance they become admirable. Especially to observers burdened by their own complexity, endurance seems the most important virtue of simple people and their most summary trait. "They endured" is Faulkner's two-word comment on Dilsey in the 1946 appendix to *The Sound and the Fury* (1929), a novel otherwise dedicated to establishing her individuality. Faulkner's "they" shows that in the end Dilsey must stand for her type, all the selfless black servants, all the survivors of the suicidal Compsons. It would not take long to find photographs by Ulmann or Bourke-White that also "said" about blacks "They endured." Endurance is recompense for poverty, the payment artists make for photographing or writing about lives reduced to the basic elements.

Not every craggy peasant face need involve a calculus of guilt. When Strand photographs his islanders against their stone walls, he is in part simply exercising his craft—ingeniously linking foreground to background, complementing one gray with another, demonstrating his sensitivity to landscape as well as human appearance. Strand's collaboration with Claude Roy, *La France de profil*, done ten years before *Tir A'Mhurain*, fixes French peasant faces into the texture of their lives with an ingenuity that draws attention to itself and becomes the book's point. Strand and his collaborator enjoy perfect analogies of appearance. The "Man of straw," for example, photographed for the right side of the page (figure 56), sports a moustache which might be made of the fodder in his barn, photographed for the left side of the page. Roy's captioning poem comments on the resemblance:

> He has for so long
> sown the grain cut the straw
> tied the sheaves of wheat . . .

56. Paul Strand.
Portrait, Gondeville,
Charente, France,
1951.

that he has become straw
handsome moustaches of smooth wheat
chin of stubble sticking out all over
eyebrows of millet beard of corn[33]

Roy appends a proverb—"to be like a rat in straw" or "to be at one's ease"—implying that the man of straw is neither pitiable nor admirable. And in the photograph he is very much at ease, proud of his moustache. If he stands for anything, it is complacency rather than endurance. Nevertheless, in being so absorbed in his work, the man loses something—a name, a distinctiveness, a chance to display unphotographable qualities. His life is after all limited by his antecedents and present circumstances, by "habits . . . social systems and economic relations."[34] This portrait of the man of straw withholds a private character from its subject, like portraits by Lange and Sander, replacing it with a photogenic universality. One knows this type. Though no rat in the straw, he smiles with what everything in *La France de profil* encourages observers to interpret as a "peasant's" sly cunning.

Vignette and Frame

No twentieth-century writer has been more fascinated by the human face than George Orwell. The hero of Orwell's early novel *Burmese Days* (1934) exhibits, in his birthmarked face, the outward sign of a colonialist's guilt and a rankling conviction of failure; the hero of his last novel *1984* (1949) moves about in a London hypnotized by posters of Big Brother's face and frenzied by Emmanuel Goldstein's goat-like face projected on a screen during the Two Minutes Hate. Orwell's essay on Charles Dickens ends with "the impression of seeing a face somewhere behind the page"—the face in this instance of a man laughing without malignity, fighting in the open and without fear, generously angry. Possibly the last words Orwell wrote, in a 1949 notebook, comment that at age fifty "everyone has the face he deserves."[35] In his most enduring works, the essays and non-fictional books on poverty, war, and politics, Orwell first identifies representative individuals in a crowd of anonymous victims, then examines each individual's face, which is the index to mind and feeling, the means of human contact—if there is to be any contact—between observed and observer.

"Shooting an Elephant" (1936), for example, which is equally about "the dirty work of Empire" and the hatred exchanged between Orwell and the Burmese he had to govern as a young policeman, interprets these subjects in visual, facial terms; Imperial dirty work shows in "the grey, cowed faces of the long-term convicts" and hatred in "the sneering yellow faces of young men." Because the essay chiefly concerns Orwell's being swayed by the will of the crowd gathered to see him act as policeman by killing the "dangerous" beast, it concentrates finally on his own face, that of the victimizer turned victim, the pukka sahib who must at all costs impress "the natives": "He wears a mask, and his face grows to fit it." In "How the Poor Die" (1946) Orwell stares in fascinated horror at the face of Numéro 57, an old man dead of cirrhosis of the liver. This tiny, screwed-up face is contorted into an expression of agony and is horribly pale, little darker than the sheets of the hospital bed. The old man's death, "brought home" to Orwell by study of the face, leads to gloomy intimations: "There you are, then, I thought, that's what waiting for you, twenty, thirty, forty years hence." Communication of a sort has taken place; Numéro 57 has whispered a memento mori to the Englishman temporarily laid up with pneumonia. But more important, Numéro 57's expressive face has rendered human again something that had been a "cirrhosis of the liver case," a "number," a "subject" for the medical students' scalpels, a specimen of disease to be showed off, in its age and pallor, like "a piece of antique china," to be rolled gently to and fro like a rolling pin handled by a woman.[36]

"How the Poor Die," in other words, shows how in the Hôpital X the poor are understood as types and treated as objects, and it resists that understanding and treatment with the devices of its prose, its carefully described encounter between one human being in his bed and another wrapped in his shroud. In Orwell's view, all powerful institutions—hospitals, colonial empires, armies, bureaucracies, industrial concerns, Party apparats—exercise and maintain their power by making people "invisible." Patients become specimens, refugees become "transferred populations," casualties become statistics. The European traveling in tropical colonies, Orwell comments in "Marrakech" (1939), "takes in everything except the human beings." The peasant hoeing at his patch is the same color as the earth and disappears into it. Old Moroccan women hobbling past Orwell's house with huge burdens of sticks register on his consciousness as a train of passing firewood, and only by an effort of will is he able to notice their "poor old earth-coloured bodies" and draw a political lesson from his delayed noticing. The essay implies that such an effort must be made. No human being must become invisible. No black African soldiers must disappear into the dust of the road down which they march. No peasant must merge into straw, no crofter into stone, however appealing the visual textures involved in such transformations. Although Orwell died in 1950, too early to see Strand's photographs, they would have confirmed his opinions of how the privileged view the unprivileged. The necessity for a different perception—equals looking at equals—is marked at the end of "Marrakech" by Orwell's sight of one soldier in the marching column of Africans, who turns and catches Orwell's eye. Face confronts face, human being looks at human being.[37]

Orwell's longer works of reportage make more of such meetings, which are remembered as distinct, self-contained episodes and set off formally from the rest of the text. These meetings always begin in full-scale portraiture, as in the description in *Homage to Catalonia* (1939) of an Italian militiaman seen for a moment in the Lenin Barracks in Barcelona:

He was a tough-looking youth of twenty-five or six, with reddish-yellow hair and powerful shoulders. His peaked leather cap was pulled fiercely over one eye. He was standing in profile to me, his chin on his breast, gazing with a puzzled frown at a map which one of the officers had open on the table. Something in his face deeply moved me. It was the face of a man who would commit murder and throw away his life for a friend—the kind of face you would expect in an Anarchist, though as likely as not he was a Communist. There were both candour and ferocity in it; also the pathetic reverence that illiterate people have for their supposed superiors. Obviously he could not make head or tail of the map; obviously he regarded map-reading as a stupendous intellectual feat. I hardly know why, but I have seldom seen any-

one—any man, I mean—to whom I have taken such an immediate liking. While they were talking round the table some remark brought it out that I was a foreigner. The Italian raised his head and said quickly:

"Italiano?"

I answered in my bad Spanish: "No, Ingles. Y tu?"

"Italiano."

As we went out he stepped across the room and gripped my hand very hard. Queer, the affection you can feel for a stranger![38]

In nearly every respect this is an uncharacterizing portrait of a simple man. Sander might have photographed the militiaman in Germany, Russell Lee or Arthur Rothstein in the United States; Robert Capa actually photographed many militiamen like him for the pages of *Death in the Making*. "Obviously"—a word used twice—the militiaman is intelligible at a glance; Orwell leaps from the leather cap pulled fiercely over one eye to the willingness to commit murder, from the puzzled frown to the illiteracy. The militiaman is intelligible because wholly typical, though with characteristic regard for accuracy Orwell corrects a viewer who might initially mistake his type: "the kind of face you would expect in an Anarchist, though as likely as not he was a Communist."

The militiaman is, moreover, useful. At the opening of *Homage to Catalonia* his "fierce, pathetic face" serves to recall the special atmosphere of revolutionary Barcelona, with its idealism and disorder, its parades and bread lines. In "Looking Back on the Spanish War" (1942), where the militiaman appears again, he symbolizes for Orwell "the flower of the European working class" and, like all the symbols Orwell made for himself, simplifies a political situation that would otherwise be ambiguous and troubling: "When I remember—oh, how vividly!—his shabby uniform and fierce, pathetic, innocent face, the complex side-issues of the war seem to fade away and I see clearly that there was at any rate no doubt as to who was in the right." Orwell wrote one of his rare poems about the Italian militiaman and quotes it in the essay, giving voice to his admiration for him:

> For the flyblown words that make me spew
> Still in his ears were holy,
> And he was born knowing what I had learned
> Out of books and slowly.

Another educated observer, James Agee, felt the same kind of admiration for the innate, unschooled courtesy of Alabama hill people. Endurance is the only virtue of simple people Orwell cannot quite attribute to the militiaman, since he foresees his being killed: "It can be taken as quite certain that he is dead." This is another way of making him instantly intelligible and, in his role as fallen unknown soldier, instantly representative. But even endurance can be hinted at in the celebratory metaphor of the poem's last stanza:

But the thing that I saw in your face
No power can disinherit:
No bomb that ever burst
Shatters the crystal spirit.[39]

Only an English Etonian who knew how different he was from an Italian Communist could have written the passage at the start of *Homage to Catalonia*. Orwell's willingness to read the future in someone's face, his social and political placements of the man, his use of an adjective like "pathetic," all measure the distance between observer and observed. But only a writer who wished to shorten that distance could have included the remark "I have seldom seen anyone—any man, I mean—to whom I have taken such an immediate liking," as though Orwell and the militiaman were social equals who might simply be attracted to each other. The two exchange national identifications in parallel form, there being no sign of the linguistic misunderstandings which elsewhere in the book mark class as well as national differences, and they then shake hands. From the physical contact, always of much import to Orwell, follows the conviction that the two have "momentarily succeeded in bridging the gulf of language and tradition and meeting in utter intimacy." At this point the Italian ceases to symbolize "the flower of the European working class" and stands instead for those collectivized bootblacks, store clerks, and waiters in Barcelona who now "looked you in the face and treated you as an equal." More exactly, he stands for nothing. He is himself. "I hoped he liked me as well as I liked him" Orwell finishes, granting him an independent will, acknowledging the fact that he is looking as well as being looked at.

Admittedly, Orwell's intimacy with this man is qualified in various English and Etonian ways, from the casual dismissal in "Queer, the affection you can feel for a stranger!" to the more studiedly cynical comment that the favorable impression he made would last only if Orwell did not see him again: "and needless to say I never did see him again. One was always making contacts of that kind in Spain."[40] These are controls on feelings expressed too openly, perhaps too Hispanically, and also on uncertainty. Orwell is unable to understand or explain, as a writer should be able to do, his attraction: "I hardly know why," the declaration of liking begins. What moves Orwell in the man's face, as opposed to the peaked leather cap allowing him to interpret the man politically, is a vague "something." Certainty goes with the uncharacterizing portrayal of an unequal; uncertainty goes with meeting an equal.

In describing people like the militiaman, Orwell is pulled in two directions. He must, for sound ideological reasons, show how they are representatively shaped by economic and historical circumstance. He must understand them. He must report every class angle and so-

cial impoverishment. Yet he must also recognize the ways in which they defy the laws of social determinism to develop an individuality and an understanding not inferior to his own. Orwell's emotional socialism depends on a belief in the classless, and therefore fully equal, society; if he could not hope for that and indeed welcome its partial and temporary manifestations in this century—in revolutionary Catalonia, the society of down and outs, or the first few months of the Second World War in England—he could not be politically active at all. He must think all human beings capable of at least as much freedom as he feels himself. Moreover, Orwell is sensitive to the condescensions associated with social analysis, whether of the doctrinaire Marxist or the casually bourgeois sort. He wishes to treat the subjects of his writing as equals and look them in the face. In practice, he serves his opposed purposes by writing scene after scene like the encounter with the militiaman. Description, which of necessity categorizes, is followed by or blended with narration of a personal encounter, which of necessity sets both Orwell and his subject partially free from categories, from their predetermined roles, whatever these may be—journalist and "subject," traveler and homebody, intellectual and proletarian. For what is never more than a moment, Orwell and those he describes come together.

The most celebrated of his encounters is reported in *The Road to Wigan Pier* (1937). Expanding on a passage in the diary he kept while investigating conditions in the industrial North, Orwell writes of seeing a laboring woman just at the moment he was escaping from her world:

The train bore me away, through the monstrous scenery of slag-heaps, chimneys, piled scrap-iron, foul canals, paths of cindery mud criss-crossed by the prints of clogs. This was March, but the weather had been horribly cold and everywhere there were mounds of blackened snow. As we moved slowly through the outskirts of the town we passed row after row of little grey slum houses running at right angles to the embankment. At the back of one of the houses a young woman was kneeling on the stones, poking a stick up a leaden waste-pipe which ran from the sink inside and which I suppose was blocked. I had time to see everything about her—her sacking apron, her clumsy clogs, her arms reddened by the cold. She looked up as the train passed, and I was almost near enough to catch her eye. She had a round pale face, the usual exhausted face of the slum girl who is twenty-five and looks forty, thanks to miscarriages and drudgery; and it wore, for the second in which I saw it, the most desolate, hopeless expression I have ever seen. It struck me then that we are mistaken when we say that "It isn't the same for them as it would be for us," and that people bred in the slums can imagine nothing but the slums. For what I saw in her face was not the ignorant suffering of an animal. She knew well enough what was happening to her— understood as well as I did how dreadful a destiny it was to be kneeling there in the bitter cold, on the slimy stones of a slum backyard, poking a stick up a foul drain-pipe.[41]

A train's slow passing gives time enough to see "everything" about "the slum girl." Orwell completes another entry in his catalogue of social miseries, ticking off the expected visual items one by one, and admitting no doubt about the propriety of his suppositions, unlike James Agee, who in analogous circumstances would certainly admit doubt. *The Road to Wigan Pier* depends on confident generalization from particulars. Whatever insensitivity is implied in, say, the casual linking of "usual" with "exhausted" is the insensitivity that social observers need if they are not to break down and weep at the pathos of individual cases. There are too many rows of little gray slum houses; Orwell cannot worry about being mistaken or patronizing. What he can do is attack suppositions far more patronizing than his own—the claim that "they" are used to the slimy stones, a variant on the claim, brought up later in *The Road to Wigan Pier,* that if you give bathtubs to miners, they will just use them to store coal. He can also rescue the girl's face from complete typicality by describing its expression as the most desolate and hopeless he has ever seen, and he can, finally, attribute to her the one human characteristic, knowledge, that puts her on a footing with himself. She is held to know her destiny with an Orwellian distaste of its physical squalor and an Orwellian certainty of its moral significance. For a moment, before the train carries him away, the slum woman and the writer are equals: a bitter enough tribute to her, considering Orwell's state of mind in this section of the book, but the only one he can make.

There are no photographic equivalents of these doubly purposed Orwell vignettes. In general, no picture can put portrayer and portrayed on the same footing; no picture can simultaneously record a face and dramatize the photographer's personal relations with the owner of the face, although captions to photographs or accompanying texts often dramatize these relations, as in *An American Exodus* or *Let Us Now Praise Famous Men.* Above all, no picture can show the knowledge of a dreadful destiny as convincingly as an Orwell text can impute it, though photographic hinting at someone's understanding, self-knowledge, is always possible: the thoughtful expression of the Texas woman photographed by Lange invites the guess that she knows what is happening to her.

Beyond this, what a picture can do is to make a man or woman beautiful, and beauty, like endurance, can in the right circumstances seem a compensation for poverty or dispossession, a stay against the impersonal forces which flatten and reduce the ordinary people of the world. In pausing to admire the Texas woman's face, observers are at least not thinking, at that moment, how little "these people" have, nor are they assigning meaning to the broken teacup and the coarse dress. They are countering the general dreariness of social reportage with aesthetic appreciation; that is, they are countering knowingness with pleasurable uncertainty, superiority with admiration. When in

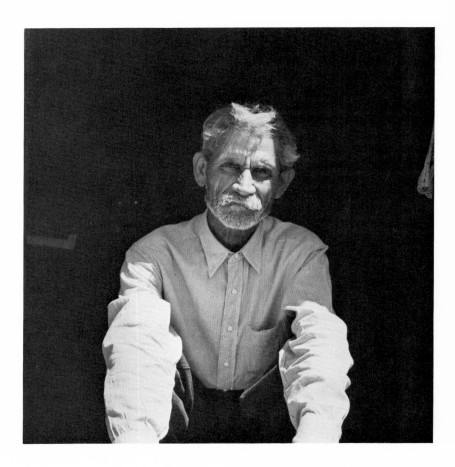

57. Dorothea Lange. Mexican laborer in the Imperial Valley, California.

1938 Elizabeth McCausland looked at the "lonely, hungry, questioning, bewildered faces" of FSA portraits, she found herself as deeply and as vaguely moved as Orwell. The "something" in the photographs was for her "the face of ourselves," "the beauty of the identity of mankind."[42] This key phrase suggests that in her decade, which was also Orwell's and Lange's, aesthetic appreciation could have political virtue; it could celebrate one kind of human equality. In portrait after portrait the photographed beauty of the identity of mankind does just that, offering a visual analogue to the narrated encounter between individuals, the handshake or exchanged direct glance celebrated in words.

Lange makes the Texas woman beautiful, not just by posing her arms and head gracefully and allowing her to comb her hair, but by setting her against dark shadow. Surrounded by black, formally singled out, she comes into view as a figure worthy of the lighting effect Lange has obviously contrived; she is presented for an assessment in tonal values—though not just for that. It is so with the pho-

tograph of an old man in the doorway of his cabin from a 1935 sequence of pictures Lange took of Mexican laborers in the Imperial Valley of California (figure 57). Nothing in the background distracts attention from the old man's grizzled, sidelighted, handsome face or from the directness of his gaze at the viewer, which has the beauty of uncomplicated dignity. The old man is as flatteringly framed as any of the wealthy San Franciscans photographed by Lange when she was a studio portraitist (figure 58), or as the jug, lamp, and table photographed through the rectangle of a doorway by Walker Evans in *Let Us Now Praise Famous Men,* a still-life counterpart to beautifying portraiture. Repeatedly in thirties photographs poor people are disposed for best effect by being framed, held within the severe borders of doorways, cabin windows, car windows, porch pillars, blackboards in rural schools, tent flaps, and strands of barbed wire. Arnold Newman's portrait of the black man in Florida owes much to the framing of the church porch. Against its whiteness, the man is very black. Against its rectilinearity, he is gracefully relaxed. Against its exact symmetry, he is pleasingly off-center. (Although Newman's is not, strictly speaking, a thirties photograph, it derives from a thirties style.) Removed as tent flaps or church porches may be from the

58. Dorothea Lange. Portrait of Peggy Wallen.

59. Arthur Rothstein.
Girl at Gee's Bend,
Alabama.

frames around the pictures in museums, they have something of the function of those frames: to concentrate a viewer's attention and give formal notice that attention will be rewarded, that the face or figure framed will be worth looking at.

Rothstein's 1937 picture of a girl in Gee's Bend, Alabama, illustrates even more clearly the effect of framing (figure 59). Detached somewhat from her ongoing life, from what would presumably be visible if there were light in the room behind her, the girl unself-consciously holds a graceful pose within the window and rests her hand delicately against part of the window frame. She would seem less striking if she were photographed against a cluttered or anecdotal background, something that spoke of ordinary activity, because repose is an important part of her beauty. To think of her as entirely reposeful, however, as though she were a museum piece, or to view her in complete detachment from ongoing life, would be to simplify the photograph. Rothstein has not forgotten his documentary pur-

poses. The cabin window is still a cabin window. The black girl faces
the picture of a conventionally pretty white woman in an ad in a
newspaper published somewhere far from and more prosperous than
Gee's Bend. Rothstein and his colleagues do their framing with the
compositional elements the decade provided, that is, with elements
also to be interpreted socially. Even the flattering black doorways of
the Lange photographs say something about the bleakness of exis-
tence in the Texas panhandle and the Imperial Valley.

This kind of portraiture was not a monopoly of the thirties. Two
women held in the frame of a South Bronx window in a 1977 Jerome
Liebling photograph make themselves available both for admiration
and for sympathy (figure 60).[43] A woman in a Lewis Hine photograph
taken between 1907 and 1917 looks out from her loom with an

60. Jerome Liebling.
Girls in the Bronx.

expression that could scarcely be more bright-eyed and engaging (figure 61). The framework of machinery centers attention on her liveliness. But the machinery is also what holds this mill worker in place, in her place. The accomplishment of portraits like Rothstein's, Liebling's, and Hine's is exactly the accomplishment of Orwell's reportage, the singling out of individuals in a way never denying their likeness to all the others, the ones without distinctiveness or beauty. It is not difficult to imagine how Orwell would write about the mill worker at her loom. He would "frame" her in a little scene distinct from the rest of a narrative, as he frames the militiaman and the woman with the stick—the latter he sees through a literal frame, the window of his train—and he would note her attractiveness and her spirit; he would have her catch his eye. At the same time he would typify her, use her to talk about all mill workers or all factories. He would picture himself walking away to other sights and generalizations to be drawn from them, leaving the woman behind her loom. His little scene would after all belong to a larger argument.

English photographers of the thirties might have supplied Orwell with images no less technically accomplished than Hine's or Lange's,

61. Lewis Hine.
Mill worker.

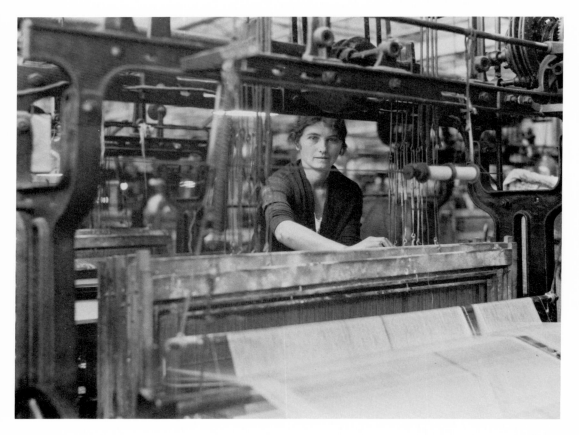

and no less perceptive about conditions in the mill or on the land. English reportage of the period, however, failed to develop anything like the ambitious American techniques of collaboration which produced *You Have Seen Their Faces* and *An American Exodus,* so that even an Orwell more interested in photographs than he seems to have been could have had no models to imitate. J. B. Priestley's *English Journey* (1934), Graham Greene's *Journey without Maps* (1936) and *The Lawless Roads* (1939), Auden and Isherwood's *Journey to a War* (1939), and Peter Fleming's *One's Company* (1934) make little real use of their illustrations; the amateurish photographs in the last two books are by the authors, Auden and Fleming. Bound within the first edition of *The Road to Wigan Pier* are thirty-three photographs from unidentified sources, but these are largely irrelevant to the book's purposes, since they depict areas Orwell did not visit, such as the mining districts of South Wales or the slums of London, and abuses he did not consider, such as houses damaged by mining activity beneath them. One or two of the photographs capture significant detail with Orwellian skill—through the window of a basement flat in Limehouse, itself seen through a street grating, the viewer catches a glimpse of a caged bird. In general, however, the photographs are uninspired and unambitious, illustrations designed to make *The Road to Wigan Pier* a more conventional documentary. *Homage to Catalonia* and *Down and Out in Paris and London,* meanwhile, were issued without photographs of any kind.

It is a matter for regret that Orwell did not collaborate with one of his contemporaries. In the thirties Bill Brandt, who later became a noted photographer of landscapes and semiabstract nudes, published views of English life which Orwell might have effectively employed in his books—industrial landscapes, glimpses of city streets, pub scenes, portraits of working-class people in London and the North. That Orwell did not use them, or mention them anywhere in his criticism or letters, is the more surprising in view of the fact that Brandt's work was widely printed in newspapers and magazines and, in the case of his collection *The English at Home* (1936), introduced by Raymond Mortimer, the literary editor of the *New Statesman and Nation,* with whom Orwell corresponded. Indeed, a passage in Mortimer's introduction about returning to England after a time abroad and welcoming the sight of its touchingly Victorian postmen and policemen, its green cozy neatness "like something seen through the wrong end of a field-glass," may have influenced Orwell's phrasing in the last paragraph of *Homage to Catalonia,* where emphasis also falls on the countryside seen at a distance, "the England I had known in my childhood," and the huge peaceful wilderness of London with its red buses and blue policemen.[44]

Brandt was as sharp-eyed as Orwell, as willing to face ugliness, and as sympathetic to the victims of the Slump. He slummed in the same world, or looked into the same world from the same distance. Some

of his interior scenes, especially those showing miners at home in the evening sitting down to tea or being washed by their wives, call to mind passages in *The Road to Wigan Pier* about working-class coziness and intimacy. Other Brandt pictures reveal the miseries of not working and not having a home. "Rest for the lowest" in *The English at Home,* the picture of a Salvation Army kip, might have been composed as an illustration for Orwell's "Common Lodging Houses" (1932) or for the opening of *The Road to Wigan Pier,* with its description of beds jammed against beds. Brandt pairs the photograph with a contrasting view of a stagecoach on exhibit in a museum, "Travel for the highest," in token of his wish to provide in *The English at Home* the same comprehensive national survey that Orwell provided in "The English People" (1947). The book depicts city and country, old and young, work and play. *A Night in London* (1938), Brandt's collection modeled on Brassaï's *Paris de nuit,* puts the pairings to ideological use as evidence of a sharpening of contradictions in late-stage capitalism. For instance, the two photographs "Madam has a bath . . ." and ". . . and leaves for a party" are followed by "Empty streets in Bermondsey" and "Working class family at home." "Late supper," showing a couple in a restaurant making their choice from an elaborate food cart, is followed by "Behind the restaurant where the waiters come out for fresh air," showing a ragpicker searching through garbage.[45] Together, the photographs give the double, dining-room/scullery view of *Down and Out in Paris and London* and, more generally, the perspective of Orwell the moralist, who was accustomed to judge surfeit by lack and who liked to render judgment from kitchens and alleys behind kitchens.

Brandt nowhere seems closer to Orwell than in his portraiture through frames. He photographs a workingman reading the paper in a room seen through a window, boys peeping through frosted glass into a pub, and miners surrounded by the machinery of the cage bringing them to the surface.[46] The picture of miners has a Sander-like specificity about the occupation of coal mining and its own statement to make, in the shapeless dark garments and the identical cloth caps, about *Abflachung*. The miners look almost literally flattened by the steel gate in front of them. At the same time, the eyes in their coal-blackened faces catch light, bringing them to life. The miners smile tentatively, like Hine's mill worker, and emerge from the dark background. They cannot finally be regarded as creatures of coal. The facing photograph in *The English at Home* shows three children looking up at the street through a basement window with lace curtains, one of them holding out a pitcher. The window is a frame encouraging viewers to value whatever facial beauty is there to be seen, though such an aestheticizing view is in this case checked by the overwhelming ugliness of the wall and the photograph's caption, "Their only window," which flatly reasserts the social meaning of the darkness behind the children and the paleness of their faces against the

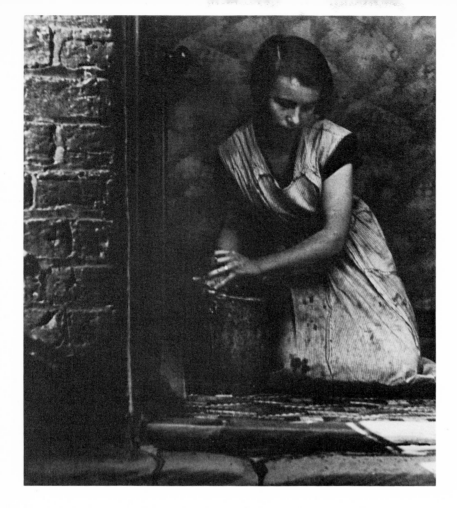

62. Bill Brandt. Young wife in Bethnal Green.

dark. Brandt's photography is as subject as any other to the influence of the words accompanying it, and its power to beautify is thus limited.

For that matter, the power of any one Brandt photograph to convey meaning is limited. The face in the photograph may seem typical or individual, constrained or free, but it must always be perceived in the context of the other carefully ordered photographs within each collection as well as of the captions, prose introductions, and whatever knowledge of the Depression in England, including knowledge learned from Orwell and other writers, viewers bring to their examination of the book. The coal miners in *The English at Home* show some life in their faces in part because other workers have been deadened by routine; Brandt does not fail to picture these more typical victims. Nevertheless, a few pictures, like a few prose passages, stand out. They are at once expressive and comprehensive. They sum up the scattered implications of an entire book. Such a picture is Brandt's portrait, in *Camera in London* (1948), of a young Bethnal Green housewife at her doorstep (figure 62). Judging by her expression, she

is lost in her work. Nothing in the situation or surroundings differentiates her from any of the other housewives in what is no doubt a long row of little gray slum houses or provokes anything but a sympathy directed to the woes of an entire class. Brandt can compensate her for being negligible only by allowing the grace of her movement and the light reflected from her wedding ring to shine forth. He takes her picture at one particularly favorable instant, in a doorway, drawing attention to her curving pose within a rectangular space. So photographed, in relative and temporary detachment from Bethnal Green, she is not simply pitiable or comprehensible. She is interesting in the way all individuals, including those who view her, are, or like to think they are. Though scrubbing rather than poking a stick up a blocked drain, looking down rather than looking up almost to catch an observer's eye, this English girl is the close counterpart of the woman Orwell sees in *The Road to Wigan Pier,* her portrait an assertion of equality in the only terms photography permits.

Photographs Line by Line

What a poem this is, what poems can be written about this book of pictures some day by some young new writer high by candlelight bending over them describing every gray mysterious detail . . .

Anybody doesnt like these pitchers dont like potry, see? Anybody dont like potry go home see Television shots of big hatted cowboys being tolerated by kind horses.

Robert Frank, Swiss, unobtrusive, nice, with that little camera that he raises and snaps with one hand he sucked a sad poem right out of America onto film, taking rank among the tragic poets of the world.

—Jack Kerouac

If somewhere in the vicinity of every photograph there is a hand holding a pen, ready to write a preface, a caption, an Agee-style excursus or Laughlin-style elegy, there is somewhere in the vicinity of many poems a photograph, real or imagined, hinted at or precisely described. Commerce between the arts runs in both directions; language occasionally needs image to assert its partial management of reality. In Archibald MacLeish's *New and Collected Poems* (1976) three short poems are gathered under the heading "Three Photographs." Two of these, "Seeing" and "White-Haired Girl," begin with the act of looking at a photograph and then proceed to other matters, the first to the psychology of vision and the second to the acquaintance between MacLeish's daughter and Ernest Hemingway. Readers know the two poems begin with the act of looking because of their common heading, and only because of the heading; otherwise they would seem to be elaborated from memory. To trace further involvements between them and actual photographs would be to learn something about MacLeish's compositional methods, in the same way one might track down the source indicated in the note "after Simone Weil" to "Seeing," but it would not in any sense be to interpret the poems, which look through photography to the experience it captures and the emotions stimulated by that experience in exactly the manner of the poetic text of *Land of the Free*.

"Family Group," the third poem included under the heading, examines photography itself and requires the reader to imagine literal pictures. It dramatizes the act only implied in the other works.

"That's my younger brother with his Navy wings" is the opening line. The poem proceeds to go over a photograph's visual details point by point: the poet's brother, aged by his wartime flying missions over the Dutch coast; the poet himself; Dunkirk in the background; and a lengthened shadow, perhaps the photographer's, falling across the brothers' feet. Another photograph, taken after the Armistice and after the flier's death, is similarly scanned: a flooded farmyard in Belgium; a faceless figure on its back, wearing "what look like Navy wings"; and another lengthened shadow falling across the muck. The poet is missing from this second shot and, to explain his whereabouts, concludes the poem with "I'm back in Cambridge in dry clothes, / a bed to sleep in, my small son, my wife."[1]

For purposes of analysis it does not matter whether the two pictures of the poem are real or imagined, though Kenneth MacLeish was in fact a Navy flier killed in the war. What matters is a conveyed understanding of all the circumstances of photography. "Family Group" notes a posing for the camera ("I'm beside him with my brand-new Sam Brown belt"), then the way all photographic posings, all self-presentations, are compromised by the camera's objectivity; it cannot help including a lengthened shadow in its field of view. As the title implies, the poem notes the effect of family photographs, which is to mitigate separations and keep the dispersed together. The first picture unites two brothers and eventually forces upon the poet an embittered awareness of being grouped with his immediate family in a small, dry survivors' life in Cambridge. This life he describes flatly, controlling his bereavement and guilt, in a rhetorical artifice analogous to, if less acknowledged than, his soldierly pose with the belt. Above all, "Family Group" notes the contention between time and photography, alternating between a past-tense admission of change, as in "winters aged you," and a present-tense defiance of change: the brother is always standing there in Belgium, always about to be twenty-three. The poem regards photographs as simulacra, or shadows of actuality lengthened across the moment of their being taken and the time of their being seen.

In considering so many aspects of the subject of photography, "Family Group" spreads itself too thin, or makes its points too schematically, hastening from detail to implication, as in the melodramatically lengthened shadows. But its inclusiveness makes it a useful index to the three kinds of photographic circumstance other writers have isolated and turned into poems. First, MacLeish's dramatized situation, examining photographs of a dead brother, is an act of looking, an invitation to memory poets have habitually accepted. Like most poems about photographs, "Family Group" turns on the difference between what can be seen and what must be understood, between momentary preservation and permanent loss. What you view

when you look at family pictures may be a house, a landscape, or children, as Louis MacNeice observes in "The Here-and-Never," one of the poems in the sequence "A Hand of Snapshots." But "what you see when you close your eyes / Is here and never: never again."[2] Second, photography's expanding, or limiting, of the MacLeish family's sense of itself implies the social context in which pictures function. Photographs are not fragments broken free from the seen world. They are kept in that world, assuaging grief, communicating news, selling products, bringing people together (You have seen their faces . . .), and teaching political lessons. Photographs are useful, and their usefulness is best understood when compared with that of language. Third, the posing for the camera in "Family Group" touches on the technique of viewing and selecting, of actually taking pictures, which is to be understood as a collaboration between the photographer and the subject, and which for poets seems inevitably to raise questions of authenticity, perspective, and accuracy, especially as these are judged against the aesthetic standards of writing.

In a sense, poems about photographs are always poems about poems, occasions for the defining of one art's potentialities vis-à-vis another art's limitations. Poems about photographs pay Paul Strand back for his antiword picture of the blind woman and Margaret Bourke-White back for her distrust of slogans. Studying such poems, however, is not just an occasion for amusing oneself with the *amour-propre* of poets or savoring yet another expression of the reflexivity of modern art. It is a task helpful in understanding how each art actually works, in time and out of time, in sequence and in composed shape, in metaphor and in image, and therefore it is a way of resisting an aesthetic attitude more limiting than any conceivable visual rebuking of the written or written rebuking of the visual, namely the attitude that, as forms of self-expression, photography and writing are perfectly complementary, indistinguishable forms of art. Taken for granted or belligerently asserted, as in "Anybody doesnt like these pitchers dont like potry, see?" this attitude has produced what Irving Babbitt scornfully called "eleutheromania," the indiscriminate mixing of genres. "We should make as many and as clear distinctions as possible," he asserted in *The New Laokoon* (1910), "and then project them like vivid sunbeams into the romantic twilight."[3] One does not have to share Babbitt's antiromanticism to believe that distinctions are important. It is out of writers' and photographers' knowledge of generic distinctions that the achievements of both arts come, as shown in the case of *Let Us Now Praise Famous Men,* among other books, and as shown in the case of poems by the Englishmen Thomas Hardy and Philip Larkin, the German Bertolt Brecht, the Americans Marianne Moore, Elizabeth Bishop, and Dave Smith, and above all the Northern Irishman Seamus Heaney.

The Act of Looking

Nothing in photography uniquely qualifies it for the depiction of an arrested moment and the suspension of belief in transience. Well before 1839 Keats was gazing at an urn and consoling a bold lover with the thought that painted beauty would never fade, in the same sense that Kenneth MacLeish's photographed youth would never be lost in the Belgian muck. The simulacra involved, urn and snapshot, have the same figurative "life," but a loved brother cannot after all be written about as Keats writes of an antique maiden. Poems about photographs are distinctive precisely because the photographs so often preserve loved or hated ones—family members, intimate friends, past selves, or figures from crucial episodes of a life. Charles Wright's "Photographs" looks at old poses of his father, mother, and himself at six—poses lurking

> like money, just
> Out of reach, shining
> And unredeemed.

Maxine Kumin's "A Family Man" puts lovers in bed and sets them looking at snapshots the man carries in his wallet. Helen Chasin's "Photograph at the Cloisters: April 1972" returns the poet to a moment of intense personal importance. Robert Lowell's "Marriage" compares his "formal family photograph," "middle-class and verismo," with the more idealized picture of family life in Van Eyck's painting the *Arnolfini Marriage*. W. D. Snodgrass's "Mementos, I" recalls the sorting-out of old papers and the accidental discovery of a photograph of a now-divorced wife. The poet recovers a lost affection, momentarily: "you stand / Just as you stood."[4]

This list might suggest that familiar photographs are a peculiarly contemporary poetic subject, as painted portraits were a peculiarly Victorian poetic subject and painted landscapes a peculiarly Romantic one. It is true that photographs are now conveniently to hand as stimulants to memory and that contemporary epistemological sophistication has enriched notions of what all sorts of commemorative images mean. In a volume called *Self-Portrait in a Convex Mirror* (1975), in a poem ending with an image upside down in a reflecting pool, it comes as no surprise that John Ashbery writes of a photograph as presenting a "veil of haze" between the long-ago past and the death-haunted present. Parts of Roland Barthes's *Camera Lucida* (1981) may fairly be considered a prose poem about or a lyrical exegesis of family portraits: "Yet in these photographs of my mother there was always a place set apart, reserved and preserved: the brightness of her eyes . . . But this light was already a kind of mediation which led me toward an essential identity, the genius of the beloved face. And then, however imperfect, each of these photographs mani-

fested the very feeling she must have experienced each time she 'let' herself be photographed: my mother 'lent' herself to the photograph." The mother lends herself to the photograph just as photography lends, but does not absolutely and permanently convey, her essential identity to her son, with the same melancholy sense of partial commitment. Such a *punctum*—to use Barthes's term for private interpretation—is like the *punctum* he elicits from contemplation of Alexander Gardner's photograph of the condemned man Lewis Payne: "*he is going to die*. I read at the same time: *This will be* and *this has been*"; that is, it derives as much from aesthetic speculation as from filial devotion or humane sympathy. Barthes thinks abstractly about photographs. They are like haikus. They all have in them a "rather terrible thing," the return of the dead. Their pathos consists in being without a future: "Motionless, the photograph flows back from presentation to retention." Their immobility "is somehow the result of a perverse confusion between two concepts: the Real and the Live: by attesting that the object has been real, the photograph surreptitiously induces belief that it is alive . . . but by shifting this reality to the past ('this-has-been'), the photograph suggests that it is already dead."[5] All these claims constitute a reasonably rigorous analysis of sensations left intact—merely felt, and recorded—in poems like "Family Group," or "Mementos, I," where the terrible thing that returns is a dead marriage.

Contemporary though these aesthetic interests may be, poets older than MacLeish, Snodgrass, and Barthes have had photographs to examine and sensations to record. They have felt the perverse confusion accompanying what might seem the simple act of looking at a picture, and they have drawn from it their own conclusions about what the art can and cannot do. The donnée of one older poem is the power of photographs to emanate so convincingly from a past reality that they become, as Barthes speculates, "a *magic*, not an art."[6] In Thomas Hardy's "The Photograph," first published in *Moments of Vision* (1917) but conceivably written much earlier, a man sorting old papers—there is no good reason not to call him "Hardy"—is arrested in the midst of this "casual clearance of life's arrears" when he comes upon the photograph of a woman once loved but now "hid amid packs of years," lost to his sight. He burns the photograph and describes the burning:

> The flame crept up the portrait line by line
> As it lay on the coals in the silence of night's profound,
> And over the arm's incline,
> And along the marge of the silkwork superfine,
> And gnawed at the delicate bosom's defenceless round.

"The Photograph" is a pendant to the business of Arabella's discarding Jude's portrait in *Jude the Obscure;* clearly the belief in a photo-

graph's magical identity with its subject ran deep in Hardy. Here, the pain Hardy's imagination imposes on the woman in the image is momentarily transferred to Hardy himself: "Then I vented a cry of hurt." The pain then yields to relief as the flames do their work and there is nothing left of the past "But the ashen ghost of the card it had figured on." Still guilty, Hardy feels "as if I had put her to death," and for exculpation he looks to further superstitions, about which he can at least raise questions:

> —Well; she knew nothing thereof did she survive,
> And suffered nothing if numbered among the dead;
> Yet—yet—if on earth alive
> Did she feel a smart, and with vague strange anguish strive?
> If in heaven, did she smile at me sadly and shake her head?[7]

A poem wholly committed to irrational belief would not be characteristic of Hardy. "The Photograph," like "The Oxen" and several of the *Poems of 1912–1913* on the death of Hardy's first wife, "argues" for an idea by giving emotional credence to it, and nowhere more expressively than in the bringing together of "gnawed" and "delicate" in the last line of the first stanza. Here the delicacy suggested in "silkwork superfine" and completed in "defenceless round" is subtly carried over into the action of the fire, which seems to go about its work of destruction with a slow fastidiousness, creeping over inclinations, following margins, that might well make Hardy cry out and avert his eyes. The poem itself pulls back from such an emotional credence: "—Well" is a verbal check of the sort Hardy had frequent recourse to at the conclusions of his moments of vision. But even before the last stanza of "The Photograph" Hardy has shown signs that he knows he is not actually burning a woman. He says plainly "she was lost to my sight," however present her image may be; he adds a cautious "I felt as if" to the thought that he has put her to death; and he uses "figured" to describe what the photograph did on its card—"appeared conspicuously on" is the main sense, but the word hints at "figurative" and "figuration." The photograph is a figure of sight, just as "unsheathed from the past" and "hid amid packs of years" are figures of speech. The poem as a whole wavers between what Hardy knows is in the photograph, lifelikeness, and what his guilt, or resentment, makes him feel is there, life. The photograph is for him, as the brother's photograph was for MacLeish, a means of betokening preservation and proving loss, with the added twist for Hardy that finding the face "preserved" leads him to want to destroy it.

Hardy's work, though not necessarily "The Photograph," has influenced a succession of twentieth-century English poets, including R. S. Thomas, C. Day Lewis, and Philip Larkin, whose traditionalism is assiduously cultivated and whose attention, when they write poems

about photographs, is, like Hardy's, given to private portraits and meanings. Thomas's "Album," from *Frequencies* (1978), studies the photographs of parents and puts a familiar photographic command to good use:

> And the camera says:
> Smile; there is no wound
> time gives that is not bandaged
> by time.[8]

Lewis's "The Album," from *Word Over All* (1943), is about looking at photographs of a beloved woman: she is first a child in a garden, then a girl regarding herself in a stream, and finally a woman surrounded by lovers and friends wearing "garlands of wild felicity." The last photograph of all, which would show her "stripped bare / By intemperate gales," is missing. Her beauty is therefore perfectly preserved, but only in a form "irreclaimable" by the poet and itself subject to time's action: the photograph of the woman as child is "faded," and "soon there will be / No trace of that pose enthralling." Larkin's "Lines on a Young Lady's Photograph Album," from *The Less Deceived* (1955), dramatizes the same act of looking, but without sentimentality. More than any other poem of recent decades it succeeds in appropriating to its own use Hardy's mixed attitude toward photographic preservation. Larkin and Hardy are alike in hoping for preservation and simultaneously doubting the means by which it is usually accomplished: photographs, personal memory, community tradition, as in Larkin's ironically titled "I Remember, I Remember," and familiar architecture, as in his best known poem "Church Going." That is, both poets are drawn to write about mortality, and the imperfect human defenses against mortality, as Larkin perhaps acknowledges when he traces his enlightened understanding of Hardy to a reading of the latter's poem "Thoughts of Phena at News of Her Death."[9] Tryphena Sparks is possibly the woman whose portrait is burned in "The Photograph."

"Lines on a Young Lady's Photograph Album" begins *The Less Deceived* as if it were part of Larkin's purpose to furnish, in this monologue of a man looking at snapshots in an album, an exemplary preface—an allegory of a reader going through poems in a volume and moving steadily from initial confusion to final clarity, becoming less deceived. That is precisely the plot of the poem. The young lady's pictures are in the first stanza a too rich confectionery on which the viewer "chokes"; too distracted to separate one kind of finish from another, he describes the prints as being "matt *and* glossy." By the last two stanzas the metaphor of eating has been replaced by abstract verbs of intelligent understanding, and the young lady herself seems "smaller and clearer." In between, the viewer describes what he sees on various photographs, always in a seriocomic style sharply distin-

guishing his sensibility from that of the album peruser in Lewis's poem. The young lady is complimented with clichés advisedly used, such as "sweet girl-graduate," and for that matter "young lady" itself, which beginning with the title lends a period air to the whole enterprise. Larkin's forms of stylization or eighteenth-century artifice are various: the hyperbolic gallantry of the opening words "At last you yielded up the album"; the smooth elegance of diction and versification, as in "what grace / Your candour thus confers upon her face!"; and the rhetorical flourishes, such as "But o, photography!" All these devices mount a defense against naked feeling and supply a foil for or a contrast to picture taking. The art, or nonart, of photography is here conceived to be "faithful and disappointing" because it records "Dull days as dull, and hold-it smiles as frauds." Photography overwhelmingly persuades the viewer that he is contemplating "a real girl in a real place," not a "young lady" in an album.

The sixth stanza, however, the turning point of the poem, argues that it is less the girl's reality than the pastness of her reality that is so moving. She contracts the viewer's heart "by looking out of date." All this prepares for two stanzas of abstract speculation:

> but in the end, surely, we cry
> Not only at exclusion, but because
> It leaves us free to cry. We know *what was*
> Won't call on us to justify
> Our grief, however hard we yowl across
>
> The gap from eye to page. So I am left
> To mourn (without a chance of consequence)
> You, balanced on a bike against a fence.

In other words, the past that photography makes visible can never literally be made present to a viewer. Snapshots give him a girl holding a cat or lifting a rose so that he shall finally feel how much he is excluded from those scenes and from her youth, and his sense of exclusion may be fully, self-indulgently expressed because it cannot touch the girl herself. Present is separate from past; its complex knowledge is separate from innocence. A man may admire a girl or mourn the loss of her youth without worry that she will ask him about his right to do so. It is sometimes said of this poem that it presents a gentleman speaking to a young lady as they look at an album together, but this makes nonsense of Larkin's careful psychological exposition. The man speaks as freely as he does precisely because the girl is not there, or is there only in photographs. "From every side you strike at my control" is the remark of someone who knows exactly how much he is in control of himself, how unconsequential his remarks are going to be, and how figurative the "you" he addresses is in the first place.

Hardy's "The Photograph" alternates between the feeling that photographs are alive and the knowledge that they are pieces of paper. So does "Lines on a Young Lady's Photograph Album." On one hand, it presents "nutritious images," a real girl in a real place, a past readily accessible and infinitely desirable. On the other hand, it presents:

> a past that no one now can share,
> No matter whose your future; calm and dry,
> It holds you like a heaven, and you lie
> Unvariably lovely there,
> Smaller and clearer as the years go by.[10]

The word "lie," especially in its position at the end of the line, slips the thought of photographic mendacity into the poem's conclusion without openly asserting it. To assert it would in fact be to overstate the case. Photographs lie but they also tell the truth. They "preserve" the past and they preserve it. The truth they depict is "smaller" but it is also "clearer." In a balancing act no less memorable than the young lady's on her bike, Larkin keeps his poise between credulity and skepticism, conveying—as not even Hardy was able to do—a full sense of the ways in which photography is real and unreal, faithful and disappointing.

The Social Context of Photographs

Sometimes the photograph about which a poem is written is not only actual but available, printed right on the page along with the poet's words. In this circumstance the photograph becomes subject to the reader's interpretation as well as the poet's, and it therefore encourages the reader to think about the process of interpreting. If the photograph in question is a public one to begin with, such as one published in a news magazine, then the reader may be led to more complicated comparisons—its meaning in the original context against its meaning to later viewers against its meaning to the poet who has singled it out.

Poets writing on such photographs give up the imaginative control of a Hardy or a Larkin, who allow the reader to see only what they see, if indeed they are looking at actual photographs at all, and never permit the reader to question their visual authority. But such poets gain, in return, something which may be of more value to them: a responsibility to the world in which photographs shape as well as report history and in which history involves more than the transformations of a young lady or a once-beloved face.

In the years of his exile from Germany, first in Scandinavia and then in the United States, Bertolt Brecht formed the habit of cutting photographs out of newspapers and news magazines like *Life* and

writing epigrammatic quatrains on the photographs. A few of these poetic captions, or "photograms" as Brecht called them, were published in the refugee newspaper *Austro-American Tribune* (1944), where they were described as "documents of our times." Later sixty-nine of the photographs with their quatrains were published in East Germany as *Kriegsfibel* [War primer] (1955). *Kriegsfibel* is a Cold War book: antiwar, antifascist, but also determinedly anticapitalist, like the photo montages with satiric doggerel which John Heartfield had published in the *Arbeiter-Illustrierte Zeitung* before the war, which may have been Brecht's immediate source. But his combining of image and language might also be traced back to stage technique, for Brecht and his favorite set designer, Caspar Neher, employed photographic projections for a variety of "documentary" or ironic effects. In the 1932 staging of *Die Mutter* [The mother], for example, photographs of pre-1914 world leaders were projected on a screen in combination with quotations from socialist classics; the resulting juxtapositions must have resembled those of the later photograms.[11]

Photograph by photograph, *Kriegsfibel* goes through the history of the Second World War, condemning German aggression, mourning victims, and suspecting the motives of the Western Allies. Under one of Robert Capa's pictures of the Normandy invasion is a quatrain noting that the attack was being made against the man "from the Ruhr" but also against the man "from Stalingrad." The book praises Soviet troops, taking the correct Communist line about the causes of the conflict. A Japanese soldier, for example, is said to owe his fiery death to the Domei Bank. It is entirely willing to turn photographs against their original uses, in the manner of Nazi propaganda itself: in 1943 the SS journal *Germanische Leithefte* attacked the United States by publishing a selection of FSA photographs with commentary. And the book is entirely willing to fictionalize history: Churchill is pictured with a submachine gun and made to say that he knows the law of gangs, having always worked well with cannibals. *Kriegsfibel* is after all a "primer" needing to make its points simply and entertainingly, in an unadorned if often sardonic style that the critic Reinhold Grimm justifiably calls that of "Marxistische Emblematik."[12]

Nevertheless, it would be a mistake to assume that all of Brecht's poems are equally politicized or to read the whole collection only in ways sanctioned by Ruth Berlau's preface: "The widespread ignorance of corporate collusions, which capitalism carefully and brutally maintains, makes the thousands of photos in the illustrated papers genuine hieroglyphic tablets—indecipherable to the unsuspecting reader."[13] *Kriegsfibel* is a less doctrinaire work than Berlau would allow. If it undeniably teaches "the art of reading pictures," as she claims, it teaches, first, that reading them is tricky and, second, that one photograph may generate alternative readings. The view of pho-

tographs to be inferred from Brecht's actual treatment of pictures in the collection is that they are as interpretable as poems, not as translatable as hieroglyphics.

One of the strengths of *Kriegsfibel* is its variety of approaches and tones. In some of the quatrains Brecht speaks to the people photographed, posing questions about their activity, noting their responses, and in general putting on record, giving a voice to, ordinary lives about to be lost, or already lost, as in the case of a voice coming from a photograph of motorized Wehrmacht troops rolling into Poland. For all that the Germans destroyed the Polish nation in eighteen days, they did suffer losses, they did leave troops behind. The soldier in the picture wants viewers to ignore Nazi boasts of lightning speed and ask about him—who lived for only seven days of the invasion.[14]

Elsewhere, imitating political cartoons, Brecht puts words into the mouths of the famous. A photograph of Joseph Goebbels and Hermann Goering staring at each other in pompous indignation is accompanied by a pointedly ironical conversation, in which Goering wonders if "Joseph" has been accusing him of theft. "Hermann, why should you steal?" the answer comes back. Who would dare to refuse Goering anything? And if Goebbels the propaganda minister did say something about stealing, whoever would believe him?[15]

Bleak humor is only one of Brecht's effects. In subsequent quatrains he is elegiac, vulgar, infuriated, cryptic, facetious, sympathetic, earnest in the manner of recruiting posters, lapidary in the manner of memorial inscriptions, and eloquently imitative of battlefield derangement. Somewhere on a desolate plain a soldier sits holding his head, babbling about pygmies and hens with little kernels in their crops, and about the "misleader" who is miles away from the suffering; in the original, the "Irreführer" or "crazy Führer" is miles away (*Kriegsfibel* never forgets Hitler for long, though it often merely hints at him with a "he" or a "someone").[16]

The photographs Brecht picks to write about are themselves a thoroughly mixed lot, including grainy newspaper halftones, Nazi publicity stills, personal photographs smuggled out of occupied Europe, studio portraits, and aerial reconnaissance photos, but the best of them express political meaning or meanings with a Brechtian economy, a visual restraint to match the poetic restraint of the four-line photograms. In a photograph of the bombed-out city of Roubaix rubble is piled along the streets so neatly as to seem an expression of civic insanity or the intolerable contradictoriness of war; Brecht's poem praises order with enthusiasm, mimicking a mind as it were shocked by violence into an insane care for neatness. A pair of photographs of Afrika Corps troops shows first Rommel drinking a toast and then a dead infantryman, head under cover, legs sticking grotesquely out of the foxhole. In a Stallings-like juxtaposition Brecht's poem supplies a

false rhetoric for the officers to besot themselves with—"O ecstasy of war music and storm of banners!"—imagines German swastikas marching by, as in countless newsreels, and then trails off into the bluntness of the dead infantryman's fate. Finally only one thing mattered to *him:* finding a place to hide. But he did not succeed in finding it.[17]

If the reader of *Kriegsfibel* were to look through the photographs to their subjects—dead infantrymen, bombed cities, munitions factories—Brecht's purpose would be defeated. The reader must always look at the photograph itself, noting what it includes and excludes, assessing the uses to which it is put, just as the audience to a Brecht play must always be aware of the dramatization, lest it be lulled into a false sense of intellectual security at the thought that it is witnessing "reality." The Brechtian alienation effect governs *Kriegsfibel* as it governs his theatrical work; it is the author's constant needling of readers, his constant effort to alienate them from the world the camera portrays so that they will pay attention to the "world"—the political assumptions, the aesthetic factors—turning the camera in a certain direction. *Kriegsfibel* includes a *Life* photo taken toward the end of the Spanish Civil War, with the original caption: "The conqueror, General Juan Yagüe, kneels before his throne-chair at an open-air mass in Barcelona's Plaza de Catalunya . . . Behind Yagüe are Generals Martín Alonso, Barron, Vega. Yagüe and Solchaga moved off to chase Loyalists to the border" (figure 63). Brecht's quatrain on the photograph is deliberately provoking, in that it "quotes" the Falangists as giving thanks to God equally as Christ and as killer. To the Falangists, the people are a worthless rabble, whereas God, the ultimate source of the fire with which Generals Yagüe and Solchaga are chasing the Loyalists to the border, is simply a Fascist. "Christ" and "Fascist" rhyme, triumphantly and horribly.[18] The imitation of conquerors' bravado is meant to be hateful but also to draw attention, via its own obvious distortions, to the subtler distortions of the photograph and caption: the picturing of the general at a moment of assumed humility, the connotations of "throne-chair," the admiring tone of "moved off to chase Loyalists to the border." By good fortune for Brecht, the photograph happens to show at least two soldiers taking pictures of the mass: an indication that the Rebels knew the ceremony had publicity value—the same value, in fact, it had for Capa in *Death in the Making.* Celebrations of the mass were ideological fronts in this war. *Kriegsfibel* does not claim that *Life*'s commentary is as slanted as or more slanted than Brecht's own; it merely insists that all photographs and all comments on photographs have at least an implicit publicity value and make some kind of "statement."

Another quatrain takes account of the way image-sated people look at photographs, which is to say, too casually. Under six *Life*

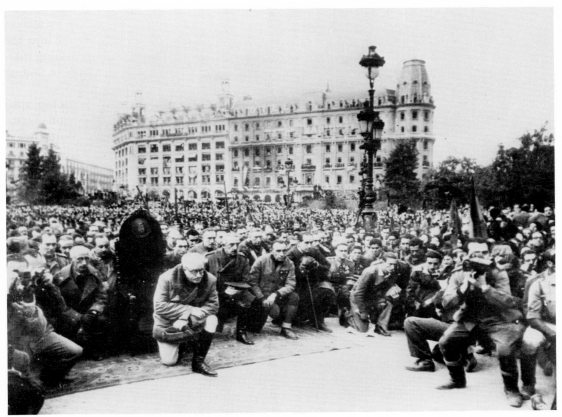

63. Anonymous. General Yagüe attending mass.

portraits of Nazi field marshals Brecht puts the label "There are six murderers," then warns us that even if we are weary of seeing evil exposed we should not go lazily away (that is, turn the page?). The correct response to exposed murderers is not a routine "of course" or "oh yes." Stripping these field marshals of their disguises, he says, has cost fifty cities and a whole generation of Europeans.[19]

Still other combinations of photograph and poetry mock the blandness with which war's horrors are presented to the public. Brecht's imitation of shell shock in a German officer is placed under a caption which can only say of the officer, with ludicrous understatement, "He is disturbed in spirit." A *Life* cover photo shows a Thai woman sheltering herself from a bombing raid. Brecht's commentary, "Many people crept anxiously away into the earth," helps to point up the irony of the word LIFE emblazoned over this "life" which has to be led anxiously in foxholes. The most intricately ironic example of all

is a news photo showing a Frenchman about to face a German firing squad over the caption "The Germans were 'kind' to this Frenchman. They blindfolded him before he was shot." The Germans themselves, granted a voice in Brecht's quatrain, seem to miss any irony about the kindness. Self-righteously, or ponderously humorous, they agree that, yes, that is how they see this "mother's son," this man like themselves, against the wall. And to let the world know about it, they took a picture of the whole affair.[20] That is, the Germans think, according to Brecht, that they are acting humanely to their prisoner, even as they are about to shoot him, and that they can prove their humanity and issue a warning at the same time simply by taking a picture. The original captioner thinks that he can prove the spuriousness of German justice and humanity simply by putting a word in ironic quotation marks. Brecht thinks that a photograph can prove more than what its taker and its captioner intend: the very openness of the Germans here, their propagandistic naiveté, reveals something they cannot see in themselves. Brecht also thinks that no form of visual or verbal proof can really be simple. This is why he accompanies the photograph with its original caption and his own words. Only by regarding the original event from different perspectives, seeing it through a tangle of imposed understandings, can one hope to comprehend its significance. The most important meaning of this photograph of a man about to be shot is that it is being *used,* that what it says depends on who is doing the talking.

The foil for Brecht's knowledge of photographic contexts is other poets' innocence of them—Yevgeny Yevtushenko's innocence, for example. The Russian poet's book *Invisible Threads* (1981) superficially resembles *Kriegsfibel* in being a collection of poems published with photographs, though the photographs are in this case Yevtushenko's own; and its political purpose is no less openly expressed. *Invisible Threads* is a kind of peace primer, an expression of the ideal of human brotherhood meant to link individuals together in spite of political differences; as poet and photographer, Yevtushenko was inspired by a 1957 Family of Man Exhibition in Moscow. For Yevtushenko, "photography, like poetry, is full of ways to overcome the distance between things." He takes a picture of a boat in Malaysia and writes a poem about the boat, "Perspective," but never writes a poem about the photograph of the boat. To comment on a photograph directly would be to shift attention from the object seen to the act of seeing; it would be to distinguish between ways of seeing, photographic and poetic, to imply a particular context for seeing, and that would in turn deny the ideal of connectedness. "What difference," Yevtushenko asks, mimicking the creative enthusiasm of a Minor White, "whether it is through words, music, painting, cinema, photography or just everyday human actions that this ideal is made real?" It makes no difference, as long as one is willing to subsume complicated processes

under the heading "make real." Yevtushenko offers an easily available reality. He photographs a man and woman embracing and comments in "Beneath the Flags of Every Nation":

> If I had my way, there would be only one flag
> For all mankind, and for an emblem
> There would be two people holding one another tight.[21]

He is apparently unaware that he *has* had his aesthetic way, that he has included just what he wanted in the photograph and published the results in just the sort of book to make his universalism seem attractive, his hope sharable. He contrives an emblem and disguises it as the reality all decent-minded people must feel.

"I find it pleasant to imagine" gives the key to *Invisible Threads;* "I find it necessary to look closely" to *Kriegsfibel*. The Brecht work—like that other compilation of texts and photographs, Morris's *God's Country and My People*—is essentially about looking or seeing. This focus explains why so many of its quatrains employ the imperative "See": see the Luftwaffe bombardier just back from a successful mission; see the two brothers trying to kill each other; see the steel helmets lying in the mud; see the artillery pieces trained on the masses. This focus also explains why so many of the photographs show people looking at the world they are in the process of shaping. A GI stares at the body of the Japanese he has killed; they had encountered each other on a narrow trail, they looked at each other, and then the American got to his gun first and fired. German assault troops peer out from beneath a railroad car. Brecht asks them questions. Is it really the enemy, the French, they are on the lookout for? Or rather their own superior officer, who is always watching *them?*[22]

In a world requiring a sharp lookout the inevitable victim is the blind man. The most pathetic quatrain of *Kriegsfibel* can do nothing but mourn the figure of a young Japanese American soldier blinded in Italy, but it mourns him eloquently, stretching out space and dropping in the exotic geographic name, as Brecht was so skilled at doing, to convey the expanse of the world now dark to him. Neither cities nor seas nor stars in the night will this soldier ever see again; nor loved ones; nor skies whether clear or cloudy, whether over Japan or over Oregon.[23]

On the next-to-last page of the book, Brecht contemplates the faces of nine Axis soldiers and thinks "You were good for more than blind world conquest." [24] Brecht himself does not belong to their number—"I'm not one of the blind praisers"—having had his eyes opened by all the photographs of the literally and figuratively blind in the book and having had his seeing educated by all the perspectives of those photographs—*Life*'s, Joseph Goebbels's, the Party's, the common soldiers', the bereaved families'.

The Limits of Photography

Photographs do not have lines, which makes the phrasing of the opening of Hardy's "The Photograph" puzzling. The last three words in "The flame crept up the portrait line by line" may be a rhyme-dictated inaccuracy and still perceptive about the manner of the poet's movement through observation and pain to final calm, a process as delicately hurtful to himself as the flames are hurtful to the woman in the portrait. If Hardy is momentarily confusing poetry and photography here, as the phrase suggests, he is only doing accidentally what other poets do deliberately. Marianne Moore's "Blue Bug" from *Tell Me, Tell Me* (1966), after the elaborate subtitle "Upon Seeing Dr. Raworth Williams' Blue Bug with Seven Other Ponies, Photographed by Thomas McAvoy: Sports Illustrated," begins:

> In this camera shot
> from that fine print in which you hide
> (eight-pony portrait from the side),
> you seem to recognize
> a recognizing eye.[25]

Here, "print" conflates the printed text surrounding the photo in the magazine, the photographic print itself (a fine one), and the photographic "fine print" of seven other ponies cluttering the picture, from which Blue Bug, with his own "recognizing eye," leaps to the poet's attention. The ambiguities record Moore's wish to put the writer's and the photographer's expressiveness on an equal footing; whether in words or halftone dots, the "fine print" is the *Too Much* (as Moore's poem "The Jerboa" puts it) making apparent Blue Bug's admirable *Abundance*. Finally, because this poet never hesitates to admit her own elaborations, the "fine print" implies the poem itself and its tangle of referents, including the painter Odilon Redon, the ballet dancer Arthur Mitchell, and the Chinese acrobat Li Siau Than, from which her regard for a pony barely manages to emerge.

In Moore's poetry generally, images are analogous to thoughts, each being a fragment detached from the larger visual and mental worlds, but photographed images are analogous to quoted thoughts, being other people's fragments appropriated by the poet's imagination and assembled into a poem. Moore is a forager, like all the animals she writes about lovingly: the frigate pelican, who prefers "to take, on the wing, from industrious crude-winged species, / the fish they have caught, and is seldom successless"; the bear "inspecting unexpectedly / ant-hills and berry-bushes"; the octopus with its "relentless accuracy," its "capacity for fact." The photographed "facts" Moore gathers tend to be images of other foragers, such as the wood rat with a grape in its hand and its offspring in its mouth in "Camellia Sabina," or individuals carrying off some graceful act, some version

of the frigate pelican's daring performance, such as the skater Dick Button holding a pose in "Style" or Roy Campanella leaping in "Hometown Piece for Messers. Alston and Reese." [26]

Nothing in these poems acknowledges photography as the source of images. Moore's notes do that. There she records her debts to *National Geographic, Literary Digest, Life,* and *The New York Times* with a respect for the outer world emulating the photographer's: "There is a great amount of poetry in unconscious / fastidiousness." She thereby makes a statement about poetry available to anyone who reads the notes, which constitute her most sustained description of poetic practice. Poetry may dwell in its own "imaginary gardens," to use Moore's most famous phrase, only if it notices the "real toads" lurking therein. [27] It must use schoolbooks, business documents, and photographs of Dodger catchers, and it must reproduce them accurately. (Comparison of her images with their sources in magazine photography confirms that she is an accurate observer and faithful describer.) Poetry may not mention photography merely to draw attention to photographic failings; that would be only another of poetry's "high-sounding" interpretations. Indeed, poetry had better not mention photographs as photographs at all. In poems Moore omits references to photographs or cameras—"Blue Bug" is a lone exception—because she wishes to avoid denigrating comparisons between writing and photography, between the fine print of one or the other sort. There is no reason to compare fact and fiction when both are essential. Moore, the literalist of the imagination, values images of whatever provenance for their unconscious fastidiousness.

Few modern American poets have agreed with Moore about photography. They have depended on it less but referred to it more openly in poems scrutinizing its manner of seeing and reproducing the world. They insist on comparisons between what they do and what the photographer does, or what "the camera" or "the lens" does, to render the process more automatic. For example, Robert Lowell's "Epilogue" in *Day by Day* (1977) starts with the poet's wish to make "something imagined, not recalled." He is tired of confessional poetry, of the "threadbare art" of the eye which now seems to him

> a snapshot,
> lurid, rapid, garish, grouped,
> heightened from life,
> yet paralyzed by fact. [28]

This is a dismissing comparison, and it arises from a persistent prejudice. When Lowell reverses himself to welcome facts ("Yet why not say what happened?") and to pray for "the grace of accuracy," he does not reverse his attitude to snapshot photography but rather praises Vermeer, whose work only seems photographic. Vermeer's is in fact an art of love, trembling "to caress the light" and bestowing

value on its subjects; the "painter's vision is not a lens." Lowell concludes that, as people are "poor passing facts," they had better give what living names they can to "each figure in the photograph," and the giving of living names is clearly within painting's or poetry's province rather than photography's.

Denise Levertov has thought photography even more helplessly "paralyzed by fact." It is, admittedly, a medium suitable for depicting the horrors of contemporary history: Levertov's "Photo Torn from *The Times*" in *The Freeing of the Dust* (1975) studies the photographed face of a mother whose ten-year-old son was killed in racial riots. Photographs like this paralyze Levertov emotionally and produce writing that can only be "lurid, rapid, garish." She is as obsessed and limited by them as the character Anna Wulf in Doris Lessing's *The Golden Notebook* (1962) is obsessed by newspaper stories pinned up on the walls of her room, stories making her angrier and angrier at the injustices they depict. When Levertov seeks an escape from anger, as in her poem "In Thai Binh (Peace) Province," also from *The Freeing of the Dust,* she must escape from photography:

> I've used up all my film on bombed hospitals,
> bombed village schools . . .
> So I'll use my dry burning eyes
> to photograph within me
> dark sails of the river boats,
> warm slant of afternoon light . . .
> Peace within the
> long war.[29]

To photograph "within" oneself is of course not to photograph at all. Levertov proposes to remember peace, or perhaps to imagine it, though for sufficient political reasons she does not admit the fact. She expropriates photography's power to authenticate even as she abjures its painful involvement with actuality—actual bombings, actual war.

A less heated and more finely described encounter between photography and imagination takes place in Elizabeth Bishop's "In the Waiting Room," the narrative of a six-year-old "Elizabeth's" visit to the dentist's office, where her aunt is being treated. The little girl passes time with the February 1918 issue of *National Geographic,* studying its photographs of an erupting volcano, the explorers Osa and Martin Johnson "dressed in riding breeches," a dead man slung on a pole, babies with pointed heads, and naked native women whose breasts seem "horrifying" to her. A cry of pain from her aunt in the dentist's chair neither surprises nor embarrasses her, the aunt being a "foolish, timid woman," but it shocks the girl by becoming, in some mysterious way, her own voice. Suddenly she feels herself falling through space with her aunt, indistinguishable from her aunt. The strange thing happening to her is a discovery of individual identity, but since the

abstract language of "identity" is foreign to a child and to the poem, the young Elizabeth puts it as a matter of feeling that she is an *I*, an *Elizabeth*, one of *them*. Before, she was purely an observer, a child lost among "shadowy gray knees, / trousers and skirts and boots." Now she interprets herself in terms of what she sees, understands that she is "held together" with her aunt and the other people in the waiting room, and senses her vulnerability. She is falling off the earth; she watches the waiting room slide beneath a big black wave. At the last moment she recovers sufficiently to recognize the waiting room for what it is, a local and familiar place, and remembers that Worcester, Massachusetts, is outside on this cold and slushy night of February 5, 1918.[30]

"In the Waiting Room" dramatizes being burdened with self-consciousness, with the "family voice" felt in the throat, as Bishop glosses it. Photography is at the starting point of this drama, not its center, in that the *National Geographic* pictures with their slightly disturbing subjects, especially "those awful hanging breasts," first threaten the six-year-old, putting her in a state to be startled by the aunt's cry and exposed to new knowledge. Yet Bishop makes literal images far less threatening to the girl than imagined ones. Elizabeth is just an observer when she thumbs through the pages of the magazine; she is a participant when she sees herself "falling off / the round, turning world / into cold, blue-black space," or feels herself sliding with the waiting room beneath the black waves. For Bishop, as for Lowell and Levertov, photography implies the literal, the factual event, whereas the essential subject of these poets is the imagined, the emotional event. The *National Geographic* with its prosaic strangeness, its travelogue exoticism, furnishes the dull background against which the girl's visionary experience is revealed and shines forth. How wonderful that one should fall off the world from the familiar yellow covers of a magazine read in a dentist's waiting room in Worcester, Massachusetts!

As it happens, the tracker of Bishop's experience looks in vain for erupting volcanoes, Osa and Martin Johnson, and naked villagers in the actual February 1918 issue of *National Geographic*. Asked about the discrepancy years later, Bishop confessed to a lapse of memory and said that the African images came from the March issue of the *Geographic,* as a visit to the New York Public Library had shown her. But nothing resembling the photographs in the poem is in the March issue either, or in any wartime issue of the magazine. Bishop apparently invented the photographs; perhaps she drew them from memory of other magazines, other times. This fact suggests that she was not willing to let someone else choose the pictures starting Elizabeth on her way to self-consciousness, but it does not otherwise affect the reading of the poem. The poem is fictionalized autobiography and enjoys the license of fiction.[31] Bishop is not, like Marianne Moore, a

frigate pelican, in spite of being the modern American poet personally closest to Moore, and she feels no obligation to the real toads of the world. "In the Waiting Room" is in fact the opposite of a poem like "Camellia Sabrina." Moore's work depends on a real photograph in a real *National Geographic* of February 1932 but is in no sense about the photograph; Bishop's work is built on fictional photographs but explicitly considers the factuality of photographic depiction and its relation to the more burdensome truths of the imagination.

In order to define what they themselves do, Lowell, Levertov, and Bishop all simplify photography, as did James Agee, a prose writer with a poetical self-consciousness, as did Sartre in a more roundabout way, and as did Ezra Pound in late 1921 when, discounting his involvement with Coburn's abstractions a few years before, he identified objectionably realistic passages of Eliot's *Waste Land* by scrawling the one word "photography" in the margins of the typescript. In the standard poetic estimation of photography, first advanced by Baudelaire, who called it "the most mortal enemy" of art, photography is capable only of giving "facts," while poetry gives the "living names" of facts. Photography isolates views of experience, which the poet may proceed to analyze, beautify, or invest with significant meaning. Photography depends on "technique," poetry on "art" or "vision." Michael S. Harper in the poem "Photographs: Negatives: History as Apple Tree" penetrates so far into photographic technique as actually to comment in some detail on darkroom processes. Black-and-white film serves him by prompting a meditation on the various racial and personal significances of black-and-white, black on white. Dave Smith explores the working methods—and miseries—of an unsuccessful traveling photographer in nineteenth-century America in his poem "The Traveling Photographer: Circa 1880."[32] But the most ambitious contemporary poem on photographing, the actual business of selecting a view and choosing a moment, is Smith's forthrightly titled "The Perspective and Limits of Snapshots," from *Cumberland Station* (1976). There is no dramatization of camera work here, but a scrutiny of the results of camera work and a consistently skeptical judging of those results.

The poem begins "Aubrey Bodine's crosswater shot of Menchville, / Virginia." It would not greatly matter if Bodine and his photograph were invented, Bishop-style, but Bodine was a real person, a *Baltimore Sunday Sun* photographer known for his pictorial studies of Maryland and the Chesapeake Bay. *Chesapeake Bay and Tidewater* (1954), one of Bodine's collections, seems to be the source of the photograph about which Smith is writing. Titled "Bridge of boats," this picture is literally a crosswater shot of the oyster-tonging boats tied up in Deep Creek at Menchville, Virginia (figure 64). Bodine's low-angle view makes it look as though one could get across the water by stepping from craft to craft. Only a few small human figures appear,

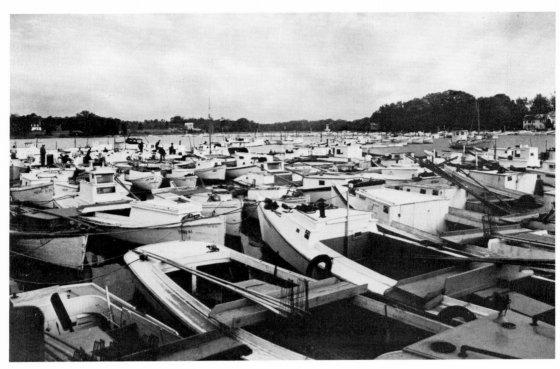

64. Aubrey Bodine. Bridge of boats, Menchville, Virginia.

indistinctly, in the background; nothing moves in the peaceful still-ness.[33] These details correspond to the description in the poem, though with a few discrepancies; Smith may have a slightly different Bodine photograph of Menchville in mind, may be remembering this one inaccurately, or may be inventing details to suit his own purposes.

In any case Smith recreates the picture in his own medium:

> Aubrey Bodine's crosswater shot of Menchville,
> Virginia: a little dream composing a little water,
> specifically, the Deep Creek flank of the Warwick.
> Two-man oyster scows lie shoulder to shoulder,
> as if you walk them, one land to another,
> no narrow channel hidden in the glossy middle
> like a blurred stroke, current grinning at hulls.
> It is an entirely eloquent peace, with lolling
> ropes and liquid glitter, this vision of traffic
> and no oystermen in sight.[34]

The key word is "composing." Bodine's composition sets Menchville within a certain frame and bestows a mood of calm on it: the water of Deep Creek is composed, like the boats and the lolling ropes. His "dream" or "vision" sees boats lying shoulder to shoulder, possibly with a Larkin-like pun on "lie," but declines to see water between the

boats. "Glossy" suggests the water surface Bodine obscures and the surface of the print itself; along with the word "glitter," "glossy" implies a superficiality, glossing over, or inability to see beneath the surface. The "blurred stroke" shown, by means of an adroit simile, to be omitted from the composition would indicate movement and therefore disturb the peace, the eloquence of which Smith overstates with "entirely." In other words, with every insinuation of which his own eloquence is capable, Smith composes a belittling view of Bodine's view. Snapshots are "bits and pieces," Mary Price has observed, "the rigidly conceived center and the accidentally inclusive or exclusive frames."[35] Smith would endorse that view, though presumably not Price's careful distinctions between snapshots and other sorts of pictures. In spite of his title, Smith addresses himself to photography in general and to what photography leaves out. The first paragraph of his poem goes on to enumerate the omissions: the neat Mennonite church, yachts, and above all people, oystermen. Bodine is no Matthew Brady, no portrayer of human actors.

Smith the poet is such a portrayer. In the second paragraph, determined to get some humanity, even a figurative humanity, into the scene, he personifies a building:

> the flat-faced store squats
> at the end of the dirt road as if musing over
> accounts receivable.

A store musing over accounts receivable is turning to the past, and movement in time is something no photograph, neither Bodine's nor anyone else's, can capture. (Bodine inadvertently substantiates this idea in his preface, where he adds up all the 1/1000-second exposures of the book and announces that his work required a total of 60 seconds.)[36] Employing time exposures himself, Smith speculates on the "years of blood spilling" the store has seen, and he watches a hound nosing "yesterday's trash fish." What Bodine "fails to see" is that very hound running uphill, under the "screen of poplars," past the "azaleas that hide the county farm"; every mention of screening or hiding drives the point home about the perspective and limits of snapshots. What he also fails to see is the oysterman imprisoned in that county farm for killing his wife. She had had a knife and mourned their boy "twenty years drowned," says Smith, opening up the historical perspective and at the same time rescuing this oysterman, this human being, from his role as colorful local. Bodine's task is to provide the *Baltimore Sunday Sun* with views picturesque and salable to the degree that they omit life, particularly ugly life: the drunks in the county farm press up against the fence, sniffing the James; the oysterman thumps his noisy wife. Smith's task is to record the omissions and redeem the dignity of the oysterman, who, if told someone was about to take his picture, would turn away,

would spit in his hand and tell
his nameless black cellmate there are many men
for whom the world is neither oyster nor pearl.

There may be violence and ugliness in the tidewater marshes Smith writes about, as he observes in "Sailing the Back River," an essay on the sources of his poetry. Every house may have "a smeared family name." But it also has "a baggage of pride."[37]

"The Perspective and Limits of Snapshots," then, is in part a complaint against photographic exploitation, like *Let Us Now Praise Famous Men* and Bruce Jackson's *Killing Time*. Smith conceives of a camera "yawning" to suck in the details of criminality—gaping crassly open, that is, hungering after someone's shame—while simultaneously being bored by the whole tiresome business. But in larger part the poem is exactly what its title says it is, a study of aesthetic management, a criticism of view-finder vision, which pays photography the back-handed compliment of believing that it does involve management. Bodine may produce glossy art, but he is after all an artist, not a purveyor of facts.

Bog Photographs and Bog Poems

In the poems Seamus Heaney wrote during the sixties and seventies in response to the photographs of P. V. Glob's *The Bog People*, the word "photograph" appears only once, in "The Grauballe Man," and then in a context suggesting that what photography supplies must be inferior to what the poetic imagination creates:

I first saw his twisted face

in a photograph,
a head and shoulder
out of the peat,
bruised like a forceps baby,

but now he lies
perfected in my memory.[38]

For the most part Heaney describes himself not as the reader of a printed book but as a kind of bogland excavator, museum visitor, or erotic archaeologist, those being the roles enacted, respectively, in "Kinship," "The Tollund Man," and "Come to the Bower." Or Heaney impersonates one of the ancients, as in "Bog Queen." His subject is not photographs; in a sense, it is everything but photography. He looks through the pictures in Glob's book to their subjects, the recovered corpses of Iron Age sacrificial victims, and he is more occupied by his relation to them and their relation to the sacrificial victims of the present than by aesthetic questions of portrayal or perspective—by questions of the sort the word "lies" in "The Grauballe Man"

would seem to raise, as it unquestionably raises them in Larkin and questionably in Smith. Heaney takes the untruthfulness of imaginative seeing so much for granted—writing of unwrapping skin to come at skulls, feeling the tug of the punitive halter around his own neck, standing face to face with a goddess—that he may not even be aware of the duplicity in "lies." In any case the word is not meant to start a debate about poetic inauthenticity and photographic authenticity, or the reverse. Comparison of *The Bog People* with the bog poems has a different function. All accomplished poems benefit from being compared with their sources, because that is how the accomplishment of their writing is displayed, and Heaney's bog poems—the best poems ever written thanks to, if not actually about, photographs—benefit in special measure from being compared with the pictures in Glob's book. That is how the manner of their perfecting images in the poetic memory is judged and how their sympathy with the past is understood.

The Bog People appeared in the same year as Heaney's second verse collection, *Door into the Dark* (1969). In that work Heaney already displayed archaeological interests. "Bogland," for example, imagines his native countryside as a bog of "black butter / Melting and opening underfoot." Through it "our pioneers"—the Irish poets, among others—keep striking "inwards and downwards," stripping away layer after layer of Irish civilization. The later collection *Wintering Out* (1972) gathered together "Bog Oak," "A Northern Hoard," and "Toome," the last with an inventive description of dislodging place names from under the "slab of the tongue": "I push into a souterrain / prospecting." *North* (1975) added the poems "Belderg," about quernstones dug up from the peat, "Viking Dublin: Trial Pieces," about relics in a museum case, and "Bone Dreams," about a white bone leading to thoughts of etymology, the skeleton of linguistic history. All these "souterrains" Heaney tended to explore with two-stress lines arranged in narrow quatrains, suggesting a kind of poetic drill hole or mine shaft sunk into the earth, which is also the past.[39] Clearly, then, Heaney made poetry out of archaeology before reading Glob, and even after reading him Heaney made archaeology speak to a wide range of political and private interests. The bog poems have to be read in the context of a fascination with exhuming so intense and so marked that Heaney, as Blake Morrison has suggested, finally has to mock it, caricaturing himself as:

> Hamlet the Dane,
> skull-handler, parablist,
> smeller of rot.

In "The Digging Skeleton," an adaptation of Baudelaire's "Le Squelette Laboureur," Heaney characterizes himself as a connoisseur of "anatomical plates / Buried along these dusty quays" of Paris bookstalls.[40]

The Bog People provides Heaney the "skull-handler" with a visual inventory and a kindred sympathy—Glob's sympathy, conveyed in the surprising ambition of a picture caption, the dramatic narrative of an excavation, and the general willingness to issue, in Heaney's words, "a requiem grounded in research." In a 1974 review Heaney couples Glob with Pablo Neruda, another admirer of "the used surfaces of things," and attributes to Glob's writings the "charms of poetry itself." Glob is an artisan of precise naming. He "relishes soils and stuffs, earth-crafts and metal-crafts; he speaks almost as a devotee of lost cults and rituals, and conjures epiphanies out of the *disjecta membra* of a culture."[41] This is an acute description of the charms of Heaney's own work. "Come to the Bower" and "Bog Queen" show him virtually translating Glob's "soils and stuffs" into poems. In "Come to the Bower" he works on the text description of "Queen Gunhild," a female body dug out of a bog in the nineteenth century and mistakenly identified as the consort of King Erik Bloodaxe. A probing of the burial site, according to Glob, produced a powerful spring welling up from the depths in a jet of water, and Heaney puts this detail into the next-to-last stanza, while the "unpin" of his erotic opening comes equally from his imagination and from Glob's description of the wooden crooks driven down tight over "Queen Gunhild's" body joints to pin her in the bog water, either drowning her or perhaps holding in place the malevolent spirit which might haunt her murderers after death. Heaney's notion of an erotic poem, a seduction of or by the long-dead queen, may have come in the first place from Glob's commentary on the supposed Gunhild's dissoluteness or from the nineteenth-century play and poem about Gunhild which Glob quotes. Glob discusses the *huldre,* "a kind of fairy, ravishingly beautiful to outward appearances but in reality hollow, who entices hunters and lone wanderers with the illusion of love and happiness." So Heaney is enticed, reaching

> past
> The riverbed's washed
> Dream of gold to the bullion
> Of her Venus bone.[42]

In "Bog Queen," meanwhile, Heaney adapts Glob's information about a buried lady found closer to home, in County Down, Northern Ireland, in the late eighteenth century. Heaney's details of the gravel bottom on which the body rests, the diadem she wears, the Phoenician stitchwork on her cape, the "swaddle" of hides around her, the stones at her head and feet, and the plait of her hair bought from a peasant by a "peer's wife," Lady Moira, all come directly from Glob and indirectly, perhaps, from the account of the burial Lady Moira herself published in 1785.[43]

In both these cases language speaks to language, there being for obvious reasons no photographs of "Queen Gunhild" or the Irish

lady's corpse. Glob's pictures speak to Heaney's interpreting language in "Nerthus," "Kinship," and "Strange Fruit." "Nerthus" is a hymn of praise to the crude statue of the goddess shown in *The Bog People*, captioned "The goddess Nerthus at Foerlev Nymølle" (figure 65). In "Kinship" the same photograph suggests the idea of "twinning," for the poem considers many sorts of alliance, analogy, duplication, and above all the connection between past and present. Heaney sinks a turf spade in the ground and lets it stand upright, matching

65. Anonymous. The goddess Nerthus at Foerlev Nymølle.

that obelisk:

among the stones,
under a bearded cairn
a love-nest is disturbed,
catkin and bog-cotton tremble

as they raise up
the cloven oak-limb.
I stand at the edge of centuries
facing a goddess.[44]

Glob's photograph shows the reader "long grains gathering to the gouged split," as "Nerthus" phrases it, and taken with Glob's text explaining the cairn and the bog-cotton makes expressive two poems that would otherwise scarcely be intelligible.

"Strange Fruit" bears comparison in a less immediate way with its source, Glob's photograph captioned "The decapitated girl from Roum" (figure 66). Without the photograph, the poem is amply descriptive and makes sense, though only a reader acquainted with Glob's interpretation of all the bog burials, whereby men and women were sacrificed to the earth goddess Nerthus in winter or early spring so that the bounty of summer should come again, can grasp the full sense of the poem's title. The girl was killed so that the earth should bear fruit. With the photograph at hand the reader can follow the act of looking Heaney insists on, going back and forth from the literal image to the figurative ones:

Here is the girl's head like an exhumed gourd.
Oval-faced, prune-skinned, prune-stones for teeth.
They unswaddled the wet fern of her hair
And made an exhibition of its coil,
Let the air at her leathery beauty.[45]

To go back and forth, to test "prune-skinned" against the head seen in the photograph and admire the justness of the phrase, may seem a naively simple way to read poetry of a considerable complexity. But it is a way readers neglect to their cost. Heaney's complex conclusions are always grounded in "soils and stuffs, earth-crafts and metal-crafts." His conclusions in "Strange Fruit" about the Roum girl's final ability to outstare, or discountenance, readers' aestheticization of her, readers' tendencies to take her with "gradual ease" or reverence, are grounded in accurate seeing and precise naming. The girl's head is in fact like an exhumed gourd, her teeth are like prune stones, her hair is like wet fern: "an exhibition of its coil" seems to refer to another photograph in *The Bog People*. Above all, the girl does present a "leathery beauty," an aspect that is both attractive and grotesquely repellent. With the fineness of his observation Heaney draws readers in to a reverence for her strange beauty, so that they shall be pulled

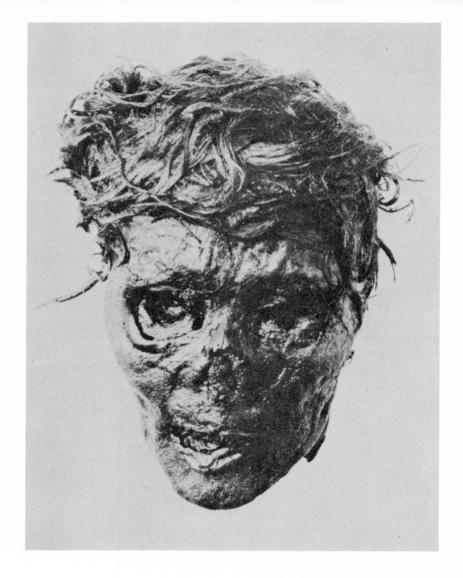

66. Anonymous.
The decapitated girl
from Roum.

up the more shortly by the bleakness of a line like "Her eyeholes blank as pools in the old workings," which is another simile to be judged against one of Glob's pictures and found just.[46]

Again and again in this poem and all the poems of the group Heaney shows himself an extraordinary describer. The eyelids of the Tollund man are exactly "mild pods," as one can see from looking at the pertinent photograph (figure 1). The Grauballe man in Glob's photographs looks exactly like what Heaney makes of him:

> As if he had been poured
> in tar, he lies
> on a pillow of turf
> and seems to weep
>
> the black river of himself.[47]

Going back and forth from photograph to poem, in the case of other poets' work, can be a destructive exercise. Looking closely at John Logan's "Eight Poems on Portraits of the Foot," say, and at the Aaron Siskind photographs printed right along with the poems, only confirms the arbitrariness of Logan's seeing and the pretentiousness of his approach:

> this African foot
> is an avocado turning sweet
> . . . I weave before it in the sand.[48]

The same stylistic discrepancies bedevil Thom Gunn's poems printed with Ander Gunn's photographs in the collaboration *Positives* (1966). Heaney's world, by contrast, is photographically distinct, empty of poeticizing, and full of peculiar beauty, as in his comparison of the ball of a foot to a basalt egg. Going back and forth from photograph to poem is in this case the task Heaney's readers owe his skill.

"The Tollund Man" introduces the major concerns of the bog poems. Heaney thinks of going to Denmark and seeing the Tollund bog for himself. He imagines the ancient sacrifice to Nerthus:

> She tightened her torc on him
> And opened her fen,
> Those dark juices working
> Him to a saint's kept body.[49]

"Torc" hints at the twisting force of "torque" but literally means the noose placed around the victim's neck, a noose woven deliberately to resemble and symbolically to represent the votive torcs or neck rings thrown as offerings into bogs, as Glob makes clear.[50] "Opened her fen" is one of several phrases interpreting the sacrifice as a sexual act, a wedding in which the Tollund man stands "Bridegroom to the goddess" and appeases her hunger. The "saint's kept body" refers to Catholic relics; one might, risking blasphemy, venerate the Tollund man as an artifact miraculously preserved. Phrasing in this single quatrain carries an impressive weight of meaning. Heaney makes a great deal of the burial without being melodramatic or ponderously symbolic about it.

The thought of venerating is most important to the poem. If an ancient sacrifice can be linked to a modern rite, in a traffic between past and present that is required by everything in the poem, including its dependence on photographs, then modern "sacrifices" can be linked to an ancient rite. Heaney at least holds out the possibility of praying the Tollund man

> to make germinate
>
> The scattered, ambushed
> Flesh of labourers,
> Stockinged corpses
> Laid out in the farmyards.[51]

That is, he holds out the possibility that killings in Northern Ireland may be not random but purposive. They may, once mourned, once ceremonialized, lead to new life. He ventures this hope at the mid-point of the poem and limits it with his close, which is lost in the melancholy of "the old man-killing parishes" and the ominous connotations of the "tumbril" carrying the Tollund man to his fate: Northern Ireland will have to get through something like the French Revolution. "The Tollund Man" is a poem about seeing ambushes and wishing they were sacrifices, and its emphasis falls on wishfulness, like the emphasis of "Funeral Rites" in *North,* where Heaney, sounding for the moment like Yeats, looks to antique orderliness for a way out of shoddy Catholic-Protestant violence:

> Now as news comes in
> of each neighbourly murder
> we pine for ceremony,
> customary rhythms . . .
>
> I would restore
>
> the great chambers of Boyne.[52]

Yeats and the other modernists imposed the patterning of myth on, in Eliot's words, "the immense panorama of futility and anarchy which is contemporary history." Heaney follows them, cautiously. The trouble with myth is that it involves a selective and excessively symbolical seeing: human failure is tidied into the soliloquies of a Fisher King, human accidents are artificed into the phases of the moon. When Heaney does his own tidying, he knows he is risking a nonreligious "blasphemy," insulting the untidy and ugly truth. "The Grauballe Man" develops this theme. Its starting point is yet another one of Glob's Iron Age burials, a man first recovered from the peat and then rendered artificially beautiful by a series of bravura Heaney transformations. The Grauballe man is reanimated: he "seems to weep" and lifts his head; he is compared, body part by body part, to a swan, a mussel, and an eel; his rusted hair might belong to a fetus; he is "bruised like a forceps baby" in what seems to be a birth, not a two-thousand-year-old death; the slash in his throat is "cured"—that is, "tanned and toughened" by the bog acids but also "healed." After such treatment,

> Who will say "corpse"
> to his vivid cast?
> Who will say "body"
> to his opaque repose?[53]

Who indeed would call a body a body when he could give it life, call it a piece of life-like statuary, or otherwise turn a twisted face into evidence of "repose"? There are satisfactions in opacity. Nevertheless,

Heaney is dissatisfied. In these lines he reminds himself of his first, photographic sight of the Grauballe man and shows what he means by the perfection of that sight in memory: he rejects aestheticization for a historically informed view. When all the similes and animations are said and done, the Grauballe man remains in the reader's corrected sight a victim of violence. He suffered. His wound is only in the chemical sense "cured." His beauty, which is genuine and indeed verifiable by means of comparison with Glob's photographs, must be "hung in the scales" with the cruelty that put him in the bog. He testifies to "beauty and atrocity" together, like the Roum girl in "Strange Fruit," and like the statue of the Dying Gaul in the Capitoline, Rome, which is brought into this poem from a distance because the Gaul's reclining pose is so much like the Grauballe man's, because he wears a torc around his neck, and because he epitomizes the artistic treatment of death. The Grauballe man finally reminds Heaney of the hooded victims of his own time, Protestants or Catholics killed in sectarian fighting. Their "actual weight" burdens the poet; their being "dumped" in the fields or back streets of Derry counterbalances the way Heaney thought of the Grauballe man, in the first line of the poem, as being handsomely "poured" in tar.

"Hooded" by itself invokes the present. The hoods on casualties of the Troubles are there to see in pictures in newspapers or on television, and such images, though never explicitly mentioned, are "present" in the poem and contribute significantly to its meaning. Looking at photographs in the *Guardian* or *Irish Times,* Heaney sharpens his eye for the pictures in *The Bog People.* The same process takes place in the opposite direction, for one photographic interpretation corrects another.

"Punishment," arguably the finest of the bog poems, follows a similar pattern and makes a similar correction. This work derives from Glob's treatment of the Windeby girl, an undernourished fourteen-year-old punished for adultery by having half her head shaved and being drowned alive in a bog in what is now northern Germany. In his usual methodical way Glob draws on Tacitus's *Germania* for testimony about head shaving and adultery and describes the finding of the birch branches and the big stone that kept the girl under water. Heaney allows himself a more intimate relation. In an early draft of the poem he says to the "Little adulteress, you are / tar black, photographed," then comes closer to her by omitting mention of the photograph and substituting "we hear / that you were flaxen-haired," and finally gets rid of all the distancing phrases. In the published version Heaney simply sees her drowned body, "the weighing stone, / the floating rods and boughs." He says he can feel the tug of her halter and the wind blowing against her nakedness.[54] Her shaved head is like a stubble of black corn, her noose a ring "to store / the memories of love." This is a very loving treatment. Heaney admits:

> I am the artful voyeur
> of your brain's exposed
> and darkened combs.

That is, he admits to an erotic interest in the girl whom his imagination has created, since her "nipples" blown to "amber beads" are nowhere on view in the photograph in *The Bog People* (figure 67). He also admits to a sympathy for her fate. To him, she is a "poor scapegoat." But the "artful voyeur" is called to complicity in judgment:

> I almost love you
> but would have cast, I know,
> the stones of silence.[55]

The New Testamental allusion to the casting of stones as punishment of adultery offsets the Old Testamental allusion to the scapegoat, and the instinct to punish offsets the wish to excuse.[56] For all his attraction to her beautiful face, Heaney realizes the Windeby girl is an adulteress.

Analogously, at home in Ulster, Heaney feels sympathy and affront:

> I who have stood dumb
> when your betraying sisters,
> cauled in tar,
> wept by the railings,
>
> who would connive
> in civilized outrage
> yet understand the exact
> and tribal, intimate revenge.[57]

The "betraying sisters" are Catholic girls who have gone with British soldiers and been shaven and tarred for doing so. Heaney has seen them in newspaper photographs. A London *Times* picture shows the fifteen-year-old Elizabeth Hyland with her hair cut off; a widely distributed Associated Press photo shows nineteen-year-old Marta Doherty shaven, tarred, and tied to a Londonderry lamppost (figure 68). That Heaney has the second image particularly in mind is suggested by the wording of a draft of "Punishment," which concludes:

> Intercede
> for your weeping sisters
> shackled to the lamp post.

(Perhaps Heaney also recalls seeing Cartier-Bresson's famous *Life* photograph of shaven-headed French girls, mothers of babies by German soldiers, being reviled by a mob.) As a participant in the world that magazines and newspapers represent, the poet should protest. A sexual code that sends girls weeping to the railings or haltered to the bog is merely a form of hatred. Primitive Germanic bloody mindedness repeats itself in the "fury of Irish Republicanism," as Heaney

67. Anonymous.
The young girl from
the Windeby bog.

68. Anonymous.
Girl tarred in
Londonderry.

notes in a 1972 interview published in the *The Listener*, both aberrations being "observed with amazement and a kind of civilised tut-tut by Tacitus in the first century AD and by leader-writers in the *Daily Telegraph* in the 20th century."[58] But what he ascribes to leader writers and says himself with ironic qualifications in *The Listener* is not what he says in "Punishment." In the poem Heaney is at best able to "connive" a civilized, Tacitus-style, *Daily Telegraph*-style outrage, be-

cause a more intimate feeling draws him toward complicity in re-
venge. He belongs, after all, to the tribe, and he feels betrayed, after
all, by the errant Catholic girls. He looks at the photographs and
stands dumb.

Heaney has been blamed, especially as his reputation has grown,
for not declaring an open allegiance to the Catholic cause in Northern
Ireland. Insofar as "Punishment" makes a distinction between con-
niving and understanding, setting the artifice of the former against
the instinctiveness of the latter, the poem should appease his partisan
critics. But it should not make them think he has committed himself.
Like "The Grauballe Man," "Punishment" is a balancing act. It is full
of the sense of "but," "yet," "almost." It admits loving and hating,
liberal intelligence and primitive superstition, and takes a complicated
view of photography, as of everything else it studies. Without Denise
Levertov's stridency, Heaney conveys her resentment that photo-
graphs should have to be involved with bombed hospitals, bombed
village schools, and all the other horrors of contemporary life. With-
out Brecht's dogmatism, Heaney conveys his idea that photographs
are social artifacts in need of interpretation. "Punishment" and the
other bog poems, juxtaposed with the pictures in *The Bog People*,
teach Heaney's readers what to make of images and thus how
to understand the directives about interpretation at the end of
"Kinship":

> Read the inhumed faces
>
> of casualty and victim;
> report us fairly,
> how we slaughter
> for the common good
>
> and shave the heads
> of the notorious,
> how the goddess swallows
> our love and terror.[59]

Conclusion

EACH PAIRING of modern writer and modern photographer, of Smith with Bodine or Pound with Coburn, suggests the possibility of a coherent, synchronous relation between photographic and literary styles in this century. Neither collaborations nor developments of analogous technique happen in isolation. The collaboration that produced vortography, for instance, took place at a moment of general artistic dissatisfaction with successful, unchallenging, old-fashioned modes. Pound's turn against crepuscular imagery was also D. H. Lawrence's turn, and HD's, and Richard Aldington's, while Coburn's turn against soft-focus Pictorialism was also Steichen's (eventually) and Stieglitz's. In some sense all these artists are Imagists, whether they use pen or camera, since all came to think they preferred sharp-edged visual effects to what they would have called "rhetoric." All seem to have participated in a single movement, the theorists for which might be identified as Amy Lowell in *Tendencies in Modern American Poetry* (1917) and Sadakichi Hartmann in "A Plea for Straight Photography" (1904). Similarly, the American snapshot-style photographers of the 1970s—Garry Winogrand, Nancy Rexroth, and Tod Papageorge—seem to be participating in a single antiformalist movement with such fiction writers as Barry Hannah and Richard Brautigan. "Do not take our art too solemnly" could be their common credo.

But there are problems with grouping writers and photographers under common rubrics, one of which is the problem of chronology. The year 1904 is not the same moment as 1917. Literary-photographic "Imagism" begins to lose definition if it must be thought of as extending from the turn of the century to the war years and then finally to the early thirties, when photographic concentration on sharp-edged visual effects becomes most disciplined and self-conscious in the work of the f64 group—Ansel Adams, Imogen Cunningham, and Willard Van Dyke—in California, a place far removed from the London–New York milieu which saw the birth of literary Imagism. By the early thirties, meanwhile, literary Imagism itself has become passé. In the twentieth century disjunctures like this have been at least as common as connections between literary and photo-

graphic history. Photography of the twenties provides little that is comparable to the willful difficulty of high modernist literature. There is no photographic "Byzantium," let alone a photographic *Ulysses;* the Walker Evans photograph of Brooklyn Bridge printed in the first edition of *The Bridge* is immediately "readable," unlike Hart Crane's poem; and even Stieglitz's avant-garde portraiture, because more accessible than Stein's, is not perfectly analogous to it. Fifty years later, at a moment when photographers are acknowledging the manipulations of their craft and the subjectivity of their seeing, poets like Robert Lowell are asserting the camera's objectivity. Bruce Jackson's *Killing Time,* with its doubts about factual documentary, and Lowell's *Day by Day,* with its denigration of the photograph "paralyzed by fact," were published in the same year, 1977. For every affiliation of the two arts there is some discrepancy or countermovement.

The histories of twentieth-century literature and photography must therefore be written separately—except for that one period when the histories coincide, stretching roughly from the late twenties to the early forties, the period of the social investigators Lange and Taylor, the social taxonomists Sander and Döblin. Here the parallels derive from genuine similarities of purpose, not from mere accidents of coinciding taste or personal involvement. Archibald MacLeish's poetic development from *The Tower of Ivory* to *Land of the Free* matches Walker Evans's discovery of a social subject or Dorothea Lange's turn from San Francisco matrons to Okies. All three developments are part of the same history. In this period it is often possible to speak of a single style, to which photographers and writers equally aspired, whether they thought of themselves as producing photojournalism, socially conscious imaginative literature, or formal documentary. A single particularized, low-key, realistic, and morally serious style united observers' efforts and stimulated collaborations, or now makes regrettable the collaborations, like that between Brandt and Orwell, which were never achieved. A single style, defined as a common responsibility to the facts of existence, is precisely what writers and photographers in the thirties were conscious of sharing, and what intelligent onlookers like Elizabeth McCausland were eager to perceive in contemporary works.

This period, with its air of virtuously discovering truths too long ignored and its excitement about combining arts in a common cause, is now over, though photojournalism and documentary as genres are not. The difference in photographing or writing has come about in part through ideological changes since the thirties. Social investigation now seems more methodologically and ethically complicated than it did, say, to Erskine Caldwell and Margaret Bourke-White, and to some observers it seems less capable of affecting the facts of existence which are its subject. Perhaps for that reason documentary has had to find different sponsorship. Governmental support on the scale

of the FSA Historical Section or the WPA-funded National Research Project, which employed Lewis Hine, for example, to take pictures of workers in various manufacturing industries, is no longer dreamed of. Documentary books have passed to the care of the academy, of university presses and grant-awarding foundations. *Killing Time,* a typical example, was funded by the Guggenheim Foundation, the American Philosophical Society, and the American Council of Learned Societies, and was published by Cornell University Press.

Photojournalism has continued to appear, but in altered forms and in a quantity which threatens its effectiveness. Take the case of a journal like *National Geographic* at different periods. The issue for February 1932, on which Marianne Moore drew for an image of a foraging wood rat, includes five articles using a total of 145 photographs, 118 black-and-white and 27 color, the latter appearing in two separately titled portfolios. All the photographs, without exception, are captioned in the same way: a headline in small capitals and two or three lines of informational text beneath the image. The issue for September 1984 includes six articles using 140 photographs or graphic displays, of which all but two—both of these old photographs—are in color; advertisements in the issue add sixteen additional photographs to the total. Captions are still employed, but they are placed beside, below, above, or in a few cases directly on the accompanying images. They provide information in the standard *National Geographic* way or attempt a kind of poetry:

> Gilded with the sun of dreams and promises
> Dallas springs from griddle-flat prairie,
> suddenly, sleekly. Reunion Tower punctuates
> the skyline like an exclamation point
> in a city blatantly up-front and upbeat.

These lines from the first page of the article "Dallas!" by Griffin Smith, Jr., and David Alan Harvey comment on a double-page spread in which the Reunion Tower at twilight really does resemble an exclamation point at the end of a "sentence" of light-catching skyscrapers. Photograph has been matched to caption with obvious care. In general, the layout of the issue has become astonishingly sophisticated. Photographs of many different sizes and shapes are carefully surrounded by solid color or bled out to the page margin, and they are varied with multicolor graphs, diagrams, and maps. Some rather abstract aerial photographs of plowing patterns are grouped in a "photo essay" with minimal text.

In the shift from black-and-white to color something of the old documentary purposefulness is lost. The photographs from 1984, more obviously beautiful than those from 1932 because presented in a full range of colors rather than a full range of grays, seem intended to catch the viewer's eye and even to display photographic virtuosity.

In sharpness of focus, sensitivity in dim light, and management of special effects like blurred moving subjects, they are indeed virtuosic. Of necessity these color photographs record some of the facts of existence, but they hardly insist on the fact of their recording, as older photographs do. They reproduce and belong to a time of shades of belief, not a time of black-and-white simplicities. One of the articles in the 1984 *National Geographic,* "The Okies: Beyond the Dust Bowl," by William Howarth and Chris Johns, makes the difference between color and black-and-white obvious by including two FSA photographs among its illustrations. A Russell Lee picture of migrants camping in Oklahoma in 1939 floods the interior of their jalopy with harsh flat light, as though under a compulsion to record every jumbled garment and odd can of food, every sign of moral dislocation. Next to this photograph a modern color portrait of Lee, holding his Speed Graphic, poses him in a flattering light and allows his face to be interesting, full of accumulated wisdom. It is a form of tribute, not documentation.

However striking the shift to color may be, it is less important than an increase in the number of images contemporary journalism is obliged to use. Counting advertisements—which must be counted since they employ the same photographic and captioning techniques as the articles—the 1984 *National Geographic* includes more photographs than the 1932 issue, and it presents these photographs to viewers who are surrounded, as they were not in 1932, by competing visual imagery. Television, other magazines, illustrated newspapers, personal photographs, books with pictures, and photographic billboards all solicit the eye. Indeed television screens, personal photographs, and glossy magazines are visible in some of the *National Geographic* pictures themselves, forming part of the background against which life is now conducted. Such images are even more numerous in the photographs of Ganzel's *Dust Bowl Descent.* Once considered "documents," special truth-revealing and truth-fixing images, photographs have by 1984 become a routine, taken-for-granted medium of communication, in spite of the considerable artistry which may have gone into their production. Photographs and their accompanying texts supply in ever-increasing and self-defeating quantities that sort of information which Walter Benjamin long ago saw as replacing communal wisdom or the exchange of experience, and which Susan Sontag has more recently blamed for an anesthetized sensibility.

Photographs must be seen to be effective. The words around photographs in captions or longer commentaries must be read. Photo texts must be studied in ways appropriate to their ambitiousness. We do not have to be as embittered as Donald McCullin to wonder if anyone is taking notice. We do not have to believe that contemporary culture is image-sated to know that we are in danger of viewing and

reading too casually all the photo-textual material presented to us or of failing to understand what all the material means. We are in danger of losing the attentiveness which the authors of *Let Us Now Praise Famous Men* and *Death in the Making, The First World War: A Photographic History* and *The English at Home,* once depended on when, combining images with words, they made the seen world as authentic as any world represented in language, and as intelligible.

Bibliography

Photo Texts, Collaborations, and Photographic Collections with Significant Introductions

Abbott, Berenice. *Changing New York*. Text by Elizabeth McCausland. New York: E. P. Dutton, 1939.

Adams, Ansel, and Muir, John. *Yosemite and the Sierra Nevada*. Boston: Houghton Mifflin, 1948.

Adams, Ansel, and Newhall, Nancy. *This Is the American Earth*. San Francisco: Sierra Club, 1960.

Adelman, Bob. *Down Home*. Text edited by Susan Hall. New York: McGraw Hill, 1972.

[Agee, James] and Bourke-White, Margaret. "The Drought: A Post-Mortem in Pictures." *Fortune*, October 1934, pp. 76–83.

Agee, James, and Evans, Walker. *Let Us Now Praise Famous Men*. Revised edition. Boston: Houghton Mifflin, 1960.

Alinder, Jim. *Picture America*. Words by Wright Morris. Boston: Little, Brown, 1982.

Anderson, Sherwood. *Home Town*. In The Face of America series, edited by Edwin Rosskam. Farm Security Administration (FSA) photographs. New York: Alliance, 1940.

Arrowsmith, William, ed. "Image of Italy." Photographs by Russell Lee. *Texas Quarterly* 4.2 (Summer, 1961):7–267.

Aubier, Dominique. *Fiesta in Pamplona*. Photographs by Inge Morath and others. New York: Universe Books, 1956.

Aubier, Dominique, and de Montherlant, Henri. Photographs by Brassaï. *Fiesta in Seville*. New York: Universe Books, 1956.

Avedon, Richard, and Baldwin, James. *Nothing Personal*. Penguin, 1964.

Avedon, Richard, and Capote, Truman. *Observations*. New York: Simon & Schuster, 1959.

Barber, Frederick A., ed. *The Horror of It: Camera Records of War's Gruesome Glories*. New York: Brewer, Warren & Putnam, 1932.

Bateson, Gregory, and Mead, Margaret. *Balinese Character: A Photographic Analysis*. New York: New York Academy of Sciences, 1942.

Beals, Carleton. *The Crime of Cuba*. Photographs by Walker Evans. Philadelphia: Lippincott, 1933.

Berger, John, and Mohr, Jean. *Another Way of Telling*. New York: Pantheon, 1982.

Berry, Wendell, and Meatyard, Gene. *The Unforeseen Wilderness: An Essay on Kentucky's Red River Gorge*. Lexington: University of Kentucky Press, 1971.

Bickel, Karl. *The Mangrove Coast*. Photographs by Walker Evans. New York: Coward-McCann, 1942.

Bischof, Werner; Frank, Robert; and Verger, Pierre. *From Incas to Indios*. Translated by James Emmons. Introduction and captions by Manuel Tuñon de Lara. New York: Universe Books, 1956.

Bodine, A. Aubrey. *Chesapeake Bay and Tidewater*. New York: Hastings House, 1954.

————*The Face of Virginia*. Baltimore: Bodine and Associates, 1967.

Bourke-White, Margaret. *Dear Fatherland, Rest Quietly*. New York: Simon and Schuster, 1946.

————*Eyes on Russia*. New York: Simon & Schuster, 1931.

————*Shooting the Russian War*. New York: Simon & Schuster, 1942.

Brandt, Bill. *Camera in London*. London and New York: Focal Press, 1948.

————*The English at Home*. Introduction by Raymond Mortimer. New York: Charles Scribner's; London: B. T. Batsford, 1936.

————*Literary Britain*. Edited by Mark Haworth-Booth. London: Victoria and Albert Museum, 1984.

————*London in the Thirties*. Edited by Mark Haworth-Booth. New York: Pantheon, 1984.

————*A Night in London*. New York: Scribner's; London: Country Life; Paris: Arts et Métiers Graphiques, 1938.

Brassaï. *Paris de nuit/Nächtliches Paris*. Texts by Paul Morand, Lawrence Durrell, and Henry Miller. Munich: Schirmer/Mosel, 1979.

Brecht, Bertolt. *Kriegsfibel*. Berlin: Eulenspiegel Verlag [1955].

Bryan, Julian. *Siege*. Introductions and captions by Maurice Hindus. New York: Doubleday, Doran, 1940.

Caldwell, Erskine, and Bourke-White, Margaret. *North of the Danube*. New York: Viking, 1939.

————*Say, Is This the USA?* New York: Duell, Sloan and Pearce, 1941.

————*You Have Seen Their Faces*. New York: Viking, 1937.

Cameron, Julia Margaret. *Victorian Photographs of Famous Men & Fair Women*. Edited and revised by Tristram Powell. Introductions (1926) by Virginia Woolf and Roger Fry. Boston: Godine, 1973.

Capa, Robert. *Death in the Making*. Preface by Jay Allen. Additional photographs by Gerda Taro. New York: Covici Friede, 1938.

Cartier-Bresson, Henri, and Han Suyin. *From One China to the Other*. New York: Universe Books, 1956.

Cartier-Bresson, Henri, and Sartre, Jean-Paul. *D'une Chine à l'autre*. Paris: Robert Delpire, 1954.

Coburn, Alvin Langdon. *Men of Mark*. New York: Mitchell Kennerley; London: Duckworth, 1913.

————*More Men of Mark*. London: Duckworth, 1922.

————*A Portfolio of Sixteen Photographs*. Introduction by Nancy Newhall. Rochester: International Museum of Photography, 1962.

Coles, Robert. *The Last and First Eskimos*. Photographs by Alex Harris. Boston: New York Graphic Society, 1978.

————*The Old Ones of New Mexico*. Photographs by Alex Harris. Albuquerque: University of New Mexico Press, 1973.

Conrat, Maisie, and Conrat, Richard. *Executive Order 9066*. Photographs by Dorothea Lange, Russell Lee, and others. Los Angeles: California Historical Society, 1972.

Crane, Hart. *The Bridge*. Photograph by Walker Evans. New York: Horace Liveright, 1930.

Cross, Charles. *A Picture of America*. New York: Simon & Schuster, 1932.

Davidson, Bruce. *East 100th Street*. Cambridge: Harvard University Press, 1970.

De Carava, Roy, and Hughes, Langston. *The Sweet Flypaper of Life*. New York: Simon & Schuster, 1955.

Duncan, David Douglas. *Self-Portrait, USA*. New York: Abrams, 1969.

Edey, Maitland, ed. *Great Photographic Essays from Life*. Boston: New York Graphic Society, 1978.

Evans, Walker. *American Photographs*. Essay by Lincoln Kirstein. New York: Museum of Modern Art, 1938.

————*Walker Evans*. New York: Museum of Modern Art, 1971.

Frank, Robert. *The Americans*. Introduction by Jack Kerouac. New York: Grove Press, 1959.

Ganzel, Bill. *Dust Bowl Descent*. Lincoln and London: University of Nebraska Press, 1984.

Gunn, Thom, and Gunn, Ander. *Positives*. Chicago: University of Chicago Press, 1966.

Gutmann, John. *The Restless Decade*. Edited by Lew Thomas. Essay by Max Kozloff. New York: Abrams, 1984.

Hare, Chauncey. *Interior America*. Millerton, N.Y.: Aperture, 1978.

Harper, Douglas. *Good Company*. Chicago: University of Chicago Press, 1982.

Harris, Alex, and Sartor, Margaret. *Gertrude Blom: Bearing Witness*. Chapel Hill: University of North Carolina Press, 1984.

Hemingway, Ernest. *The Spanish Earth*. Illustrations by Frederick K. Russell. Cleveland: J. B. Savage, 1938.

Herron, Gaylord Oscar. *Vagabond*. Tulsa: Penumbra Projects, 1975.

Hine, Lewis. *America and Lewis Hine*. Essay by Alan Trachtenberg. Millerton, N.Y.: Aperture, 1977.

————*Men at Work: Photographic Studies of Men and Machines*. New York: Dover; Rochester: International Museum of Photography, 1977 [1932].

————*Women at Work*. Edited by Jonathan L. Doherty. New York: Dover; Rochester: International Museum of Photography, 1981.

Hockney, David, and Spender, Stephen. *China Diary*. New York: Abrams, 1983.

Howarth, William, and Grehan, Farrell. "Following the Tracks of a Different Man: Thoreau." *National Geographic* 159.3 (March 1981): 348–387.

Howarth, William, and Johns, Chris. "The Okies: Beyond the Dust Bowl." *National Geographic* 166.3 (September 1984): 322–349.

Jackson, Bruce. *Killing Time: Life in the Arkansas Penitentiary*. Ithaca and London: Cornell University Press, 1977.

Kauffman, Richard. *Gentle Wilderness: The Sierra Nevada*. Edited by David Brower. Text by John Muir. San Francisco: Sierra Club, 1967.

Knopf, Alfred. *Sixty Photographs*. New York: Knopf, 1975.

Lange, Dorothea. *Dorothea Lange*. Introduction by George P. Elliott. New York: Museum of Modern Art, 1966.

————*Dorothea Lange: Photographs of a Lifetime*. Essay by Robert Coles. Millerton, N.Y.: Aperture, 1982.

Lange, Dorothea, and Jones, Pirkle. "Death of a Valley." *Aperture* 8.3 (1960):127–165.

Lange, Dorothea, and Taylor, Paul. *An American Exodus*. New York: Reynal and Hitchcock, 1939.

————*An American Exodus*. Revised edition. New Haven and London: Yale University Press, 1969.

Laughlin, Clarence John. *Ghosts along the Mississippi: An Essay in the Poetic Interpretation of Louisiana's Plantation Architecture*. New York: Scribner's, 1948.

Lerski, Helmar. *Köpfe des Alltags*. Introduction by Curt Glaser. Berlin: Verlag Hermann Reckendorf, 1931.

Levitt, Helen. *A Way of Seeing.* Essay by James Agee. New York: Viking, 1965.

Life: The First Decade. Boston: New York Graphic Society, 1979.

Limpkin, Clive. *The Battle of the Bogside.* Harmondsworth and Baltimore: Penguin, 1972.

Lord, Russell. *Behold Our Land.* Photographs from the FSA and Soil Conservation Service. Boston: Houghton Mifflin, 1938.

Lorentz, Pare. *The River.* Book of the FSA documentary film. New York: Stackpole Sons, 1938.

————*The Roosevelt Year: A Photographic Record.* New York and London: Funk & Wagnalls, 1934.

Macaulay, Rose, and Beny, Roloff. *The Pleasure of Ruins.* Edited by Constance Babington Smith. London: Thames & Hudson, 1964.

McCullin, Donald. *Is Anyone Taking Any Notice?* Cambridge: MIT Press, 1971.

MacLeish, Archibald. *Land of the Free.* New York: Harcourt, Brace, 1938.

————*Land of the Free.* Introduction by A. D. Coleman. New York: Da Capo, 1977.

Masefield, John. "Ships." Photographs by Alvin Langdon Coburn. *Harper's Monthly,* December 1914, pp. 114–122.

Morgan, Barbara. *Martha Graham: Sixteen Dances in Photographs.* New York: Duell, Sloan and Pearce, 1941.

Morris, Wright. *God's Country and My People.* New York: Harper & Row, 1968.

————*The Home Place.* New York and London: Scribner's, 1948.

————*The Inhabitants.* New York and London: Scribner's, 1946.

————*Love Affair: A Venetian Journal.* New York: Harper & Row, 1972.

————*Wright Morris: Photographs & Words.* Edited by James Alinder. The Friends of Photography, 1982.

Mydans, Carl, and Demarest, Michael. *China: A Visual Adventure.* New York: Simon & Schuster, 1979.

Nationalsozialistische Deutsche Arbeiter Partei: Schützstaffel. *SS Germanische Leithefte,* III, 1–2. FSA photographs captioned for Nazi propaganda. Berlin: Deutscher Verlag, 1943.

Newman, Arnold. *One Mind's Eye.* Introduction by Robert Sobieszek. Boston: Godine, 1974.

Nixon, Herman Clarence. *Forty Acres and Steel Mules.* FSA photographs. Chapel Hill: University of North Carolina Press, 1938.

Parks, Gordon. *Gordon Parks: A Poet and His Camera.* New York: Viking, 1968.

————*In Love.* Philadelphia: Lippincott, 1971.

————*Moments without Proper Names.* New York: Viking, 1974.

Peterkin, Julia, and Ulmann, Doris. *Roll, Jordan, Roll.* New York: Robert Ballou, 1933.

Plowden, David. *The Hand of Man on America.* Old Greenwich, Conn.: Chatham Press, 1971.

Raper, Arthur F. *Tenants of the Almighty.* FSA photographs by Jack Delano. New York: Macmillan, 1943.

Raper, Arthur F., and Reid, Ira De A. *Sharecroppers All.* FSA photographs. Chapel Hill: University of North Carolina Press, 1941.

Ray, Man. *Photographs by Man Ray: 105 Works, 1920–1934.* New York: Dover, 1979 [1934].

Renger-Patzsch, Albert. *Die Welt ist schön.* Edited and introduced by Carl Georg Heise. Munich: Kurt Wolff Verlag, 1928.

Resettlement Administration. *First Annual Report.* Washington: Superintendent of Documents, 1936. Photographs.

Rosskam, Edwin. *San Francisco.* Introduction by William Saroyan. In The Face of America series. New York: Alliance, 1939.

————*Washington: Nerve Center.* In The Face of America series. New York: Alliance, 1939.

Rothstein, Arthur. *The Depression Years.* New York: Dover, 1978.

Roy, Claude, and Strand, Paul. *La France de profil.* Lausanne: Editions Clairefontaine, 1952.

Rukeyser, Muriel. "Worlds Alongside." *Coronet,* October 1939, pp. 83–97.

Salomon, Erich. *Berühmte Zeitgenossen in unbewachten Augenblicken.* Munich: Schirmer/Mosel, 1978 [1931].

Sandburg, Carl. *Poems of the Midwest.* Photographs selected by Elizabeth McCausland. Cleveland and New York: World, 1946.

Sander, August. *Antlitz der Zeit.* Introduction by Alfred Döblin. Munich: Schirmer/Mosel, 1976 [1929].

————*Men without Masks: Faces of Germany, 1910–1938.* Foreword by Golo Mann; afterword by Gunther Sander. Greenwich, Conn.: New York Graphic Society, 1973 [1971].

Saroyan, William, and Rothstein, Arthur. *Look at Us/ Let's See/ Here We Are/ Look Hard, Speak Soft/ I See, You See, We All See / Stop, Look, Listen / Beholder's Eye / Don't Look Now, But Isn't That You? (Us? U.S.?).* New York: Cowles, 1967.

Schuster, M. Lincoln. *Eyes on the World: A Photographic Record of History in the Making.* New York: Simon & Schuster, 1935.

Seymour, Daniel. *A Loud Song.* New York: Lustrum, 1971.

Singer, Isaac Bashevis. *A Day of Pleasure.* Photographs by Roman Vishniac. New York: Farrar, Straus and Giroux, 1969.

Siskind, Aaron, and Logan, John. *Photographs and Poems.* Rochester: Visual Studies Workshop, 1976.

Smith, Griffin, Jr., and Harvey, David Alan. "Dallas!" *National Geographic* 166.3 (September 1984): 272–305.

Stallings, Laurence, ed. *The First World War: A Photographic History.* New York: Simon & Schuster, 1933.

Stegner, Wallace. *One Nation.* Photographs from *Look.* Boston: Houghton Mifflin, 1945.

Steichen, Edward. "The Road to Victory: A Procession of Photographs." Text by Carl Sandburg. *Bulletin of the Museum of Modern Art,* June 1942, pp. 1–22.

Steinbeck, John. *Bombs Away.* Photographs by John Swope. New York: Viking, 1942.

————*The Forgotten Village.* Photographs from the film. New York: Viking, 1941.

————*Their Blood Is Strong.* Photographs by Dorothea Lange. San Francisco: Simon J. Lubin Society, 1938.

Steinbeck, John, and Capa, Robert. *A Russian Journal.* New York: Viking, 1948.

Stieglitz, Alfred. *Georgia O'Keeffe: A Portrait.* Introduction by Georgia O'Keeffe. New York: Viking/Metropolitan Museum of Art, 1978.

Strand, Paul, and Aldridge, James. *Living Egypt.* London: MacGibbon & Kee, 1969.

Strand, Paul, and Davidson, Basil. *Tir A' Mhurain: Outer Hebrides.* London: MacGibbon & Kee, 1962.

Strand, Paul, and Newhall, Nancy. *Time in New England*. New York: Oxford University Press, 1950.

Swope, John. *Camera over Hollywood*. New York: Random House, 1939.

Taylor, Paul. "Again the Covered Wagon." Photographs by Dorothea Lange. *Survey Graphic*, July 1935, pp. 348–351, 368.

———"From the Ground Up." Photographs by Dorothea Lange. *Survey Graphic*, September 1936, pp. 526–529, 537–538.

Vance, Rupert B. *How the Other Half Is Housed*. FSA photographs. Chapel Hill: University of North Carolina Press, 1936.

Vishniac, Roman. *Polish Jews: A Pictorial Record*. Introduction by Abraham Heschel. New York: Schocken, 1965.

Wells, H. G. *The Door in the Wall and Other Stories*. Photographs by Alvin Langdon Coburn. Boston: Godine, 1980 [1911].

Welty, Eudora. *One Time, One Place: Mississippi in the Depression: A Snapshot Album*. New York: Random House, 1971.

Weston, Edward. *The Flame of Recognition*. Edited by Nancy Newhall. New York: Aperture, 1977.

White, Minor. *Mirrors Messages Manifestations*. New York: Aperture, 1969.

Whitman, Walt. *The Illustrated Leaves of Grass*. Introduction by William Carlos Williams. New York: Madison Square Press/Grosset & Dunlap, 1971.

———*Leaves of Grass*. Edited by Emory Holloway. Introduction by Mark Van Doren. Photographs by Edward Weston. New York: Limited Editions Club, 1942.

Wilson, Charles Morrow. *Backwoods America*. Photographs by Bayard Wootten. Chapel Hill: University of North Carolina Press, 1934.

———*Roots of America*. Photographs, many from the FSA. New York: Funk & Wagnalls, 1936.

Wright, Richard. *12 Million Black Voices*. FSA photographs. Photo direction by Edwin Rosskam. New York: Viking, 1941.

Yevtushenko, Yevgeny. *Invisible Threads*. Translated by Paul Falla and Natasha Ward. New York: MacMillan, 1981.

Zavattini, Cesare, and Strand, Paul. *Un paese*. Turin: Einaudi, 1955.

Notes

Introduction

1. Quoted in Vicki Goldberg, ed., *Photography in Print* (New York: Simon & Schuster, 1981), p. 264.

2. Paul Valery, "The Centenary of Photography," *Occasions*, trans. Roger Shattuck and Frederick Brown (Princeton: Princeton University Press, 1970), p. 161; Evans interview by Leslie Katz, in Goldberg, ed., *Photography in Print*, p. 368.

1. Photographs with Captions

Epigraph: MacLeish interview by Benjamin DeMott (1974), in *Writers at Work*, 5th series, ed. George Plimpton (New York: Viking, 1981), p. 26.

1. Hank O'Neal, *A Vision Shared: A Classic Portrait of America and Its People, 1935–43* (New York: St. Martin's, 1976), p. 308.

2. William Saroyan, "The Eye Looks Out," in Saroyan and Arthur Rothstein, *Look at Us / Let's See / Here We Are / Look Hard, Speak Soft / I See, You See, We All See / Stop, Look, Listen / Beholder's Eye / Don't Look Now, But Isn't That You? (Us? U.S.?)* (New York: Cowles, 1967), p. v. For a succinct discussion of ways images are always implicated with texts, see Alan Trachtenberg, "Camera Work: Notes toward an Investigation," in *Photography*, ed. Jerome Liebling, special issue of the *Massachusetts Review* 19.4 (Winter, 1978): 834–858.

3. P. V. Glob, *The Bog People*, trans. Rupert Bruce-Mitford (Ithaca: Cornell University Press, 1969), p. 31.

4. Walter Benjamin, *Illuminations*, ed. Hannah Arendt, trans. Harry Zohn (New York: Harcourt, Brace, 1968), p. 38 (Arendt's introduction quotes Benjamin's *Schriften* I, 571); Glob, *The Bog People*, p. 31.

5. Glob, *The Bog People*, p. 7.

6. William Carlos Williams, Introduction [1960] to *The Illustrated Leaves of Grass*, ed. Howard Chapnick (New York: Madison Square Press, 1971), n.p.; for "War, the Destroyer!" see *Harper's Bazaar*, March 1, 1942, p. 49; Paul Mariani, *William Carlos Williams: The New World Naked* (New York: McGraw-Hill, 1981), p. 457; Molly Holden, *To Make Me Grieve* (London: Chatto & Windus/Hogarth Press, 1968), p. 9.

7. Beaumont Newhall, *The History of Photography*, rev. and enlarged ed. (New York: Museum of Modern Art, 1982), p. 32; Susan Sontag, *On Photography* (New York: Dell, 1977), p. 69.

8. Sontag, *On Photography*, pp. 71, 73, 106; Roland Barthes, "The Photographic Message," in *Image/Music/Text*, ed. and trans. Stephen Heath (New York: Hill and Wang, 1977), p. 26. Of course Barthes never entertains any real belief in a "denotative" or objective photography; see esp. pp. 20–25 of his essay.

9. For an amusing and enlightening discussion of how different captions can change the meaning of news photographs, see Gisèle Freund, *Photography & Society* (Boston: Godine, 1982), pp. 162–173.

10. Archibald MacLeish, *Land of the Free* (New York: Harcourt, Brace, 1938), p. 7.

11. *Dorothea Lange,* intro. George P. Elliott (New York: Museum of Modern Art, 1966), p. 9; *Dorothea Lange: Photographs of a Lifetime* (Millerton, N.Y.: Aperture, 1982), p. 84.

12. Richard Wright, *12 Million Black Voices* (New York: Viking, 1941), pp. 30–31.

13. Sontag, *On Photography,* p. 106 (the sociological or historical meaning of a photograph "is bound to drain away; that is, the context which shapes whatever immediate—in particular, political—uses the photograph may have is inevitably succeeded by contexts ["art"] in which such uses are weakened"); F. Jack Hurley, *Portrait of a Decade* (Baton Rouge: Louisiana State University Press, 1972), p. 19; Wright, *12 Million Black Voices,* pp. 38–39.

14. Charles Morrow Wilson, *Roots of America* (New York: Funk and Wagnalls, 1936), pp. 100–101, 110, 116–117. Wilson miscredits the photo to Arthur Rothstein.

15. David Plowden, *The Hand of Man on America* (Old Greenwich, Conn.: Chatham Press, 1971), p. 55; Walt Whitman, *Leaves of Grass,* with photographs by Edward Weston, ed. Emory Holloway (New York: Limited Editions Club, 1942), I, 16; Arthur F. Raper and Ira De A. Reid, *Sharecroppers All* (Chapel Hill: University of North Carolina Press, 1941), pp. 180–181; John Gutmann, *The Restless Decade,* ed. Lew Thomas, with an essay by Max Kozloff (New York: Abrams, 1984), p. 73.

16. Plowden, *The Hand of Man,* p. 43.

17. Frederick Barber, ed., *The Horror of It* (New York: Brewer, Warren and Putnam, 1932), pp. 44, 50, 87, 67.

18. Laurence Stallings, ed., *The First World War: A Photographic History* (New York: Simon & Schuster, 1933), pp. 129, 131, 58, 78.

19. The definitive study of the attack and its targets in cultural myth is Paul Fussell, *The Great War and Modern Memory* (New York: Oxford University Press, 1975). For Owen, compare "poets' tearful fooling" in "Insensibility" and "'Death sooner than dishonour, that's the style!' / So Father said" in "S.I.W." Wilfred Owen, *Collected Poems,* ed. C. Day Lewis (London: Chatto & Windus, 1974), pp. 55, 37, 74. For Sassoon, compare "And the Bishop said; 'the ways of God are strange!'" in "They." Siegfried Sassoon, *War Poems,* ed. Rupert Hart-Davis (London: Faber & Faber, 1983), pp. 91, 57.

20. The sources here are Owen's "Anthem for Doomed Youth," Remarque's German title for *All Quiet on the Western Front,* Ford's novel, Hans Fallada's novel, and Rupert Brooke's sonnet.

21. Stallings, *The First World War,* pp. 220-221; Richard and Maisie Conrat, *Executive Order 9066* (Los Angeles: California Historical Society, 1972), pp. 42–43. Many of the photographs in this work—though not the one described— are by Dorothea Lange; a few are by Russell Lee.

22. Dorothea Lange and Pirkle Jones, "Death of a Valley," *Aperture* 8.3 (1960): 126–165. The contrast between captions proper and typed specification becomes a little blurred when typescript is also used for recording some populist "voices," as in "It's kind of sickening what one of those big cats can do."

23. Walker Evans, *American Photographs* (New York: Museum of Modern Art, 1938), Part I, p. 15; Dorothea Lange and Paul Taylor, *An American Exodus,*

rev. ed. (New Haven and London: Yale University Press, 1969), p. 87; Herman Clarence Nixon, *Forty Acres and Steel Mules* (Chapel Hill: University of North Carolina Press, 1938), pp. 52–53; Arthur Rothstein, *The Depression Years* (New York: Dover, 1978), p. 56; Humphrey Spender, *Worktown People* (Bristol: Falling Wall Press, 1982), p. 36. The movie adaptation of the first billboard photograph is noted in Howard M. Levin and Katherine Northrup, ed., *Dorothea Lange: Farm Security Administration Photographs, 1935–39* (Glencoe, Ill.: Text-Fiche Press, 1980), I, 36.

24. Hurley, *Portrait of a Decade,* p. 141; Margaret Bourke-White, *Shooting the Russian War* (New York: Simon & Schuster, 1942), p. 181; David Hockney and Stephen Spender, *China Diary* (New York: Abrams, 1983), p. 55.

25. Rothstein, *The Depression Years,* p. 71; Edward Steichen, "The F.S.A. Photographers," *U.S. Camera,* 1939, p. 45.

26. Steichen, "The F.S.A. Photographers," pp. 57, 46, 47, 63, 61.

27. *Walker Evans,* with an introduction by John Szarkowski (New York: Museum of Modern Art, 1971), p. 11; Richard Whelan, *Double Take* (New York: Clarkson N. Potter, 1981), p. 81.

28. Nixon, *Forty Acres and Steel Mules,* pp. 30–31; John Szarkowski, *The Photographer's Eye* (New York: Museum of Modern Art, 1966), p. 29.

29. *Dorothea Lange: Photographs of a Lifetime,* p. 115; Nixon, *Forty Acres and Steel Mules,* pp. 30–31.

30. Whelan, *Double Take,* pp. 132–133; Spender, *Worktown People,* p. 119.

2. Collaborations

Epigraph: Santayana, quoted in Vicki Goldberg, ed., *Photography in Print* (New York: Simon & Schuster, 1981), pp. 260–261.

1. Henri Cartier-Bresson, *D'une Chine à l'autre* (Paris: Robert Delpire, 1954), n.p., also published in English as *From One China to the Other* (New York: Universe Books, 1956), with a preface by Han Suyin substituted for Sartre's, in the same 1956 Delpire-Universe Books series as *From Incas to Indios,* with photos by Werner Bischof, Robert Frank, and Pierre Verger, text by Manuel Tuñon de Lara; *Fiesta in Pamplona,* with photos by Inge Morath and others, text by Dominique Aubier; and *Fiesta in Seville,* with photos by Brassaï, text by Aubier and Henri de Montherlant. "Blood, sensuality, death" alludes to the title of a Barrès book (1892) about travel in Spain; "*Bérénice chinoise*" to his *Garden of Berenice* (1891). All translations unless otherwise specified are by Jefferson Hunter.

2. "A Last Look at Peiping," *Life,* January 3, 1949, reprinted in Maitland Edey, ed., *Great Photographic Essays from Life* (Boston: New York Graphic Society, 1978), p. 79.

3. H. G. Wells, *The Door in the Wall,* with photographs by Alvin Langdon Coburn (Boston: Godine, 1980 [1911]), p. 6; Henry James, Preface to *The Golden Bowl* (New York: Scribner's, 1909), p. xi; Jeffrey A. Wolin, Afterword to Wells, *The Door in the Wall,* p. 156.

4. Roy De Carava and Langston Hughes, *The Sweet Flypaper of Life* (New York: Simon & Schuster, 1955), back cover.

5. Julia Peterkin and Doris Ulmann, *Roll, Jordan, Roll* (New York: Robert O. Ballou, 1933), jacket copy.

6. Although Vishniac often photographs scholars reading, he cannot show the extent to which Polish Jewry lived in and for its books, in its imagination, and in its examination of Scripture. As Abraham Heschel puts it, the "little Jew-

ish communities in Eastern Europe were like sacred texts opened before the eyes of God." Abraham Heschel, Introduction to Roman Vishniac, *Polish Jews: A Pictorial Record* (New York: Schocken, 1965), p. 16.

7. *Walker Evans*, intro. John Szarkowski (New York: Museum of Modern Art, 1971), p. 14; Carleton Beals, *The Crime of Cuba*, with 31 aquatone illustrations from photographs by Walker Evans (Philadelphia: Lippincott, 1933), pp. 17–18.

8. David Brower, Preface to Ansel Adams and Nancy Newhall, *This Is the American Earth* (San Francisco: Sierra Club, 1960), p. xiii.

9. Strand to Newhall, June 5, 1946, in Beaumont Newhall, ed., *Photography: Essays and Images* (New York: Museum of Modern Art, 1980), p. 299.

10. Cesare Zavattini and Paul Strand, *Un paese* (Turin: Einaudi, 1955), publisher's note; James Aldridge and Paul Strand, *Living Egypt* (New York: Horizon, 1969), p. 11.

11. Brower, Preface to *This Is the American Earth*, p. xiv.

12. Ansel Adams and John Muir, *Yosemite and the Sierra Nevada* (Boston: Houghton Mifflin, 1948), pp. 123–125.

13. Adams and Muir, *Yosemite and the Sierra Nevada*, plates 20, 33.

14. Margaret Bourke-White, *Eyes on Russia* (New York: Simon & Schuster, 1931), p. 65.

15. Lewis Hine, *Men at Work: Photographic Studies of Men and Machines* (New York: Dover; Rochester: International Museum of Photography, 1977 [1932]), n.p. Curiously, the words Hine quotes from James are not to be found in the collected version of "The Moral Equivalent of War." For commentary on Hine, see Alan Trachtenberg, *America and Lewis Hine* (Millerton, N.Y.: Aperture, 1977), pp. 118–157.

16. Minor White, *Mirrors Messages Manifestations* (New York: Aperture, 1969), p. 15.

17. Charles Baudelaire, "The Salon of 1859," in Goldberg, ed., *Photography in Print*, p. 125.

18. A. D. Coleman, *Light Readings* (New York: Oxford University Press, 1979), pp. 160–161; Clarence John Laughlin, *Ghosts along the Mississippi* (New York: Charles Scribner's Sons, 1948), plates 28, 98.

19. Laughlin, *Ghosts along the Mississippi*, plate 1.

20. "The Era of Sentiment and Splendor," *Life*, October 24, 1960, in Edey, *Great Photographic Essays from Life*, esp. p. 218; Laughlin, *Ghosts along the Mississippi*, plates 2, 3, 5, 6, 39. An earlier magazine publication of "Ghosts along the Mississippi" came in *Harper's Bazaar*, March 1, 1942, pp. 58–59, 113.

21. Jay Allen, Preface to Robert Capa, *Death in the Making* (New York: Covici Friede, 1938), n.p. See also Richard Whelan, *Robert Capa* (New York: Knopf, 1985), pp. 90–133.

22. On the documentary "you," see William Stott, *Documentary Expression and Thirties America* (New York: Oxford University Press, 1973), p. 28.

23. Wright Morris, *The Inhabitants* (New York and London: Scribner's, 1946), n.p.

24. Morris interview by Jim Alinder, September 1975, in *Wright Morris: Structures and Artifacts, 1933–1954* (Lincoln, Neb.: Sheldon Memorial Art Gallery, 1975), pp. 111–114.

25. Morris interview, *Wright Morris*, p. 112. Morris's depopulated pictures troubled Roy Stryker, to whom he had applied for work with the FSA. See Wright Morris, *A Cloak of Light* (New York: Harper & Row, 1985), p. 51.

26. Morris interview, *Wright Morris*, p. 112.

27. Wright Morris, *The Home Place* (New York and London: Scribner's, 1948), p. 5.

28. Wright Morris, *God's Country and My People* (New York: Harper & Row, 1968), n.p.; Wright Morris, "Photography in My Life," in *Wright Morris: Photographs & Words,* ed. James Alinder (The Friends of Photography, 1982), p. 47. Morris supplied words for Jim Alinder's photographs in the phototext *Picture America* (Boston: Little, Brown, 1982).

29. In *God's Country* the photograph is reversed. See Morris interview, *Wright Morris,* p. 114.

3. American Documents

Epigraph: John Berger, *About Looking* (New York: Pantheon, 1980), p. 57.

1. The names given are the fictitious ones of *Let Us Now Praise Famous Men;* the family's real name was Fields.

2. Hank O'Neal, *A Vision Shared* (New York: St. Martin's, 1976), p. 308. For confirmation of this idea—that survivors of the Depression have not conveyed the experience to their children or grandchildren—see Studs Terkel, *Hard Times: An Oral History of the Great Depression* (New York: Pantheon, 1970).

3. Walter Benjamin, *Illuminations,* ed. Hannah Arendt, trans. Harry Zohn (New York: Harcourt, Brace, 1968), pp. 83–84.

4. Berenice Abbott, *Changing New York* (New York: E. P. Dutton, 1939), pp. vi–vii; Sherwood Anderson, *Home Town* (New York: Alliance Book, 1940), pp. 4, 22. This is another work in Edwin Rosskam's Face of America series, and the photo editing and captioning may well have been by Rosskam.

5. Malcolm Cowley, "Fall Catalogue," *New Republic,* November 24, 1937, pp. 78–79; Alfred Kazin, *On Native Grounds* (New York: Reynal and Hitchcock, 1942), p. 493.

6. "I Wonder Where We Can Go Now," *Fortune* 19.4 (April 1939): 90–100, 112, 114, 116, 119–120. This text is probably by Archibald MacLeish and should be read in conjunction with his *Land of the Free* (New York: Harcourt, Brace, 1938).

7. Cowley, "Fall Catalogue," p. 78. See also Norman Cousins, "Book of the Future," *Current History* 47.3 (December 1937): 8; Margaret Marshall, "Their Faces," *The Nation* 145.23 (December 4, 1937): 622.

8. Herman Clarence Nixon, *Forty Acres and Steel Mules* (Chapel Hill: University of North Carolina Press, 1938), p. 3.

9. O'Neal, *A Vision Shared,* p. 176; Erskine Caldwell and Margaret Bourke-White, *You Have Seen Their Faces* (New York: Viking, 1937), p. 165; William Stott, *Documentary Expression and Thirties America* (New York: Oxford University Press, 1973), pp. 219–220; "Children of the Forgotten Man," *Look,* March 1937, p. 19.

10. Caldwell and Bourke-White, *You Have Seen Their Faces,* pp. 168, 9, 61, 91, 147; Robert Van Gelder, "A Compelling Album of the Deep South," *New York Times Book Review,* November 28, 1937, p. 11. See also Donald Davidson, "Erskine Caldwell's Picture Book," *The Southern Review* 4.1 (Summer, 1938): 15–25.

11. Margaret Bourke-White, "Success Story," *Fortune,* December 1935, p. 117; Edwin R. Embree, "Southern Farm Tenancy," *Survey Graphic,* March 1936, p. 150; Arthur E. Morgan, "Bench-Marks in the Tennessee Valley," *Survey Graphic,* January 1934, pp. 5–10.

12. "The South of Erskine Caldwell Is Photographed by Margaret Bourke-

White," *Life*, November 22, 1937, p. 51.

13. James Agee and Walker Evans, *Let Us Now Praise Famous Men* (Boston: Houghton Mifflin, 1960), p. 204.

14. Stott should be consulted on the important photographic changes Evans made for the 1960 edition; he added many new pictures, dropped a few, re-cropped others. See Stott, *Documentary Expression and Thirties America,* pp. 278–287.

15. [James Agee] and Margaret Bourke-White, "The Drought," *Fortune,* October 1934, pp. 78, 79.

16. Agee and Evans, *Let Us Now Praise Famous Men,* pp. 229, 307, 326, 471; Agee, Preface to Helen Levitt, *A Way of Seeing* (New York: Viking, 1965), p. 5. Agee's essay was written in the late forties; Levitt is among the photographers Agee listed as "usable" (others are Brady, Dovschenko, Evans, and Cartier-Bresson) in *Let Us Now Praise Famous Men,* p. 353.

17. Henry Miller, "The Eye of Paris," *The Wisdom of the Heart* (Norfolk, Conn.: New Directions, 1941), pp. 173, 174. See also Miller, *The Tropic of Cancer* (New York: Grove Press, 1961), pp. 189–190; for photographs, Brassaï, *Paris de nuit/Nächtliches Paris* (Munich: Schirmer/Mosel, 1979).

18. Agee and Evans, *Let Us Now Praise Famous Men,* pp. 234, 149, 324, 146, 441–42.

19. Agee and Evans, *Let Us Now Praise Famous Men,* pp. 235–36, 202.

20. Archibald MacLeish, *New and Collected Poems, 1917–1976* (Boston: Houghton Mifflin, 1976), p. 107.

21. MacLeish, Foreword to James Agee, *Permit Me Voyage* (New Haven: Yale University Press, 1934), p. 6; MacLeish, *Land of the Free,* p. 10; T. K. Whipple, "Freedom's Land," *New Republic,* April 13, 1938, pp. 311–12. For a bibliography listing MacLeish's *Fortune* articles, see Arthur Mizener, *A Catalogue of the First Editions of Archibald MacLeish* (New Haven: Yale University Library, 1938).

22. Milton Meltzer, *Dorothea Lange* (New York: Farrar, Straus and Giroux, 1978), p. 171; F. Jack Hurley, *Portrait of a Decade* (Baton Rouge: Louisiana State University Press, 1972), pp. 137–38; Roy Stryker-Dorothea Lange correspondence, April 21, May 10, and October 21, 1937, Dorothea Lange Collection, Oakland Museum; MacLeish, *Land of the Free,* p. 89.

23. See Howard M. Levin and Katherine Northrup, ed., *Dorothea Lange: Farm Security Administration Photographs, 1935–1939* (Glencoe, Ill.: Text-Fiche Press, 1980), I, 132; [Archibald MacLeish], "I Wonder Where We Can Go Now," *Fortune,* April 1939, p. 96; Meltzer, *Dorothea Lange,* pp. 220–221; Bill Ganzel, *Dust Bowl Descent* (Lincoln and London: University of Nebraska Press, 1984), p. 7; Stott, *Documentary Expression and Thirties America,* p. 249, commenting on Anderson's *Puzzled America.*

24. MacLeish, *Land of the Free,* pp. 4, 7.

25. Zöe Brown, "Dorothea Lange: Field Notes and Photographs, 1935–1940," M.A. thesis, John F. Kennedy University, 1979, II, 185; Field Notes, Dorothea Lange Collection, Oakland Museum.

26. Elizabeth McCausland, "Photographic Books," in Willard Morgan, ed., *The Complete Photographer* (New York: National Educational Alliance, 1943), VIII, 2785–2787.

27. Arthur Raper, *Tenants of the Almighty* (New York: Macmillan, 1943), Book II, Plate 22; A. D. Coleman, Introduction to MacLeish, *Land of the Free* (New York: Da Capo, 1977), n.p. Cf. the MacLeish-style phrasing of the last text comment in *The Inhabitants:* "these people are the people and this is their

land." Steichen, Sandburg's brother-in-law, picked the photographs for "The Road to Victory." For a published version of the exhibit, see the *Bulletin of the Museum of Modern Art,* June 1942.

28. Levin and Northrup, *Dorothea Lange* I, 45, 47, 132.

29. Levin and Northrup, *Dorothea Lange* I, 2; O'Neal, *A Vision Shared,* p. 75. For transcripts of all three 1935 reports, and Taylor's Commonwealth Club address, see Levin and Northrup, *Dorothea Lange* I, 45–119.

30. Paul Taylor and Dorothea Lange, "Statement in Support of Project to Establish Camps for Migrants in California," August 22, 1935, Dorothea Lange Collection, Oakland Museum; the captions are handwritten by Lange.

31. Paul S. Taylor, "Again the Covered Wagon," *Survey Graphic,* July 1935, p. 349, with photographs by Lange. Another article by Taylor with Lange pictures is "From the Ground Up," *Survey Graphic,* September 1936, pp. 526–538.

32. Lange and Taylor, *An American Exodus* (New York: Reynal and Hitchcock, 1939), pp. 148, 86.

33. Brown, *Dorothea Lange,* II, 320; Lange and Taylor, *An American Exodus,* pp. 80–81.

34. Dummy Book for *An American Exodus,* Dorothea Lange Collection, Oakland Museum. The full caption includes an extraneous interchange with a family on the highway.

35. Lange and Taylor, *An American Exodus,* p. 76.

36. Lange and Taylor, *An American Exodus,* pp. 32, 38, 46, 47, 50, 56, 91, 108, 110, 111, 121; Elizabeth McCausland, "Photographic Books," in Morgan, *The Complete Photographer,* VIII, 2793.

37. Dorothea Lange and Paul Taylor, *An American Exodus,* rev. ed. (New Haven and London: Yale University Press, 1970), pp. 122, 127, 128, 121; John Szarkowski, review of *An American Exodus, New York Times Book Review,* March 8, 1970, p. 35.

38. Lange and Taylor, *An American Exodus* (1939), p. 6.

39. Lange and Taylor, *An American Exodus* (1939), p. 6.

40. *Dorothea Lange: Photographs of a Lifetime,* with an essay by Robert Coles (Millerton, N.Y.: Aperture, 1982), pp. 152; Edwin Rosskam, Afterword to Anderson, *Home Town,* p. 144; Eudora Welty, *One Time, One Place: Mississippi in the Depression: A Snapshot Album* (New York: Random House, 1971), pp. 3, 4; M. Lincoln Schuster, *Eyes on the World* (New York: Simon & Schuster, 1935), p. 11; Elizabeth McCausland, "Rural Life in America as the Camera Shows It," *Springfield* [Mass.] *Sunday Union and Republican,* September 11, 1938, p. 6E; Maitland Edey, *Great Photographic Essays from Life* (Boston: New York Graphic Society, 1978), p. 4.

41. Oliver Wendell Holmes, "The Stereoscope and the Stereograph," in Beaumont Newhall, ed., *Photography: Essays & Images* (New York: Museum of Modern Art, 1980), p. 55.

42. See Meltzer, *Dorothea Lange,* pp. 199–200; Hurley, *Portrait of a Decade,* p. 37. See also Ganzel, *Dust Bowl Descent,* p. 8. Stryker disapproved of the retouching. For other shooting scripts, see Thomas H. Garver, *Just Before the War* (New York: October House, 1968), pp. 8–14.

43. Arthur Rothstein, "Direction of the Picture Story," in Morgan, *The Complete Photographer,* IV, 1357, 1358–59 (in *Land of the Free* MacLeish reversed Rothstein's original image); Stott, *Documentary Expression and Thirties America,* p. 61, a critical comment on Rothstein's view of the woman; Hurley, *Portrait of a Decade,* pp. 86–92; Margaret Bourke-White, *Eyes on Russia* (New York: Simon & Schuster, 1931), pp. 55–59, 82.

44. See *Walker Evans: Photographs for the Farm Security Administration, 1935–1938,* intro. Jerald C. Maddox (New York: Da Capo, 1973), photographs 200–386, for prints of the photographs not chosen; Laurence Bergreen, *James Agee: A Life* (New York: Dutton, 1984), p. 244.

45. Dorothea Lange Collection, Oakland Museum, "Contact Prints": vol. 19, photographs 38222, 38229, 38208–09, 38242; vol. 20, photograph 38258; vol. 17, photographs 38111, 38113. Cf. Lange and Taylor, *An American Exodus,* pp. 26, 35, 101, 76–79, 57. See also Meltzer, *Dorothea Lange,* pp. 218–19.

46. One recent work on authenticity in photography (and painting) is Mark Roskill and David Carrier, *Truth and Falsehood in Visual Images* (Amherst: University of Massachusetts Press, 1983). See also Joel Snyder and Neil Walsh Allen, "Photography, Vision, and Representation," and James C. A. Kaufmann, "Photographs and History: Flexible Illustrations," in Thomas F. Barrow, Shelley Armitage, and William E. Tydeman, ed., *Reading into Photography* (Albuquerque: University of New Mexico Press, 1982), pp. 61–92, 193–200; Ian Jeffrey, "Photographic Time and 'The Real World'," in Jonathan Bayer, ed., *Reading Photographs* (New York: Pantheon, 1977), pp. 84ff; Allan Sekula, "On the Invention of Photographic Meaning," in Vicki Goldberg, ed., *Photography in Print* (New York: Simon & Schuster, 1981), pp. 452–473; E. H. Gombrich, "Standards of Truth: The Arrested Image and the Moving Eye," and Joel Snyder, "Picturing Vision," in W. J. T. Mitchell, ed., *The Language of Images* (Chicago and London: Chicago University Press, 1980), pp. 181–217, 219–246; Alan Trachtenberg, "Albums of War: On Reading Civil War Photographs," *Representations* 9 (Winter, 1985): 27.

47. Roy Stryker, "Documentary Photography," and Arthur Rothstein, "Direction of the Picture Story," in Morgan, *The Complete Photographer* IV, 1372, 1357; O'Neal, *A Vision Shared,* p. 265.

48. Agee and Evans, *Let Us Now Praise Famous Men,* pp. 9, 72; Welty, *One Time, One Place,* p. 8; Christopher Isherwood, *Goodbye to Berlin,* in *The Berlin Stories* (New York: New Directions, 1963), p. 1.

49. MacLeish, *Land of the Free,* p. 89; Jonathan Silverman, *For the World to See* (New York: Viking, 1983), p. 78.

50. Daniel Seymour, *A Loud Song* (New York: Lustrum, 1971), n.p.

51. Robert Frank, *The Americans,* intro. Jack Kerouac (New York: Grove Press, 1959), p. i.

52. Bruce Jackson, *Killing Time: Life in the Arkansas Penitentiary* (Ithaca and London: Cornell University Press, 1979), p. 26; Nicholas Lemann, *Out of the Forties* (Austin: Texas Monthly Press, 1983), p. 34; Bruce Davidson, *East 100th Street* (Cambridge: Harvard University Press, 1970), intro.; Agee and Evans, *Let Us Now Praise Famous Men,* p. 7; A. D. Coleman, review of *East 100th Street,* in *Light Readings* (New York: Oxford University Press, 1979), pp. 46–47.

53. Donald McCullin, *Is Anyone Taking Any Notice?* (Cambridge: MIT Press, 1971), n.p.

54. Sontag, *On Photography,* p. 14; Coleman, *Light Readings,* p. 45. Another book extraordinarily alert to the possible exploitativeness of documentary and the difficulty of generalizing is Stephen Spender and David Hockney, *China Diary* (New York: Abrams, 1983). See Jefferson Hunter, "China Books," *Hudson Review* 37.3 (Autumn, 1984): 516–520.

55. Jackson, *Killing Time,* pp. 25, 27.

56. Robert Coles and Alex Harris, *The Last and First Eskimos* (Boston: New York Graphic Society, 1978), plate 62. For a glimpse of the work of a documentary photographer in something like the old style, Gertrude Blom, see Alex Har-

ris and Margaret Sartor, *Gertrude Blom: Bearing Witness* (Chapel Hill and London: University of North Carolina Press, 1984); O'Neal, *A Vision Shared,* p. 302. For criticism of documentary, see Allan Sekula, "Reinventing Documentary," in Lew Thomas, ed., *Photography and Language* (San Francisco: NFS Press [1976]), p. 13; Sekula, "Dismantling Modernism, Reinventing Documentary (Notes on the Politics of Representation)," in *Photography,* special issue of the *Massachusetts Review,* Winter, 1978, pp. 859–883; cf. Sekula's "photonovels" *This Ain't China* (1974) and *Aerospace Folktales* (1973). O'Neal, *A Vision Shared,* p. 302.

57. Douglas Harper, *Good Company* (Chicago: Chicago University Press, 1982), pp. 141, 142–43, 147; Harper, "Life on the Road," in Jon Wagner, ed., *Images of Information* (Beverly Hills and London: Sage Publications, 1979), pp. 27, 30. See also John Collier [an FSA photographer], *Visual Anthropology* (New York: Holt, Rinehart and Winston, 1967).

58. Ganzel, *Dust Bowl Descent,* p. 8.

59. See the discussion of Hare in Janet Malcolm, *Diana & Nikon: Essays on the Aesthetic of Photography* (Boston: Godine, 1980), pp. 159–162. Another *hommage* is presented in Jim Alinder's photograph of Stieglitz's famous "Steerage" being displayed on a TV screen: Jim Alinder and Wright Morris, *Picture America* (Boston: Little, Brown, 1982), p. 71.

60. Roland Barthes, *Camera Lucida,* trans. Richard Howard (New York: Hill and Wang, 1981), pp. 87, 47.

4. Varieties of Portraiture

Epigraph: Italo Calvino, *Difficult Loves,* trans. William Weaver (San Diego: Harcourt Brace Jovanovich, 1984), pp. 228–229.

1. Edward Weston, "Portrait Photography," in Willard Morgan, ed., *The Complete Photographer* (New York: National Educational Alliance, 1943), VIII, 2935; Nancy Newhall, ed., *The Daybooks of Edward Weston,* vol I: Mexico (Rochester: International Museum of Photography [1961]), references to Tina Modetti *passim;* Nancy Newhall, ed., *Edward Weston: The Flame of Recognition* (New York: Aperture, 1977), pp. 14, 11, 12, 37; Robert Sobieszek, Introduction to Arnold Newman, *One Mind's Eye* (Boston: Godine, 1974), pp. vii–viii. For a copiously illustrated history of photographic portraiture, see Ben Maddow, *Faces* (Boston: New York Graphic Society, 1977).

2. Roland Barthes, *Camera Lucida,* trans. Richard Howard (New York: Hill and Wang, 1981), p. 13.

3. For illustrations, see *Life: The First Decade* (Boston: New York Graphic Society, 1979).

4. *Alvin Langdon Coburn, Photographer: An Autobiography,* ed. Helmut and Alison Gernsheim (London: Faber & Faber, 1966), p. 16.

5. *Alvin Langdon Coburn,* pp. 108, 37–38; Roger Fry, Introduction to Julia Margaret Cameron, *Victorian Photographs of Famous Men & Fair Women,* rev. and ed. Tristram Powell (Boston: Godine, 1973), pp. 23–24.

6. *The Letters of Ezra Pound 1907–1941,* ed. D. D. Paige (New York: Harcourt Brace, 1950), pp. 45, 42, 53; for commentary on Coburn's relation to vorticism generally, see Richard Cork, *Vorticism and Abstract Art in the First Machine Age* (Berkeley and Los Angeles: University of California Press, 1976), II, 495–505; *Letters of Ezra Pound,* pp. 104–105; *Alvin Langdon Coburn,* p. 102.

7. *Collected Early Poems of Ezra Pound,* ed. Michael John King (New York: New Directions, 1976), pp. 34–35. Copyright © 1976 by the Trustees of the Ezra Pound Literary Property Trust. Reprinted by permission of New Directions Pub. Corp. (New York) and Faber and Faber, Ltd. (London).

8. *Alvin Langdon Coburn,* p. 24; Alvin Langdon Coburn, *More Men of Mark* (London: Duckworth, 1922), p. 10; Coburn, "The Future of Pictorial Photography," in Beaumont Newhall, ed., *Photography: Essays & Images* (New York: Museum of Modern Art, 1980), pp. 205, 207; Ezra Pound, "Vortographs," *Pavannes and Divisions* (New York: Knopf, 1918), pp. 251–252. This last piece slightly revises Pound's preface, which is reprinted in *Ezra Pound and the Visual Arts,* ed. Harriet Zinnes (New York: New Directions, 1980). For the age demanding an accelerated grimace, see Pound's "Hugh Selwyn Mauberley," II, 1–2.

9. Max Weber, *Cubist Poems* (London: Elkin Mathews, 1914), p. 11.

10. Pound, *Pavannes and Divisions,* p. 254.

11. Cork, *Vorticism,* II, 505; *Photographs by Man Ray: 105 Works, 1920–1934* (New York: Dover, 1979 [1934]), p. 42. For Rodchenko's photography, see Beaumont Newhall, *The History of Photography,* rev. and enlarged ed. (New York: Museum of Modern Art, 1982), pp. 199–215. For the German photographers, see Van Deren Coke, *Avant Garde Photography in Germany, 1919–1939* (New York: Pantheon, 1982), *passim.* For the Bragaglia photograph, see Anton Bragaglia, *Fotodinamismo futurista* (Turin: Einaudi, 1970), plate 15.

12. Richard Avedon and Truman Capote, *Observations* (New York: Simon & Schuster, 1959), p. 136; Weston J. Naef, *Counterparts: Form and Emotion in Photographs* (New York: Metropolitan Museum/E. P. Dutton, 1982), p. 123.

13. Dorothy Norman, *Alfred Stieglitz: Introduction to an American Seer* (New York: Duell, Sloan and Pearce, 1960), pp. 64, 30; Italo Calvino, *Difficult Loves,* p. 233.

14. Georgia O'Keeffe, Introduction to *Georgia O'Keeffe: A Portrait by Alfred Stieglitz* (New York: Metropolitan Museum of Art/Viking Press, 1978), n.p.; Herbert J. Seligmann, "291: A Vision through Photography," and Lewis Mumford, "The Metropolitan Milieu," in Waldo Frank, Lewis Mumford, Dorothy Norman, Paul Rosenfeld, and Harold Rugg, ed., *America and Alfred Stieglitz: A Collective Portrait* (New York: Literary Guild, 1934), pp. 117, 116, 57.

15. Sue Davidson Lowe, *Stieglitz: A Memoir/Biography* (New York: Farrar, Straus and Giroux, 1983), p. 242.

16. Dorothy Norman, *Alfred Stieglitz: An American Seer* (New York: Random House, 1973), p. 137. See also Mumford, "The Metropolitan Milieu," in Frank et al., *America and Alfred Stieglitz,* p. 51.

17. Paul Rosenfeld, "The Boy in the Dark Room," and Seligmann, "291," in Frank et al., *America and Alfred Stieglitz,* pp. 86, 118.

18. Norman, *Alfred Stieglitz,* pp. 35, 142–143; Bram Dijkstra, *The Hieroglyphics of a New Speech: Cubism, Stieglitz, and the Early Poetry of William Carlos Williams* (Princeton: Princeton University Press, 1969), p. 111.

19. Paul Rosenfeld, "Stieglitz," in Newhall, *Photography: Essays & Images,* p. 210, revised in Rosenfeld, *Port of New York* (Urbana: University of Illinois Press, 1961 [1924]); Rosenfeld, *Men Seen* (New York: Dial Press, 1925), pp. 52–53; Waldo Frank, *Time Exposures* (New York: Boni & Liveright, 1926), pp. 32, 34.

20. Gertrude Stein, *Lectures in America* (New York: Random House, 1935), pp. 176–177.

21. Gertrude Stein, "One: Carl Van Vechten," *Geography and Plays* (New York: Haskell House, 1967 [1922]), p. 199; for another portrait in words, see

Stein, "Van or Twenty Years After," *Portraits and Prayers* (New York: Random House, 1934), pp. 157–159; Wendy Steiner, *Exact Resemblance to Exact Resemblance: The Literary Portraiture of Gertrude Stein* (New Haven and London: Yale University Press, 1978), p. 160.

22. Gertrude Stein, "Alfred Stieglitz," in Frank et al., *America and Alfred Stieglitz,* p. 280.

23. Gunther Sander, "Photographer Extraordinary," in August Sander, *Men without Masks: Faces of Germany, 1910–1938* (Greenwich, Conn.: New York Graphic Society, 1973 [1971]), pp. 295, 298, 299; August Sander, "Photography as a Universal Language," trans. Anne Halley, in *Photography,* special issue of the *Massachusetts Review,* Winter, 1978, p. 677. See also Ulrich Keller, "Photographs in Context," *Image* 19 (December 1976): 1–7.

24. Golo Mann, Foreword to Sander, *Men without Masks,* p. 7. For helpful brief commentaries on Sander's typification, see Susan Sontag, *On Photography* (New York: Dell, 1977), p. 61; Walter Benjamin, "A Short History of Photography," in Alan Trachtenberg, ed., *Classic Essays on Photography* (New Haven: Leete's Island Books, 1980), pp. 210–211.

25. Alfred Döblin, Introduction to August Sander, *Antlitz der Zeit* (Munich: Schirmer/Mosel, 1976 [1929]), pp. 7, 9, 11, 10.

26. Alfred Döblin, Introduction to *Antlitz der Zeit,* pp. 12–13.

27. Rupert Vance, *How the Other Half Is Housed* (Chapel Hill: University of North Carolina Press, 1936), p. 2; Lincoln Kirstein, "Essay," in Walker Evans, *American Photographs* (New York: Museum of Modern Art, 1938), pp. 197, 195; Elizabeth McCausland, "Rural Life in America as the Camera Shows It," *Springfield* [Mass.] *Sunday Union and Republican,* September 11, 1938, p. 6E.

28. Kenneth Fearing, *Collected Poems* (New York: Random House, 1940), p. 44.

29. Muriel Rukeyser, "Worlds Alongside: A Portfolio of Photographs," *Coronet,* October 1939, pp. 86–87, 89, 90–91; Rukeyser, "We Aren't Sure . . . We're Wondering," *New Masses,* April 26, 1938, pp. 26–28.

30. Rukeyser, "Worlds Alongside," pp. 97, 93.

31. Werner Bischof, Robert Frank, and Pierre Verger, *From Incas to Indios,* intro. and cap. Manuel Tuñon de Lara, trans. James Emmons (New York: Universe, 1956), plate 17.

32. Dave Smith, "Sailing the Back River," in William Heyen, ed., *American Poets in 1976* (Indianapolis: Bobbs-Merrill, 1976), p. 348.

33. "Il avait tellement longtemps/semé le grain coupé la paille/lié les gerbes de froment . . ./qu'il était devenu de paille/belles moustaches de blé lisse/menton du chaume qui piquaille/sourcils de mil barbe en maïs . . ." Claude Roy and Paul Strand, *La France de profil* (Lausanne: Editions Clairefontaine, 1952), p. 59.

34. Roy, *La France de profil,* p. 30.

35. George Orwell, "Charles Dickens," *The Collected Essays, Journalism and Letters of George Orwell,* ed. Sonia Orwell and Ian Angus (New York: Harcourt Brace Jovanovich, 1968), I, 460; Orwell, "Extracts from a Manuscript Notebook," *Collected Essays,* IV, 515. Orwell's authorized biographer doubts that the remark about the face at fifty was actually Orwell's last. See Bernard Crick, *George Orwell: A Life* (Boston: Little, Brown, 1980), p. 400. Excerpts from *The Collected Essays, Journalism and Letters of George Orwell,* ed. Sonia Orwell and Ian Angus, vols. 1, 2, 4: Copyright © 1968 by Sonia Brownell Orwell. Reprinted by permission of Harcourt Brace Jovanovich, Inc.

36. George Orwell, "Shooting an Elephant," *Collected Essays,* I, 236, 239; Orwell, "How the Poor Die," *Collected Essays,* IV, 227–229.

37. George Orwell, "Marrakech," *Collected Essays,* I, 390–392.

38. George Orwell, *Homage to Catalonia* (New York: Harcourt, Brace, 1952 [1939]), p. 3. Copyright 1952, 1980, by Sonia Brownell Orwell. Reprinted by permission of Harcourt Brace Jovanovich, Inc.

39. George Orwell, "Looking Back on the Spanish War," *Collected Essays*, II, 264–267. There was almost a tradition of facial heroism in works about the Spanish Civil War. See Jasper Wood, Introduction to *The Spanish Earth* (Cleveland: J. B. Savage, 1938), pp. 13–14: "we see faces, faces in battle and going to battle, faces in charges and retreats, faces of young and of old, faces fired with loyalty and honor, tired faces, and faces white as chalk which will never see or grin or smile again."

40. Orwell, *Homage to Catalonia*, p. 4.

41. George Orwell, *The Road to Wigan Pier* (London: Gollancz, 1937), p. 18. Reprinted by permission of Harcourt Brace Jovanovich, Inc.

42. McCausland, "Rural Life in America as the Camera Shows It," p. 6E.

43. Jerome Liebling, portfolio in *Photography,* special issue of the *Massachusetts Review,* Winter, 1978, plate 52. For a telling contrast, see Liebling's plate 55, the photograph of a South Bronx youth breaking out of the frame of a doorway and not presenting himself for admiration.

44. George Orwell to Raymond Mortimer, 1938, *Collected Essays*, I, 299–302; Raymond Mortimer, Introduction to Bill Brandt, *The English at Home* (New York: Scribner's; London: Batsford, 1936), p. 3; Orwell, *Homage to Catalonia*, pp. 231–232. For a modern edition with many of Brandt's thirties photographs, see Bill Brandt, *London in the Thirties,* intro. Mark Haworth-Booth (New York: Pantheon, 1984).

45. George Orwell, *The English People* (London: Collins, 1944), which appeared in the "Britain in Pictures" series and was illustrated; Bill Brandt, *A Night in London,* intro. James Bone (London: Country Life; Paris: Arts et Métiers Graphiques; New York: Scribner's, 1938), pp. 4–7, 42–43.

46. Brandt, *A Night in London,* pp. 7, 13, 18.

5. Photographs Line by Line

Epigraph: Jack Kerouac, Intro. to Robert Frank, *The Americans* (New York: Grove Press, 1959), pp. iii, vi.

1. Archibald MacLeish, *New and Collected Poems, 1917–1976* (Boston: Houghton Mifflin, 1976), p. 22.

2. Louis MacNeice, *Visitations* (London: Faber, 1957), p. 28.

3. Irving Babbitt, *The New Laokoön: An Essay on the Confusion in the Arts* (Boston: Houghton Mifflin, 1910), pp. 223, 244.

4. Charles Wright, *The Grave of the Right Hand* (Middletown, Conn.: Wesleyan University Press, 1970), p. 49; Maxine Kumin, "A Family Man," in Carol Konek and Dorothy Walters, ed., *I Hear My Sisters Saying* (New York: Crowell, 1976), pp. 46–47; Helen Chasin, "Photograph at the Cloisters: April 1972," in Florence Howe and Ellen Bass, ed., *No More Masks!* (Garden City, N.Y.: Doubleday/Anchor, 1973), p. 263; Robert Lowell, *Day by Day* (New York: Farrar, Straus, and Giroux, 1977), p. 69; W. D. Snodgrass, *After Experience* (New York: Harper & Row, 1968), p. 7.

5. John Ashbery, "City Afternoon," *Self-Portrait in a Convex Mirror* (New York: Viking, 1975), p. 61; Roland Barthes, *Camera Lucida,* trans. Richard Howard (New York: Hill and Wang, 1981), pp. 66–67, 96, 49, 9, 90, 79.

6. Barthes, *Camera Lucida,* p. 88.

7. Thomas Hardy, *Complete Poems,* ed. James Gibson (London: Macmillan, 1976), p. 469.

8. R. S. Thomas, *Frequencies* (London: Macmillan, 1978), p. 36.

9. *Poems of C. Day Lewis, 1925–1972,* ed. Ian Parsons (London: Jonathan Cape/Hogarth Press, 1977), pp. 124–125; Philip Larkin, *Required Writing: Miscellaneous Pieces, 1955–1982* (London and Boston: Faber, 1983), pp. 29–30.

10. Philip Larkin, *The Less Deceived* (Hessle, E. Yorkshire: Marvell Press, 1955), pp. 13–14. Reprinted by permission of the Marvell Press, England.

11. James K. Lyon, *Bertolt Brecht in America* (Princeton: Princeton University Press, 1980), pp. 160–61; Ronald Hayman, *Brecht: A Biography* (New York: Oxford University Press, 1983), p. 165. See also John Fuegi, *The Essential Brecht* (Los Angeles: Hennessey & Ingalls, 1972), illus. 9. Brecht adapted some of his projection technique from Erwin Piscator, who favored film in his productions as giving a documentary effect.

12. Penelope Dixon, *Photographers of the Farm Security Administration: An Annotated Bibliography* (New York: Garland, 1983), p. 268; Reinhold Grimm, "Marxistische Emblematik zu Bertolt Brechts 'Kriegsfibel,' " in Renate von Heydebrand and Klaus Günther Just, ed., *Wissenschaft als Dialog* (Stuttgart: Metzler, 1969), pp. 351–379.

13. Bertolt Brecht, *Kriegsfibel* (Berlin: Eulenspiegel Verlag, [1955]), Preface.

14. Brecht, *Kriegsfibel,* p. 5. Passages from this work are described or paraphrased here, rather than quoted in full, because the Brecht Estate has refused permission for quotation.

15. Brecht, *Kriegsfibel,* p. 27.

16. Brecht, *Kriegsfibel,* p. 58.

17. Brecht, *Kriegsfibel,* pp. 9, 35, 36.

18. Brecht, *Kriegsfibel,* p. 4.

19. Brecht, *Kriegsfibel,* p. 30.

20. Brecht, *Kriegsfibel,* p. 12.

21. Yevgeny Yevtushenko, *Invisible Threads,* trans. Paul Falla and Natasha Ward (New York: Macmillan; London: Martin Secker and Warburg, Ltd., 1981), pp. 43, 10, 46. Copyright © 1981 by Yevgeny Yevtushenko. Reprinted with permission of the publishers.

22. Brecht, *Kriegsfibel,* pp. 40, 8.

23. Brecht, *Kriegsfibel,* p. 51.

24. Brecht, *Kriegsfibel,* p. 68.

25. "Blue Bug," from *The Complete Poems of Marianne Moore,* by Marianne Moore (New York: Viking Penguin; London: Faber and Faber, 1981), p. 218. Copyright © 1962 by Marianne Moore. Originally published in The New Yorker. Reprinted by permission of Viking Penguin, Inc.

26. Moore, *Complete Poems,* pp. 25, 72, 76, 17, 169, 182. Excerpts from "The Frigate Pelican" and "An Octopus" reprinted by permission from *The Collected Poems of Marianne Moore,* copyright 1935 by Marianne Moore, renewed 1963 by Marianne Moore and T. S. Eliot.

27. Moore, "Critics and Connoisseurs" and the original version of "Poetry," *Complete Poems,* pp. 38, 267.

28. Lowell, *Day by Day,* p. 127.

29. Denise Levertov, *The Freeing of the Dust* (New York: New Directions, 1975), pp. 23, 35. Copyright © 1975 by Denise Levertov. Reprinted by permission of New Directions Pub. Corp. In the same volume see also "A Letter to Marek about a Photograph," pp. 100–101. For a benigner view of photography and its uses for the poet, see Levertov, "Looking at Photographs," in *The Poet in the World* (New York: New Directions, 1973), esp. pp. 87–88.

30. Elizabeth Bishop, *Complete Poems, 1927–1979* (New York: Farrar, Straus and Giroux, 1983), pp. 159–161.

31. Bishop's interview with George Starbuck, in Lloyd Schwartz and Sybil P. Estess, ed., *Elizabeth Bishop and Her Art* (Ann Arbor: University of Michigan Press, 1983), p. 318. The episode recounted in the poem appears also in Bishop, "The Country Mouse," *Elizabeth Bishop: The Collected Prose,* ed. Robert Giroux (New York: Farrar, Straus and Giroux, 1984), pp. 32–33.

32. T. S. Eliot, *The Waste Land: A Facsimile and Transcript . . . ,* ed. Valerie Eliot (New York: Harcourt Brace Jovanovich, 1971), p. 11; Vicki Goldberg, ed., *Photography in Print* (New York: Simon & Schuster, 1981), pp. 123–126; Michael S. Harper, *Photographs: Negatives: History as Apple Tree* (San Francisco: Scarab Press, 1972), n.p.; see also Harper, "Photographs: A Vision of Massacre," *History Is Your Own Heartbeat* (Urbana: University of Illinois Press, 1971), p. 43; Dave Smith, *Dream Flights* (Urbana: University of Illinois Press, 1981), pp. 49–54.

33. A. Aubrey Bodine, "Bridge of Boats," *Chesapeake Bay and Tidewater* (New York: Hastings House, 1954), p. 78. See also Bodine, *The Face of Virginia* (Baltimore: Bodine and Associates, 1967), p. 45.

34. Dave Smith, *Cumberland Station* (Urbana: University of Illinois Press, 1976), p. 72.

35. Mary Price, "The Snapshot," *Yale Review* 70.3 (Spring, 1981): 373.

36. Bodine, *Chesapeake Bay and Tidewater,* p. 9.

37. Smith, *Cumberland Station,* p. 73; Smith, "Sailing the Back River," in William Heyen, ed., *American Poets in 1976* (Indianapolis: Bobbs-Merrill, 1976), p. 346.

38. Seamus Heaney, *Poems, 1965–1975* (New York: Farrar, Straus and Giroux, 1980), p. 191. Eight of these poems—"Bone Dreams," "Come to the Bower," "Bog Queen," "Punishment," "The Grauballe Man," "Strange Fruit" (titled "Tete Coupee"), "Kinship," and "Belderg" (titled "Beldberg")—were published separately in Heaney, *Bog Poems* (London: Rainbow Press, 1975), with illustrations by Barrie Cooke. The illustrations are nonrepresentational and contribute little. To this group should certainly be added "The Tollund Man" and "Nerthus," first collected in *Wintering Out.* All the other bog poems appeared in *North.*

39. Heaney, *Poems, 1965–1975,* pp. 86, 92–93, 121, 104, 168–169, 176–179, 182–185. For Heaney's narrow stanzas, see Blake Morrison, *Seamus Heaney* (London and New York: Methuen, 1982), p. 45.

40. Morrison, *Seamus Heaney,* p. 60; Heaney, "Viking Dublin: Trial Pieces," *Poems, 1965–1975,* pp. 178, 180–181.

41. Seamus Heaney, "Summoning Lazarus," *The Listener,* June 6, 1974, pp. 741–42.

42. Heaney, *Poems, 1965–1975,* p. 186; P. V. Glob, *The Bog People,* trans. Rupert Bruce-Mitford (Ithaca: Cornell University Press, 1969), pp. 70–79.

43. Heaney, *Poems, 1965–1975,* pp. 187–189; "Lady Moira's Account of a Skeleton Found in Drumkeragh in County Down," *Archaelogia* 7 (1785): 90–110.

44. Heaney, *Poems, 1965–1975,* pp. 127, 197; cf. Glob's plate 23, a photograph of sticks and branches that pinned "Queen Gunhild" in the bog. These sticks may influence the description of the "ash-fork staked in peat" of "Nerthus."

45. Heaney, *Poems, 1965–1975,* p. 194.

46. See Glob, *The Bog People,* plates 26, 22.

47. Heaney, *Poems, 1965–1975,* p. 190; Glob, *The Bog People,* plates 9, 14, 17.

48. Aaron Siskind and John Logan, *Aaron Siskind Photographs/John Logan Poems* (Rochester: Visual Studies Workshop, 1976), p. 9.

49. Heaney, *Poems, 1965–1975,* p. 125.

50. Glob, *The Bog People,* p. 159, plate 60.

51. Heaney, *Poems, 1965–1975,* p. 126.

52. Heaney, *Poems, 1965–1975,* p. 171.

53. Heaney, *Poems, 1965–1975,* pp. 190–191.

54. Arthur E. McGuinness, "The Craft of Diction: Revision in Seamus Heaney's Poems," *Irish University Review* 9.1 (Spring, 1979): 82.

55. Heaney, *Poems, 1965–1975,* pp. 192–193.

56. John 7:53; Leviticus 16:8.

57. Heaney, *Poems, 1965–1975,* p. 193.

58. See Robert Fisk, "Belfast Schoolgirl 'Informer' Tarred by IRA after Five-Night Ordeal," London *Times,* May 11, 1972, p. 1; May 12, 1972, p. 1; Manchester *Guardian,* November 11, 1971, p. 6; McGuinness, "The Craft of Diction," p. 84; Seamus Heaney, "Mother Ireland," *The Listener,* December 7, 1972, p. 790. For a comprehensive selection of Ulster photographs (not, however, including ones showing the tarred girls) see Clive Limpkin, *The Battle of Bogside* (Harmondsworth and Baltimore: Penguin, 1972).

59. Heaney, *Poems, 1965–1975,* p. 200.

Acknowledgments

A sabbatical leave granted by Smith College and a fellowship awarded by the National Humanities Center made the writing of this book possible. To both institutions I am deeply indebted. To the National Humanities Center, indeed, I am indebted for much more than funding: the Center's librarian, Alan Tuttle, and his associates, Rebecca Sutton and Jean Houston, located books for me; Karen Carroll, Maggie Blades, and Linda Morgan typed the manuscript with skill and astonishing speed; Richard Schramm shared ideas on Walker Evans and James Agee; and Kent Mullikin and Jean Leuchtenburg made me feel at home in North Carolina. I am grateful to them all.

Friends and colleagues interrupted their own work to read early versions of these chapters. In particular, I thank John C. Elder, Daniel Horowitz, Cushing Strout, and David Simpson for helping me understand my subject and giving me the benefit of their learning. I profited from suggestions made by R. Jackson Wilson and Morris Eaves and learned much from conversations with Charles Caramello, Phoebe Lloyd, and Leon Kass. Philip Berk improved translations from French, Alan Beyerchen translations from German. William Howarth supplied useful criticism and ideas about black-and-white photography. Alex Harris of the Center for Documentary Photography, Duke University, helped me to see from a working photographer's perspective. At the Oakland Museum, Therese Thau Heyman and Loretta Gargan guided me through the Dorothea Lange Collection. Bill Ganzel, Arnold Newman, Jerome Liebling, John Hill, and John Lawrence aided me in obtaining photographs. Martin Price and Elizabeth Harries encouraged me at the start of the project; Margaretta Fulton encouraged me at the midpoint and later helped materially with the illustrations; my discerning editor, Virginia LaPlante, encouraged me at the end, improved my phrasing, and gave me much useful advice. For all this assistance I am grateful.

For permission to reprint photographs I am indebted to the following photographers and publishers:

Frontispiece. Ralph Gibson. Gibson, *The Somnambulist* (Lustrum, 1970), p. ii. Used by permission of the photographer.

Figures 1, 65, 66, 67. Anonymous. P. V. Glob, *The Bog People: Iron-Age Man Preserved* (Ithaca, N.Y.: Cornell University Press, 1969), pp. 29, 180, 99, 110. © P. V. Glob 1965. English translation © Faber and Faber Limited, 1969. Used by permission of the publishers, Cornell University Press and Faber and Faber Ltd.

Figure 2. Dorothea Lange for the Farm Security Administration. Roy Stryker and Nancy Wood, *In This Proud Land* (Greenwich, Conn.: New York Graphic Society, 1973), p. 62.

Figures 3, 33. Dorothea Lange for the Farm Security Administration. Archibald MacLeish, *Land of the Free* (New York: Harcourt, Brace, 1938), pp. 7, 2.

Figure 4. Russell Lee for the Farm Security Administration. Richard Wright, *12 Million Black Voices* (New York: Viking, 1941), pp. 38–39.

Figure 5. Carl Mydans for the Farm Security Administration. Charles Morrow Wilson, *Roots of America* (New York: Funk & Wagnalls, 1936), p. 116.

Figure 6. David Plowden. Plowden, *The Hand of Man on America* (Old Greenwich, Conn.: Chatham Press, 1971), p. 55. Used by permission of Chatham Press.

Figures 7, 8. Anonymous. Laurence Stallings, *The First World War: A Photographic History* (New York: Simon & Schuster, 1933), pp. 131, 120.

Figures 9, 34. Dorothea Lange for the Farm Security Administration.

Figure 10. Margaret Bourke-White. *Life,* February 15, 1937, p. 10. © Time Inc. Used by permission.

Figure 11. Dorothea Lange for the Farm Security Administration. Edward Steichen, "The F. S. A. Photographers," *U. S. Camera Annual* (1939), p. 48.

Figure 12. Russell Lee for the Farm Security Administration. Edward Steichen, "The F. S. A. Photographers," *U. S. Camera Annual* (1939), p. 48.

Figure 13. Paul Strand. Public domain.

Figure 14. John Vachon for the Farm Security Administration.

Figure 15. Walker Evans. Used by permission of the Estate of Walker Evans.

Figure 16. Alvin Langdon Coburn. H. G. Wells, *The Door in the Wall* (Boston: Godine, 1980 [1911]), p. 100. Used by permission of the International Museum of Photography at George Eastman House, Rochester.

Figure 17. Walker Evans. Carleton Beals, *The Crime of Cuba* (Philadelphia: Lippincott, 1933), plate 11. Used by permission of the Estate of Walker Evans.

Figure 18. Paul Strand. Strand and Nancy Newhall, *Time in New England* (New York: Oxford University Press, 1950), p. 76. Copyright © 1950, 1971, 1976, 1980, Paul Strand Archive, Aperture Foundation, as published in *Sixty Years of Photographs,* Aperture, Millerton, New York, 1976.

Figure 19. Ansel Adams. Adams and John Muir, *Yosemite and the Sierra Nevada* (Boston: Houghton Mifflin, 1948), plate 20. Courtesy of the Trustees of the Ansel Adams Publishing Rights Trust. All rights reserved.

Figure 20. Lewis Hine. Hine, *Men at Work* (New York: Dover; Rochester: International Museum of Photography, 1977). Used by permission of the International Museum of Photography at George Eastman House, Rochester.

Figures 21, 22. Clarence John Laughlin. Laughlin, *Ghosts along the Mississippi* (New York: Scribner's 1948), plates 26, 1. Used by permission of The Historic New Orleans Collection, 533 Royal Street; accession numbers 3138, 3875.

Figures 23, 24. Robert Capa. Capa, *Death in the Making* (New York: Covici Friede, 1938). Used by permission of Magnum Photos, Inc., New York.

Figure 25. Wright Morris. Morris, *The Inhabitants* (New York: Scribner's, 1946). © 1946 by Wright Morris. Reproduced by permission of Russell & Volkening, Inc., as agents for Wright Morris.

Figures 26, 27. Wright Morris. Morris, *God's Country and My People* (New York: Harper & Row, 1968), © 1968 by Wright Morris. Reproduced by permission of Russell & Volkening, Inc., as agents for Wright Morris.

Figures 28, 31. Walker Evans for the Farm Security Administration. Evans and James Agee, *Let Us Now Praise Famous Men* (Boston: Houghton Mifflin, 1960 [1941]).

Figure 29. Walker Evans for the Farm Security Administration. Evans, *American Photographs* (New York: Museum of Modern Art, 1938), p. 39.

Figure 30. Margaret Bourke-White. Bourke-White and Erskine Caldwell, *You Have Seen Their Faces* (New York: Viking, 1937), p. 61. Used by permission of the Estate of Margaret Bourke-White.

Figure 32. Walker Evans. Evans and Agee, *Let Us Now Praise Famous Men.* Used by permission of the Estate of Walker Evans.

Figure 35. Arthur Rothstein for the Farm Security Administration. MacLeish, *Land of the Free,* p. 23.

Figures 36, 37, 40, 42. Dorothea Lange. Lange and Paul Taylor, *An American Exodus* (New York: Reynal & Hitchcock, 1939), pp. 80–81, 101, 57. Used by permission of the Dorothea Lange Collection, Oakland Museum.

Figures 38, 41. Dorothea Lange for the Farm Security Administration. Lange and Taylor, *An American Exodus,* pp. 77, 78.

Figures 39, 59. Arthur Rothstein for the Farm Security Administration.

Figure 43. Jack Delano for the Farm Security Administration.

Figure 44. Arthur Rothstein for the Farm Security Administration. Bill Ganzel, *Dust Bowl Descent* (Lincoln: University of Nebraska Press, 1984), p. 46.

Figure 45. Bill Ganzel. Ganzel, *Dust Bowl Descent,* p. 47. Used by permission of the photographer.

Figure 46. Edward Weston. Weston, *The Flame of Recognition,* ed. Nancy Newhall (New York: Aperture, 1971), p. 36. © 1981 Arizona Board of Regents, Center for Creative Photography. Used by permission.

Figure 47. Robert Frank. Frank, *The Americans.* Copyright © 1958 by Robert Frank. Reprinted by permission of Pantheon Books, a Division of Random House, Inc.

Figures 48, 49. Arnold Newman. Newman, *One Mind's Eye* (Boston: Godine, 1974), plates 189, 9. © Arnold Newman. Used by permission of the photographer.

Figure 50. Alvin Langdon Coburn. Used by permission of the International Museum of Photography at George Eastman House, Rochester.

Figure 51. Alfred Stieglitz. Stieglitz, *Georgia O'Keeffe: A Portrait by Alfred Stieglitz* (New York: Metropolitan Museum of Art/Viking, 1978). Used by permission of the Metropolitan Museum of Art.

Figures 52, 53. August Sander. Sander, *Antlitz der Zeit* (Munich: Schirmer/Mosel, 1976 [1929]), pp. 23, 60. Copyright the August Sander Archive, Cologne. Courtesy of Sander Gallery, New York.

Figures 54, 57. Dorothea Lange. Negative numbers OM 38111, OM 35024. Used by permission of the Dorothea Lange Collection, Oakland Museum.

Figure 55. Russell Lee for the Farm Security Administration.

Figure 56. Paul Strand. Strand and Claude Roy, *La France de profil* (Lausanne: Editions Clairefontaine, 1952), p. 59. Copyright © 1952, 1980 Paul Strand Archive, Aperture Foundation, as published in Paul Strand: *La France de Profil*, La Guilde du Livre, Lausanne, 1952.

Figure 58. Dorothea Lange. Therese Thau Heyman, *Celebrating a Collection: The Work of Dorothea Lange* (Oakland: Oakland Museum, 1978), p. 23. Used by permission of the Dorothea Lange Collection, Oakland Museum.

Figure 60. Jerome Liebling. Liebling, ed., *Photography,* special issue of *Massachusetts Review,* Winter, 1978, plate 52. Used by permission of the photographer.

Figure 61. Lewis Hine. Hine, *Women at Work* (New York: Dover; Rochester: International Museum of Photography, 1981), p. 23. Used by permission of the International Museum of Photography at George Eastman House, Rochester.

Figure 62. Bill Brandt. Brandt, *A Night in London* (New York: Scribner's;

London: Country Life; Paris: Arts et Metiers Graphiques, 1938). Courtesy Edwynn Houk Gallery, Chicago.

Figure 63. Anonymous (Acme). *Life,* February 20, 1939, p. 15; Bertolt Brecht, *Kriegsfibel* (Berlin: Eulenspiegel Verlag, [1955]), p. 4. Used by permission of Bettman Newsphotos, New York.

Figure 64. Aubrey Bodine. Bodine, *Chesapeake Bay and Tidewater* (New York: Hastings House, 1954), p. 78. Used by permission of Hastings House.

Figure 68. Anonymous. *New York Times,* November 11, 1971, p. 1; *Manchester Guardian,* November 11, 1971, p. 6. Used by permission of Wide World Photos, New York.

Index